A CENTURY OF
AFRICAN AMERICAN ART

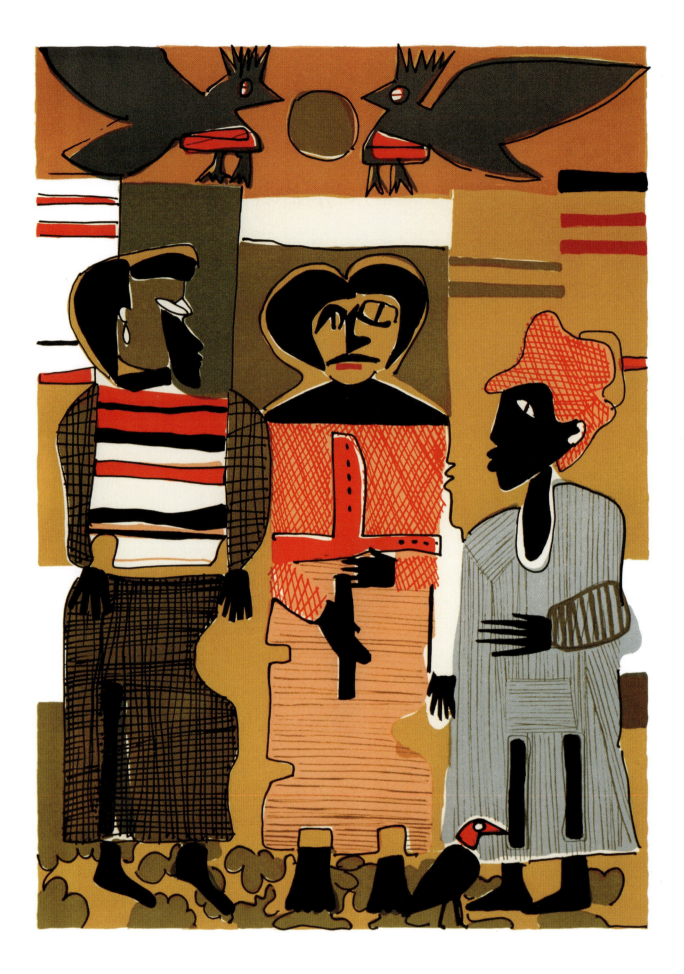

A CENTURY OF

African American Art

THE PAUL R. JONES COLLECTION

Edited by Amalia K. Amaki

THE UNIVERSITY MUSEUM, UNIVERSITY OF DELAWARE

NEWARK, DELAWARE

AND

RUTGERS UNIVERSITY PRESS

NEW BRUNSWICK, NEW JERSEY, AND LONDON

Second printing, 2006

LIBRARY OF CONGRESS CATALOGING-IN-PUBLICATION DATA

A century of African American art : the Paul R. Jones collection / edited by Amalia K. Amaki.

p. cm.

Includes bibliographical references and index.

ISBN 0–8135–3456–9 (hardcover : alk. paper) — ISBN 0–8135–3457–7 (pbk. : alk. paper)

1. African American art—20th century—Exhibitions. 2. African American art—21st century—Exhibitions.
3. Jones, Paul R. (Paul Raymond), 1928– —Art collections—Exhibitions. 4. University of Delaware—Art collections—Exhibitions.
5. Art—Private collections—Delaware—Newark—Exhibitions. I. Amaki, Amalia.

N6538.N5C45 2004

704.03'96073'007474932 dc222004000582

A British Cataloging-in-Publication record for this book is available from the British Library.

Manufactured in China

FRONTISPIECE:

Romare Bearden, *Firebirds*, 1979. Lithograph, 28 x 24 in. © Romare Bearden Foundation / Licensed by
VAGA, New York, NY. The Paul R. Jones Collection, University of Delaware, Newark.

Contents

Illustrations

President's Statement

THE OPENING of the first major exhibition of works drawn from the Paul R. Jones Collection is cause for great celebration at the University of Delaware.

The primary mission of the University is education, and we believe you will find this exhibition to be a wonderful learning opportunity. As such, we encourage you to take your time as you move about the recently renovated historic home of the collection, Mechanical Hall, and the other venues on campus where works are on display so that you can both enjoy the art from the Paul R. Jones Collection and truly experience it.

I have a special fondness for the Paul R. Jones Collection, first and foremost because the collection contains wonderful works in a variety of media created by the nation's leading African American artists and also because of the man who built and nurtured it over the course of the last four decades, devoting his life to the art and the artists who for too long had been overlooked and underappreciated.

Paul R. Jones is a most remarkable man—in all ways, a gentleman—a collector and connoisseur of admirable personal and professional qualities, and one of my very best friends.

His achievement in gathering one of the world's largest and most comprehensive collections of works by African American artists is extraordinary, and the story of his success is inspiring.

As you may know, Paul is not independently wealthy. He did not inherit a fortune with which to fund his profound interest in the arts. Rather, he was the grandson of farmers and the son of a mineworker, who later became a mining contractor, Will Jones, and grew up in a work camp near Bessemer, Alabama, where, during times of labor strife, he remembers the sound of bullets raining on the tin roofs. Paul's mother, Ella, loved to tend garden and thereby introduced her son to the beauty the world can hold.

As a college student, Paul was a victim of the restrictive Jim Crow laws of his native and beloved South, having been denied admission to law school because of his race. He persevered and went into public service, working in the fields of civil rights and housing and urban development, and spending time as a deputy director of the Peace Corps in Thailand.

Early in the 1960s, Paul's interest in the arts began to blossom. He was walking along a street in Atlanta when a sidewalk vendor selling prints of works by the masters caught his eye. Paul went over and picked up three prints, one each by Toulouse-Lautrec, Degas, and Chagall, which he framed himself and hung on the walls of his home. It soon occurred to him that if he were to begin collecting art with any degree of seriousness, he should collect originals. He began visiting museums and galleries and found that conspicuously absent from collections there were works by African American artists.

Paul determined that he would collect such works, and thus became a pioneer in the field. Over the years, he was as much social worker as collector, often providing an artist his or her next meal or month's rent in return for the opportunity to purchase their work. It was not long before the art overran Paul's modest home in Atlanta, causing him to move to a larger home. Even then, the walls were quickly filled and the art spilled over onto beds and chairs and into drawers and closets.

Paul came to realize the need for a considerably larger location for his art, a permanent home capable

of preserving and sharing his collection, and we are grateful that he selected the University of Delaware to be that home.

I am deeply appreciative of the Paul R. Jones Collection because it represents so much more than a prized donation to the University of Delaware.

It is the gift of a lifetime of collecting and an inspiring record of appreciating.

It is the gift of some of the finest examples of work by America's African American artists, artists who have contributed greatly by sharing their unique visions in the wider realm of American art.

It is the gift of collaboration, building bridges between the University of Delaware and the nation's historically black colleges and universities.

It is a gift that keeps on giving, having already been added to through a generous donation from the Brandy- wine Workshop in Philadelphia, an organization that champions cultural diversity in the visual arts, which honored Paul in 2002 with its James VanDerZee Award for lifetime contributions to the arts.

It is a gift of sharing, and through the University's respected programs in art, art history, art conservation, Black American studies, and museum studies, and through its leading edge technological resources, we plan to preserve, digitize, and display the works in the years ahead so they can be appreciated by as wide an audience as possible.

And, ultimately, it is a gift of great friendship, epitomized by Paul R. Jones, who is a bright light on our campus, particularly inspiring to our students.

The University of Delaware is deeply indebted to Paul and we thank him for his wonderful gift. We are pleased now to open the first major exhibition of the Paul R. Jones Collection to the world. Enjoy!

DAVID P. ROSELLE
PRESIDENT, UNIVERSITY OF DELAWARE

Director's Foreword

THIS INAUGURAL exhibition of the Paul R. Jones collection marks an exhilarating new departure for the University of Delaware. This stunning gift brings to the University artworks of the highest quality, by artists both well and less well known. Many among them, including Romare Bearden, Beye Saar, Jacob Lawrence, Margaret T. Burroughs, Elizabeth Catlett, Allan Rohan Crite, Roy De Carava, James VanDerZee, Benny Andrews, and Charles White, are well recognized, having been given their well-deserved place in texts and exhibitions on African American art and culture. Those who follow contemporary art may best know other artists such as Nanette Carter and Cedric Smith. Given the wide range of this collection, what impresses most about it is the consistent beauty and quality of its components.

This major collection of African American art of the twentieth and twenty-first centuries provides an important resource for study of the works themselves, the artists who created them, as well as the social and historical contexts that engendered them. The University of Delaware is well prepared to take full advantage of this collection, given its excellent resources in Black American studies, art, art conservation, art history, sociology, history, English—to mention only a few.

We are deeply indebted to Paul R. Jones for this generous gift. By choosing to give this art to an institution of higher education, Paul Jones has made a decision that will enhance our understanding of the pivotal role played by African American art within the context of American art for years to come. Students and faculty across this and other institutions will now be able to examine and discuss these works, which will undoubtedly inspire new directions in scholarship. It is, clearly, a win-win situation.

We are also deeply indebted to David P. Roselle, president of the University of Delaware, for his recognition of the importance of bringing this collection to campus. His enthusiastic support and leadership made possible the renovation of a turn-of-the-century building on campus, now fully transformed, which provides state-of-the-art facilities for the exhibition, study, care, and storage of these works of art.

The foundation of every exhibition is the expertise of its curator. For this, we are grateful to Amalia Amaki, curator of the Paul R. Jones Collection. Dr. Amaki defined the scope of the exhibition, developed the ideas presented in the catalogue, edited and contributed to the catalogue, and worked with museum staff to design an exhibition that does justice to its beautiful surroundings. Thanks also goes to the many scholars who contributed to the catalogue, representing a range of fields—from art history to sociology—that reconfirms the interdisciplinary nature of the studies that this collection invites.

I would like finally to thank all of those, too many to name, who contributed to the success of this exhibition and catalogue. These include the staff of many different offices within the University of Delaware, particularly, that of the University Museums and the Office of Public Relations; and the staff of Rutgers University Press. Many students have also already contributed to the development of this project—marking the beginning of what will be a long and mutually beneficial relationship among this unique collection, its collector, the public, and the students, faculty, and staff of the University of Delaware.

JANIS A. TOMLINSON
DIRECTOR, UNIVERSITY MUSEUMS

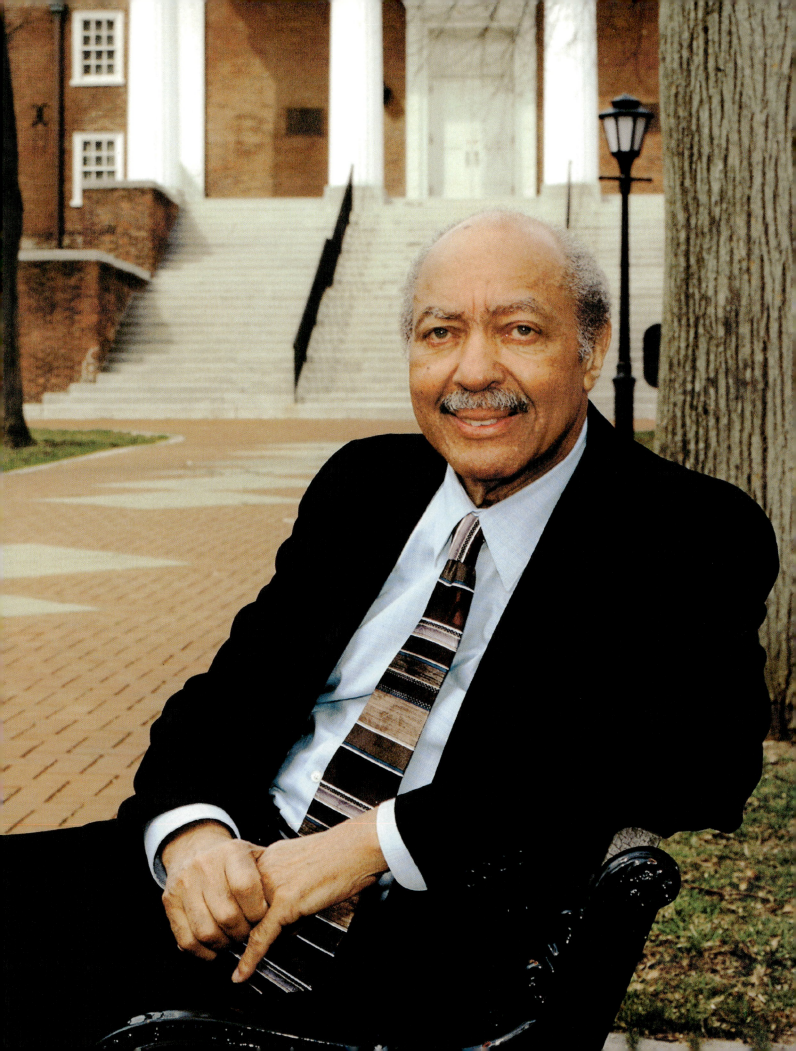

Collector's Foreword

THIS EXHIBITION and publication mark the culmination of an extensive search for the best home to house an art collection that has taken more than forty years to amass. The artworks have been more to me than precious images created by talented men and women who, in many cases, created them in the face of tremendous personal challenges; they have been true companions—like members of my family—offering daily opportunities to learn about the thoughts, expressions, and ways of living of the makers. They have spoken to me in fresh voices with each encounter, and it was important that these works be deeded to a place where they could continue to inform and enrich the lives of new discoverers. It was also important that the works be properly considered in the context of American art and that they serve as a catalyst for examining other aspects of the nation's cultural dynamics. Further, it was critical to have the artwork available to scholars, students, art lovers, and others in any number of communities via innovative educational, technological, and outreach programs.

I am pleased that the University of Delaware has accepted this challenge, assumed its leadership role, and taken initial steps that all but guarantee a successful implementation of programs utilizing the collection in campus-wide initiatives. The Paul R. Jones Lecture, anniversary celebration of the announcement of the Jones gift, and the initiation of an artist award are pivotal among the numerous annual events designed to engage a broad range of audiences. Over the past three years since the agreement, the collection has taken on a life of its own, with its number of friends steadily increasing, involving people who have truly taken the collection to heart.

I particularly appreciate the courageous leadership of President David P. Roselle. Thanks go out to the offices of the Provost and the Dean of Arts and Science. Finally, special thanks to Dr. Amalia K. Amaki, curator of the collection, whose commitment to the collection, related programs, and the University has been central to the success of projects and this exhibition.

PAUL R. JONES

FACING PAGE:
Portrait of Paul R. Jones, 2001

Introduction

"Every man is a volume if you know how to read him."

THESE CAREFULLY inscribed words are the entrée to the huge scrapbook cradling hundreds of photographs, documents, and other materials from earlier decades of the life of collector Paul R. Jones. The depth of meaning in the words is more astutely realized and more acutely felt after carefully exploring the wealth of data contained on each oversized page, and with the understanding that from his seemingly humble beginning in a small, rural, southern town to his official presence in the nation's capital, an American story is told. It is a notably significant example of the convergence of person and nation in the expressed living of a specific American.

So it is with the lives and work of the artists that are the subject of the essays in this text. While they represent the more than three hundred artists in the complete Jones collection and the sixty-six whose works comprise this exhibition, the selected artists and their corresponding artworks bring cultural currency of national origin and importance within their unique styles and approaches. The essays in this text make intentional efforts toward the de-race-ing of African American art—not stripping the works of the idiomatic cultural constructs from which they germinate, but moving away from readings grounded in strict and unnatural perceptions of previous Euro-American stylistic sources. Here, the writers' discussions are not restricted to the singularity of ethnic cloaking, but rather are legitimate attempts to peel off the many layers of conception, classification, and manifestation that brought the imagery to fruition.

Sharon Pruitt's contextualization of Bearden's photomontage and collage styles in an Archimedean metaphorical group consciousness presses the boundaries of its more typical placement within the confines of cubist-derived collage. These bounds are challenged even more by her allusions to Bearden's subjects and themes as salutation to a mythologized past expressed through social activism and facilitated by West African art aestheticism. Ann Gibson's analysis of the mark making in Nanette Carter's collage style in the *Light over Soweto* series takes into account its differentiating properties as both a protective veil and point of revelation. Gibson practically moderates multiple discussions of modernist principles of interpretation in tracing the range of meanings dispersed in a single work by Carter—its psychological mincing of outrage and proactivity that at the same time is mimetic of the physicality of the South African terrain. The southern landscape of the United States is central to Ikem Okoye's examination of the functionality of muted color in the work of Leo Twiggs. Framing his analog with questions surrounding the validity of ethnic affinity for wild coloration, he places Twiggs's palette (*Low Country Landscape*) side by side with that of Margaret Burroughs (*Three Souls*). He culminates with a discussion of color codification and its complex and inevitable association with social and political innuendos, particularly as they relate to race and class within the construct of the rural South. The paradoxical nature of color consumes the investigation of Marcia Cohen and Diana McClintock's discourse on illusion, deception, and appeal. While engaged in a curt academic exercise, they touch on the spectrum of implications of color both as an element and a structural

armature supporting an array of formal considerations in art from the Jones collection.

Carla Williams explores the relationship between image, self, and desire—the permeation of a realized ever-changing self through collective poses based upon desired appearance. Her treatment of the collaboration between the sitter and the image-maker and the expectations affecting the final product sets the stage for an examination of the photographs of Prentice Herman Polk, whose portraiture crossed multiple categories and layers of social and artistic meanings. Winston Kennedy's comments on prints as important images to African American oeuvres illuminate the print's place in history and the significance of the medium to this aspect of American art history. At the same time, he introduces creative patterns that are specific to the printmaking methods of some, such as John Wilson's translation of a Richard Wright text in a series of prints, while focusing on the individual style characteristic of others typified in other media, as seen in Jacob Lawrence's *The Library*.

Margaret Andersen offers insight into her initial work on a biography of collector Paul R. Jones, introducing the special challenges confronting a sociologist rooted in race, class, and gender who undertakes writing a biographical account. Debra Hess Norris concludes with a discussion of the care and preservation of photographs in the Jones collection in light of the vast number contained therein.

Collectively, the essays serve many functions. Some bring to brighter light the work of mature, yet underexposed artists whose careers have spanned decades. Some offer new insights into the imagery of artists whose names and works are well known. In other cases, the personal creative path of a specific work is charted and examined. And still in others, the significance of a medium evidenced in a large body of work by different artists is emphasized as a way of further investigating the contributions of individuals. The artworks are subjected to an array of cultural, social, political, psychological, and historical contexts in efforts to tap into the spectrum of interests pursued by and implied in the work of the artists in the exhibition.

In the final analysis, each writer contributes to the placement of African American art in the natural order of its existence—the order being in the context of the broader and truer realization that the life of an artwork, like that of its maker, exists within, and was formed out of an American cultural reality.

AMALIA K. AMAKI

A CENTURY OF
AFRICAN AMERICAN ART

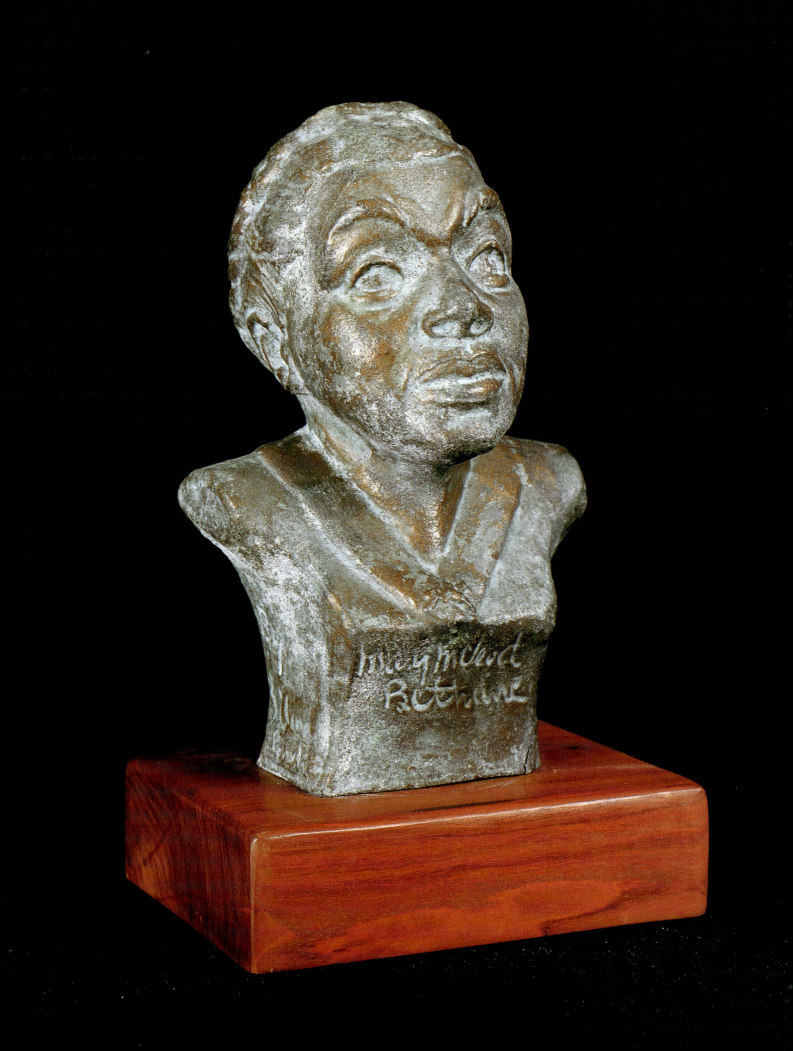

Political Sight:

On Collecting Art and Culture

AMALIA K. AMAKI

THE MAN

BUILDING AN ART COLLECTION IS RARELY PERCEIVED AS A RADICAL or political act. But there is a distinct aggressiveness to the acquisitions methodology of Paul R. Jones that suggests just that. From the beginning, he aligned collecting with social and moral responsibility, perceiving it as a necessary, though seldom acknowledged, affirmation of the intrinsic value of African American expression to the totality of American art. He approached collecting as a means to constructing community, recalling how art-related events have historically appealed to African Americans across social and other strata. Moreover, he found art so inviting and alluring that it constituted an effective mechanism for cross-cultural engagement.

Recognized as having one of the top art collections in the country,[1] Paul Jones was motivated to collect largely because of absence—too few works by African American artists on museum walls, in gallery displays, and at auctions. Though not considerably wealthy, he was sustained in his collecting endeavors by a firm belief in the cultural merit of the creativity of the artists and a respect for the inevitability of change, convinced that the time would come when the accomplishments of African American artists would be sufficiently recognized.

Intrigued by art at a young age, his maturation began in the small mining camp on the outskirts of Bessemer, Alabama, where he grew up. There, under the watchful eyes of parents Ella Reed Phillips Jones and William "Will" Norfleet Jones, and four older stepsisters, Sophronia "Sal" Phillips Sims, Maggie "Moch" Phillips Ray, Louella "Pip" Phillips, and Leah Kate Phillips Watts, he was encouraged to actively explore his surroundings—a very loving, secure, and creative environment. He was groomed in his youth to understand the subtle negotiation

and conciliation techniques that established his father as one of the most powerful men in the county. Grounded in a strong work ethic, he was raised to appreciate family, respect friends, and honor the nobility of a humble, simple existence.

Intermittent stays in the north during the school year (where his mother and sisters felt he received a better education) and frequent travel with his father exposed him to different people, situations, and ways of life. Experiences at Alabama State College, Howard University, and Yale University informed his acute awareness of the need to combat social ills based on racial prejudice proactively, strategically, and methodically. Of particular note were his years at Howard, where he encountered leading thinkers across disciplinary lines. He was exposed to such pioneering figures as artist and art historian James A. Porter (1905–1970) who wrote the first history of African American art, *Modern Negro Art,* in 1943; philosopher Alain Leroy Locke (1886–1954), the leading proponent of the New Negro movement (ca. 1917–1934) who called for "a school of Negro art" in the early 1920s to entail the conscious development of an African American style and aesthetics; and, artists Loïs Mailou Jones (1905–1998), James Lesesne Wells (1902–1993), and Alma Woodsey Thomas (1891–1978). Thomas was Howard University's first fine art graduate (1924) and founding vice president of the Barnett-Aden Gallery in Washington, DC.[2] The Barnett-Aden Collection may possibly have played a small yet significant role in the formation of interest or strategies in the collecting of Paul Jones.

Beyond art, Jones had contact with such illustrious Howard professors as political scientist, statesman, and Nobel Peace Prize recipient Ralph J. Bunche (1904–1971), who was Undersecretary General to the United Nations between 1951 and 1971, and played a key role behind the scenes of the 1965 Selma to Montgomery march. Other prominent professors that he encountered were sociologist E. Franklin Frazier, author of the 1939 study, *The Negro Family in the United States,* and John Hope Franklin (b. 1915), one of the nation's most celebrated historians and author of the literary landmark *From Slavery to Freedom* (1947). Elsewhere, Jones associated with activists Fred L. Shuttlesworth, Charles Evers, Ralph David Abernathy, Martin Luther King, Jr., and other figures on the forefront of the push for equity in America during the civil rights era. Before and after his Howard experiences, Jones profited from rich engagements with extraordinary people in all walks of life and art-related matters. Occasional visits to art venues, interactions with leaders of the art world, and recollections of his mother's award-winning gardens provided additional wealth of diverse experiences that gradually coalesced to prime Paul Jones for the leadership roles he assumed as a nationally recognized conciliation specialist, successful businessman, and pioneer art collector.

For Jones, art became a conduit of the outward expression of a private passion—to bridge distinct communities through a broad-based understanding of the African American cultural tradition as a part of American life and heritage. To this end, he considered it an imperative that visual expressions from the African American constituency assume their proper, inseparable placement within the study and history of American art. "As a young boy, it was instilled in me to respect education, especially higher education, because I was told it was the place where serious quests for truth took place. It is time for a more complete understanding and treatment of American art that properly weaves in the part played by so many omitted African Americans."[3] While the art holds a special place for him in its own right, he remains most enamored with the tenacity of the people who create it. Inquire about the collection in general and Jones will deliver a ten-minute overview of its content, his buying strategies, and why he has entrusted so much of it to the University of Delaware. Ask about a specific work in the collection and he will potentially present an hour-long, detailed discussion of the artist's life, work, how he came to know him or her, and his view of that person's relevance to the overall cultural identity of America. As he frequently states: "the sheer essence of art collecting is expression and communication in the company of many nationalities of artists. Its variety of statements,

and its diverse forms and techniques attest to its intended catholicity."[4]

THE MISSION

Collections, as a rule, are identified with the predominant classification of its inclusive objects, emphasizing a descriptive era, style, media, movement, national culture, or geographical region. When the art makers in a collection are racially defined, the ethnic group heading supersedes other descriptions, even the dominant slant in terms of style, theme, period, or medium, a habit that tends to perpetuate overgeneralized, superficial treatment (if any) of the work of individual artists and the body of images as a whole. The objectives of the collector of these racially tagged holdings are usually minimized similarly. Little to no consideration is afforded the fact that their selection process is likely driven by cultural directives and data that contribute to both a deeper knowledge of the various modes of ethnic expression and a broader understanding of what American art truly encompasses.

The collector of the African American model, like his or her counterpart with other emphases, chooses specific works of art in the presence of a vast range of alternatives. The selected works reflect a particular spectatorship, appropriation, or acknowledgment on the part of the collector formed by any range of preferences, assumed meanings, personal taste, or the art historical/art critical phenomena referred to as a good eye. Collecting patterns are phenomena worthy of examination in their own right. The two fundamental lurking questions at the heart of the collecting act—Why buy? and How high?—assume drastically different connotations in America when the art in question is produced by African Americans. Such collections are seldom taken seriously as exemplars of American art, and are generally pigeonholed into monolithic interpretations of black experience or oversimplified chronologies. As art historian Richard J. Powell writes: "When black people—be they college students, office workers, politicians, or visual artists—come together as a socially cohesive ideologically kindred group, we assume that the reason for the assembly has to do with race. Why? Because race—and specifically racial and cultural 'blackness'—has a peculiar way in Western society of obliterating all existing subtleties, specifics, nuances, and complexities, especially in the cultural and social dominion."[5]

In building his collection, Paul Jones purposely challenged existing canons of art buying and connoisseurship. He was not unaware of the prevalence of what cultural critic Cornel West refers to as "xenophobic America's suspicion that black artists do not measure up to the rigorous standards of high art."[6] He simply dismissed it, confident that he and other collectors possessed indisputable evidence to the contrary; adamant in his belief that, eventually, cracks in the illogic would come, at which time appropriate works would gain warranted, if overdue, acceptance.

In "making the careful selections he was compelled to make," Jones avoided establishing a marginal, panoptical, encyclopedic view of African American art by "basing purchasing decisions on character rather than conduct," namely, seeking purpose in the specific object instead of buying blindly based solely on the reputation of the artist. In deference to the few obvious black favorites of the art establishment, he remained most intrigued by firsthand discoveries of well-trained, highly skilled artists who were underexhibited, underrepresented, and thus, practically hidden from view. He rejected the historical survey as a collecting approach, and rather than looking through catalog listings as a guide, preferred to trust his own judgment and the work of living artists.

Jones believed the climate of the civil rights era charged, enhanced, and spawned creativity within the African American artist community to an extent unmatched by any previous period in the nation's history.

The March on Washington permanently altered America. And with the utmost respect for what [Bayard] Rustin and [A. Phillip] Randolph and [Martin Luther] King and all the other people on the front line and behind the scenes pulled off, it had the tremendous impact that it did because a certain determina-

tion was enlarged in this country. The climate was set. People would not be denied. It was a politically charged momentum that could not be stopped. That climate, that mood and motion—that energy and drive of the era was facilitated and fed to some degree by the creative expressions and energies of talented black artists. I came to really know "Kofi" Bailey and John Riddle [pl. 2] and others well in the smoke of that period. Almost every aspect of the movement engaged artists and used their images to get the word out and to get people out.[7]

In the midst of this activism, Jones, ironically, discerned an indelible inclusion of African American expression within the American construct. He perceived transcultural significances and meanings even in the codified references to racial distinction, affirmation, and documentation. Identifying art as a credible and luring vehicle around which the multicultured American creative spirit could be unified, Jones saw a greater potential in the art he acquired beyond gathering and sharing for the sake of inspiring others to collect. In the process, his personal approach changed, resulting in his essentially looking "to" the art rather than merely looking at it. "There is something invaluable about certain works of art that speaks to the very essence of an experience or feeling or acknowledgment when words fall short . . . it's like an extension of poetry."[8]

Continuing to operate outside of more typical acquisition modes and avoiding the ritual of trend buying, Jones occasionally purchased work that he "did not understand by artists he did not know [were not well known]" because, in the collector's words: "something in it [the image] drew me in . . . and I trusted it to take me somewhere. . . . I became awfully curious about it and did not have to know everything at that moment . . . there was this mystery."[9] Frequent engagements with these objects in his home did not always produce definitive answers. But he continued to value the experience the exploration provided. He "learned to accept the fact that it [the image] was whatever it was, even if there were no specific words to define it."[10] Submitting to the curious nature of the object, he began making connec-

tions with other visual experiences and events. In so doing, he effectively made a certain disconnect with art history in deference to a more culture-based contextualization of the image.

This practice calls to mind the thinking that Nicholas Mirzoeff espoused in discussions of the visualization of things that are not actually visual and the propensity for modern and postmodern society to place a premium on rendering experience in visual terms.[11] Commenting on the process of visualizing as a collective of sensory experiences, Mirzoeff states: "Visual culture directs our attention away from structured, formal viewing settings like the cinema and art gallery to the centrality of visual experience in everyday life."[12]

It was precisely the daily in-home interaction with acquired objects that initiated the rethinking and subsequently the restructuring of viewing habits on the part of Paul Jones. Drawing associations from a spectrum of sources in order to explore more fully the art he acquired and admired, Jones became aware of the increasing reliance on the visual in the course of any given day. Further, he seemed fascinated by the impact of time on the delicate balances of such powerful concepts as then and now, us and them, in and out—indices constructed and perpetuated by societies whose preference is to gaze rather than to visualize.

So often I have been amazed by lengthy, eloquent, intellectual speculations about a single aspect of a work of art on the part of an art historian or critic when the artist's immediate reaction was that they were not thinking about any of that when they made it. My first thought was—the artist is here . . . why don't you ask? Then I began to realize there was a lot at stake when you take to heart the fact that the subject—what you see—is affected by how you see it. I also began to think about the psychology of art, the politics of art and the business of art. That, in turn, made me even more aware of the need to free up conversations about art—open up the exchange and conduct different discussions around art—bring in different voices and different ways of seeing.[13]

What Jones suggests has more to do with communicating across a redefined, perhaps arbitrary line than it does with encroaching on the recognized role of the art historian or critic. His comments further touch on an even more complex issue, namely, the need for a different vocabulary to parallel the visual dictionary of media taking center stage in our current lives. As Jones points out: "artists are constantly responding to new visual experiences. As a collector and lover of art, more and more, I want to stay in tune with the kinds of things that capture the artists' imagination and that they think speaks to their time and their experience."[14]

Irit Rogoff in the essay "Studying Visual Culture" examines the role and nature of "vision as critique" through challenging queries about intellectual standards and practices in the field of art history that touch on similar observations to those expressed by Jones. In her comments, she, too, addresses the need for a new language to investigate more purposely and a new dialogue about visual experiences, especially encounters with works of art. Elaborating on her belief that "one cannot ask new questions in an old language," she examines the allegiance of the academy to what may be described as the traditional/historical approach to considering an image. In making a case for the intellectual feasibility of investigations that emerge out of individual inquisitiveness rather than conditioned response, Rogoff concludes that asking old questions will invariably perpetuate old knowledge.

> When I was training as an art historian, we were instructed in staring at pictures. The assumption was that the harder we looked, the more would be revealed to us; that a rigorous, precise, and historically informed looking would reveal a wealth of hidden meanings. The belief produced a new anatomical formation called "the good eye." Later, teaching in art history departments, whenever I would complain about some student's lack of intellectual curiosity, about their overly literal perception of the field or of their narrow understanding of culture as a series of radiant objects, someone else on the faculty would always respond by saying "Oh, but they have a good eye."[15]

By allowing a variety of visual tools collectively to inform his perception, and ultimately his purchasing habits, Jones essentially amassed a collection that became recognized for its uniqueness as much as its eclecticism. He essentially deconstructed the Eurocentric/Western traditional connoisseurship model and made individual selections based on considerations of multiple issues including more recent currents specific to popular culture.

His frame of reference ultimately extended beyond the shores of the United States to reflect, in particular, a certain awareness of art trends and developments from various parts of Asia, Africa, Central America, and South America as well as North America and Europe. Of note is his acknowledgment of the fact that modernism was a worldwide phenomenon, and not a movement exclusive to the European-centered Western world.[16] He further took into account the questionable relationship existing between certain galleries, museums, art critics, and art historians in the United States, a cooperation that, to his mind, potentially jeopardized the legitimacy of an art community in pursuit of true innovative, informative, compelling, and important expression.[17]

Deeply concerned about the minimal representation of imagery by African Americans in the matrix of American art arenas, he focused his attention acutely on their work. An initial affinity for figurative work led to purchases that were, in varying degrees, reminiscent of the styles of late nineteenth-century European painters Edgar Degas, Marc Chagall, and Henri de Toulouse-Lautrec—makers of images that had interested him earlier.[18] As his sphere of appreciation quickly expanded and his willingness to take risks grew, he began to include a broad range of subject matter and approaches undertaken by young, mid-career, and mature contemporary African American artists. Almost simultaneously, ideas about the collection's use became more clear. His primary objective became not only to build a broad-based collection of work by contemporary artists but to lend actively to different groups, organizations, and institutions in order to bring as much attention as possible to the work so that others might begin to collect work by African American artists.

Pressing toward this goal, Jones explored every available avenue to gaining sufficient insight, knowledge, and experience to inform wise collecting. He visited artists in their homes, studios, and at art shows, engaging them in discussions of music, sports, food, foreign affairs, and an array of other topics in addition to art. He became a regular attendee of art openings of work by artists of every conceivable background. He frequented exhibition receptions, artist talks, gallery tours, and lectures at venues across the country. He deliberately sought out and interacted with writers and speakers on the subject of African American art, African American culture, American art, and American culture. He familiarized himself with the most independent-thinking educators, curators, and museum directors in the field. He was an ardent reader of exhibition catalogs, artist biographies, reviews, articles, and books. In the process, his passion for art deepened and his intent toward collecting became more determined.

THE MODEL

Having fine-tuned the negotiation skills he inherited from his father during his many years as a governmental employee—including federal work at the White House and as deputy director of Peace Corps in Thailand—Jones developed into a shrewd bargainer who seized every opportunity to make a wise purchase.[19] He had an equal regard for all artists, whether they enjoyed a local, regional, or national reputation. By the late 1960s, the word was rapidly spreading throughout the African American art circuit about his willingness to purchase works across the spectrum of development and achievement. Ten years later, artwork had overtaken his home, consuming the existing wall space—including that in his baths and kitchen. Art was stored in closets, dresser drawers, armoires, and bookcases as well as under beds and behind doors. As the collection grew, so did his determination to improve the visibility of the artists' works.

At the same time, Jones was gaining recognition as "a trailblazing collector who bought art based on the merit of the work and the artist's need to make a sell as much as the person's reputation," according to artist

Jenelsie Walden Holloway, who brought a few artists to his attention. Referring to Jones as "a dean of African American collectors," Holloway was amazed by his diligence in both buying art and establishing lifelong relationships with artists.[20] "He single-handedly kept some artists going by encouraging them to continue to do their work and insisting that over time, someone would appreciate what they were doing."[21]

Jones shared the collection with the same conviction with which he acquired it. With so few collectors liberally lending their collections to a comprehensive array of venues—he loaned generously and never charged a fee—he endeared himself over the years to any number of Historically Black Colleges and Universities (HBCUs), small businesses, community groups, churches, and other alternative spaces. W. W. Law, a founder and director of the King-Tisdell Cottage in Savannah, Georgia, stated in 1985, "Paul's generosity to the institute has put us on the map" (pl. 3).[22] Reacting to the amount of media coverage afforded the Jones exhibition when it was on view, Law appreciated the attention it brought to the organization as well.[23]

Since 1968, Jones has loaned work to more than one hundred exhibitions and has allowed in excess of thirty complete shows to be formed from his collection and seen in forty-two states. While he loaned to such venues as the Los Angeles County Museum of Art, the Walker Museum, and the Smithsonian Institution, he did likewise for the Phoenix Art Center, Eastern Illinois University, and Alabama State University. He loaned the first African American art exhibition to the Parthenon in Nashville, Tennessee (1976), emphasizing the inclusion of work by David C. Driskell (b. 1931), Earl Hooks (b. 1927), and Ted Jones, who were Tennessee-based at the time. Years later, the Marietta-Cobb Museum of Art hung art from the collection in all of its galleries, marking the first occasion in the history of the institution that a single exhibition was presented throughout the museum.

Serving as head of the Model Cities program in Charlotte, North Carolina, between 1968 and 1970, Jones hung art throughout the city. He loaned "A Collection of Negro Culture Art" to a local Savings and Loan in 1968

(pl. 4). In 1973 works from the collection were mounted for a month in the auditorium of a Unitarian church located just north of Atlanta, Georgia. Later that same year, a show was mounted in the Alma Simmons Gallery at Frederick Douglass High School in Atlanta. Simultaneous shows occurred at the High Museum of Art and Spelman College in Atlanta. Selections from the collection have been placed on loan in the mansion of one governor (Florida) and the offices of another (Georgia). Although fulfilling his mission has sometimes put the art at some degree of risk, Jones maintains a commitment to "closing the knowledge gaps" pertaining to African American artists.

Some of these shows were reminiscent of the pioneering exhibitions held at churches in Baltimore and Philadelphia in the mid-1800s, and at YMCAs, public libraries, and the national headquarters of the NAACP in New York around the turn of the twentieth century.[24] Like Bishop Daniel A. Payne, Reverend John Cornish, Arthur Alfonso Schomburg, and others who spearheaded these early presentations, Jones was determined to facilitate artists in establishing a track record of shows that would in turn aid them in gaining future exhibition opportunities. In making the art accessible to viewers who might not otherwise have an opportunity to see it, he created a potential means of enticing an unlikely group toward the collector pool. In other instances, he felt that exposing young students firsthand to the breadth of artistic expression among African Americans would, perhaps, nurture future interest in their becoming collectors and also assist educators in becoming more knowledgeable of African American art as a part of American culture. He also maintained the desire for the work to be considered for its distinct quality and its content. As historian Henry Louis Gates, Jr., is quoted in *Multiculturalism: Roots and Realities* (2002): "a rigorous multiculturalism promotes the inclusiveness that is committed to closing conceptual gaps and that also offers fresh images of human excellence."[25]

Despite the likelihood that many borrowers outside the African American community were motivated by the voyeuristic platform an exhibition provides rather than a genuine interest in the objects as visual emissaries of individual expression, collective creative prowess, or national significance, Jones continued to believe in the potential of the work to impact change.

THE COLLECTION

The Jones collection, rapidly approaching 2,000 works, contains paintings, drawings, photographs, prints, sculpture, batiks, quilts, assemblages, and mixed media works by artists from every region of the country and most of the fifty states. The collection spans the first decade of the twentieth century through the present, the greatest number of works were created after 1960. The art reflects an array of subjects, styles, and materials, and the nature of many pieces, like most successful works of art, lends itself to a range of investigative angles. The large-scale painting *Countdown* (1981) by James Little (b. 1952) is a quintessential statement of the principles of multiple approaches evenly conveyed in a single image. The work successfully incorporates elements of collage, quilt-making, abstract expressionism, and color field painting while also referencing the textile tradition, coloration, and (oversized) flags of sub-Saharan Africa. Linda Goode-Bryant and Marcy S. Philips, co-writing on the theory of contextures—a concept defining any number of post-1970s abstract, transient approaches employed by African American artists where clarity and definition (reality) are dependent upon the contextual and transitive process used by the artist, and the synthesis through which the context whole of a given reality is presented—considers Little's juxtaposition of colors and styles within one canvas jolting.[26] They further point out that the artist "encloses, almost imprisons, his active brushy surface with bordering stripes."[27] In addition to framing the work in a general study of abstraction, any one of these linkages could initiate an insightful examination of his work. The same applies to the imagery of painter Bill Hutson (b. 1936). In his 1987 work on raw canvas, entitled *Maiden Voyage* (pl. 5), Hutson, like Little, brings a definite sense of physicality to the surface of the image. Adding to that quality, he incorporates a system of overlapping and intersecting fields that creates an overall

spatial ambiguity that is enhanced by linear overlays and interplays of color and emphasized edges. Ample opportunities exist for such scrutiny in many other works, including art by Howardena Pindell (b. 1943), Alvin Smith (1933–2001), Jack Whitten (b. 1939), Frank Bowling (b. 1936), and others. In fact, one of the collection's most amazing properties is the possibility that, given its scope and despite its eclecticism, many works converge at various points that make varied formal and content examinations possible.

One-on-one interaction with artists became something of a Paul Jones trademark. In addition to becoming seriously engaged with individual artists, he vigorously explored the various aspects of creative processes in attempts to understand more thoroughly how artists worked, what motivated them, where their ideas came from, and how they developed their individual techniques. There were artists that he periodically subsidized, making purchases he otherwise might not have made except that funds were needed by the artists to pay their next month's rent, buy the next meal, or to purchase a ticket home. Herman "Kofi" Bailey (1931–1981) was one of the artists whose work he gladly received under similar such circumstances. They initially met on the recommendation of close friend, Lillian Miles Lewis, who, while working in Special Collections at the Atlanta University Trevor Arnett Library, knew of Jones's interest in art. Born in Chicago, Illinois, but a long-time resident of Los Angeles, Bailey created works that were dramatically influenced by the social climate in America during the 1960s and 1970s. He had strong personal ties with historian, writer, editor (*Crisis*), and activist William Edward Burghardt (W.E.B.) Du Bois (1868–1963) and President Kwame Nkrumah of Ghana, both of whom informed much of his imagery, particularly his interest in Pan-African models and depiction of well-known African American contemporary and historical subjects. He created a series of lithographs to support the efforts of the Student Nonviolent Coordinating Committee (SNCC) under the leadership of militant student activist and friend Stokely M. Carmichael. Bailey's talent was also utilized for projects supporting the efforts of the Southern Christian Leadership Con-

ference (SCLC) on the invitation of another prominent associate, Martin Luther King, Jr.

Working primarily in charcoal and conte crayon—a compound of graphite and clay—Bailey drew heavily from observations of people in Ghana, operating during his extensive stays there as official artist to the president. He was equally sensitive to the African American leadership at home, which he perceived to be courageous and fearless during a most turbulent time in America. Being something of a periodic fixture around the Atlanta University Center, having served as artist in residence at Spelman College and sold artworks to faculty and administrators across all of the campuses, Bailey was embraced by the city with the level of familiarity and affection usually confined to local talent. His talent and accessibility led Jones to acquire six original works, including his signature work (pl. 6), *Woman Grinding Peppers* (1973). In this work, Bailey characteristically creates a soft, linear portrayal of a somber, solitary female figure engrossed in daily activity, situated within a lyrical, monochromatic, and atmospheric background.

Jones took a personal interest in everyone he supported, especially younger artists. The premiere example is his long-standing relationship with Amos "Ashanti" Johnson (b. 1950), a prolific draftsman, printmaker, and painter born in Berkley County, South Carolina. Johnson was just beyond his teens when he met Jones. He had studied at Syracuse University and greatly admired the work of Charles White (1919–1979). Taking a lead from White, Johnson hoped to establish his reputation on powerful portrayals of the dignity, pride, and resilience of African Americans. The popularity of White's work peaked around the decade between 1970 and 1980 when Johnson was an art student and thinking seriously about a full-time art career. He became nearly obsessed with White's work, approaching it as if under the tutelage of the renowned artist. Johnson studied his imagery religiously, and, in a manner inspired by the traditional French Academy, he sat almost daily in front of actual works and reproductions of pieces by White, literally copying them in attempts to fine-tune his own drafting skills. In some cases, he created versions of White's images by imitating his technique stroke by stroke. Like

White, as an artist he put a premium on meticulous draftsmanship, and saw realist presentations as an effective means to conveying a sense of cultural identity. Johnson's best technical achievement is *The Original Man* (1968), a reversed-tone pastel drawing addressing notions of the evolution of man, and alluding to the fundamental relatedness of all people (pl. 7). With the background blacked out, the multiethnic head appears to float out of infinity. Jones was drawn to the work because it was purely imagined, and not designed to capture the likeness of a model—the skill for which the artist was best known. At one point, Jones had over sixty works by Johnson in the collection, the number decreasing as the result of donations to museums and purchases by individuals new to the collector ranks.

Leo Twiggs, a batik artist based in Orangeburg, South Carolina, was rethinking his commitment to a practicing artist career when he became acquainted with Jones. Settled in a teaching position at South Carolina State College (currently University) where he was having a strong positive impact, Twiggs was not exactly pleased with the way his art sells were going. Jones owned a piece of his work (pl. 8), *Old Man with Wide Tie* (1970), purchased at an Atlanta University Annual Art Competition and Exhibition (AU Annual). Responding to an invitation by the artist, Jones attended a 1974 opening of his solo exhibition at a library in Gainesville, Georgia. Unknown to him at the time was the fact that Twiggs was close to making the decision to withdraw from the profession. Jones, in usual fashion, publicly identified the four works he intended to buy. Twiggs, not very familiar with him at that point and being a bit despondent about selling, was skeptical. When he received payment for the works, he feared the check would bounce. Not only did the check turn out to be good, but so was their relationship—and the future of Twiggs as an artist. Ten years later, when he had a one-person show at the Studio Museum in Harlem, Twiggs surprised Jones with a signed exhibition poster with the notation: "To Paul, who knew when to buy it early . . . My first collector. Best of luck, Leo Twiggs."[28]

There were countless instances when an ability to act expeditiously paid off for Jones in terms of an important acquisition. Such was the case when he obtained (pl. 9) the etching *Return to the Tomb* (ca. 1910) by Henry Ossawa Tanner (1859–1937), the most renowned African American artist of the nineteenth and early twentieth centuries. Jones spotted Tanner's name on a list of artists whose works were advertised in an auction announcement in a Sunday edition of the *Atlanta Journal/Constitution*. Realizing the auction was in progress as he read, he rushed to the location, eased into an empty seat in the rear of the auction hall, and inquired on the status of Tanner's work from the stranger seated beside him. He learned that there was a single Tanner entry—an etching, which was pulled because no one offered the minimum. Surmising that the pool of bidders probably did not know who Tanner was, he rushed to find a staff person as soon as the auction ended. Making the necessary contacts, Jones agreed to pay the minimum requested and took possession of his wrapped (concealed) purchase sight unseen. It was not until he arrived home and removed the brown paper wrapping that he laid eyes on his acquisition for the first time. The Tanner etching not only gave Jones an example of work by the first African American artist to become internationally known and respected, it added an important historical dimension to a collection that emphasized work produced after 1960.

Two people played noteworthy roles in assisting Jones in building further depth in his collection early on—Norah McNiven, director of public relations at Atlanta University and coordinator of the AU Annual, and Hans Bhalla, chair of the Art Department at Spelman College. The AU Annual, officially initiated as "The Annual Exhibition of Paintings, Prints, and Sculpture by Negro Artists of America," occurred every April between 1942 and 1970. Conceived by artist and educator Hale Aspacio Woodruff (1900–1980), the juried show brought national attention and patronage to more than nine hundred African American artists from around the country[29] and included the presentation of acquisition awards. With so few outlets for their work, the Annual attracted work by the most advanced African American artists at the time.

McNiven learned of Jones's affinity for younger, emerging, and underrepresented artists in addition to

those who were established. Committed to ensuring that the work of every participating artist was marketed in such a way that it might sell, she quickly introduced herself to Jones, and began routinely walking him through the entire pool of entries before the shows were mounted. On several occasions, she did so prior to the selection process. This enabled him to make leisurely purchases with discretion and without the competitive pressure of opening night. Via this method, he secured the work of twenty-two entrants, including Philadelphia painter Benjamin Britt (1927–1996), New Orleans–based artist Eddie Jack Jordan (b. 1927), and Maryland painter Jimmie Mosely (1927–1974). Source of some of his earliest acquisitions, the AU Annual was also the event where he saw the work of additional artists for the first time which he would later acquire. A few examples were Chicago artist William Carter (1919–1997), who was the first recipient of the Annual's prestigious John Hope Award,[30] Arthur L. Britt (1934–1986), and Freddie Styles (b. 1944), a painter who participated in the last Annual exhibition. Although the historical annual ended in 1972, during its run Jones had made the acquaintance of Bhalla, which would prove beneficial later as they became friends, and Bhalla began to facilitate meetings between Jones and artists.

Bhalla was a photomontage artist and painter from Pakistan whose work Jones purchased. As their relationship developed, Bhalla became increasingly familiar with Jones's particular tastes and interests. Consequently, when Jamaican artist Barrington Watson's work became available at the close of an exhibition at the High Museum of Art in Atlanta, Georgia, Bhalla successfully touted the artist's softly painted watercolor (pl. 10) of a reclining semi-nude female to Jones. In his capacity as host of Spelman's art openings, he extended personal invitations to Jones to attend events. He arranged private dinners and small, informal social gatherings where the collector could better interact with exhibiting artists, and shared information about additional contacts with him on a regular basis. Through Bhalla, Jones met, bought work, and established lifelong friendships with more than a dozen important national artists, two of the most accomplished being Hale Woodruff and Charles White.

Although Jones and Woodruff were neighbors, living in the same apartment building on Carter Street in northwest Atlanta for the better part of a year, they would formally meet in connection with Woodruff's exhibition at Spelman College in 1974. Gathering after a meal at the home of fellow collector William Arnett, who at the time was acquiring African art, they continued the discussion of the work on view at the college. The conversation quickly evolved into a lengthy, intellectual dialogue on African art aesthetics and its significance to modernism and African American art traditions. Woodruff did most of the talking, commenting on its influence on his work, including that on exhibit at Spelman. Jones subsequently purchased *Monkey Man #2* (1971), one of the works Woodruff had discussed (pl. 11). Intrigued by the body of work in its own right, and even more enamored with it because of the passion witnessed by the artist, Jones added a painting from the series almost ten years later. This painting was in turn sold to a younger couple after several years who were relatively new collectors and who searched vigorously for Woodruff's work.

Bhalla was also responsible for the collector meeting and befriending Charles White. Within moments of their introduction, Jones and White were almost completely in awe of one another—White in appreciation of an African American collector that he knew well by reputation and Jones for being in the presence of a major artist that he greatly admired. Once again, the occasion for their meeting was an exhibition at Spelman College. Aware that Bhalla brought in leading artists in spite of limited funds, Jones volunteered to host a reception for White at his home following the opening. Having done so, and once the crowd had departed, the two men relaxed for the remainder of the evening with a bottle of scotch—White's drink of choice. According to Jones, they "talked until the wee hours of the morning" touching on any number of topics ranging from the artist's WPA days and his experiences with the Mexican muralists he encountered in that country to "the special challenges confronting the Black artist in America."[31] They maintained contact, mostly via late-night telephone conversations initiated by White. Within the first year of contact, as Jones con-

sidered which of his works to pursue, White arranged for his dealer in California to give Jones "the family discount" as he did not get involved in the business end of the art enterprise. Jones acted quickly, purchasing four pieces—*John Henry* (1975), *Nude* (1970), *Wanted Poster Series # L-5* (1970, gifted in the late 1980s to the High Museum of Art in Atlanta), and a second print that he subsequently sold to a close friend, Dr. Calvin McLarin, to facilitate his building a collection. He later added, in separate purchases, a graphite drawing, *Prophet* (1936), and an etching on a sterling plate entitled *Vision* (1973). These additions marked a partial shift in emphasis on the part of the collector as he began broadening the base of the kinds of art sought, targeting work by established artists while maintaining an interest in that of emerging and younger practitioners.

Bhalla was also the source of the initial meeting between Jones and a promising young artist named David Driskell. Once again, they met at an art reception for Driskell at Spelman College. Although Jones did not make a purchase from that show, Driskell invited him to another, two-man show at Fisk University of his work and that of sculptor Earl Hooks while they were on the faculty there. Jones purchased five works by each artist from the show. His acquisitions of Driskell's 1973 works were *Woman in Interiors, The Worker, Ghetto Girl, Masked Man,* and another painting, sold to a younger aspiring collector. His purchases by Hooks included *B. B. King, Torso, Bust of Woman, Untitled* (Faces), and *Man of Sorrows,* his signature work. Hooks's pieces were significant in that they boosted the sculpture component of the collection. Jones eventually added to this sector with a bust of Mary McLeod Bethune by Selma Hortense Burke (1900–1995), and *Michael* (ca. 1950), a bronze work by William E. Artis (1914–1977). Both artists were involved, to varying degrees, with presenting noble, positive portrayals that moved away from pointed presentations of suffering and victimization, and were highly representational. Their pieces contrasted the abstract references to human form in the monochromatic works by Hooks.

The person largely responsible for the collection containing a strong African American abstract and non-objective component is New Jersey–based art consultant Ed Anderson. Formerly in community relations for AT&T, Anderson amassed an impressive private collection of nonrepresentational art by African Americans during the 1970s and 1980s. When he decided to liquidate in 1990, Anderson immediately contacted Paul Jones. The acquisition of ten major works by leading African American abstractionists added considerably to the depth to Jones's overall holdings, bringing to the collection works by Howardena Pindell, Alvin D. Loving, Jr., Alvin Smith, Nanette Carter, Jack Whitten, James Little, Bill Hutson, and Frank Bowling.

Untitled #35 (1974) represented a popular body of work by Pindell that burst onto the national art scene in the early 1970s. Reflecting her personal approach to a minimalist treatment of color, surface, edges, line, and texture, her untitled and numbered dot pieces series also addresses issues related to process-oriented painting and construction/assemblage art. She created the images by painting old cancelled checks, reconfiguring them with a hole-puncher, and meticulously gluing the resulting dots to a support. The act of recycling thus transforms her personal, recorded past into a statement that lacks specificity, and renders her safe from her past, namely, anonymous, although the data defining her former self (past) remains in an abstracted, distorted state.

Among the other paintings enriching the abstract sector was Jack Whitten's *Annunciation XVIII* (1979) and two untitled mixed media drawings from 1977 (pl. 12). Representing his interest in abstraction that was cemented in the late 1960s, the works incorporate the optical energy characteristic of work from the period within a grid field that evolves out of his related knowledge of architectural drawings. Although he typically works in a very large format, his smaller canvases in the *Annunciation* series of paintings and the drawings read, technically, as compressed statements on subtle variations of intersecting vertical and horizontal linear, color elements. Like the canvases of De Stijl painter Piet Mondrian (1872–1944), Whitten's insistence on order, clarity of line, cube formats, and allusions to primary colors simplifies an otherwise highly complex image to the point of symbolic significance. At the same time, the works are spatially ambigu-

ous, intriguing, and mysterious. Jones began to see the potential for these artists' work to become as celebrated in the future as that of Jacob Lawrence (1917–2000) and Romare Bearden (1911–1988). Both these artists, over and above their distinguished careers within the context of American art, rose to significant levels of influence in terms of their stylistic affect on generations of African Americans artists and others. Their creative references and responses to photography, fact-derived allusions to universal concepts with the African American face as its model, reporting style utilizing the series format, and their manipulation of spatial contexts that infuse unusual, alternative perspectives have set a stage that will soon be shared with artists from subsequent generations.

LAST, BUT NOT LEAST

Photography as a medium and a conscious component came later to the Jones collection. The collector had obtained a portfolio of slightly more than fifty images of scientist George Washington Carver by Prentice Herman Polk in 1978 when the photographer printed a set for the U.S. Parks Service (which was absorbing the Carver Museum and other spaces on Tuskegee's campus). Polk, who served the University for fifty years, shared in common with Jones the fact of being born in Bessemer, Alabama. Jones's presence on campus—assisting the president with development affairs for one year—led to their meeting and being close friends until Polk passed in 1984. During this time, Jones collected more than one hundred of his photographs. Before Polk's death, Jones encouraged a number of institutions and organizations to develop projects around his work. Most notable among the developments was a project undertaken in 1979–1980 by Nexus Contemporary Art Center (currently The Contemporary) in Atlanta that resulted subsequently in several of his negatives being restored, the creation of a special portfolio containing eleven images, and the publication of a limited edition (1200) photography book, *P. H. Polk: Photographs* (1980), by Nexus Press. One-man shows followed, including a traveling exhibition—"Alabama Album: The Photographs of Prentice H. Polk"—ad-

ministered by the Southern Arts Federation and mounted in 1985, which toured the southeast for more than twelve years. In 1992, when the Paul R. Jones Collection was brought to the attention of the University of Delaware, William Innis Homer, H. Rodney Sharp Professor and Chair of the Department of Art History, was particularly drawn to the body of work by Polk. Homer expressed interest in Polk's "effort to record the personalities and physical plant at Tuskegee."[32] The introduction of Polk's work to the university through the Jones collection inspired one of the institution's art history graduate students to pursue his photography as master's research topic and resulted in Delaware mounting yet another one-person exhibition—"Through These Eyes: The Photographs of P. H. Polk" (1998). Just as loans and collaborations contributed to the broadening of public knowledge of the important work of Polk, the Jones collection would bring other mature and gifted artists in the medium various levels of visibility.

Five years after making the initial Polk purchase, Jones acquired two works of James VanDerZee's (1886–1983) best known images (pl. 13), *Couple in Raccoon Coats* (1932) and *The Barefoot Prophet* (1928), adding a portrait of one of Marcus Garvey's soldiers (1924) three years later. Examples of work by other distinguished photographers were quickly added to the collection, including three works by Roy DeCarava (b. 1919), three by Carrie Mae Weems (b. 1953), eighteen by Bert Andrews (1929–1993), three by Frank Stewart (b. 1949), two by Clarissa Sligh (b. 1939), and two by Adger W. Cowans (b. 1936).

Later, Jones was introduced to an unusual portfolio by photographer Ming Smith Murray, and he immediately began buying. To date, the collection contains more images by Ming Smith Murray than any other photographer other than Polk. The more than fifty prints are a mix of black and white, painted black and white, and color images of roughly forty personalities in the performing and visual arts fields. Spanning the period from the 1970s to the present, her most striking and dramatic work is *Katherine Dunham and Her Legacy* (1984). In speaking to the grace, elegance, and solitude associated with individual performance and personal achievement, the work also addresses the fragility of the

diva state (pl. 14). Its fleeting and haunting nature is conveyed through Murray's decision to focus on a mannequin wearing Dunham's characteristic costume and fans. Portraits of the "real" Dunham in the act of dancing appear tightly cropped in the rear. Her robe (costume) and her role (dancer) are presented in a celebrated fashion on the one hand; however, at the same time, they come across as a somber memorial of her life and career in a potentially shocking way—when the fact of the mannequin as a fake or a dummy is perceived as a metaphor for the unreality of celebrity and the fickleness of stardom. It is this quality in her work—luring the viewer in with pretty, well-designed compositions that gradually reveal points of tension—that drew Jones to Ming's work.

Jim Alexander's visual record of the final decades of the life of legendary jazz great Duke Ellington, stark portrayals of numerous other entertainers, and photo essays of the rural south are among the works of living photographers that serve prominent roles in the context of performance imagery. Others include John H. Cochran, Jerome Miles Wolf, Leonard Mainor, and William Crite.

Certain artists represented in the collection are best known in the southern region although their career paths have granted them considerable exposure in all regions of the country. Gerald Straw (b. 1943), one of the founders of the publication *The Black Photographer's Annual,* enjoys a solid reputation as the recorder of America's rapidly changing urban terrain. Straw is joined in terms of broad exposure with William ("Onikwa Bill") Wallace and Lawrence Huff. William Anderson (b. 1932), who also works in other media, is most recognized for his photography.

The third largest group of photographs by a single artist in the collection is by William Anderson (pl. 15), with almost twenty images included. Having known Anderson for many years, Jones successfully promoted the photographer's work to fellow collectors, museum curators—for acquisitions and shows—and exhibition organizers.

As with the work in other media, the vast number of photographs in the Jones Collection present diverse subjects, styles, techniques, and points of view on any number of issues. Likewise, they collectively speak to the talents and interests of African American practitioners, and are appropriate models for broader discussions and examinations within the context of American art. The photographic component also exposes the open-mindedness of collector Paul R. Jones, reflecting his ability to follow the urges of artists in a variety of material-based modes of expression and his willingness to be inclusive where others have been reluctant.

While the attention may rest momentarily upon the name The Paul R. Jones Collection, what has been imparted to the University of Delaware is a mammoth trust. It is a trust that is, perhaps, best demonstrated metaphorically within the written words of gratitude from an artist yearning to know visibility in an art world that has been conditioned by, or at least has practiced, shortsightedness. The letter reads:

> Mr. Paul Jones, you are like Superman when I was 6 years old—my hero! . . . It was a pleasure meeting you on your journey to Chicago in August. Listening to you speak about collecting art was a great inspiration for me. After hearing you speak, I jumped back into my studio and started painting like a madman. Since then I've had three shows and all were a success. Especially the Chicago Jazz Festival, where my piece was selected to be the official logo. . . . Please accept this token of my appreciation . . . a signed Chicago Jazzfest poster. . . . I hope to see you again soon in our travels, and please continue to inspire people to collect art. Without people like you there would be no me. [Jason E. Jones, Evergreen Park, Illinois][33]

1 Bobbie Leigh and Rebecca Dimling Cochran, "Top 100 Collectors in America," *Art and Antiques* 26 (March 2003): 86

2 Alma Thomas became vice president of the Barnett-Aden Gallery in 1943 on the invitation of Howard professor James V. Herring, who founded the art department and was her former teacher and mentor. Herring co-founded the gallery with Alonzo J. Aden (the gallery was named in honor of his mother Naomi Barnett Aden) who served as curator of Howard's gallery for ten years. The Barnett-Aden Gallery was initiated in the northwest Washington, DC, home where Herring and Aden resided. Adolphus Ealey directed the gallery, which presented work by artists regardless of race or creed.

3 Paul Jones commenting at the opening reception of the exhibition "Original Acts: Photographs of African American Performers in the Paul R. Jones Collection," at the University of Delaware, February 2002.

4 This comment was in the "Collector's Note" in the catalog to the exhibition, *Master Works Selected from the Paul Jones Collection*, Schatten Gallery, Robert W. Woodruff Library, Emory University, in 1984.

5 "Immeasurably Unbound" in the exhibition catalog *African American Art: Twentieth-Century Masterworks,* II, Michael Rosenfeld Gallery, 1995, 5.

6 For a more detailed discussion of West on this topic and related issues see the essay "Horace Pippin's Challenge to Art Criticism," in Kymberly N. Pinder, ed., *Race-ing Art History: Cultural Readings in Race and Art History* (New York: Routledge, 2002).

7 Collector Paul R. Jones speaking at the Arts Exchange during the second National Black Arts Festival in Atlanta, Georgia, July 1990, in conjunction with the exhibition "The Paul R. Jones Collection Master Works."

8 Comments made to Spelman and Morehouse College students during a guest lecture for the History of African American Art course at Spelman in the fall semester 1997.

9 Collector Paul R. Jones speaking to Atlanta University Center students at the Robert Woodruff Fine Arts Building auditorium at Spelman College, February 11, 1990, in conjunction with the opening of the exhibition "Photographs: The Paul R. Jones Collection—A Decade of Collecting."

10 Ibid.

11 For a thorough reading on Nicholas Mirzoeff and visual culture studies consult the following: Nicholas Mirzoeff, *Introduction to Visual Culture* (New York: Routledge, 1999), (1st and 2d eds., Routledge, 1998 and 2003) and Nicholas Mirzoeff, ed., *Diaspora and Visual Culture: Representing Africans and Jews* (New York: Routledge, 2000).

12 Nicholas Mirzoeff, ed., *The Visual Culture Reader* (London and New York: Routledge, 1998), 6

13 Paul Jones has repeated this comment in various terms over many occasions, but did so publicly for the first time during a collector's talk at the King-Tisdell Cottage in Savannah, Georgia, in 1984. It was during the opening reception for the exhibition "Selected Works from the Paul R. Jones Collection," marking the first exhibition at the site of borrowed works from a private collection.

14 Jones speaking at a conference, "Lens 2003," at North Georgia College and State University in Dahlonega, Georgia, October 10, 2003.

15 Irit Rogoff, "Studying Visual Culture," in *The Visual Culture Reader,* ed. Mirzoeff, 17.

16 While U.S. Deputy Director of Peace Corps in Thailand during the Richard Nixon administration Paul Jones traveled extensively throughout Asia (especially Southeast Asia) in the early 1970s, and made trips to Central and South America later in that decade into the 1980s. His excursions were primarily for art viewing and to gain firsthand knowledge of their cultural life. The trips heightened his awareness of art movements and important artists in these regions. During this time, he also became an avid reader of materials on the various regions and art approaches in Africa. Between 1970 and 1980, he collected roughly 150 African art objects, representing almost every region of the continent.

17 His desire to minimize the influence of the gallery/museum/critic structure on his acquisition decisions led him practically to dismiss the gallery as a source of buying art in the early decades. He became somewhat known as a collector who bought exclusively from artists out of their studios.

18 Among the first objects that Jones placed on the walls of his home were reproductions of paintings by Degas, Chagall, and Lautrec, which he placed in raw frames that he stained himself. He purchased the frames from a local discount store. He holds on to these reproductions as reminders of his humble beginnings as a collector.

19 In addition to having held a White House staff position, his governmental experience included serving as Executive Secretary to the Jefferson County (Birmingham, Alabama) Interracial Committee, Probation Officer and Referee in the Juvenile and Domestic Relations Court of Jefferson County, United States District Court Probation Officer in San Francisco, Community Relations and Conciliation Specialist for the Department of Justice in Washington, DC, Citizen's Participation Advisor for Model Cities Program with Housing and Urban Development (HUD), Director of the Office of Civil Rights, National Highway Safety Bureau (Department of Transportation) in Washington, DC, United States Embassy Team as Deputy Director in Thailand, Southeast Regional Director of ACTION, and, Southeast Regional Director of Minority Business Development Enterprise (Department of Commerce).

20 Jenelsie Walden Holloway chaired the Spelman College department of art for more than thirty years. She knew Jones during most of that time and made comments about his role as a collector during the reception to the Herman Bailey memorial exhibition in 1981.

21 Holloway, commenting at Spelman College art opening in 1990.

22 Comments made at the reception to the exhibition February 3, 1985, and repeated in a handwritten letter to Paul Jones in March 1985, the Paul R. Jones Archives, Atlanta, Georgia.

23 Both local papers, the *Savannah News Press* and the *Herald,* published articles promoting the February opening and a local television station taped a brief segment during the reception.

24 See the unpublished dissertation, "The All-Black Exhibition in America, 1963-1976: Its History, Perception, and the Critical Response" (Emory University, 1994) by Amalia K. Amaki for a thorough review of the history of these and other African American art shows.

25 Henry Louis Gates, Jr., "The Lives Grown Out of His Life: Frederick Douglass, Multiculturalism, and Diversity," in C. James Trotman, ed., *Multiculturalism: Roots and Realities* (Bloomington: Indiana University Press, 2002), 5.

26 Linda Goode-Bryant and Marcy S. Philips, *Contextures* (New York: Just Above Midtown, Inc., 1978), 39.

27 Ibid., 19.

28 Paul R. Jones Archives, Atlanta, Georgia.

29 Tina Dunkley in "Clark Atlanta University Galleries," in Richard J. Powell and Jock Reynolds, *To Conserve a Legacy: American Art from Historically Black Colleges and Universities* (Cambridge, MA: MIT Press, 1999), 18.

30 The John Hope Award was the Annual's top honor and carried the name of Atlanta University's president. Hope founded the AU Center (Spelman, Morehouse, Morris Brown, Clark Atlanta University, and a theological seminary).

31 Paul Jones and Charles White knew each other by reputation before their first face-to-face meeting at the opening of White's work at Spelman College in 1973. As cited in the brochure to the exhibition, *The Paul R. Jones Collection: Art and Everyday Life* (Marietta Cobb Museum of Art, 1999): "Moments after being introduced, Jones and White became almost completely enamored with one another—White was in appreciative awe of an African American who [was not wealthy but] was vigorously buying art by Black artists; Jones was in awe of White's talent and presence as a major artist."

32 William I. Homer, "Foreword," in *African American Art: The Paul R. Jones Collection* (Newark: University of Delaware, 1993).

33 September 2003 letter to Paul Jones, the Paul R. Jones Archives, Atlanta, Georgia.

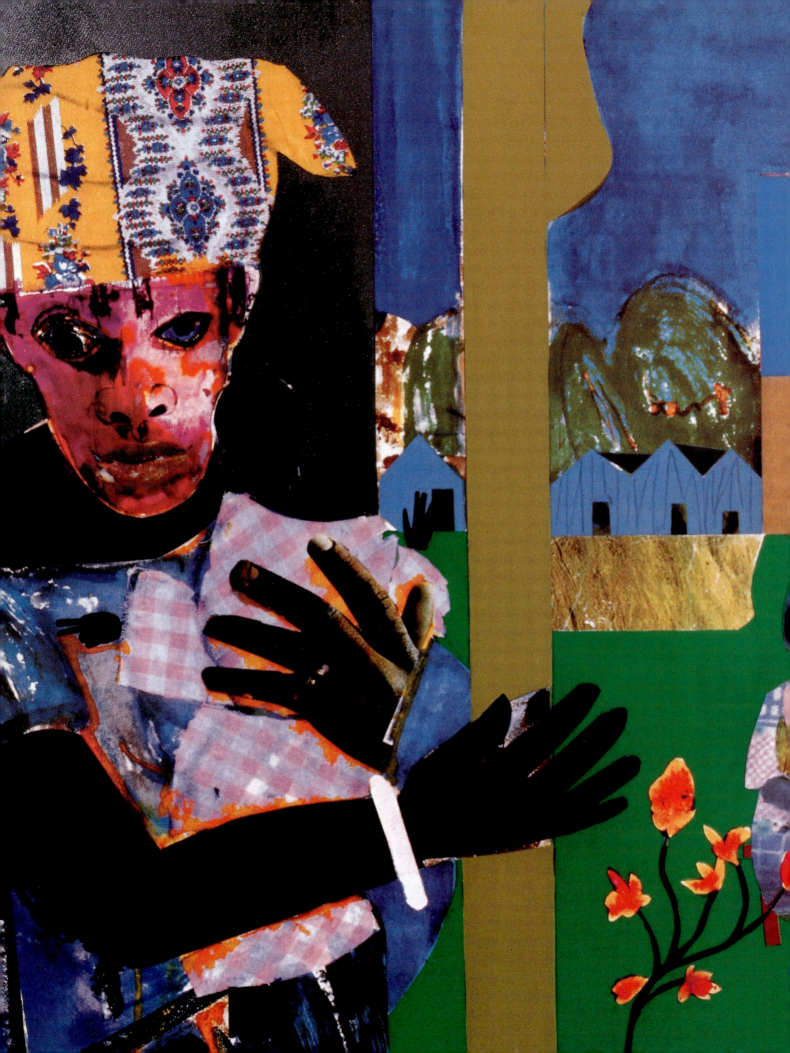

Collage and Photomontage:

Bearden's Spiralist Reflections of America and Africa

SHARON PRUITT

I suggest that Western society, and particularly that of America, is gravely ill and a major symptom is the American treatment of the Negro. The artistic expression of this culture concentrates on themes of "absurdity" and "anti-art" which provide further evidence of its ill health. It is the right of everyone now to re-examine history to see if Western Culture offers the only solutions to man's purpose on this earth. —Romare Bearden

R OMARE BEARDEN, AMERICA'S PREMIERE COLLAGIST OF THE twentieth century, began working in the medium in the early 1960s while affiliated with the Spiral Group, a coalition of African American artists in New York. His initial collages and photomontages were created in efforts to participate artistically in the civil rights movement. The works were narratives inspired by contrasting regions in the United States—the urban north and the rural south—and resonate with a global awareness of art including the Parisian cubist aesthetics and collage technique, the Berlin dada aesthetics and photomontage technique, and the traditional West and Central African aesthetics and motifs. Finally, Bearden's works indicate the complexity of defining a black identity in art during an era when racial tensions were exploding in the United States.

The identity of the African American, not simply confined to a region in America, is also realized by both the disconnect from African culture resulting from European infractions, and a reconnection to the motherland encouraged by American movements and philosophies fostering black pride and black history. Similar to African American artists of the "New Negro Movement," which dates to the earlier part of the twentieth century, Bearden reinforced the philosophy to appropriate African American and African imageries and concepts within a Euro-American art context.

According to Bearden, his oeuvres are not re-creations of social protest events. They do not depict violent mistreatment of African Americans.[1] Nevertheless, after careful scrutiny of his art and philosophy, it is apparent that Bearden's approach to the creative process and his artistic images reflect reactions to social maladies. However, social maladies cannot be assessed effectively without considering the political and economic status of the individual. There is much evidence that Bearden was a socially and politically conscious artist who created images suitable for didactic lectures on Black History, Black Pride, and Racial Equality.

BEARDEN'S EDUCATION AND EARLY ART CAREER

Born in 1911 in Charlotte, North Carolina, Bearden, an only child, moved with his family to New York City's Harlem when he was around four years old. His family was extremely mobile as he grew up, spending a year in Moose Jaw, Canada, when he was in the third grade, and also spending time with his maternal grandmother in Pittsburgh. Finishing most of his primary education and the first two years of high school in New York City, he graduated in Pittsburgh. When Bearden was in school in New York City, his family spent the summers with his paternal grandparents in Charlotte.[2]

Bearden spent part of his freshman year in college attending Lincoln University, a historically black male university in Pennsylvania. He attended Boston University for two years, and was graduated from New York University (NYU) in 1935 with a bachelor's degree in mathematics. As early as 1932, Bearden knew about George Grosz, a Berlin dada artist who immigrated to the United States after World War I. A year after graduating from NYU, he entered the Art Students' League in New York in order to study drawing under Grosz. With Grosz's guidance, Bearden improved his cartoon drawings from previous work for Boston University's *Beanpot,* NYU's *The Medley,* and the *Baltimore Afro-American,* a nationally distributed newspaper.

In 1950, Bearden studied philosophy in Paris at the Sorbonne. Not inspired to paint in Paris, he returned to New York and became a writer of jazz music. "Seabreeze," recorded with Billy Eckstine, became a hit in the mid-1950s.

The only African American to hold major exhibitions at the Samuel Kootz Gallery, a mainstream gallery in downtown New York, Bearden also exhibited paintings at the Whitney Museum of American Art. Both exhibitions received positive reviews from such acclaimed publications as the *New York Times, Art Digest,* and *Art News.*[3] During this period, Bearden supplemented his art income with full-time employment as a welfare caseworker in New York's Department of Social Services, a position he held with few interruptions until 1966.[4] In the 1960s, while affiliated with the Spiral Group, Bearden's fame increased and he developed a new form of expression—collages and photomontages.

THE FORMATION OF THE SPIRAL GROUP

The civil rights movement of the 1960s spawned the Spiral Group. Under the leadership of Bearden, Norman Lewis, and Hale Woodruff, the members mobilized to establish collective visions, examine their cultural identity, and explore the possibility of defining a black aesthetic. As purveyors of black cultural life, the artists sought to empower themselves through this process of self-examination and self-discovery.

Spiral members also responded to a movement initiated by A. Philip Randolph,[5] a prominent civil rights labor leader who spent his career working to get better jobs and equal opportunities for African Americans. In 1935, after negotiating for ten years, Randolph successfully unionized the porters in the Pullman Company, the nation's largest employer of African Americans at the time. He was the architect of the cancelled March on Washington, DC, in 1941 by the Brotherhood of Sleeping Car Porters, and was the brain behind the March on Washington in 1963.[6]

Bearden was particularly suited to identify with Randolph's political concerns since his father, Howard, worked as a steward for the Canadian railroads. In addition, when the family settled in New York City Bearden's mother, Bessye, was very active in Democratic party politics and often entertained politicians in their home.[7]

Randolph encouraged Bearden and other New York artists to define their role in the civil rights movement. Bearden met and befriended many artists in the Harlem Artists Guild and the "306 Group,"[8] some of whom were formerly members of the Works Progress Administration (WPA) Federal Art Project.

On July 5, 1963, a group of established and younger, relatively unknown artists met at Bearden's downtown studio loft at 357 Canal Street[9] "for the purpose of discussing the commitment of the Negro artist in the present struggle for civil liberties, and as a discussion group to consider common aesthetic problems."[10]

Besides Bearden, Lewis, and Woodruff, other Spiral members included Charles Alston, James Yeargans, Felrath Hines, Richard Mayhew, William Pritchard, Emma Amos, Reginald Gammon, Alvin Hollingsworth, Calvin Douglass, Perry Ferguson, William Majors, Earl Miller, and Merton Simpson.[11] Bearden, Lewis, Woodruff, Alston, and Yeargans were among the older accomplished members who assumed a leadership role.

Initially, members discussed participating in the March on Washington itself, but ultimately abandoned the idea. They focused on defining and discussing aesthetics and philosophical problems unique to African American artists. Defining a black identity in a white-dominated society was not a new discourse, having been discussed by artists in the 1920s during the Harlem Renaissance period and restated in the 1930s discussions of the Harlem Artists Guild.[12] For the Spiral Group, the inquiry about the artistic representation of blackness was met with a variety of solutions. One was the investigation of an African legacy that the Harlem Renaissance artists had explored. Bearden suggested that "identity" be addressed by examining the philosophy of African writers such as Alioune Diop and Léopold Senghor, Senegalese cultural theorists. In 1940, Bearden had already befriended Claude McKay, whose writings inspired Senghor's concepts about the Négritude movement. Another approach was to study African art. Although some Spiralists had previously viewed African art in venues such as the Schomburg Center for Research in Black Culture and the Museum of Modern Art,[13] they all were further enlightened by lectures on African art presented by Simpson, a Spiralist who was also an African art dealer.[14]

The Spiralists discussed representing black peoples' plight in America in terms of universal construct. Alston suggested Pablo Picasso's post-cubist painting *Guernica* (1937) as an example of an image with a sociopolitical universal theme (man's inhumanity to man) that moved beyond representation of a locale (Spain during the Spanish Civil War). Also, its large scale (11'6" x 25'8"), replete with black, white, and gray images, simulated photojournalism.

The group's concern for universality was not only confined to social politics in art but extended to the social politics of identity in a society that disparaged their achievements. They saw themselves as artists existing in a universal scheme and their philosophical position developed from an identity of self, which was conceived from experiences of cultural hybridizations. Also, they had a worldview about races of people and interracial relationships. These issues were particularly germane to Bearden, who had already met and befriended a diverse array of prominent artists in visual, literary, and performing arts realm of different heritages.[15] Bearden stated: "The Negro artist must come to think of himself not primarily as a Negro artist, but as an artist. . . .There is only one art . . . and it belongs to all mankind. . . . Examine the art forms of any culture and one becomes aware of the patterns that link it to other cultures and peoples."[16]

Lewis advocated the need for excellence whatever form the artwork took. He believed Spiral members would serve as future leaders for other artists and, therefore, were obligated to establish high standards. The members' artworks were critiqued, though some of the younger artists vehemently opposed the harsh criticisms their works received from older members.

Reflecting on the significance of the group discussions years later, Mayhew conceded that each artist was forced to confront two crucial and timeless questions. First, how relevant is the artwork to the struggles of black people? Secondly, how honest is the artist in expressing concepts presented in his or her artwork? The younger artists wanted to portray overt militancy while

the older members rejected these themes. They concluded that images of violence and death were not considered constructive or innovative and were simply an imitation of life lacking artistic creativity, and that scenes of militancy and violence were already well known to the black community. Instead, the older generation felt that real protest or constructive painting should be uplifting and stimulating. While the majority of the members were not inclined to represent a repertoire that was an imitation of life,[17] Reginald Gammon's painting *Freedom Now* (1964) depicts a civil rights march.[18] "He [Mayhew] recalled a young black painter asserting, 'I've got to do protest painting?' To which Mayhew responded, 'Do protest paintings—not to protest but to be innovative and constructive in relationship to art and your relationship with the community. . . . Real protest painting or constructive painting should be involved with an uplifting and stimulating element.'"[19]

Bearden expressed a similar attitude about social protest art.[20] However, his position on the role of the African American in mainstream society vacillates between the ideas of Dr. Martin Luther King, Jr., and those of Malcolm X: "either the Negro, through such figures as Dr. King, will give this country a transfusion it badly needs, or the Negro must reject the values of this society completely."[21]

In 1966, when fourteen of the sixteen members were interviewed for a review of a group exhibition, each Spiralist expressed different opinions about his/her contribution.[22] Years after the group dissolved, members acknowledged this impact by constantly questioning their honesty in the creative process. Bearden realized the significance of periodically returning to "a Spiral discussion moment" to understand the disgust some African Americans had toward the imagery in his work. In May 1985, when Bearden was creating collage paintings, he stated:

> One painter wrote from the South that my stuff [artwork] was forced and deliberately painted to cater to what the [white] critics think a Negro should paint like. To many of my own people, I learn, my work

was very disgusting and morbid—and portrayed a type of Negro that they were trying to get away from. One man bought a painting and brought it back in three days later because his wife couldn't stand it in the house. . . . So I ask myself, is what I'm doing good or bad, are my paintings an honest and valid statement. Have you ever felt like this? . . . [a Spiral moment]. I guess to be anything of a painter you need to have the hide of an elephant. There is a lot more to it than just putting the paint on canvas.[23]

The Spiralists' focus on abstract forms and distorted figures almost guaranteed opposition from some members of the black community. Considered elitist, the artists' works were viewed as being divorced from their racial and cultural origins.[24] The Spiralists sought an aesthetics that rejected the traditional Eurocentric qualifiers of physical beauty grounded in the Greek art tradition.[25] They wanted to establish a new paradigm for symbols of beauty. Bearden, in particular, opted to create abstract black figures influenced by African figural sculpture to relate to heritage. By doing so, he prescribed a new and African American aesthetics, which proclaimed that "African art and blackness are beautiful."

Older Spiral members, such as Lewis and Woodruff, produced paintings in the mainstream fashion of the New York school of abstract expressionism. They created large paintings filled with gestural brushstrokes, frequently devoid of any recognizable objects.

Previously, Bearden experimented with abstract expressionism but abandoned it for a cubist, abstract style. He studied the structural relationships of planar spaces, similar to Picasso's cubist style. Before Spiral, his abstract paintings were reminiscent of the linear exaggeration of figures expressed in Picasso's synthetic and post-cubist styles. Despite their diverse painting styles, the Spiralists remained unified in their commitment to follow the path of a "spiral."

The name, Spiral Group, was coined by Woodruff. In nature, the spiral is the form found in kinetic energies such as tornados, hurricanes, smoke, etc. However, the name is specifically derived from a principle theo-

rized by Archimedes, who is considered by modern scholars to be the greatest Greek mathematician and whose numerous mathematical principles are so complex that they are still queried today. The choice of a mathematical construct applied to the group appears apropos. The vortex of the spiral suggested for them the freedom to move upward and outward. The relationship between the arts and mathematics dates back to the ancient Egyptian and Greek periods.[26] For the artists, mathematical systems used in art allowed for the existence of order.

Thus, the name Spiral symbolizes the philosophy of the art group who felt a moral obligation to communicate to the community through their art. In spite of the turbulent social climate, their mission entailed uplifting and keeping afloat their own spirits and well as those of their people. As Mayhew notes, "The name 'spiral' embodied this extending concept of evolving and unifying, bonding and constructively supportive relationships with one another, which was an art of Afro-American [and traditional African] sensibility."[27]

The Spiral Group was short-lived (1963–1965), disbanding in 1965 when the group lost their lease at their meeting place—Christopher Street Gallery. Although criticized by members of the Black Arts Movement, their significance in the 1960s cannot be ignored. As Floyd Coleman stated, the Spiralists "paved the way for those African-American artists who followed, if not in their footsteps, at least in the broad paths they cleared. Thus, the legacy of Spiral will expand and remain secure for generations to come."[28]

THE EVOLUTION OF BEARDEN'S COLLAGES: DECONSTRUCTION, FRAGMENTATION, IMPROVISATION

Bearden probably understood the spiral concept better than most members given his degree in mathematics. Perhaps, in an attempt to symbolize the solidarity of his people both as an extension of the spiral and as an example of community or group activity similar to the impending March on Washington, Bearden suggested that the Spiralists create a collaborative work. He had collected a bag full of cut-out photographs from *Life, Look,* and *Ebony* magazines[29] and explained to the group his concepts for creating a photomontage. Group members quickly lost interest and resumed working individually on their own projects. Bearden was compelled to complete the photomontage alone. Upon the suggestion of Gammon, he enlarged five or six of his small photomontages by photostating them, increasing their size $8^1/_2$ x $11^1/_2$ inches to three by four feet, or six by eight feet.[30]

At the time, Bearden was the only African American artist included in the circle of artists exhibiting at the Cordier & Ekstrom Gallery,[31] a mainstream gallery in downtown New York City originally based in Paris. Arne Ekstrom, one of the dealers of the co-owned gallery, visited Bearden's studio to discuss his next exhibition. Bearden was reluctant to show the photostatic photomontage, but, at the request of Ekstrom, who saw the work wrapped up alongside the studio wall, Bearden discussed the enlarged photomontage. Much to Bearden's surprise, Ekstrom was fascinated by the enlarged photomontage and suggested that, along with twenty more, they would be Bearden's next one-man show. This was a pivotal moment for Bearden, who used collages as his primary medium for the rest of his career.[32]

The twenty-one enlarged photostatic photomontages debuted in an exhibition entitled *Projections*, which opened first at Cordier & Ekstrom in October 1964 and a year later at the Corcoran Gallery in Washington, DC. The works were well received by the art community in both locations. In 1971, the series was exhibited at the Museum of Modern Art and the works were described as having "a starkness more akin to *cinéma vérité* than to painting."[33]

Technically, the photomontages were collages (French, *papier collé*), which is a "technique in art consisting of cutting natural or manufactured materials and pasting them to a painted or unpainted surface." Bearden's magazine photographs were not only manufactured, but represented a new medium for him. Whereas, previously, he painted abstractly on canvas, now he employed "found" objects, or ready-mades, for his works. In the late 1950s, Bearden moved from painting in an abstract cubist fashion toward experimenting

with collage technique in a nonrepresentational manner by placing large areas of paint and paper onto the canvas, in doing so adapting an ancient Chinese method he had discussed with Mr. Wu, a bookstore owner whom Bearden regarded as a master teacher of Chinese painting. "Bearden brushed broad areas of color on various thicknesses of rice paper. . . . He glued these to the canvas in as many as nine layers. Then he tore sections of the paper away, always tearing upward and across the picture plane. When he found a pattern or motif he liked, he added more paper and painted additional colored areas to complete the work."[34]

Bearden's collages and photomontages did not integrate words, much drawing, nor much painted surface, but did incorporate the angular cubist aesthetics that was derived from Picasso's and Braque's observation of traditional African sculpture. With rare exception, drawing and painting are not dominant in his collages and photomontages, as seen in cubist collages. Occasionally, Bearden pasted cut-out colored magazine paper in the photomontage. However, the majority of the surface of these works is in black and white. Similar to the Chinese painters,[35] Bearden thought that color was deceptive and one could read color better in black and white.

During the early twentieth century, collage elements were the basic medium for European dada and surrealist painters, who sought to create a "new art" that deconstructed European traditions. For Bearden's dada connections one has only to examine its history through the participation of George Grosz, one of Bearden's former teachers.

Dada as a movement initiated officially in Zurich and developed almost simultaneously in other centers—Berlin, Paris, Cologne, Hanover, and New York. Of all the dada centers, Berlin produced as much political material—newspapers and posters—as it did political art.[36] The photographic collage was the artistic contribution of the Berlin dadaists and was used to criticize the society. Social and political attacks were vented against the German military and World War I.

The term photomontage was invented by the Berlin dadaists, or Club Dada as they were known, to detach their work from the cubist collage and to distinguish their efforts with engineers or mechanics. The invention of photomontage in Germany is attributed to two groups of the Berlin dadaists, who combined photographs with typography and cut and pasted papers from newspapers and magazines.[37] On the one hand, the new development is claimed by George Grosz in collaboration with John Heartfield (born Helmeut Herzfelde) and on the other hand by Hannah Höch in association with Raoul Hausmann.[38]

The Berlin dada analyzed society by the means with which it advertised—symbols and emblems of cut photographs, typography, newspaper clippings and advertisements, and magazine advertisements and images. They heightened the inflammatory commentary and presented a scathing indictment of society in their work by employing abrupt shifts in scale and in perspective, dramatic foreshortening, sharp diagonals, and unusual juxtapositions of imagery. In brief, the Berlin dadaists found the perfect medium—collage and photomontage—to portray "a world they thought had gone mad."[39]

In his criticism of American mainstream art and its social ills, Bearden used terms such as absurdity and anti-art—terms that are couched in both French and German dada semantics and were voiced as an element of social change in those countries.[40] Bearden indicated that dada art philosophy resonated in the United States in 1966 in the destruction of its moral fiber—the mistreatment of African Americans. There are elements of the dada movement that Bearden renounced and others that he retained. Besides the concepts of absurdity and anti-art, Bearden relinquishes the humor, frivolity, and triviality in dada art. Instead, his photomontages capture the graveness of the black survival. While dada artists repudiated Picasso, Paul Cézanne, and the Renaissance artists, Bearden ultimately reveres them.[41] Bearden was a voracious reader of history, literature, and philosophy.[42] He infused into his art the teachings of world art histories—Asian, African, ancient, medieval, Renaissance, Dutch baroque, impressionism, postimpressionism, and the modern and contemporary movements in both Europe and America. While cubism, dada, and surrealism employ typography, Bearden did not. Also, his pho-

tomontages exceed the physical scale of the European collages and photomontages.

Nevertheless, there are components of dada art that are not only apparent in Bearden's art but also occur in both cubist and surrealist art. Close scrutiny of the characteristics of the three art movements—cubism (begun ca. 1910),[43] dada (begun ca. 1917), and surrealism (begun ca. 1924)—and Bearden's work reveal similarities. All use mass-produced objects as essential media, often making reference to urban industrialization. Like Bearden, all three movements create oeuvres in which forms and pictorial space are deconstructed then reconstructed in an improvisational manner. The collage deconstructs the illusionistic space that is standard in the tradition of Western art. The artists used art to protest or to deviate from the doctrines of aesthetic realism that sustained the European art academies from the fifteenth through the nineteenth centuries. Almost by definition, collage is a method that deconstructs, fragments, improvises, and reconstructs forms and meaning in the pictorial space. This type of work exemplifies the cerebral arts and constantly challenges the viewer to deconstruct known paradigms regarding art, beauty, and social constructs. By so doing, the art forms empower the viewer to look anew at art, cultural values, and social disorder. Finally, Bearden and members of all three of the art movements created revolutionary art. All were members in a movement associated with political programs. Also, their art displayed, although sometimes subtly, opposition to the modern bourgeois society.[44]

Like the cubist artists, Bearden's black and white constructions had references to the performing arts. He was an eclectic intellectual who astutely perceived the interrelationships in the arts. However, his interest was not confined to European but included African American arts. Bearden was energized by all the arts of classical music, old and new jazz music, dance, and film.[45] For his visual deconstruction of structures, de-fragmentation of imageries, and improvisations, Bearden did not rely solely on the twentieth-century European art movements but integrated it with the African American expressive art form of jazz. In the 1950s, Bearden was so familiar with jazz that he wrote and published music

for such luminaries as Billy Eckstine and Billie Holiday.[46] Ralph Ellison, a friend of Bearden, correlated jazz and surrealism in Bearden's collages. Ellison saw similarities with "the sharp breaks, leaps in consciousness, distortions, paradoxes, reversals, telescoping of time and *surreal* [italics mine] blending of styles, value, hopes and dreams that characterize much of Negro American History."[47] Thus, because the constructs of jazz as well as cubism are derivative of the traditional sculpture of Africa, their similarities are not surprising. It is against this extensive background of artistic knowledge that Bearden was able to change his artwork in reaction to the social ills of the 1960s.

BEARDEN'S COLLAGES AND SOUTHERN MEMORIES

Bearden used the collage "to literally piece together his memories of the past."[48] For the narratives in many of his collages and photomontages, he derived images from his childhood memories of the South and North, which included experiences in Charlotte, Mecklenburg County, North Carolina; Pittsburgh; and New York City. To capture the power of the memories, Bearden had to construct three interrelated mental activities: he reached beyond the photographs to the human qualities they illustrated; he reconstructed the original in his mind's eye; and he re-created images in an unusual, striking manner. By portraying these memories, he recalled images that preserved the history and culture of African Americans.

The major subject matter for Bearden's collages and photomontages were black people, which remained dominant from the beginning of his career in the 1940s until his death in 1988. He produced social realist paintings about black life in the 1940s, abstract paintings of biblical figures and nondescript ethnicity in the 1930s and 1940s, collages and photomontages in the early 1960s, and collage paintings in the late 1960s, 1970s, and 1980s.

In depicting black images and African proportion in his collages and photomontages, Bearden does not deny his African American and African heritage in order to exhibit in mainstream society. This is a particularly honest statement for an artist, whose racial identity was

not always discernible because of his fair-skinned and blue-eyed features. In Paris upon his first meeting with Bearden, Albert Murray, the African American novelist and jazz historian, thought Bearden was Russian "or what[ever]" until he laughed. Then, Murray identified Bearden's laughter as that of a black man.[49]

The black images that he employed in his photomontages were more contorted and confrontational with the viewer than those in his earlier paintings. In *Mysteries*, the magnified faces consist of fragments from a variety of cut-out magazine images. Their stark directness possesses the quality of being "in-your-face." These colossal heads seem to reflect the lessons Bearden learned from at least two influential sources: (1) George Grosz and (2) African art.

While a Berlin dadaist, Grosz portrayed provocative visual satires of antimilitaristic and antibourgeois caricatures.[50] He encouraged Bearden to concentrate on his drawing style and introduced him to political cartoons and drawings by Europeans that portrayed the pain and sufferings from political wars and opposition movements.[51] Like other Berlin dadaists, Grosz used photographic collage technique in which heads of people were emphasized for satire and for mocking the concept of nationalism in Germany.[52]

Whether or not Bearden adopted this exaggeration from his former teacher is uncertain. However, because Bearden created satirical cartoons earlier in his career and considering the impact of the tense racial climate of the 1960s upon Bearden, it is plausible that the 1964 *Projections* mocks the concept of nationalism in the United States. Furthermore, Bearden's representation of enlarged heads with direct gazes is described as engaging the viewer in a direct confrontation and presenting "an assertion of presence and a demand for recognition."[53] These were the unwelcome, poverty-stricken African Americans who were shunned by the American public and the government. Their destitute economic condition was one with which Bearden was familiar from his observations of living conditions in the South, from his clients as a caseworker in New York City, and from the inflammatory mantra of the war on poverty espoused by civil activists during the 1960s.

Nevertheless, the African sculpture association is indeed plausible. In traditional African sculpture, emphasis on the head occurs in both figural sculpture and masks. The proportion and style in Bearden's photomontage figures are reminiscent of traditional African figural sculpture in which the head is exaggerated, often in relation to the proportions of the rest of the body, in a ratio of 1:3 or 1:4. This enlargement occurs because the head is considered the "seat of power;" it is the body part that identifies a human being, and it is the location where spiritual connections occur.

Bearden was familiar with the use of masked imagery in paintings by Jacob Lawrence, an old artist friend practicing in New York City. Both artists studied African art at the 135th Street Public Library and were escorted by "Professor" Wylie Seyfert, who had lectured to them on the subject, to an African art exhibition at the Museum of Modern Art.[54] Furthermore, while a Spiralist, Bearden heard additional lectures on the subject and saw more art in the private collection of Merton Simpson, an African art dealer and member of the Spiral Group.

In works such as *Mysteries* and *The Prevalence of Ritual: Baptism,* specific sculptural heads or masks from West and Central Africa are discernible in the fragmented heads. In *Mysteries*, the face on the left is composed using part of the face from a photo of a Benin bronze sculptural head. Whereas in *The Prevalence of Ritual: Baptism,* the Africanized faces include the centrally placed Kwele mask from Gabon, and, in the lower left, a portion of a Kalabari Ijaw mask from Nigeria surmounted by patterns that are reminiscent of the Kifwebe mask from both the Luba and Songye ethnic groups, located in the Eastern Congo Basin (currently, the Democratic Republic of Congo). Bearden was familiar with the multiplicity of art forms and ethnic groups in Africa. When asked his opinion about black art, Bearden replied: "In Africa there are some tribes [ethnic groups] like the Dogon [in Mali] who make funereal [sic] things that are extremely Abyssinian [in Ethiopia]. There may be another tribe across the river who makes very realistic things. There are great stylistic differences in tribal art of Africa."[55]

In Bearden's photomontage and in the traditional African sculpture, the masked faces suggest a transformative function—the mask conceals human identities and reveals the spirit of beings.

Perhaps better stated, an African ritual performance is a practice in which a performer uses some combination of facial disguise, costume, body decoration, props, movement, vocalization, drumming, and music to create the illusion of the spirit world. A masquerader can become what one in ordinary life cannot—a reversal of roles: men into women, old into young, human into animal, mortals into gods, dead into living, or the reverse of these. In the new persona, the masquerader is a mediator between humans and the spiritual realm. As the embodiment of spiritual powers, the masquerader represents the spirit(s) who restructure social maladies.

SOUTHERN LANDSCAPES WITH NORTHERN EXPOSURES

Despite their experience of physical, mental, and emotional slavery, the South represents a portion of a historic legacy that demonstrates the strength, perseverance, and survival of persons of African descent. It provides a reservoir for both African American and African retentive cultural traditions (pl. 16). As August Wilson, an African American playwright whose plays were greatly influenced by Bearden, stated: "Africa is our [African Americans'] South."[56]

Bearden's emphasis on memories, particularly of the South, is reminiscent of a statement made by his friend James Baldwin. Baldwin proclaimed: "When blacks migrated from the south to the north, the northern culture did not take. The memories are important because if they are in our souls and spirits, they will sustain man once he leaves home."[57]

In such comments, it is apparent that the South represents a wellspring of strength and endurance for Bearden. As his home site, he characterizes the South as a shrine,[58] and the specific details in the actual landscape assume a secondary role. Using this approach, Bearden brings together in a cohesive manner both the intellectual and emotional parts of human nature.

Bearden believed that both the visual arts and music generate levity in times of melancholia. While producing his art in New York City, he found solace in the pleasurable experiences of southern life. In his remarks about a blues melody sung by Bessie Smith, Bearden recalled:

Here she's [Bessie Smith] talking about a poignant personal event—her love is gone. But behind her the musicians are "riffing," changing something tragic into something positive and farcical. This is why I've gone back to the South and to jazz. Even though you go through these terrible experiences, you come out feeling good. That's what the blues say and that's what I believe—life will prevail.[59]

People connect with the land, and landscape themes include the relationship of figures to the terrain.[60] In *Cotton*, the figures are actively engaged in picking or carrying loads of cotton in the fields. As if in a musical expression, the images' entire bodies are contorted. The figures are placed in landscapes that are generalized and devoid of minute details. Bearden formulates time in space as if seen for the first time, which is very similar to the mechanics of a photographer.

The relationship of the European American planters to the knowledge of the skill of the cotton pickers is well documented. The planters were knowledgeable about the agricultural cultivation practices in various regions of West and Central Africa. They could identify the different African ethnic groups and were often able to relate the various groups to the types of cultivation—rice, cotton, and indigo—found in Africa.[61]

Bearden re-creates an aspect of the African Americans' social condition on cotton farms, and he records an element from the historic annals of agriculture in Mecklenburg County. In the South, the end of slavery crippled plantation agriculture. However, even before the Civil War, Mecklenburg County had been one of North Carolina's most productive cotton growing counties. It was comprised, like the rest of the state, of many medium-sized cotton farms rather than a few large cotton plantations.[62]

Bearden's opportunities for observing cotton laborers was probably not confined to those on the cotton farms but was expanded to workers who engaged in the activities of transporting the cotton to the processing buildings in and out of Charlotte. One of the processing buildings was on the other side of the railroad bridge near Bearden's great-grandparents' house, where he originally lived and later spent his summer vacations. It was the Magnolia Cotton Mill.[63]

During this period—the early twentieth century—Charlotte developed into an industrialized urban area specializing in the textile industry. Besides the Magnolia Cotton Mill, there were several mills for spinning and weaving cotton in the Charlotte and the Mecklenburg County area. By 1900, Mecklenburg County boasted sixteen mills, and it was North Carolina's second most important textile manufacturing county. Supporting the slogan "Bring the Mills to Cotton!" North Carolina emerged as the South's leading textile producer by the 1920s.[64]

In Charlotte, cotton was weighed, put in bales, and shipped to mills where it was processed into cloth. Cotton was transported to Charlotte by trains or wagons from other parts of the country for the train ride north to be manufactured into cloth, or "milled." The opening of railroads in the 1850s made Charlotte a major cotton trading hub for farmers throughout the North Carolina southern Piedmont area.[65]

In *Cotton*, Bearden's figures and landscape service social or collective motives. Specific imagery in the local and regional landscape highlights a social dilemma of polemics. For example, the cotton fields in southern landscapes supplied an economic means for southern white farmers and plantation owners. However, its imagery evokes contrasting feelings of historical associations: (1) allegiance to the cotton regions, including support of the legalization of slavery of blacks and (2) recognition of and repulsion to the injustices of slavery.

In response to the latter, one must consider the role of the artist both to social issues and to his viewers. Bearden admired Gustave Courbet, a French nineteenth-century social realist painter, for his interest in defining the social responsibility of the artist and his considera-

tion of the viewing audience.[66] In these photomontages, Bearden's role as an artist appears to be similar to that of a visual illustrator or a recorder of life experiences. He stated: "I create social images within the work so far as the human condition is social, I create racial identities so far as the subjects are Negro, but I have not created protest images because the world within the collage, if it is authentic, retains the right to speak for itself."[67]

In allowing the viewer to develop personal interpretations of his work, Bearden realized that viewers found more social meaning in his artwork than he originally intended.[68] Years later, artist Carl Holty and Bearden agreed that: "Not all who look see the same thing; some people, for instance, will be pleased by a particular image, others depressed—each according to his temperament, his imagination, and his spiritual needs. But whatever the image, the only visual reality present is the structure."[69]

Regardless of one's interpretations of these landscape scenes, the subject matter of the cotton farms is significant in confirming a national destiny. These artworks furnish glimpses of conditions that recall social, economic, and political upheavals as well as progressive changes in American history. These innovative narrative images record the significance of the man-made landscape and respond to a cultural legitimacy.

During Bearden's childhood experiences, trains were continuous sights and sounds. He remembered the long train ride from Moose Jaw back to New York. Like the Magnolia Cotton Mill, a train trestle and railroad bridge were near Bearden's great-grandparents' house.[70] Young Bearden visited the train station with his grandfather "to watch the good trains go by."[71] He recalled many experiences of watching trains arrive and depart from Charlotte.

His favorite train was the New York and Atlanta Special, which steamed southbound from Charlotte station every morning at 10 o'clock. It came back every evening at 7:30, headed for Washington, New York, and points north. That endless train, with its huge steam engine and coal car, and its Pullman drawing room sleeping cars, dining car, and parlor observation car, was a magical sight for Bearden and his cousins.[72]

The contrasting slow and fast rhythmic tempos of the trains' movements and the shrill of train whistles are echoed in the manner in which Bearden relates the sounds to jazz.[73] He manipulates line, shape, and color in spaces, creating dissonant and harmonious arrays in his pictorial art. However, trains are not merely a visual or musical art form, but are symbols of the lives of people. Trains denote movement and place for Americans. They transport people and commodities to places far away and form part of the distant vistas. The train symbolized hope for blacks as they migrated from the South to the North for better jobs and education.

Trains structured portions of the landscape that link and divide regions. They connected the South to other parts of the country, particularly to the North. Simultaneously, train tracks were laid in cities, such as Charlotte, in a manner that demarcated the separation between racially divided communities. The train tracks became a dividing line, separating black and white communities and defined the social, political, and economic division of communities. For Bearden, the train is a cultural symbol: "I use the train as a symbol of the other civilization—the white civilization and its encroachment upon the lives of blacks. The train was always something that could take you away and could also bring you to where you were. And in the little town it's the black people who live near the trains."[74]

Finally, other familiarities with trains in Bearden's life include the prestigious jobs with railroads held by African American men close to him. His father was a steward for the Canadian trains, his paternal great-grandfather, H. B. Kennedy, was a mail agent for the CC&A Railroad in Charlotte,[75] and A. Philip Randolph pursued equitable working conditions for Pullman porter.

In his artwork, Bearden unifies figures with the life force of nature and man-made objects in nature. Portrayed as onlookers and detached observers, the lives of rural African Americans are routinely juxtaposed to trains in Bearden's work and are disconnected with the urban, industrial development of Charlotte. In comparison to their bodies and the terrain, the scale of the heads of figures is characteristically magnified in much of his work. In such cases, their large visages, which are remi-niscent of the enlarged heads in traditional West and Central African figural sculpture, overpower their surroundings. The abstract character derived from African sculpture for Bearden's figures is "made to focus our attention upon the far from abstract reality of a people."[76] The size relationship of the figures to the land, and particularly to the mountains in the distance, elicits a psychological impact and a testament to their steadfastness.

Regardless of their impoverished attire and condition often portrayed, each person represents an important and a collective part of the national character of America. They are all organic components of the lifeline of the nation. The combination of these dissimilar and seemingly disjointed members culminates in a complete product that reflects the essence of the American fabric in general and the African American identity in particular. Similarly, in the African traditional worldview it was accepted that in a cohesive and integrated society each member had a place.[77] Viewed from this perspective, it becomes apparent that Bearden must have admired the people that he created and regarded the peopled landscape as a form of profound satisfaction and solace. As a fixation of his memory, these are not imagined figures but are real human beings who walked into his compositions. As he recalled events that occurred, people began to come into his paintings. Bearden remarks: "I just let them come in, like opening a door to guests."[78]

Similar to the visual journey that a train passenger experiences, in *Watching the Good Trains Go By*, various visual imageries allow the viewer to participate as an itinerant traveler through time and space. The forms convey the idea of transporting the viewer *from* and *to* different locations. For example, the journey takes one from the rural farms and the urbanized industrialization in the South to vistas and the urban North, symbolized by north-bound trains, and possibly ultimately to remembrances of the land of the ancestors—West and Central Africa, comprising ethnically diverse peoples. From this conglomeration of images, Bearden's skill as a narrator of human experiences, as if presented on a stage or in a film, is revealed. Each fragmented figure and image becomes a separate frame of a story or movie. These African American images were counter to

the protest and violent treatment that appeared daily in black and white on American television.

SUMMARY AND CONCLUSIONS

Bearden attempted to place his narratives about the social conditions of blacks within a European, African, and African American construct. By Bearden's use of the collage and photomontage technique from Europe, which reflected an African based aesthetics, his works become a full circle back to his ancestral heritage. Moreover, like the oral traditions in Africa, Bearden's narratives assist in passing on African American legacies. He embraced slave ancestry, rituals, and the past because they provided strength for him and his people. The resiliency of these cultural narratives had sustained African Americans in the past and, like an Archimedean spiral, was the buoyancy for sustenance for the Spiral Group during the civil rights movement.

Bearden, a political activist concerned about the visibility of black artists in major American museums, participated with other demonstrators in a picket line at the Whitney Museum in New York in 1968. The protest was about the exclusion of Negro artists from the Whitney's current exhibition, "The 1930s: Painting and Sculpture in America."[79] In 1997, Bearden's works were shown posthumously at the Whitney in an exhibition entitled "Romare Bearden in Black and White: Photomontage Projections, 1964." His own visuality as a collage artist is emphasized in other venues. Among the three or four African American artists whose artworks appear in current world art history textbooks published in the United States, Bearden is represented as a collage artist.

Bearden photomontages and narratives of black people desegregated mainstream art museums, galleries, and textbooks. Prior to Bearden's photomontages, American art did not realize collage as a viable medium in the context of art. Romare Bearden is the dean of collage art in the United States and as such paved the way for other collage and photomontage artists.

NOTES

1 Myron Schwartzman, *Romare Bearden: His Life Art* (New York: Harry Abrams, Inc., 1990), 131–132.

2 Ibid., 15–18, 28.

3 For a discussion of these exhibitions, see ibid., 132–152.

4 Huston Paschal, *Riffs and Takes: Music in the Art of Romare Bearden* (Raleigh: North Carolina Museum of Art, 1988), n.p.

5 Gail Gelburd and Thelma Golden, *Romare Bearden in Black and White: Photomontage Projections, 1964* (New York: Harry Abrams, 1997), 18.

6 For a discussion of Randolph's philosophy of the civil rights movement, see Paul F. Pfeffer, *A. Philip Randolph, Pioneer of the Civil Rights Movement* (Baton Rouge: Louisiana State University Press, 1990).

7 For information on Bearden's father, see Schwartzman, *Romare Bearden*, 17. For information on Bearden's mother, see ibid., 67.

8 Named after the address of the artists' studio loft, 306 West 141st Street, where the first meeting was held. The loft was the art space that was shared jointly by painter Charles "Spinky" Alston, a former WPA artist and cousin of Bearden, and sculptor Henry ("Mike") Bannarn; see Mary Schmidt Campbell and Sharon Patton, *Memory and Metaphor: The Art of Romare Bearden, 1940–1987* (New York and Oxford: Studio Museum in Harlem; distributed by Oxford University Press, 1991), 20–21.

9 By mid-October 1963, meetings were moved to the 147 Christopher Street in the Village, see Romare Bearden and Harry Henderson, *A History of African American Artists: From 1792 to the Present* (New York: Pantheon Books, 1993), 401.

10 Ibid., 400.

11 In Jeanne Siegel, "Why Spiral?" *Art News* 65, 5 (September 1966): 48–51, on the Spiral Group's exhibition in 1966, Mayhew and Pritchard are not mentioned. Mayhew joined a year after the group was originally formed. It is uncertain if the same is true of Pritchard.

12 Bearden and Henderson, *A History of African American Artists*, 400.

13 Schwartzman, *Romare Bearden*, 84. The Museum of Modern Art held an exhibition of "African Negro Art" in 1935. Bearden and Lewis attended the exhibit with Wylie Seyfert and Jacob Lawrence.

14 Siegel, "Why Spiral?" 50.

15 After serving in the U.S. Army from 1942 to 1945, Bearden received a GI Bill to study philosophy at the Sorbonne in Paris. There he befriended eminent European visual artists as Constantin Brancusi and Georges Braque as well as American expatriates: novelists Albert Murray and James Baldwin, poet Samuel Allen, and painters William Rivers and Paul Keene. See Gelburd and Golden, *Romare Bearden in Black and White*, 77.

16 Schwartzman, *Romare Bearden*, 131.

17 Bearden and Henderson, *A History of African American Artists*, 474–475.

18 This painting was exhibited in the Spiral exhibition in 1964. See Siegel, "Why Spiral?" 50.

19 Ibid.

20 For a discussion, see Schwartzman, *Romare Bearden*, 131–132.

21 Ibid., 400.

22 Siegel, "Why Spiral?" 50.

23 Schwartzman, *Romare Bearden*, 121.

24 Floyd Coleman, "The Changing Same: Spiral, the Sixties, and African-American Art," in William E. Taylor and Harriet G. Warkel, eds., *A Shared Heritage: Art by Four African Americans* (Bloomington: The Indianapolis Museum of Art: distributed by Indiana University Press, 1996), 150–151.

25 The Spiralists abandoned the Western ideal of beauty in human forms that originally appeared in Greek sculpture and paintings as the perfect Greek male nude athlete, Greek god, and Greek goddess and was appropriated in later Western art traditions.

26 The Greeks are the first Western culture to write theories placing arts and mathematics in separate categories.

27 Coleman, "The Changing Same," 149.

28 Ibid.,157.

29 Richard J. Powell, "What Becomes a Legend Most? Reflections on Romare Bearden," *Transitions: An International Review* 55 (1992): 66, identifies the magazine sources.

30 Schwartzman, *Romare Bearden*, 210.

31 Schwartzman, *Romare Bearden*, 206. Cordier & Ekstrom, a colossal and expansive space on 978 Madison Avenue, was the gallery where Bearden exhibited from the early 1960s to his death in 1988. The gallery was run by Daniel Cordier, Arne Ekstrom, and Michel Warren. Besides Bearden, the gallery exhibited works by eminent European artists, such as Dubuffet, Matta, Michaux, Duchamp, Lindner, and Noguchi.

32 Ibid., 210–211.

33 Charles Allen, "Have the Walls Come Tumbling Down?" *New York Times*, Sec. 2 (April 11, 1971), 28

34 Schwartzman, *Romare Bearden*, 186.

35 Ibid., 187.

36 Diane Waldman, *Collage, Assemblage, and the Found Object* (New York: Harry N. Abrams, Inc., 1992), 102.

37 Ibid., 103, 107.

38 Ibid., 104.

39 Ibid., 112–113.

40 Dada art began in Germany and France and was brought to New York City by French artist, Marcel Duchamp, during the early part of the twentieth century. For a brief discussion of dada art in the United States, see Amy Goldwin, "The Dada Legacy," *Arts Magazine* 39 (September/October 1965): 26–28.

41 Schwartzman, *Romare Bearden*, 128.Bearden spent a great deal of time "struggling to understand the structure and composition of Cézanne's work. In the end [in works after the 1960s], Cézanne had as much or more influence on Bearden's handling of the picture plane than Picasso."

42 Ibid., 207.

43 Although Picasso is most known for developing cubist abstraction, the style was technically the joint invention of Picasso and his artist friend Georges Braque. The style was built upon the foundation of Picasso's early work.

44 For a discussion of the surrealists' political protest against the French government for the civil rights of African Americans in Paris, particularly the exploitation of Al Brown in a boxing championship, see Bennetta Jules-Rosette, *Black Paris: The African Writers' Landscape* (Urbana and Chicago: University of Illinois Press, 1998), 26–30. Also, for Picasso's association with the surrealist and the impact of surrealism on his painting *Guernica*, see William S. Rubin, *Dada, Surrealism, and Their Heritage* (New York: Museum of Modern Art, 1968), 279–309.

45 Schwartzman, *Romare Bearden*, 128.

46 Gelburd and Golden, *Romare Bearden in Black and White*, 77.

47 Aaron Myers, "Bearden, Romare," in Anthony Appiah and Henry Louis Gates, eds., *Africana: The Encyclopedia of the African and African American Experience* (New York: A Member of the Perseus Group, 1999), 207.

48 Mary Schmidt Campbell, "Tradition and Conflict: Images of a Turbulent Decade, 1963–1973," in *Tradition and Conflict: Images of a Turbulent Decade, 1963–1973* (New York: Studio Museum in Harlem, 1985).

49 Schwartzman, *Romare Bearden*, 168.

50 For a discussion of the Berlin dada, Grosz's participation in the movement, and Grosz's art, see Rubin, *Dada, Surrealism, and Their Heritage*, 82–93.

51 Grosz introduced Bearden to European artists who portrayed the theme of "man's inhumanity to man" in black-and-white prints and drawings. These artists include Honoré Daumier (French), Francisco Goya (Spanish), and Kathë Kollowitz (German). These artists use black-and-white imagery as if mimicrying the photojournalist style as if reporting in print a newsworthy documentary on societal ills.

52 Waldman, Collage, *Assemblage, and the Found Object*, 113.

53 Lee Stephens Glazer, "Signifying Identity: Art and Race in Romare Bearden's Projections," *The Art Bulletin* 76 (September 1994): 423.

54 Schwartzman, *Romare Bearden*, 84.

55 Camille Billops and James V. Hatch, "Romare Bearden," in *Artist and Influence* 17 (New York: Hatch Billops Collection, Inc., 1998): 14.

56 See August Wilson and Mateo Belinelli, *August Wilson: A Conversation with August Wilson* (videorecording), Swiss Television Production, San Francisco, CA: California Newsreel, 1992.

57 James Baldwin, quoted in Schwartzman, *Romare Bearden*, 168.

58 For a discussion of homes as shrines, see Peter Howard, *Landscapes: The Artists' Vision* (London and New York: Routledge, 1991), 188–189.

59 Avis Berman, "Romare Bearden 'I paint out of the blues,'" *ARTnews* (December 1980): 66.

60 John McCoubrey, *American Tradition in Painting* (Philadelphia: University of Pennsylvania, 1999), 32.

61 Joseph E. Holloway, "The Origins of African-American Culture," in Joseph E. Holloway, ed., *Africanisms in American Culture* (Bloomington and Indianapolis: Indiana University Press, 1990), 15.

62 Thomas W. Hanchett, "Charlotte's Textile Heritage: An Introduction," *Charlotte-Mecklenburg Historic Landmarks Commission* (Charlotte, NC: Historic Landmarks Commission, n.d.), http://www.cmhpf.org/essays/textiles.html.

63 Myron Schwartzman, *Celebrating the Victory* (New York, London, Hong Kong, Sydney, Danbury: Franklin Watts, Inc., 1999), 24.

64 Hanchett, http://www.cmhpf.org/essays/textiles.html.

65 Schwartzman, *Celebrating the Victory*, 24; Hanchett, http://www.cmhpf.org/essays/textiles.html; and Dan Morrill, "A Survey of Cotton Mills in Charlotte and Mecklenburg County for the Charlotte-Mecklenburg Historic Landmarks Commission," *Charlotte-Mecklenburg Historic Landmarks Commission* (Charlotte, 1997), http://www.cmhpf.org/essays/cottonmills.html.

66 Henri Ghent, an interview with Romare Bearden for the Archives of American Art, June 29, 1968. Microfilm reel 3196, Archives of American Art, Smithsonian Institution, Washington, DC, 217.

67 Charles Childs, "Bearden: Identification and Identify," *ARTnews* 63, 6 (October 1964): 25.

68 Henri Ghent, interview with Romare Bearden for the Archives of American Art, June 29, 1968, 21.

69 Romare Bearden and Carl Holty, *The Painter's Mind* (New York and London: Garland Publishing, 1981), 20.

70 Myron Schwartzman, *Celebrating the Victory*, 24.

71 Sharon F. Patton, *African American Art* (Oxford and New York: Oxford University Press, 1998), 39.

72 Schwartzman, *Celebrating the Victory*, 25. Also, stated slightly differently in his earlier book (see Schwartzman, *Romare Bearden*, 20–21).

73 *Romare Bearden: Visual Jazz* (Chappaqua, 1998), videorecording.

74 Patton, *African American Art*, 39.

75 Schwartman, *Romare Bearden*, 14.

76 Ralph Ellison statement in the foreword, from Bearden and Holty, *The Painter's Mind*, xiii.

77 Margaret Washington Creel, "Gullah Attitudes toward Life and Death," in Joseph E. Holloway, ed., *Africanisms in American Culture* (Bloomington and Indianapolis: Indiana University Press, 1990), 71.

78 Billops and Hatch, "Romare Bearden," 35.

79 Grace Glueck, "1930s Show at Whitney Picketed by Negro Artists Who Call It Incomplete," *New York Times* (November 18, 1968), Sec. L, 31.

FACING PAGE:

Detail from Romare Bearden's
Island Scene, *1984*
(Plate 51)

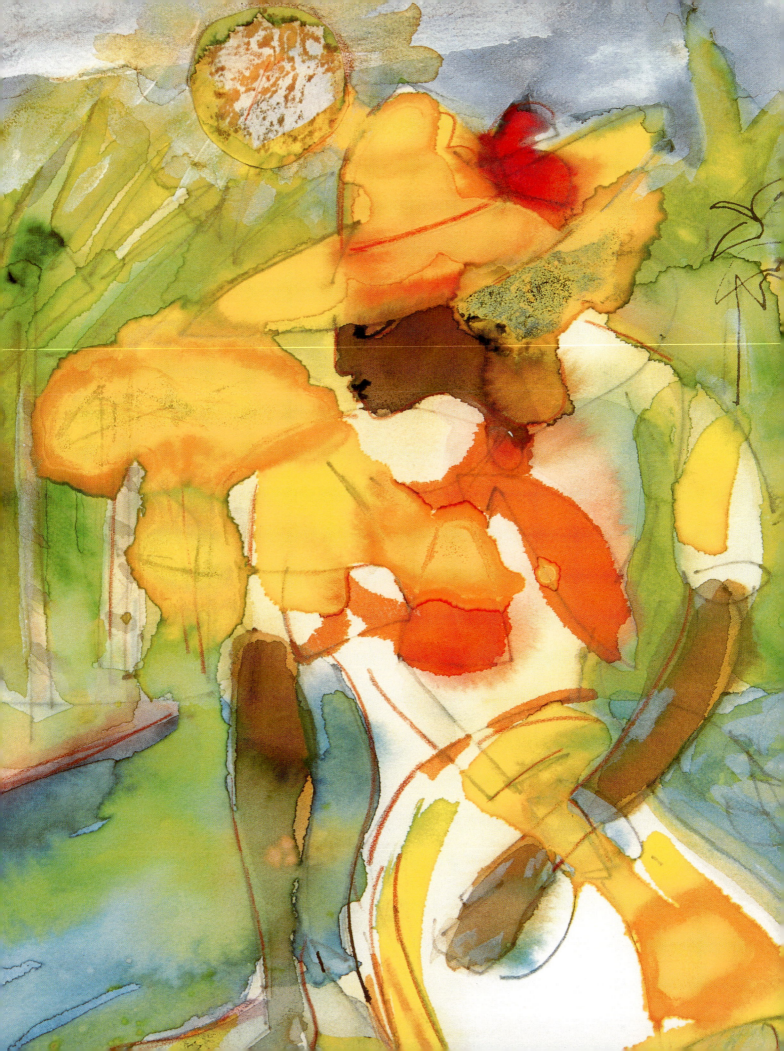

Nanette Carter's Discursive Modernism:

The Collage Aesthetic in *Light over Soweto #5*

ANN EDEN GIBSON

FACING PAGE:

Detail from Nanette Carter's
Light over Soweto #5, *1989*
(Plate 17)

NANETTE CARTER'S *LIGHT OVER SOWETO #5* (1989) IN THE Paul R. Jones Collection at the University of Delaware is one of a series of works in oil pastel on black paper, numbered one to five. Carter has occasionally described her work as "mark-making," a term that fits the appearance of these dynamic drawings, since at first inspection they present the viewer with a display of marks—broad and slender, erratic and directed, crisp and blurred, in sizes from relatively large to small and dot-like. Applied in values ranging from white to dark gray and colors from all along the spectrum, they explode in this collaged drawing from a point of greater density at the lower right to dispersion at the top. Beneath these strokes in the earlier panels in the series hover grays of various tonalities, and in one, a dull red mist of the smallest particles obscures their clarity. But in *Light over Soweto #5,* as in the other drawings in the series, the bare but toothy ground of the absorbent black of the paper becomes deep space, the color of no color, no light. It turns into a vacuum of infinite distance, unknowable—and becomes the most illusionistic part of the whole picture. Into it, the explosion of violet and red flecks ascends electrically as a large and erratic streak of violet arcs into jagged points. On a horizontal panel of paper collaged to the very bottom of the picture, blue, purple, and brown marks flow horizontally from one border of the drawing to the other. Another piece of paper colored deep red is carefully torn into a deckled edge so that its exposed black core serves as a zig-zag outline at the very top of the drawing, effectively bracketing the storm of darting, jumping strokes of a more intense red, salmon, and

violet. Bleeding off the right hand edge, the narrow edge of an impossibly tall form the color of all human flesh below the skin—an ancestor of Carter's "tree person-age," as George Preston Nelson called such a shape when a similar form appeared in a later work—stands, rooted in the collaged band of horizontal marks at the bottom, stretched between the land or water below and the sky above.[1]

Collages gather material from different worlds in a single composition that demands "a geometrically multiplying double reading of each element." They thus call attention to what Thomas Brockelton in his book on collage and the postmodern has called "the irreducible heterogeneity of the 'postmodern'."[2] The definition of the use of the collage aesthetic, a term that may be more appropriate to describe the methods used in the physical and conceptual description of *Light over Soweto #5* than might at first be evident, is a concept and a practice whose significance for modernity is still undergoing revision. A number of scholars have been at work in the latter decades of the twentieth century and the first years of the twenty-first revising the concept of modernity to include as an important landmark the previously unstressed invention and development of the early twentieth-century practice of cubist collage. They have argued that it influentially changed what we think art is, a change concurrent with developments in philosophy, and one that has more and more frequently informed the making and viewing of art practice until, in the late 1960s, it emerged as a genre that some called the postmodern. Seeing the invention of collage as more than the attempt of analytic cubism to produce a non-naturalistic realism, Yves-Alain Bois has argued that it introduced an entirely different understanding: that all of art's products, from a naturalistic portrait in oils to a piece of newspaper glued to a canvas, are signs—"emblems," as Picasso's scholar-dealer called them, "of the external world, not mirrors."[3] As Christine Poggi has observed, that insight founded an increasingly lively alternative to the modernist tradition.[4] More recently, Brockleton has noted that such revisions, when factored into developing histories of postmodernism, make it possible to argue that postmodernism was imbricated in modernism from the very beginning: "right in the heart of cubism."[5]

As suggested by the progression of the description of *Light over Soweto #5* with which this essay starts, Carter's "mark-making"—a term usually associated with a literal and material approach to drawing that sees it as the sum of the literal and material activity that produced it—lends itself as readily to the modernist device of metaphor as it does to the modern materialism of understanding drawing as mark-making.[6] Collage's production of complex pictorial space was noted early on by observers such as Apollinaire.[7] But as the innovations of modernism became more programmatic, critic Clement Greenberg asserted that collage affirms painting's two-dimensional surface, although in fact most viewers tend to see a literally flat piece of paper or canvas as space at the provocation of the smallest dot on its surface.[8]

In an art world context, Carter's work presents an interesting paradox, reuniting as it does what Peter Wollen termed "the two avant-gardes," observable in the contrast between the processes and image juxtapositions of Sergei Eisenstein's mimetic and overtly revolutionary montage in film as compared to the pure and hermetic significations of Clement Greenberg and Michael Fried's "modernist painting."[9] These aspects of the avant-gardes may be seen in the two lines of artistic descent from the contrasting examples of Duchamp, representing more oppositional and conceptual understanding of the avant-garde, and Picasso, seen as the avatar of a modernism more concerned with formal innovation. By the 1970s, these directions had become so divorced that audiences began to distinguish them by identifying the Duchampian strain as postmodern and Picasso's lineage as modernist. In terms of modes of signification, metonym became the rhetorical device of postmodern choice, as metaphor was for modernists.[10] Thus, for Duchampian artists such as Jeff Koons, the metonymy of inserting everyday mass-produced objects into a gallery or museum setting gave them the status of "Art"; but for Picasso and Pollock, or so their proponents averred, it was the metaphoric progress toward continually purer formal means that deserved that appellation.

One might claim that *Light over Soweto #5* displays the dual or split characteristics of the collage aesthetic of postmodernism, knitting back together Wollen's "two avant-gardes" and in so doing reinvigorating the oppositional of modernity that seemingly died away in the last half of the twentieth century.[11] Recent scholarship on collage hermeneutics suggests that it leads not to a resolution, but instead toward a transformative event, splitting the ideal of universality by recognizing its impossibility, the way Kant recognized the unknowability of the sublime. We are becoming comfortable with the idea that there may be no one right way for everyone. Brockleton thinks the project of late modernity may be the reinterpretation of the reductivist view of the modernist project to find the story of how, in the formative moments of modernity, its split subject emerged.[12]

Carter is entirely aware that she employs landscapes as metaphors in *Light over Soweto #5* for political and sociological stances, as Karen Wilkin has observed.[13] The suggestion of running water or a path below and of an electrifying explosion above is reinforced by the energized bravura of lines that compose them. But in addition to metaphor, in the outline of the tree-like form Carter employs mimesis, a traditional figurative device whose effectiveness modernism derided. Her work "blur[s] the line between figuration and abstraction," as one critic succinctly observed.[14]

In Carter's work, however, implications of these *different* systems, multivalent as they are, may be seen as pulling together if one considers the title part of the work. "You can't put down a line about nothing," Carter notes. "My abstractions don't negate reality, or escape it. They are always *about* it."[15] What does she mean? Her marks, put down like hundreds of tiny colored bits of collage, one by one, are certainly abstract by virtue of their size and distance from one another; they do not become visually, that is, mimetically realistic. Yet their organization and the directions in which they appear to be moving read almost like a diagram: "explosion" and "electricity." The mimetically drawn form of a tree, on the other hand, impossibly narrow, straight, and tall, reads more like a cut-out and glued-on collage element, although it is drawn with oil stick right onto the black

paper. The actual collage elements, with the tree, form a *repoussoir* of sorts in the form of an interrupted frame around nearly three quarters of the painting, consisting of a ceiling or lintel from under which one peers at this spectacle, framed by the tree on the right and a field of beaten-down grass or a river at the bottom, across which one anxiously regards but incompletely grasps a powerful and riveting event.

Like windows, whose shapes and functions they echo, frames have symbolically functioned since the Renaissance to tell viewers that what is inside is in a different world than the one in which they are now standing. The interrupted or broken frame that Carter provides, composed of collaged pieces of paper, and the faux-collage tree that is actually drawn, makes an eloquent appeal to spectators, most of whom will be familiar with the function of a frame as something that protects the art inside it. They will also, however, be familiar with a more ambivalent function of frames, one that marks a definitive border between the art and the wall upon which it hangs, but at the same time serves as an element in interior décor, one whose color and style will inevitably have a relationship, whether harmonious or strikingly at odds with its surroundings.

Because of this function as a border between two lands, neither one of which they wholly occupy, but between which they mediate, frames have tended to guarantee the illusionary and representational function of the picture inside. In the twentieth century, however, as paintings became more abstract, more self-sufficient, reluctant to submit to the representational status of standing for something other than themselves, frames, especially elaborate ones, became less necessary, in fact, even disreputable. To frame something is to imply that it represents, or was motivated by something outside itself. It is not autonomous. By the 1950s many artists had dispensed with frames altogether, or replaced them with simple lattice strips to protect the painting in handling. Art historians have deduced from this that a broken frame might serve as the emblem of this movement toward the autonomy to which modern art—or at least modernist art—aspired. The artist's presentation of an incomplete or broken frame as a part

of the art was especially modern, since it addressed the liberation of art from representation, and represented as well as exemplified the production of art "that no longer means, but simply 'is'."[16]

But as Carter has remarked, "The title informs you, once you read it." She was speaking about the title of her more recent *Point-Counter-Point* series, where the theme of negotiated balance of the picture plane (a modernist, self-reflexive subject-matter) developed as she followed the histories of tensions and news of attacks and counterattacks in wars in Europe and Africa where, as she noted, two opposing forces in the same country were eventually going to have to hang together, for better or worse.[17] Titles are crucial in nearly all her work. In the *Point-Counter-Point* collages, however, one would not necessarily know that the artist was thinking about Bosnia or Rwanda unless one was otherwise informed, since the title describes an interaction whose structure is common to many fields of endeavor, including war and art. Nevertheless, assessment of their delicately calculated asymmetrical balance required viewers to weigh colors, lines, and forms against one another to discover it, thus experiencing the tit-for-tat kind of exchanges that the title names. When a viewer is invited by a title like "Soweto," however, to speculate on the historical and perhaps present meaning of a place name, especially one loaded with current significance, emphasis rests less easily on the act of viewing. The question arises: what meanings did "Soweto" have by 1989?

Unfortunately for those who lived there, but for good reason, "Soweto" became nearly synonymous with another word, "apartheid," after a series of riots that began there spread throughout South Africa in 1976–1977. Apartheid, which literally means "living apart," became law in South Africa in 1948 when the National party came to power. In two decades, the government, run nearly exclusively by a minority of the descendants of European settlers, relocated over 3 million Africans to townships against their will; in the more rural ones workers commuted 3.5 to 7 hours a day to work in the cities, an average of 706 people shared one water tap, and the rate of active tuberculosis for children

by 1987 was 46 percent. Urban townships had a few more amenities, but even there, the lack of post offices, pharmacies, dentists, public libraries, and playgrounds was common. Black opposition movements were banned and driven underground. By the 1960s, white Africans enjoyed a boom matched only by Japan in a country with the most unequal distribution of income data of all economies for which data was available.[18] But with OPEC oil prices rising drastically in the early 1970s and a war in the Middle East, South Africa entered a period of crisis and recession, which brought unemployment and inflation. Wages earned by Africans there, half of which were already "below the most generously drawn poverty line," dropped. Since oppositional negotiation regarding apartheid was illegal, this led to the growth of black organizations and militancy.

On June 16, 1976, students in Soweto marched to protest a government directive that Afrikaans be used as a language of instruction in black schools. It turned into a general uprising and spread to other townships. State police responded and between 1976 and 1977 nearly 1,000 people were killed, eighteen organizations were banned, and a black newspaper was closed down. In October of 1977, Steven Biko, the young leader of the black consciousness movement, was murdered while under arrest. World headlines and news programs reported these events. A grass-roots trade union movement grew rapidly and the militant black consciousness movement grew stronger, calling on blacks to be assertive and proud of their heritage, psychologically freeing themselves from dominant Eurocentric values rather than cooperating in their own oppression.[19]

If one is familiar with even a few aspects of this sparse discussion of apartheid as it was lived in South Africa, the broken frame in *Light over Soweto #5* can work in precisely the opposite way than one might expect, given its modernist pedigree. Via the title, the broken frame permits whatever information the viewer has, or gets, about the implication of "light over Soweto" to imbue those marks with the narrative of an oppressed people's battle against the forces of their oppression. This is just what Carter has in mind. "I want my pictures to be read like a story," as she has re-

marked.[20] At the same time, these meanings leak out into the galleries and museums where viewers stand, and if the work is privately acquired, perhaps into the homes and collections in which it resides. Meaning from outside the world of art gets read into this art, and may be amplified and dramatized there for viewers by the visual devices the artist has used. Such a title predisposes viewers to read these structures in its light, so to speak, directing them to reverse the generally accepted modernist understanding of the broken frame as an emblem of modern art. It suggests that *Light over Soweto #5*, with its collage-like appearance, participates in what Rosalind Krauss called "the historical logic of modernism itself, in which the newly liberated circulation of the token-sign always carries as its potential reverse an utterly devalued and empty currency." In the case of Picasso's pastiches, with their mass produced and ambiguously located collage images, and of his paintings and drawings done in the styles of other artists, Krauss has characterized this historical logic as "not necessarily destiny of modernism, but . . . its guilty conscience." But Carter, unlike Krauss's Picasso, participates in this history to *expose* matters of modern conscience rather than to hide them.[21] In other words, Carter's incomplete frame signals that her use of collage, despite its current status as the avatar of the counter-cultural version of a modernism whose value lies in its revelation that meaning is never inherent in any sign, uses this understanding to pry open the issue, not of the artist's motivations, but of the viewers'. In this *discursive* space, the signs Carter has marshaled—the collage elements, the ground, the oil-stick marks, and the images they evoke—are metamorphosed by viewers who can construct a story by reading them with the title. As one would expect, the devalued currency that this coin offers on its reverse, perhaps especially for viewers for whom "Soweto" evokes no narrative, as the self-referentiality of modernist formalism, does, often, seem to refer to precisely those aspects of the outside world that its makers found most disturbing.

Paul Gilroy has used the formulation of the politics of fulfillment and the politics of transformation by philosopher Seyla Benhabib to describe such goals and strategies in the arts, but in the field of music. In his discussion of the black Atlantic as a cultural contact zone in which a system of exchanges that formed a counter culture to modernity took place, Gilroy called attention to the efficacy of black music in developing black struggles to communicate. It assisted them at multiple levels of address to organize consciousness, and develop forms of consciousness capable of the self-awareness, confidence, and determination necessary to exercise effectively political agency. He described this aspect of the music as a *discursive* mode of communication to distinguish its interactive character. In doing so, he demonstrated a grasp of the idea that its modes of exchange with its public, its manner of presentation—its style—carried information as important as that carried by its words. He rightly drew attention to the challenge of transferring the critical edge in such music as the Jamaican "sound system culture" of hip-hop transplanted to the South Bronx in the 1970s to real world politics, emphasizing that it was important to pay attention to the social application of both its lyric and formal innovations. In the latter, Gilroy wrote, the elements of style performed information and points of view metaphorically and even emblematically, at the same time that the mimetic or semi-mimetic form of the lyrics signified in a more traditional way.[22]

Because of the devices of signification that Carter has chosen to use in *Light over Soweto #5*, it can, like Gilroy's description of hip-hop in the South Bronx, generate interpretations that work to accomplish what Seyla Benhabib has called "the politics of transfiguration," that is, become part of a "deliberative" discourse by which democratic societies transfigure themselves by establishing understandings that enable the crafting of new desires, social relations, and forms of resistance to its oppressors, as South Africa was doing in 1989.[23] Benhabib uses concepts such as these in her efforts to promote a useful form of discourse theory, which is part of the critical social theory that is her field. Discourse theory is situated, like that of the Frankfurt School, between practical philosophy and social science, notes Benhabib, "sharing and radically reformulating the intentions of both." She saw an important part of that

project in 1986 when she published *Critique, Norm and Utopia: A Study of the Foundations of Critical Theory* in which she urged the development of a "communicative ethics." Communicative ethics is a term that describes more specifically the deliberative ethics that she believes is crucial to the kind of democratic theory she opposes to multicultural theory's more static and essentialist aspects. As I see the operation of Carter's discursive modernism, in *Light over Soweto #5,* as participating in an interplay between formal structures and social advocacy for political purposes as well as professional advancement, so Benhabib's democratic theory posits "a social constructivism that considers the interplay between structural and cultural imperatives is possible as well as desirable."[24] The discourse ethics Carter's work engages also encourages people to think of themselves as belonging to what Benhabib has described as a community of needs and solidarity rather than rights and entitlements. It involves a shift from the latter to the former via an emphasis on consensus rather than on majority rule, which is based on the views of individuals as either participants or observers in public life. Instead, Benhabib emphasizes knowledge and judgments that are reached intersubjectively, that is, in a process of conversation with others rather than a process of discourse in which each individual thinks for him or herself, and then the majority's idea carries. Benhabib's vision of a community of needs and solidarity corresponds respectively to the "norm" and "utopia" of her title, and also, respectively, to the "politics of fulfillment" and the "politics of transformation" mentioned by Gilroy.[25] This entails not only the enablement of a politics of transfiguration but also of a politics of fulfillment, that is, a vision of a society of the future that is able to attain more adequately what the present has not been able to accomplish.[26] When read in the terms described in this essay, in *Light over Soweto #5,* Carter accomplishes something similar. Her understanding of the intellectual, political, and art historical contexts of her work is easier to grasp if you know the basics of her preparation for entrance into the art world.

Carter's own history suggests that her early personal as well as her educational background surely provided her with the motivation and tools to accomplish such an ambitious turn of modernism's methods to social ends. A long-time activist, as a high school student and a member of the Junior NAACP Carter demonstrated to integrate Hanes department store in Montclair, New Jersey. Like most Americans, Carter's political attention in the late 1960s and early 1970s was focused on the black freedom struggles in the United States. Her activism was bolstered by her father, active in New Jersey politics and a commissioner and then mayor of Montclair, and a mother who taught reading in the public schools and dance in her own studio in Orange, New Jersey, after school, introducing Carter and her sister to black theater and dance on nearly weekly weekend trips into New York City. When politicians and businessmen came to this busy household, Carter and her sister were invited not only to listen, but to voice their views and ask questions, Carter recalls. Both parents were involved with the NAACP and the Urban League. Carter first encountered the fact of apartheid in South Africa while attending Oberlin College (1972–1976) in a book of photographs that contained pictures of the Soweto riots in 1960. Her interest in freedom struggles in Africa and the part played by leaders such as Nelson Mandela, Patrice Lumumba, and the African National Congress in educating its members was further focused by the experience of acting in a play at Oberlin about Lumumba, the first African prime minister of Congo.[27]

"In the eighties I got involved with the problem of apartheid," reports Carter. "I think you can see that in the work, when you know what I was thinking about."[28] One of the most important elements in Carter's education on South African apartheid was the hard-hitting articles of Randall Robinson, executive director of Transafrica, a lobby that sought to influence positive legislation toward Africa in the United States, and cochairman of the Free South Africa Movement.[29] But perhaps what really brought the struggles of African peoples, and especially those in South Africa, to her attention as topics for art, was her acquaintance with South Africans Hugh and especially Barbara Masakela. She met the Masekelas through artists Al Loving, Ed

Clark, and Bill Hutson, all of whom helped Carter as she strove to get a toehold in the art world in New York.[30] Hugh was a musician, and Barbara, his sister, was to become minister of cultural affairs and later ambassador to France for South Africa under Nelson Mandela.[31] But at that point, Barbara, already very active in the ANC and teaching at Rutgers, had decided that she wanted to promote black visual artists, and that the best way to do that was to sell their work.

With her apartment-mate Elaine Simpson, and the help of critic Dorothy White, Barbara Masakela opened her large apartment on West End Avenue as an art gallery—Yolisa House.[32] "She was articulate, well-read, and charismatic, a story-teller," recalls Carter of Barbara Masakela.[33] White curated shows there that included Carter, Clark, Hutson, Loving, Madeline Raab (later a cultural commissioner in Chicago), Lula Mae Blockton, Mildred Thompson, and Yvonne Pickering Carter—mostly abstract artists, recalled Nanette Carter. Quincy Troupe lived in the building and came to buy, along with many writers and other musicians. He introduced Masakela's artists to Margaret Porter, who had a gallery in San Francisco.[34]

So by the early 1980s, Carter was mentored by some of the most important abstractionists of the decade. She was determined to make art that was (a) available to people with average incomes, and (b) spoke to African Americans especially, but also to people around the world about issues of vital importance whose significance was insufficiently recognized. To do this, Carter realized that she needed to develop a visual language that could communicate at various levels to differing sensibilities. Thinking back across her work in the last quarter century she mused, "I've never considered myself as anything but an artist who uses nature as metaphor. It's thematic—wind, sky; this is where the universal comes into play." And about the title *Light over Soweto,* but also most of her other titles: "Hopefully, if you read the title, it can work that way for you."[35]

When Carter used the words "*Light over Soweto #5*" as a title for this drawing, she employed the figural devices of metaphor and mimesis that Gilroy had noticed in music to turn dashes, dots, and jagged lines of red, violet, and blue oilstick on black paper into a conflagration that reaches deeply into the night skies of South Africa, thereby standing for struggles for independence. Metaphor *and* mimesis, because of the intense color and dynamic directionality of her strokes, both direct and jagged, are not only visually *like* Yoruban emblems for Shango, god of thunder and war, one of whose emblems is the zig-zag form of lightning, but given the African retentions in the New World that so impressed Carter in Brazil in 1985 (see below), the jagged forms in *Light over Soweto #5* are also emblems for such retentions in general, as well as mimetic references to what most viewers will recognize as the explosive and electric energy unbound in fireworks displays and in futuristic electric devices in science fiction movies and even in cartoons in newspapers, movie theaters, and on television.[36]

If metaphor uses similarity to connect basically unlike things, metonymy, on the other hand, demands no likeness, and operates merely on the basis of contiguity—of nearness. Carter's use of the word *Soweto,* the well-publicized name of the South African township where, by many estimates, the revolt that led to the true democratization of South Africa began, links the entire freedom struggle of that country, and, by extension, others as well, to this image. Although this essay about her collaged drawing in the Paul Jones collection is about her particular interest in South Africa, it is important to note that in other series she has demonstrated concern for freedom struggles around the world, using references over the years to Brazilian, Native American, and Japanese cultures as well as those of Europe and Africa.

The effectiveness of *Light over Soweto #5* is due in part to the fact that Carter has chosen to apply several layers of figuration: not only the metonymy of a title and the metaphors of strokes whose directions, forms, and rhythms, in the presence of this title, mimic several sorts of fiery events (bomb, electric explosion, chemical fire, etc.). The skill with which she has chosen the size, texture, color, and dimensions of her support, her choice of oilstick, which so accurately records the pressure and speed of the arm and hand that applies it, instead of more elegant paint or gentler pastels, and her

composition of those strokes also, however, make it possible for her in this work, as in most of those she has produced for some time, to offer substantial and subtle insights into complex and specific topics in ways that challenge viewers. This is particularly impressive and amazing, since they operate with such abstract elements. They are organized into shapes that evoke in turn the relatively generalized presentation of basic aspects of nature: earth, air, fire, and water, which are then further metamorphosed by both their visual juxtaposition on the picture plane, and later, the titles.

Carter has made a number of series that thematize other aspects of African struggles. There are too many to detail here, but I will mention a few in order to characterize the fullness of the universal that, as she states, "comes into play" in her work, and to specify its limits as well. The artist's universal consists of sounds and smells, touch and taste, as well as normally visual phenomena, working from the senses. She does not, however, assume that others have the same responses to their sensations that she does to hers.[37] Since her imagination encompasses and transfigures sensations from all the senses into vision, when she seeks to present to view what black Africans lost—in the series *Savannah Winds* (1984), for instance—she means to call up the color, the textures, the smells, she says, of "the grassy plains—of Africa in general; South Africa is said to be so beautiful, the water, the air, and the light; the visual richness of the land in memory and imagination." The *Illumination* series (1985–86), was sparked by Carter's recognition on a trip to Brazil of the depth and breadth of African retentions in Brazilian life, not only in the rhythms of the Bossa Nova and samba, but in every element of life there.[38] In 1986, as she read in the *New York Times* and magazines such as *U.S. News and World Report* about the last years of apartheid rule, Carter found the South African government's censorship and seizure of any unapproved copy or photographs by either local or foreign reporters particularly frightening in view of the imposition of a nationwide emergency decree on June 12, in which the police were given the right to hold prisoners incommunicado, and were granted immunity for their acts. A spokesman for Amnesty was quoted as saying of this latitude in one of the articles Carter read at the time: "this seems to be a license to torture."[39] "This was *very* frightening," Carter recalls. "What could happen to the children?"[40] In *Burning Apartheid* and *Burning All Hatred,* both of 1986, Carter intended to transform the destructive nature of the fires, literal and figurative, that characterized the killings, bombings, and arson in black African townships, including homes, schools, and eventually churches, as well as the offices of the African National Congress in cities across the country.[41] Maybe the concept of apartheid itself could be burned—completely dismantled—so we could begin anew, she thought. The flames, then, might be seen as not only terrible, but also cleansing—"as destroying the concept of slavery—getting rid of the idea that some people are less than human. *That's* what makes slavery possible."[42]

In her desire to memorialize and, in future, restore African savannahs to their condition before the winds of colonial rule and then revolution swept over them, in her vision of African retentions in Brazil—despite their origin in the horrors of the middle passage—as nevertheless comprising a most brilliant and life-affirming aesthetic innovation, in her reading of a positive message of hope and certainty of a better future in the flames themselves, and in transfiguring the electrifying power released in the *Light over Soweto* series into an image of the incineration of apartheid itself, Carter's aims for her work to echo Seyla Benhabib's politics of fulfillment and transfiguration.

Benhabib's critical theory is a concept of social action based on communication. Briefly, Benhabib rejects the most prominent presuppositions of revolutionary critical theory, though not for the same reasons. She rejects the adequacy of Hegel's critique of Kant's moral philosophy, if not Hegel's goal of superseding Kant. Nor is she satisfied with either Karl Marx's model of work as social action (which is the cornerstone of what is now called the "philosophy of the subject") or Theodor Adorno's critique of identity philosophies. Both privilege collective singularity, that is, the satisfaction of one group or organization acting in the name of all, of plurality—the understanding that our embodied identity

and the stories we tell to describe who we are give us a way to see the world that is only revealed in a community of action with others. Group actions in this case would take into account the desires of all of those who wish to be included (i.e., the "consensus of all concerned").

Understanding Carter's vision of *Light over Soweto #5* prompts such conversation but in different ways. In her understanding of the fiery forms she has limned as not only signifiers of the terrible human costs of apartheid, but also of the potential of South Africa's struggles to cleanse the world of the very concept that supported apartheid, she creates a powerful promise of fulfillment, visible in the simultaneous messages of exaltation and destruction in what one might call the sublime of the billowing clouds of energy that are the central images in this series but heavily dependent on the consensus in the United States coalescing in 1986 that South African apartheid was a crime. In Benhabib's terms, Carter presents "a view of social transfiguration according to which emancipation carries to its conclusion, in a better and more adequate form, the already attained results of the present." "Emancipation," Benhabib adds, "is realizing the implicit but frustrated potential of the present." Benhabib uses the term transfiguration to suggest that the form that emancipation will take is that of a radical and qualitative break with some aspects of the present. Fundamentally, this means that the society of the future will need to radically negate elements of the present.[43] Carter has named one element of such a negation in her vision of a future in which the attitude that prompted slavery—that some people were less than human—would become unthinkable. In *Light over Soweto #5*, Carter aims to reverse the damaging conviction that many, not only in South Africa but elsewhere, still hold to be a fact of nature, and whose effects are still at work in the United States.

NOTES

1 See George Preston Nelson's remark in Ruth Bass's review of Carter's exhibition at June Kelly, "Nanette Carter," *ARTnews* (February 1991): 140.

2 Thomas P. Brockleton, *The Frame and the Mirror: On Collage and the Postmodern* (Evanston, IL: Northwestern University Press, 2001), 10–11.

3 Yves-Alain Bois, *Painting as Model* (Cambridge, MA: MIT Press, 1993), 74.

4 Christine Poggi, *In Defiance of Painting: Cubism, Futurism, and the Invention of Collage* (New Haven, CT: Yale University Press, 1992), xiii.

5 Brockleton, *The Frame and the Mirror,* 6.

6 For metaphor as a privileged figural device in modernism, see Ann Eden Gibson, "The Rhetoric of Abstract Expressionism," in Michael Auping, ed., *Abstract Expressionism: The Critical Reception* (New York and Buffalo: Abrams and the Albright-Knox Gallery, 1989).

7 Rosalind Krauss, *The Picasso Papers* (New York: Farrar, Straus, and Giroux, 1998), 218. As Krauss notes, this realization was Apollinaire's, a phenomenon that inspired what he called the "internal frame," in which something from the outside is projected into a work of art, making art and reality exchange places.

8 The essay is retitled "Collage" in Greenberg's *Art and Culture: Critical Essays* (Boston: Beacon Press, 1961).

9 Peter Wollen, "The Two Avant-Gardes," in *Readings and Writings: Semiotic Counter-Strategies* (London: Verso Editions and NLB, 1982), 92–122.

10 Although it can be argued that all metaphor collapses into metonym. See Gibson, "The Rhetoric of Abstract Expressionism."

11 For the waning of the subject, see Peter Bürger, *Theory of the Avant-Garde,* trans. Michael Shaw (Minneapolis: University of Minnesota Press, 1984).

12 Brockleton, *The Frame and the Mirror,* 184–187.

13 Karen Wilkin, in *Nanette Carter: Slightly Off Keel* (New York: June Kelly Gallery, 2002), 3.

14 Following this remark, critic George Baumgardner noted that "Nanette Carter's highly abstracted landscapes make effective use of the texture of the supporting canvas [or in the case of *Light over Soweto,* paper] to heighten the nervous, all-over strokes of pastel color. The flickering surface seems to be in constant movement, a sort of landscape that hovers on the horizon of abstraction." "Tibetan Art in the Making and Varieties of Abstraction," *Ithaca Journal* (March 21, 1991).

15 Nanette Carter, interview, Sag Harbor, July 26, 2003.

16 Brockleton, *The Frame and the Mirror,* 24–28. Brockelton is discussing Karsten Harries's ideas in *The Broken Frame: Three Lectures* (Washington, DC: Catholic University Press of America, 1989).

17 Nanette Carter, interview, New York City, July 24, 2003.

18 Mike Savage, "The Costs of Apartheid," *Third World Quarterly* 9:2 (April 1987): 601–621 and Colin Bundy, "South Africa on

Switchback," *New Society* (January 3, 1986): 7–12, cited in Andre Odenthal, "Resistance, Reform, and Repression in South Africa in the 1980s," in *Beyond the Barricades, Popular Resistance in South Africa* (New York: Aperture Foundation, Inc., in association with the Center for Documentary Studies at Duke University and with the cooperation of Afrapix and The Centre for Documentary Photography, Cape Town, 1989), 126.

19 Ibid.

20 Carter in Wilkin, *Slightly Off Keel*, 3.

21 Krauss, *The Picasso Papers*, 241.

22 Paul Gilroy, "The Black Atlantic," in Jana Evans Braziel and Anita Mannur, eds., *Theorizing Diaspora* (Malden, MA, and Oxford: Blackwell Publishing Ltd., 2003), 69, 72–74.

23 See Seyla Benhabib, *Critique, Norm, and Utopia: A Study of the Foundations of Critical Theory* (New York: Columbia University Press, 1986), 13.

24 Seyla Benhabib, *The Claims of Culture, Equality, and Diversity in the Global Era* (Princeton, NJ, and Oxford: Princeton University Press, 2002), ix, 11.

25 Benhabib, *Critique, Norm, and Utopia*, 10–13, 71–72, 98–99, 111, 336–337.

26 Ibid., 2–3, 12–13.

27 Nanette Carter, telephone interview with the author, August 20, 2003; interview with the author, Sag Harbor, August 24, 2003.

28 Nanette Carter, telephone interview with the author, August 8, 2003.

29 Carter has identified articles such as "Foreign Oil, a Lubricant of Apartheid" (*New York Times,* Thursday, March 20, 1986, A 27) by Robinson and Richard L. Trumka, president of the United Mine Workers of America, as one of those that "got African Americans involved with the ANC" (Carter, interview, August 20, 2003). Robinson's articles differed from those of most reporters to the *Times,* even those favorably disposed to South African independence, in that he clearly and persuasively described the mechanisms of oppression operating in South Africa, the part that many were unwittingly playing in that oppression, and what everyday Americans and not-so-everyday Americans could do to make a difference.

30 Carter in "Nanette Carter, Visual Artist," interviewed by Calvin Reid, November 16, 1997, *Artist and Influence* 17, ed. James V. Hatch, Leo Hamalian, and Judy Blum (New York: Hatch-Billops Collection, Inc., 1998), 62.

31 Carter, interview, August 20, 2003.

32 Carter in "Nanette Carter, Visual Artist," interviewed by Calvin Reid, 62.

33 Carter, interview, August 20, 2003.

34 Ibid.

35 Nanette Carter, interview, Sag Harbor, July 26, 2003.

36 For the significance in African art of zig-zag forms, see Robert V. Roselle, Alvia Wardlaw, David C. Driskell, Tom Jenkins, eds., *Black Art: Ancestral Legacy: The African Impulse in African-American Art* (Dallas: Dallas Museum of Art, 1989).

37 Benhabib, *The Claims of Culture*, 13–14. In this, Carter falls on the side of what Benhabib has called the discourse model of variants of contractarian and universalist models of normative validity. The discourse model of "interactive universalism" is able to take into account in its dialogue the particular life-world dilemmas and experiences of its participants without imposing prescribed moral ideals. It considers individuals' needs as well as their principles, the stories of their lives as well as moral judgments. It does not privilege observers and philosophers, but rather considers that all beings capable of sentience, speech, and action are potential moral conversation partners. Only through entering conversation as far as one is able to do so, can one become aware of the otherness of others, of those aspects of their identity that makes them concrete and specific. Since cultural narrative is crucial to the narrative constitution of individual self-identities, claims Benhabib, these processes of interactive universalisms are crucial in multicultural societies.

38 Nanette Carter, interview, Sag Harbor, July 26, 2003.

39 James Brooke, "3000 Reported Held by Pretoria in Crackdown," *New York Times* (June 19, 1986), A 1, 10. This is only one among many sources of news about African struggles for justice and freedom that Carter perused in the 1980s. Another article from the *Times* she read with interest at this time, from Alexandra, South Africa, entitled "Harsh Restrictions and Hostile Protesters Hamper the Press," was published the day before that by Brooke, in section 1, p. 6.

40 Nanette Carter, interview, Sag Harbor, July 26, 2003.

41 For the destruction of the years between 1983 and the end of 1987, see Odenthal, "Resistance, Reform, and Repression in South Africa in the 1980s," 127–138.

42 Carter, interviews, June 26, August 20, 2003.

43 Benhabib, *Critique, Norm, and Utopia*, 347, 348, 315.

FACING PAGE:

Detail from Nanette Carter's
Light over Soweto #5, 1989
(Plate 17)

Reign(ing) in Color:

Toward a Wilder History
of American Art

IKEM STANLEY OKOYE

T HE PERCEPTION OF COLOR AS A JARRING, IMMIGRANT, RACIAL other is a provocative idea that marked early assessments of African American art aesthetics. Stereotyped views of color usage by African American artists contributed to a tendency for the art itself to be differentiated on the part of the broader American public in negative ways.[1] The emblematic notion of color was an idea that African American artists attempted to wrest positively from the minds of critics who insisted on defining such qualities in negative terms. But the systematic use of color serves purposes other than surface appearance, and it is interesting the degree to which this aspect of its application has been ignored. To form an argument about color in such contexts without considering this additional function is equivalent to ignoring the role of overlap, extrusion, and separation in an image where the composition is derived from the juxtaposition of hues. A comparison of work by Margaret Burroughs and Leo F. Twiggs presents the opportunity to examine this juxtaposition.

Margaret Burroughs (b. 1917) is a Chicago–based artist, educator, art administrator, and activist who was initially known for genre paintings but later became established for making black-and-white prints. Born in Saint Rose Parish, Louisiana, she attended the Saturday honors class at the Art Institute of Chicago taught by critic and educator Dudley Craft Wilson and painter George Bueher where Charles White was also a student. She later studied at Teacher's College at Columbia University, Northwestern University, and in Mexico City. She was one of the founders of the South Side Community Art Center in Chicago (1940) under the sponsorship of the Works Progress/Work Projects Administration (WPA) and was director and founder of the DuSable Museum of African American Art

45

(1961).[2] Her signature prints and paintings are generally informed by observations from routine trips to continental Africa and from African American life in the inner city. Burroughs lives her avidly Afrocentric politics through extensive travel and arts activism, including founding the National Conference of Artists (NCA), and her advocacy for the connectivity of African Americans to Africa.

Her painting entitled *Three Souls* (1964) explores the sociopolitical implications of skin color and the racially charged innuendoes associated with tonal difference (pl. 19). Burroughs addresses this touchy issue within the African American community that historically deals with degrees of blackness as it relates to complexion. In this context, the safest range is medium brown—being too light or too dark can trigger an undesirable reaction from members of the African American community. Burroughs places the lighter-skinned figure in the center and portrays her with the most pronounced features. Their faces and torsos overlap in a manner that seems to indicate unification—sisterhood. At the same time, the image alludes to dual existence—representing the individual self while also representing the group (race), a common experience for African Americans. By title, however, Burroughs affirms their right to their individual selves, but ironically, at the same time, there is the understanding that the surface difference—skin tone—is insufficient in the face of racial classification which essentially renders all coloration ultimately the same—racially defined as African American.

Leo F. Twiggs (b. 1934) does not appear to be what in common parlance is viewed as political or as an outward proponent of direct associations with Africa. He grew up in St. Stephens, South Carolina, a small town where his family dated back to the antebellum era. After graduating from Claftin College, he received a master's degree in art from New York University (NYU) and became the first African American to receive a doctorate degree in art education and criticism from the University of Georgia (UGA, 1970). He established the first art department in a state-supported historically black college, South Carolina State College, admitting its initial art students in the fall 1973.[3] A batik painter, he is best known in the South Carolina context.[4]

Like Alma W. Thomas (1896–1978), Hale Woodruff (1900–1980), and many other accomplished African American artists, Burroughs and Twiggs were dedicated teachers, devoting their early careers to nurturing sustained interest and leadership within the ranks of young students. Perhaps to the detriment of their personal endeavors as practitioners that may well have brought them fame at an early age, both worked for a deeper survival through a reproductive plenitude, contributing to the continual process of art teaching and art making. On the other hand, each artist mastered media that have not always been considered high art, and their color usage is quite different.

Burroughs's *Three Souls* is derived from an understanding of European (even primitivist) modernist tradition. Albeit in her work the disjunction of color from nature, as well as its interrogations of contemporary social approbia, is focused on subject matter close to home—domestic and diasporic sisterhood or the nuances of skin color and their paradoxical effect. Twiggs, who produces batik images—a technique historically associated with textile arts—identifies different subject matter as crucial and engages another deployment of color. He is certainly not interested in images of an overt Africanicity. Although his series Silent Crossings evokes, formally, the characteristics of collage, its colors are muted over large areas of batik, bringing a wistful, dreamy quality to the subject matter. In Twiggs's work, the moments of color stand out like beacons in a fog, drawing a viewer's attention toward particular zones of activity, where the issues he chooses to explore, social anxiety and social memory, might easily congregate. There is a difference, more than simply in terms of a generational separation, that might be traced across broader landscapes of African American art.

A DIGRESSION, EUROPE

The tracks were laid in Europe in the 1880s for the ultimate theoretical alliance of color with the primitivism of early modern art in France and Germany. Beginning at

that time, the meaning of color underwent a radical change in European art that involved the detachment of the expressive power of color from its primary connection to reality.[5] It is therefore not surprising that a certain vividness, density, and dazzling juxtaposition of color became increasingly attached to artistic wildness, as is evident beyond France in the work of German Expressionist artists such as Emile Nolde and Ernst Kirchner. And, given the role Africa was recruited to play in the consolidation of primitivism in such places, it is not surprising that dramatic color would be associated with being African by American-born artists of the diaspora and within the context of Western art history as discipline.

Such things would be of no particular import to the history of African American art were it not for the well-known fact that African American artists of the first and second public generations invariably traveled to Europe, as did their Euro-American compatriots.[6] The purported aim was always to expand artistic horizons. Though many of these artists already had some notion of what a specifically African American art could be (in its imaginable difference from a white American art), French and German art, in conceptualizing Africa within the primitive, seemed to offer ready-made templates for artistic identification and subjectivity.[7] Many years after being initially validated in avant-garde European practices, these patterns were adopted contextually by African American artists in ways that suggest a kind of wish fulfillment with potentially troubling dimensions.[8]

THOUGHTS ON A HISTORY OF COLOR

From the beginnings of the modernist era to the present, color, as well as its absence, has functioned as a significant political metaphor in African American art. The work of Norman Lewis (1909–1979), Adrian Piper (b. 1943), Robert Colescott (b. 1925), Houston Conwill (b. 1947), Kara Walker (b. 1969), and many others attest to the new and unprecedented ways in which color is manipulated and explored.[9] Nevertheless, the metaphoric usages of color identifiable in the work of these artists and their peers needs to be given a more meaningful scrutiny, particularly within the narrative of African American

art. Specific works by Twiggs and Burroughs are used to briefly introduce discussions of a history of color in African American art, paying careful attention to the artists' locales, an aspect typically omitted from the recent plethora of publications on African American art.

Color in art rarely acquires an indexical value that is consciously related to a race-based subjectivity. That is, a broad survey of Western art history will hardly reveal that artists consistently employ color as a self-racializing language, one, for example, whose syntactic and semantic possibilities trace how the artist positions himself or herself as subject, whether in the capacity of a professional or private autobiography.[10] Yet, this is what the colorfulness of artistic images most typically evokes in the history of African American art precisely in its emergence, and to the extent that it lives a temporarily separated existence from the broader context of American art. Examples include the insistently color-studied work of Alma Thomas and Romare Bearden (1911–1988), and the dazzlingly color defining AfriCobra, both in their development out of the Committee of Bad Relevant Artists (COBRA) and in their separateness from the earlier European group CoBra (pl. 20) with which they share some ideas and concerns.[11]

Interestingly, in no sense were artists riveted by a concern with the meaning of color—of materials, or of the representational images that arise from them—beyond its perceptual and constructional qualities in the work of the pioneer artists of "that class of Americans called Africans."[12] In other words, there were many artists who either fled from the oppressive discomfort of a racialized American polity, or became political activists working toward liberation from racism. Sometimes both tactics coincided in the biographies of the same individual.[13] There is little in the oeuvres of black artists that would produce a sustained, convincing argument for the play of color as pigment with the play of color as a euphemism for racialization. For African American artists, apart from the emblematic quality of color in art, neither color itself, nor the structure of its relationships, nor its character as one of many media open to an artist's manipulation, were ever particular arenas of rhetoric through which to explore the racialized politics

of America. Instead, and to the possible advantage of other purposes, colorfulness came to be appropriated in particular ways as a means by which African American artists constructed their own particular subjectivities.

COLOR AND DIFFERENCE

There is an advantage to exploring the issue of color in the work of artists who, though well known in their particular locales, have yet to be acknowledged nationally in the manner of such individuals as Jeff Donaldson, Adrian Piper, or Kara Walker. In the example of Jeff Donaldson (b. 1932), we understand that, working in the context of AfriCobra, it became possible to formulate a manifesto in which several issues, color among them, were articulated with clarity and precision. It would therefore be possible, given this and the very name AfriCobra itself, to understand that Donaldson was probably aware of a European movement predating the one he founded in Chicago. The European group CoBra revived some aspects of primitivism that rhetorically rendered recuperation of an imagined Africa in an appeal, once again, to African Americans in a way that would not have been the case in the years after WWII reading Picasso or Alain Locke.

Given European CoBra's construction of a color theory where art labeled primitive was once again pressed into service, and given the group's interest in jazz, Donaldson's concerns, like European CoBra's, relocated to the particular political culture of post-civil-rights Chicago, and to the naming of AfriCobra in its formation. Whether considering Jeff Donaldson's work or its variation in the 1980s work of fellow members Wadsworth Jarrell (b. 1929) or Michael D. Harris (b. 1948), AfriCobra, like CoBra, revisits the question of connection to the art of African ancestors engaged in New Negro era art, especially the manner of its association with vividness, complexity of color rhythm, and stark color juxtaposition to both Africa and to jazz. In a sense, what was later theorized as a blues aesthetic—an aesthetic sensibility across all kinds of artistic media structured by African originated cultures wherever they reside[14]—was already a working hypothesis with AfriCobra.

Contra AfriCobra, Africans were no more enamored with color than other groups historically; and the fusing of the identity "African" with a penchant for color is not unlike the common fusion of rhythm with African-ness that reflects a troubling racialized thinking. What is important, however, is the fact that in searching for difference, African American artists imagined an Africa that was relevant to their art making, and therein, responded to color. Color in its wildness—not being fixed, tied down, predictable, or controllable in its effects—came to be granted a crucially important role that produced a style and aesthetic both distinguishable and noteworthy. This historical fact can hardly be in dispute, even if its theoretic of the blues can.

ANOTHER STORY FOR COLOR

How might the concerns and issues previously expressed have played out in the larger community of African American artists, especially to those residing in locations other than major cosmopolitan spaces such as New York and Chicago since 1968? In what ways might such rhetoric have resonated, or not, in South Carolina or Georgia; and how might the contextual nuances read in such suggestions for writing a history of African American art into American art history?[15]

The work of Leo Twiggs lends itself to an exploration of this issue.[16] Although Twiggs spent several years working in New York under the tutelage of Hale Woodruff in the heyday of the New York school and of abstract expressionism, his experiences before and afterward seem squarely rooted in the rural South. Residing in a small town, his father died when he was fourteen, which led to Twiggs caring for his younger siblings—a sister and five brothers—while his mother worked. At that time, it seemed unlikely that he would receive the educational support and training to pursue art—a career path thought to be highbrow and unattainable. Nonetheless, Twiggs managed to earn three academic degrees.

Woodruff, who was a central figure of the New York group Spiral at the time, espoused methods, approaches, and aesthetics of abstract expressionism that increasingly focused on a rhetorical African symbol-

ism. He exposed Twiggs to directions of American modernism,[17] particularly investigations of the alliance between abstract expressionism's democratic American-ness and the idea that the only true American music form was jazz. Twiggs recalled that Woodruff was not enthusiastic about his initial work. According to Twiggs, there was an incident when the likelihood of his successfully completing the program at NYU was assessed and, after a moment's hesitation, Woodruff commented, "He is really coming along."[18]

Twiggs regarded Woodruff's response as merely a general statement on his progress. However, it possibly indicated that the two had different interests. Woodruff, as a central figure of the Spiral group, explored means to achieving an intense absorption of Africa and its art into his work. Considering Africa the source of his creative ancestral models, he created protest paintings that relied on African-derived concepts of representation, rejecting the classic European example. Twiggs, on the other hand, having originated in the South where connections to Africa were more intrinsically paired with nuances of common, everyday life, made no direct references to Africa in his work.

Contrarily, by 1910 and continuing through the New Negro/Harlem Renaissance era and beyond, a distinctive, urban phenomenon evolved in African American art aesthetics rooted in Africa that was inseparable from a certain politics of identity, even without getting into the legitimacy of its particular arguments.[19] During the civil rights movement many artists rallied around a cultural and political sense of blackness and the Alain Locke/W.E.B. Du Bois views of ancestral legacy in art.[20]

Woodruff's comment on his student's progress may also suggest that Twiggs was very close to adopting some of the ideologies of the New York school's brand of abstract expressionism. Twiggs, aged twenty-seven when he started his two-year study at NYU, moved toward a greater deployment of color and less reliance on figurative references in his work during his stay in New York.

Unlike Margaret Burroughs, who left Louisiana in the 1930s and settled permanently in the academic and art communities in Chicago, Twiggs returned south upon the completion of his master's study, joining the faculty at Orangeburg and electing to examine definitive aspects of regional culture from the local perspective. Moreover, he conducted the investigation using unconventional materials—painting on batik. Although the production of dyed images on fabric might be associated with modern West African art, particularly the Oshogbo school of Nigeria in the early 1960s, Twiggs linked his work historically with practices of ancient Egypt. His departure from canvas as such in favor of explorations in painting based on methods connectible to Africa is significant. However, it is his choice of subject matter and the negotiation of objectivism/non-objectivism involved that distinguishes Twiggs's imagery from larger trends in American art.

FADING CONFEDERATE COLORS

Most of the work of premiere first-generation African American abstract expressionist artists such as Woodruff, Charles Alston (1907–1977), Romare Bearden (1911–1988), and Norman Lewis (1909–1979)—who was the only African American artist considered a participant in the movement from the start—identified with their racial selves.[21] Lewis, perhaps more emphatically than the others, tended to do so through direct links to the activism of the civil rights era, often reiterating this fact with his titles. All successfully explored figurative abstraction in their progression toward this more improvisational style and retained an association with African art in their work. Twiggs's work did not reflect the same interest in African imagery, turning instead to the very pressing matters affecting the daily lives of people of African descent in the 1960s Carolinas. As he engaged in doctoral work at the University of Georgia, making the necessary drive between Orangeburg and Athens, Georgia, for a period of years, and experienced the travails of the civil rights struggle, he formulated the artistic ideas that would surface in the early 1970s in a distinct exploration of Confederate iconography.

Passing through a number of small, conservative southern towns during his routine commute, he observed the nostalgic lure of Confederate symbols throughout, signs and symbols that later emerged recognizably in

his most abstract, nonfigurative work. In so doing, he possibly addressed the impact of returning to his home state and experiencing a new ambivalent sense of estrangement and alienation prevalent in the daily function of African American life. He witnessed racial violence firsthand in 1968 when three students were killed and twenty-seven others were wounded when state troopers fired on demonstrators demanding desegregation of Orangeburg's only bowling alley. Called the Orangeburg Massacre, it was the first in a series of confrontations between students and troopers across America's university campuses; only one other, at Kent State University in Ohio, involved the death of students.[22] While the death of white students in the Ohio protest made national headlines, the earlier tragic deaths of African American students in South Carolina received little attention. Later that same year, the incident was overshadowed by the assassinations of Dr. Martin Luther King, Jr., and Robert Kennedy. It is interesting to note that Cleveland Sellers, a Danish professor who was among those wounded during the Orangeburg incident and subsequently imprisoned for inciting the riot, was a fellow countryman to a founding member of the European CoBra group, an organization astutely opposed to all forms of fascism.

In this milieu where actual sociopolitical representation was an issue over which people were murdered, Twiggs was conceivably less interested in the art theoretical explorations of the New York school and the Africanistic color-coded references to which he was exposed in Chicago at the Art Institute and at NYU. Such issues may have seemed overly idealistic, mandating a careful attentiveness to the politics of everyday life, directly and indirectly, to Twiggs as an educator and a witness to turbulent events of national importance. This is not to say that Twiggs's work lacked a political edge. However, his work moved away from a kind of idealism that differentiated it from the previous generation's desire for connectivity to Africa.[23]

Twiggs's batik paintings stand out initially as images assembling forms, colors, and textures in particularly thoughtful and engaging ways. His symbolic use of color and its interaction with the signs and symbols ex-tracted from the southern landscape function as markers of physical and other realities. One of the most commonly applied symbols in his work is the large X. The potential meanings for the sign are numerous and varied. It may refer to the Confederate flag and its role as a pervading remnant of the Civil War South. It may signify Malcolm X, in which case the "X" iterates the namelessness and separation of African Americans from their ancestral lineage due to slave ownership. It may call to mind the use of the "X" as a substitute for the signature of those who could not write, and more poignantly in the context of slavery where African Americans were legally denied the right to learn to read and write. The "X" might reference the railroad—a frequent historical definer of racial boundaries and barriers in countless communities across the country, and also being an important means of relocation for blacks from the South to other regions. The symbol may represent any number of decisions, impasses, crosses we bear, namely, any crossroads in life including death. It may allude to X-files or "X" marks the spot. Many of these and other possible references can be read in his work dating back to a *Confederate Flag* series from the 1970s. The imagery tends to be deceptively quiet and calm on one hand, yet potentially explosive in its referencing Confederate ideology as subject matter and the tensions it continues to produce and sustain within American society and its cultures.

Although Twiggs accepts the range of symbolic resonance of the cross as crossroads, the driving signification rests with the questions and anxieties still raised by southerners who, well beyond nostalgia, re-energize the meaning of Confederate paraphernalia as they invoke meaning for the Confederate flag's cross. Twiggs's observations and experiences during commutes to Athens apparently brought him to an exploration of this issue. Nostalgia for an old South was palpable, almost as if such valuation could expel the memory of the slavery upon which it was based. Twiggs became increasingly interested in the durability of certain images and the symbolism attached to them.

Of course, being a descendant of those enslaved in the very vicinity of places revisited is significant. Even

the physical act of drawing and redrawing, painting and painting over the very forms of these symbols can hardly be benign. Repetition has a way of reinforcing meaning, but it can also diminish its symbolic impact, especially being reproduced by those most aware of this history, namely, its victims. Twiggs is therefore aiming at a kind of subversion, one whose political force cannot, once informed, be easily lost. "Crossings can be impediments that we all come in contact with. Maybe we don't even talk about them . . .we internalize and endure it silently. Life is a series of crossings; Death, being the final crossing."[24] Twiggs's work, especially in the context of the more recent controversies surrounding Confederate flags in southern states, is understated, artistically innovative, and politically charged. This work, in its constant dissimulation of the symbols and everyday objects of the Confederacy, effectively subverts the singularity of meaning that is, in the southern context, both the key to its communication and its disturbing power.

As for color, Twiggs's work does not by any stretch of the imagination approach achromatism. Nevertheless, he avoids any assertive use of color to metaphorically relay notions of blackness as theorized in the concept of a blues aesthetic. Teri Tynes surmised that among the issues with which one might surround the narrative of art by African Americans is one centered on the problematics of color, as well as the import from popular culture of positive attitudes toward brightness and even "shine."[25] It is not that Twiggs rejects color; rather he found richness to be more effective than intensity of color.

In *Low Country Landscape* (1972), an atmospheric portrayal of deep pastels hovers over a simple terrain with a vague form of a tree and tiny smatterings of textures and light toward the right of the image. A thin, slithering light blue line horizontally intersects the picture plane bringing with it any number of possible interpretations. Typical to Twiggs's style of symbolic application, the linear element may signify a body of water such as a lake, river, or creek. It may represent the horizon, refer to a heightened vantage point (looking down into a valley), or be a metaphor for a passageway—a path, trail, road, or train track. Its overall pinkish

coloration with earthy undertones is reminiscent of daylight filtering through a partly clouded dawn or dusk sky. The deep-rose-colored tree is presented almost like a huge bloodstain, emerging in isolation as yet another potential object whose southern role is pointed and paradoxical. While trees were associated within many positive contexts, there was the horrific linkage to lynching. In the vocal lines of singer Billie Holiday, "southern trees bear strange fruit, blood on the leaves and bloody through, Black bodies swinging in the southern breeze, strange fruit hanging from the poplar trees." The most intriguing aspect of Twiggs's batik paintings is its irony. Laced within his soft-hued, gently rendered narratives of the region's landscape, Twiggs's palette constrains the wildness of color,[26] an approach confirmed earlier when he painted old, faded, discarded Confederate flags as if to insist on the representation of decayed, forgettable ideas. The final effect is a form of restful harmony, perhaps, in anticipation of the calm of the American democratic ideal advancing as Confederate ideas recede. And unlike those (such as Burroughs and Woodruff) whose work was more overtly political, Twiggs retained the naturalness of color to its related form.

What does Twiggs's trajectory mean within the history of African American art and its relationship to color? How does it relate to other artistic practice? Does it provide a means to clarifying the construction of African American art history and other means to approaching issues of color? Can it enable its inevitable insertions within American art history more singularly and more broadly? A reasonable response is that Twiggs's work does provide such means. His work successfully appropriates the ideological concept of the blues aesthetic in the spatial context of the southern (metaphorical) landscape, affirming that, like the concept of race itself, it is a reality. But are there conceptual boundaries? Do the same possibilities exist purely within the context of other regions? Although any history of color in African American art would explore the evolution and application of a blues aesthetic as it maps its spatial dispersion and reach,[27] it would also have to produce historical logics *outside* of such bounds.[28]

NOTES

1 See James J. Winchester, *Aesthetics across the Color Line: Why Nietzsche (Sometimes) Can't Sing the Blues* (Lanham, MD: Rowman & Littlefield, 2002)

2 Margaret Burroughs initially named the Chicago museum the Ebony Museum of Negro History and Art.

3 South Carolina State College was known earlier as the Colored Agricultural and Mechanical College. It embraced the philosophy of Booker T. Washington, emphasizing practical training.

4 See Frank D. Martin, "Introduction," *Cultural Reflections: Twenty Years of the Visual Arts Tradition at South Carolina State University* (Orangeburg: South Carolina State University, 1998).

5 Color, and its manipulation, has, of course, been central to visual representation for as long as have images been projected externally (on to surfaces or objects). There are ways of understanding the history of West European art, and perhaps of all art, in terms of a progressively sophisticated interest in, and ability to theorize color and (in practice) modulate tones, shades and values in the production of a simulacra for reality (or at least of the human perception of it). This is especially so given the historical relationship in the West between visual representation and external reality (very different of course in say African or Pre-Columbian art of the Americas). Although, in West Europe, the new idea of color was most evident in impressionist and neoimpressionist art, it was perhaps taken to its most fluid and poetic conclusion in the work of the Parisian fauves.

6 Teresa A. Leininger-Miller, *New Negro Artists in Paris: African American Painters and Sculptors in the City of Light, 1922–1934* (New Brunswick, NJ: Rutgers University Press, 2001); and Jody Blake, *Le Tumulte noir: Modernist Art and Popular Entertainment in Jazz-Age Paris, 1900–1930* (University Park: Penn State University Press, 2001).

7 Richard Powell, "In My Family of Primitiveness and Tradition; William H. Johnson's 'Jesus and the Three Marys'," *American Art* (Fall 1991).

8 In early modern Western thought, as evidenced in the various national Romantic movements, color came to be associated with emotionality where line, regarded in some instances as superior (Quatremère de Quincy), was associated with intellect and reason. It is this logic that later comes to govern, perhaps unknowingly, William H. Johnson's public self-representation and trajectory, much as Henry Tanner may have disapproved of it.

9 Ann Gibson, "Black Is a Color: Norman Lewis and Modernism in New York," in Norman Lewis's *Black Paintings, 1946–1977* (New York, Studio Museum in Harlem, 1998), 21–22; and Ikem Stanley Okoye, "Shamanic Penumbra: Houston Conwill's Art of Color," *New Observations* 97 (September/October 1993).

10 There is something remarkable about this fact, given that the profession of artist has not, until relatively recently, been a particularly status-granting one, and that many artists reputable within art history, from Lissitsky, Picasso, and Picabia backward, operated in contexts of intensified ethnic differencing or in contexts that would have marked them *as* different—milieu and experiences that today would likely be racialized.

11 It is fortunate in a sense that this reassessment is possible at this moment in time, since CoBra is, as I write, receiving new press in Europe through a traveling exhibition that represents the history of the group. CoBra certainly produced a manifesto of sorts, and among its important focuses is that gathered around making art accessible to a wider, non-elite culture (CoBra was Marxist in its orientation), and which in part involved a less ascetic approach to art making than was the case for abstract expressionism to which their lineage reaches back (CoBra's birth in the aftermath of the trauma wrought by Nazi Germany on Europe's self-identity is comparable to AfriCobra's concern with "relevance" given its birth in the civil rights era response to segregation and its traumas); a return to art's mythical potentiality (contrary, for example, to a certain modernist code); and CoBra's deployment in this regard of a lively color palette reinforced over time by the groups' interest in jazz (Karel Appel, CoBra's most prominent artist, visited New York in 1957, six years after CoBra had been declared defunct by its members. Yet Appel's engagement with the jazz scene [he painted portraits of its musicians] reveals an interest earlier than this moment, and that music historians understand as pervading the cultures of western Europe especially in the aftermath of American culture's influence through the presence of GIs [although in this regard in ways distinctly removed from either its cubist/expressionist and surrealist appropriations]). See for example, *Karel Appel: Rétrospective*, exh. cat. (Nice: Poinchettes-Art Contemporain, 1987). Also *Karel Appel: Recent Paintings and Sculpture*, exh. cat., essay D. Kuspit (New York: del Re Gallery, 1987). Alfred Frankenstein (with M. McLuhan and J.-C. Lambert), *Karel Appel: Works on Paper* (New York: Harry N. Abrams, 1980).

12 As Lydia Maria Child put it succinctly in a very different context (I refer to the title of her influential book, *An Appeal in Favor of That Class of Americans Called Africans* [Amherst, MA: University of Massachusetts Press, 1996]).

13 Edmonia Lewis, Henry Ossawa Tanner, Augusta Savage, Lois Jones, William H. Johnson, and Elizabeth Catlett might number among the well known.

14 E. Elthelbert Miller, "Black and Blue: Toward and African Aesthetic," and Wanda Coleman, "A Second Heart," in *High Performance* (Winter 1992): 22–26. The idea is theorized with greater sophistication in Barbara A. Baker, *The Blues Aesthetic and the Making of American Identity in the Literature of the South* (New York: P. Lang, 2003). Richard Powell edits a series of skirmishes with its central notions, some located within black visual art specifically (see Richard J. Powell, *The Blues Aesthetic: Black Culture and Modernism* [Washington, DC: Washington Project for the Arts, 1989]).

15 This was already recognized in a 1990 exhibition and its related catalogue, although the focus was on artists of a generation after Twiggs. *Next Generation: Southern Black Aesthetic* (Winston-Salem, N.C: Southeastern Center for Contemporary Art, 1990).

16 Twiggs's one-person show is mounted at the Georgia Museum of Art in Athens in the winter 2004 and will travel nationally for three years.

17 Woodruff, one of the central figures of African American art history, experienced part of his early career in Atlanta where he organized a crucial exhibition in 1942 that engaged African American artists nationwide. From the beginning, Woodruff's paintings pushed the limits of color application and contrast while maintaining a sense of visual harmony. By the time he joined the circle of postwar New York artists exploring the possibility of an American modernist art, he, unlike some of the central figures of abstract expressionism, sustained an interest in an expressionist art that although abstract, remained organized around distinctive symbolism of African origin (see Helen Shannon, ed., *Hale Woodruff: Fifty Years of His Art* [New York: Studio Museum in Harlem, 1994], 36). Woodruff intended to create a visual anchor that allowed his imagery to be abstract yet remain easily readable and accessible to the African American community. Although he developed a tendency over the years to use contrasting areas of color against unified signature tones (for example, the grey-green in *Torso* and the earthy reddish brown in *Celestial Gate*), this approach cannot be plotted as a coded narrative on color (race) nor marked as intentionally African. His work can be narrated as a politics of Africanicity in the sense that its resistance to the extreme forms of fluidity and boundlessness that defines the abstract expressionism of Rothko or Pollock was blocked by symbolic forms derived from African examples in the work of Woodruff, and with a legibility that was guaranteed by color. (Woodruff was undoubtedly interested in African art throughout his career as he was also interested in the concept of modern African American art that might connect Africans in America with continental Africans, as evidenced by his participation in the Dakar FESPACO exhibition and his contributing to the show's catalogue.)

18 See Elton C. Fax, *Black Artists of the New Generation* (New York: Dodd, Mead & Co., 1977), 339.

19 For a brief and succinct challenge to this thinking see Elizabeth Mudimbe-Boyi, "Harlem Renaissance and Africa: An Ambiguous Adventure," in V. Y. Mudimbe, ed., *The Surreptitious Speech: Présence Africaine and the Politics of Otherness, 1947–1987* (Chicago: University of Chicago Press, 1992).

20 Henry Louis Gates, Jr., ed., "The Art of the Ancestor," "Enter the New Negro," and "The American Negro as Artist," in Alain Locke and Jeffery C. Stewart, eds., *The Critical Temper of Alain Locke: A Selection of His Essays on Art and Culture* (New York: Garland Publishing, 1983).

21 Ann Gibson, *Abstract Expressionism: Other Politics* (New Haven, CT: Yale University Press, 1997).

22 The protest march was a response to an earlier demonstration where students attempted to integrate a local bowling alley and were refused admittance. For more on this incident, see Jack Bass and Jack Nelson, *The Orangeburg Massacre* (Macon, GA: Mercer, 1984, and New York: World Publishing Co., 1970.)

23 In this regard, it might be noted, for example, and by contrast, that as recently as 2002, Margaret Burroughs, many years his senior, still makes such a connection central to the very idea of an artistic subjectivity. She continues to travel to Africa in the capacity of artist, recently (and joyously) leading the Fourth International Conference of the National Conference of Artists (the NCA is an American organization) to a major conference held at Cape Coast and Kumasi (Ghana) last July.

24 "Hampton III Galleries" *Carolina Arts* (December 2001) features work by Leo Twiggs.

25 The article summarizes an interview about Twiggs conducted with Edward Spriggs, the Atlanta-based curator who, early on, took an interest in Twigg's work, thus: "African-American artists . . . might use a color palette brighter and more various than the more muted tones valued by the dominant art culture. There are issues of composition where African-American artists may use a lot of layering, and, . . . there is sometimes the quality of brightness or "shine" that artists may bring to their visual work from popular culture." Teri Tynes, "Leo Twiggs and the Icons of Memory," *Free Times*, 1997 (archived on http://www.freetimes.com/Reviews/art_reviews/twiggs.html)

26 An interview conducted with Twiggs in 1997 makes clear that Twiggs is aware that African American artists as a group do not run shy of an unrestrained use of color, a fact that he uses in part to account for its failure to take its rightful place in the history of American art more broadly. In that discussion there was no sense in which he was indicating that his work was therefore any less restrained.

27 It would have to discover who and what were its channels, and where located were those cultural spaces that were "resistant" to it. For example, having described Twiggs's work in the manner I have, it is also the case that a younger southern artist, Tyrone Geter, so many years after AfriCobra, can still produce work which like his own specific claims to Africanness (Geter's being more merely than a birthright, because he spent close to eight years living and teaching as an artist in Nigeria). What accounts, in other words, for its longevity?

28 As such, it would also have to explain, remaining within the realm of painting, both Robert Colescott's highly colorful images deployed in the service of an idea not too far from Kara Walker's miserly, almost misanthropic relation to the same medium. There are ways in which Walker's art derives in fact from Colescott's, and what is striking is, nevertheless, that Colescott's subscribes to the wildness of color (even if he does so with a degree of wit), while Walker's wit/irony does without it completely (although there are clearly ways in which her earlier work might be connectible to the monochromatics of Aaron Douglas's oeuvre).

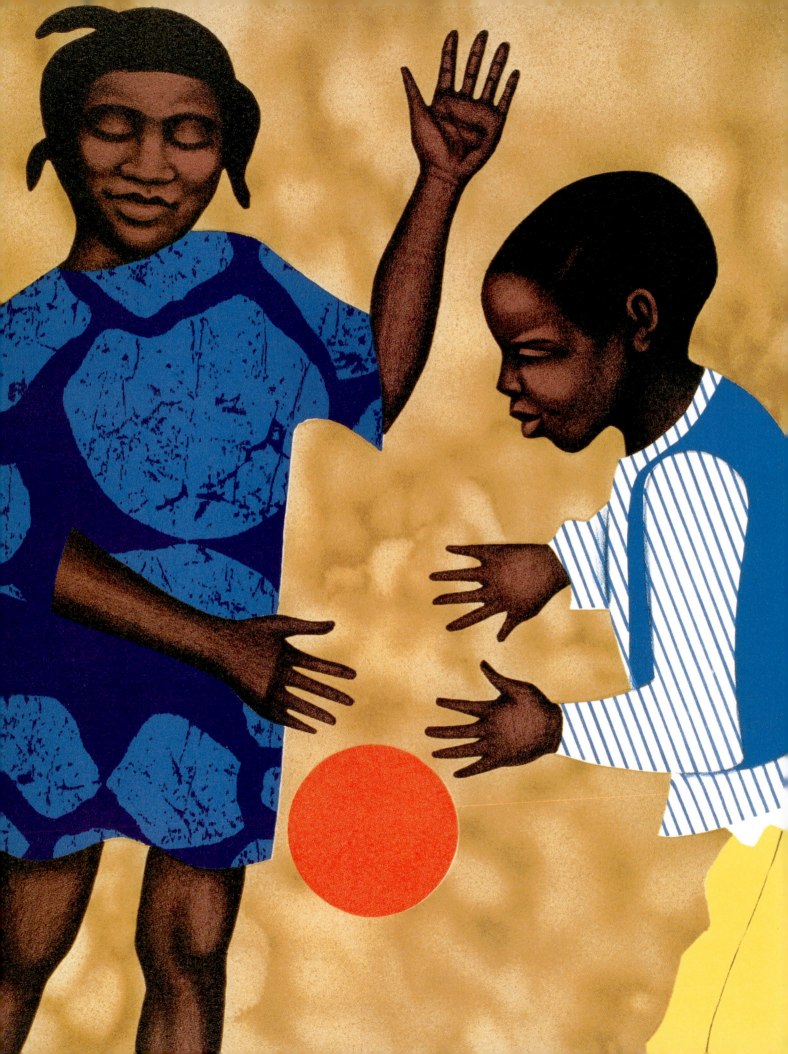

On the Surface:

Color, Skin, and Paint

MARCIA R. COHEN AND DIANA McCLINTOCK

COLOR IS INHERENTLY PARADOXICAL: THE CLARITY OF ITS PRECISE scientific measurement opposes the ambiguity of its elusive associations. Visible color has been understood as the result of known and measurable wavelengths of light since Isaac Newton's experiments with a prism in the late eighteenth century; however, scientific measurements of color fail to explain its ability to communicate by analogy. Any color is omnidirectional, and can elicit multiple, often contradictory associations. For example, yellow badges marked Jews in Nazi Germany, but "high yellow" identified the desirable pale skin shades of mulatto women in early twentieth-century America. Although blue conjures up favorable thoughts of clear skies and good weather, the ancient Romans denigrated the color blue and associated it with death and the underworld. Blue eyes were considered a sign of bad character, indicating loose morals in women.[1] Everyone knows that the blue base of a flame is hotter than its yellow or red tip, and yet yellow and red are considered warm colors, whereas blue is considered cool. In his comprehensive examination of the use and significance of color throughout history, John Gage notes "colour is within the experience of almost everyone. . . . But, of course, artists have a special way of seeing colour and a special way of presenting what they see."[2] Esteemed painter, teacher, and color theorist Joseph Albers wrote, "If one says 'Red' (the name of a color) and there are fifty people listening, it can be expected that there will be fifty reds in their minds. And one can be sure that all these reds will be very different."[3] The architectonic arrangement of color and proportion in Alvin Smith's *Untitled* (1985) references Albers's systematic explorations of color perception. Smith's use of blue envelops the space. Yet the nature of his oceanic expanse of cool blue is transformed by the splash of warm red in the upper left, which alters the typical spatial reading of advancing warm and receding cool colors.

Since the beginnings of recorded history, humans have pondered the nature and meaning of color. In the fourth century BCE, Aristotle identified colors as properties of lightness and darkness, blue and yellow comprising the opposite ends of the spectrum. He elaborated the theory of his contemporary, Plato, who hypothesized that color vision results when processes originating in the eye interact with rays emitted from objects. Accordingly, the perception of color is a property of vision, not an inherent quality of objects, produced by the interaction of certain qualities of the object and the perceiving subject.[4] Two thousand years later Isaac Newton discovered that the visible color of an object results from reflected light. Reporting to the Royal Society on his experiments with a prism in 1672, he identified colors as "original and connate properties" of rays of light, not qualities of objects.[5] Although Newton sought objectively to quantify his theory of color, and to eliminate the subjective, unpredictable factor of human perception and interpretation as much as possible, his research failed to account for variations in the appearance of identical colors under different circumstances among different individuals—the subjective effect of color phenomena that had been studied by dyers and painters since antiquity. Seizing upon the shortcomings of Newton's theory, a century later the German poet Goethe adopted a vehemently anti-Newtonian stance in his opposing theory of color, *Farbenlehre*, of 1810. Not surprisingly, many of Goethe's ideas were initially informed by conversations with artists and experiences of art during Goethe's Grand Tour of Europe in the 1780s.[6] Unlike Newton, Goethe investigated optical effects at the boundaries between two colors, after-images resulting from the prolonged perception colors, and the apparent changes in colors when viewed through various mediums and lighting conditions. Significantly, he used himself as the perceiving subject in many of his experiments, allowing the subjective dimension of color perception to become a very real factor in his ultimate conclusions. In this way Goethe drew attention to the psychological effects of color. In simplest terms the differences between Newton's and Goethe's respective theories of color represent the objective, scientific approach versus the more philosophical, subjective orientation—the scientist versus the poet.

Interestingly, in their treatment of color as either a property of light or a perceptual phenomenon, both Newton and Goethe emphasized that color was not an intrinsic quality of objects. Yet most people regularly consider the color we perceive to be a physical property of the object of perception, an assumption that enables the practice of "color coding." Dictionary.com defines a color code as a "system using colors to designate classifications."[7] Color coding appears throughout nature. For example, the deadly coral snake is distinguished from the harmless king snake only by the order of the colored stripes on their red bodies: "Black and yellow, dangerous fellow; yellow and black, pat him on the back." Colorful displays of certain orchid varieties that imitate female insects in order to seduce male insects and ensure pollination exemplify deceptive color coding that guarantees survival. Conspicuous color enables animals to communicate. The yellow and black pattern of stripes on a bee or wasp, for example, bodes a poisonous sting or an unpleasant taste. Deftly colored camouflage conceals both prey and predator by mimicry, mimesis, and deception, as demonstrated by the octopus that swiftly assumes a wide range of colors to match its surroundings, or the zebra whose distinctive black and white stripes create confusing patterns that make it difficult to discern when moving within its habitat. Howardena Pindell's points of color in *Untitled #35* (1974) (pl. 22) similarly create chromatic confusion. Bright dots punched from multicolored (hand-painted) paper (canceled checks) mimic the pixel-like flat surface of a pointillist painting. Pindell's space is literally constructed of layers of polychrome particles, creating an elusive push and pull in both two and three dimensions. In another act of mimicry, Pindell camouflages, and thus conceals, the original appearance and surface quality of the material—checks—by altering its color with paint and its form by hole punching that imitates dots and is reassembled as a multihued field.

In human culture, color coding has long been a strategy for identifying and marking groups of people or individuals. Colored flags and pennants identify nations and

athletic teams. Heraldic colors have traditionally established family lineages and legitimized ancestral claims. The bold geometry of James Little's *Countdown* (1981) indexes the symbolic ordering common to emblems and banners (pl. 23). His juxtaposition and placement of color and pattern forms a gestalt, like a flag, that can be read with immediacy.

Color coding can alternatively ostracize and condemn. Hester Prynne is forced to prominently display a scarlet letter *A* on all of her clothing, forever marking her sin of adultery in Nathaniel Hawthorne's *The Scarlet Letter*. Jewish citizens of pre-Nazi Germany believed themselves to be part of the indigenous culture until the imposition of yellow badges singled out their difference. Color coding also organizes peoples' perceptions of each other: perceived differences in skin color become linked to recognized color codes that denote qualities or characteristics attributed as intrinsic to those people. Local color, indigenous color, is understood in metaphorical terms.

The coding of skin colors historically has involved locating an individual skin color within an imagined range of tones that are organized into a system, like a map of color space. At certain times in certain cultures, skin tones at different ends of the spectrum have been considered desirable. In nineteenth-century Europe, for example, lighter skin was desirable as an indication of social class because the wealthy didn't have to work in the sun. Women went to extremes such as risking death by eating arsenic in desperate attempts to lighten their skin. In 1929, however, the trendsetting fashion magnate Coco Chanel proclaimed that a "girl must be tanned,"[8] and by the 1970s teenage girls commonly basted their skin with baby oil in an attempt to accelerate the effects of the sun and achieve a sought-after deep bronze tan. In these and similar examples, skin color is visualized by human society as a palette of gradations of darkness and lightness, organized by desirability.

For the painter, the palette is also a system, like a color atlas, from which everything is generated. The term "palette" describes both the physical object upon which the painter blends paint and the range of color that characterizes an individual work. In his historical account of the artist's palette as both a tool and a system of organization, John Gage notes that from the eighteenth century, artists' palettes revealed an increasingly personal range of choices of color and color organization, and also reflected prevailing tastes and societal attitudes.[9] Charles A. Riley has observed, "The palette holds colors in a natural order that bears a strong relation to the internal order of the work of art."[10] It can be argued that social codes embedded within human societies similarly position skin color in an order that bears a strong relation to the internal order of each society. Comparing the color chart, spectrum, and palette as spatial organizations or maps of color, Riley continues: "All three maps are surface arrangements for selection and organization; but the spectrum is a natural order, whereas the palette's main rule of organization depends on usage. Customarily, the most frequently used color is given a bigger, special place on the palette, just as the typesetter's case has a large box of frequently recurring letters close at hand."[11] Through their prominence on the palette's surface, the colors most favored by the artist are revealed, as is the case within the social hierarchy where the colors most favored by a society are also indicated through their prominence.

Riley has observed: "The first thing to realize about the study of color in our time is its uncanny ability to evade all attempts to codify it systematically. The sheer multiplicity of color codes attests to the profound subjectivity of the color sense and its resistance to categorical thought."[12] On the first page of his famous study *Interaction of Color*, Joseph Albers wrote: "In visual perception a color is almost never seen as it really is—as it physically is. This fact makes color the most relative medium in art. In order to use color effectively it is necessary to recognize that color deceives continually. To this end, the beginning is not a study of color systems. . . . First, it should be learned that one and the same color evokes innumerable readings."[13]

Color is a vitally important property in the biological and cultural realms. Art historian David Hilbert asserts: "The perception of color must have some utility

since the only higher organisms that lack sensitivity to color are those whose nocturnal lifestyles make the perception of color very difficult."[14] Color affects every aspect of human life. It is a visual illusion that is perceived, conceived, and interpreted. Color coding enables recognition and identification in nature, classification, naming, and marking in human society. In *The Descent of Man* (1871), Charles Darwin noted, "We know that the color of the skin is regarded by the men of all races as a highly important element in their beauty."[15] Partially as a result of the civil rights movement, Crayola renamed its "flesh" crayon "peach" in 1962, and in 1999 "Indian red" was renamed "chestnut" because children wrongly perceived that it represented the skin of the native North American.[16] In the early 1990s, the company introduced its new line of multicultural crayons that featured a wide array of skin tones. As Phillip Ball observes in his comprehensive study *The Bright Earth: Art and the Invention of Color,* "there are no culture-independent concepts of basic colors."[17] As early as 1969, in their seminal study of color and language, *Basic Color Terms,* Brent Berlin and Paul Kay established that all languages contain terms for black and white, and that if any language contains a third term for color, it contains a word for red.[18] This suggests that there are certain predispositions toward color naming that are common across all human societies.

In the realm of the human body, skin color is a complex socio-biological phenomenon fraught with racist and culturally determined associations. Skin is the boundary between the interior and the exterior, between self and world,[19] and skin color becomes the surface that names and marks the individual. People can be classified and ordered according to schemata of color, symptomatic "of a human impulse we can call the tendency to tabular thinking . . . in the case of color, the tabular approach is often hierarchical and prescriptive."[20] In this way a palette of human color emerges, selected according to subjective impulses and cultural perceptions.

In David Driskell's mixed-media image, *Woman in Interiors* (1973), the figure of a woman sits calmly and, from a patchwork of floral patterns, spectral colors, and disrupted space, gazes resolutely past the viewer. Her solid figure is integrated with the fabric of the collage-like surface, and the fractured space of pattern and color effectively obscures the boundaries of her form (pl. 24). Yet her centrality establishes her as a distinct part of a fragmented whole. Flat, geometric color swatches are seemingly ordered around the woman, ranging from primaries to secondary and tertiary colors, creating an aedicule of color in which the vibrant figure is enshrined. The brilliant colors are reflected in the varied and glowing tones of her brown skin. As with camouflage in nature, she is simultaneously concealed and revealed within her environment. She finds refuge in the rhythmic hues of the palette, a person of color within a chromatic diaspora.

Girl/Boy/Red Ball (1992) by Elizabeth Catlett, a seemingly obvious image of a young boy and girl playing with a ball, opens to multiple readings based on the disposition of color. Wearing a primary blue dress, the girl stands to the left of center, and the boy in his yellow pants, blue vest, and blue-and-white striped shirt bends toward her from the right. Their dark brown skin stands out against the leathery brown membrane of the background. In spite of their appealing clothing, the children's bare feet suggest their vulnerability. The bright red ball hovers between them in an ambiguous space, like a punctuation mark or a stop sign, as if demarcating their separate places. They grasp at the ball, but it is somehow unattainable. Albeit a straightforward and simple arrangement, the disposition of the color and the confinement of the composition impart multiple layers of meaning.

Sensations of color arise from an elaborate series of factors involving the eye, the brain, and the mind, and profoundly affect how we conceptualize the world.

NOTES

1 Michel Pastorou, *Blue: The History of a Color* (Princeton, NJ: Princeton University Press, 2001), 27.

2 John Gage, *Colour and Culture: Practice and Meaning from Antiquity to Abstraction* (Boston: Little, Brown and Co., 1993), 8.

3 Joseph Albers, *Interaction of Color* (New Haven, CT: Yale University Press, 1963), 3.

4 David Hilbert, *Color and Color Perception: A Study in Anthropocentric Realism* (Palo Alto, CA: Stanford University Center for the Study of Language and Information, 1987), 2; Pastorou, *Blue*, 30.

5 Margaret Livingstone, *Vision and Art: The Biology of Seeing* (New York: Harry N. Abrams, 2002), 19.

6 Gage, *Colour and Culture*, 202.

7 http://dictionary.reference.com.

8 Joel Swerdlow, "Unmasking Skin," *National Geographic* (November 2002): 54–55.

9 Gage, *Colour and Culture*, 180.

10 Charles A. Riley, *II Color Codes: Modern Theories of Color in Philosophy, Painting and Architecture, Literature, Music, and Psychology* (Hanover and London: University Press of New England, 1995), 8.

11 Ibid., 9.

12 Ibid., 1.

13 Albers, *Interaction of Color*, 1.

14 Hilbert, *Color and Color Perception*, 121.

15 Augustine Hope and Margaret Walch, *The Color Compendium* (New York: Van Nostrand Reinhold, 1990), 258.

16 Bonnie B. Rushlow, *A Century of Crayola Collectibles: A Price Guide* (Grantsville, MD: Hobby House Inc., 2002), 123.

17 Phillip Ball, *The Bright Earth: Art and the Invention of Color* (New York: Farrar, Strauss and Giroux, 2001), 16.

18 Brent Berlin and Paul Kay, *Basic Color Terms* (Berkeley: University of California Press, 1991), 2.

19 Claudia Benthien, *Skin: On the Cultural Border Between Self and the World* (New York: Columbia University Press, 2002), 2.

20 Riley, *II Color Codes*, 8.

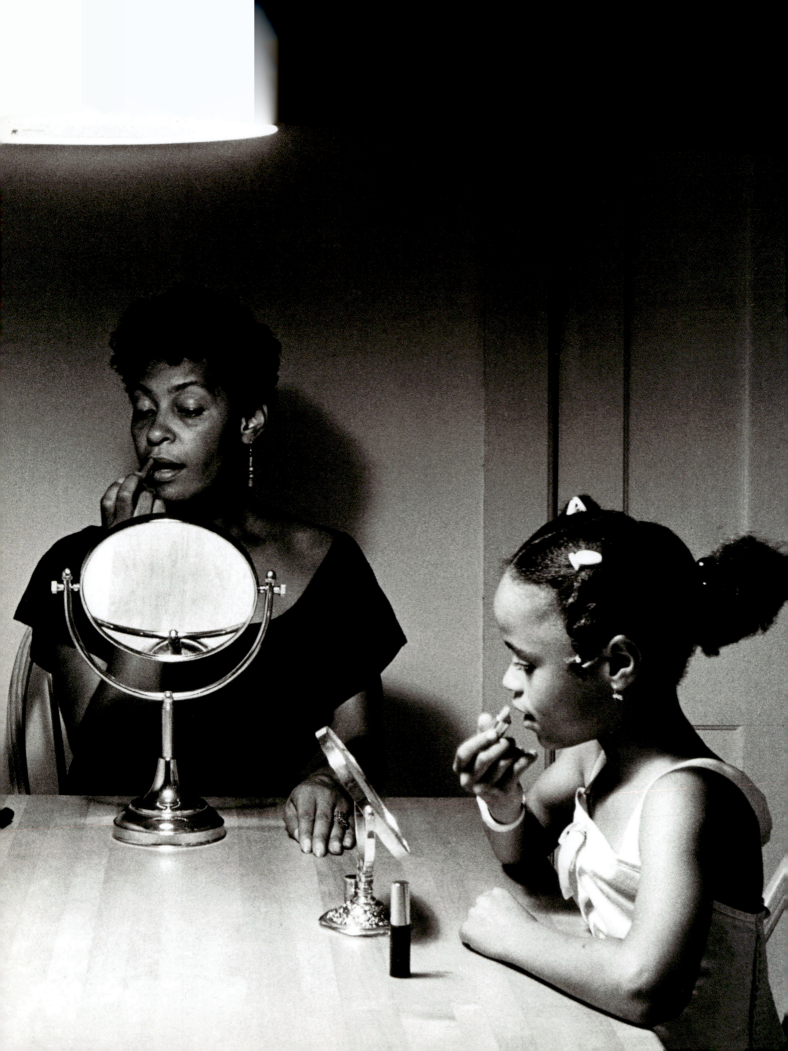

Collecting Memory:

Portraiture, Posing, and Desire

CARLA WILLIAMS

What is often overlooked is that photography is a way of looking at the world. Why does a person stop and take a picture? Why do we pose when someone points a camera? How often do we look at a picture we have taken and see something we did not see at the time? When does a photograph become memory?

THE SIMPLE QUESTIONS E. ETHELBERT MILLER POSES ARE AT the heart of the relationship with camera-based imagery we know as portraiture.[1] In creating a portrait, whether by a professional in a studio or by an amateur taking a snapshot, the maker and the subject have a personal agenda regarding the final product. Why we choose to have portraits made and what we desire by doing so have many answers. We make portraits to record our likeness for identification, to mark time or remember significant events, to flatter, aggrandize, or project a certain image of ourselves. We do so for reasons that are both public and private. "Such is the power of the photograph, of the image, that it can give back and take away, that it can bind," remarks writer bell hooks.[2]

The underlying reasons for having our portraits made is related to our understanding that photographs are capable of preserving, creating, and communicating our likeness in ways that may delight or embarrass us. How often do we extend a hand to ward off the camera's gaze to prevent a photographer from rendering an image of us for posterity? Likewise, how often have we looked at an image we once hated with new insight, suddenly pleased to have the visual record of that time and place?

The importance of any given photograph among the countless exposures made since the medium's invention more than one hundred sixty years ago cannot be underestimated. The 1994 anthology *Picturing Us: African American Identity in Photography* featured essays by eighteen contributors who were asked to write about a single image that was important to them. Most writers chose a family photograph,

FACING PAGE:

Detail from Carrie Mae Weems's Kitchen Table Series, *1999 (Plate 25)*

with studio photographs and snapshots represented. Their choices revealed how pivotal one photograph can be to memory and the construction (and reconstruction) of personal and family history.

The studio portrait, though made in a professional setting that is, in effect, a public space, transfers to the private realm when taken home by the sitter. It becomes a family possession in a sense, being thoughtfully framed and hung in a place of prominence in the home or carefully and strategically placed in a scrapbook along with other studio photographs, snapshots, and ephemera. Although the studio portrait is a formal memory code and is created with more deliberation and control than the casual snap, it is also a constructed image—a fictionalized version of reality. Because we see likeness in the image we infer truth regarding what is represented when, in fact, the picture is presented through prisms of desire on the part of the photographer and the sitter.

THE FORMAL PORTRAIT

Clarissa Sligh's 1996 black-and-white photograph of collector Paul R. Jones (pl. 26) reveals much about the expectations associated with the portrait-making process. Photographed in his well-appointed Atlanta home, the Alabama-born Jones is seated on an upholstered white couch, his right leg crossed over the left, his right hand resting assuredly on his knee. The camera is positioned slightly above him as his body sinks into the plush sofa, a slight diminution of power in a portrayal of the collector as worldly gentleman. Atop the white wall-to-wall carpet at his feet lay a zebra-skin rug, an ethnographic allegorical reference to the collector as hunter and conqueror, though in this instance it is art that is the trophy displayed on the wall behind him. The surface of the large artwork reflects the soft tones and texture of lace curtains—allusions to his taste and refinement. The mirror over the mantle to his right echoes this trait as pieces of African sculpture from his collection are captured just within its reflection. Royal staffs—one iron and one wood with leather overlay—lean inconspicuously against the right side of the white

fireplace. What does the image reveal about the photographer and sitter?

Sligh, who was born in Virginia in 1939, is the keeper of her family's photographs, preserver of family history and ardent storyteller. She became a photographer after a successful career on Wall Street and is best known for her autobiographical non-silver images that combine family photographs, drawing, and text.

Her portrait of Paul Jones fits squarely within the studio tradition. Its formal structure and the conscious nature of the sitter's pose indicates it is a well-planned image. She made this portrait of Jones, whom she had not met before the sitting, for a photography book on the suburban South.[3] Jones's portrait is the very picture of success, material achievement, and cultural pride. The photograph was published as the right panel of a diptych, its companion image being a close-up of Jones's hand holding a double-framed set of much earlier photographs, one of a much younger Jones with his young son, and the other of the son alone. Sligh wrote on the photograph "Mr. Paul R. Jones" in the manner of repetitive writing on a school blackboard.[4] Sligh recalled: "He [Jones] looked very different, but his hands were the same."[5] In the diptych, the photographer drew a poignant parallel between the expectations of the younger man posed with his future—his son—and the older man who has achieved success yet bears no evidence of the earlier familial bond in the later image. *Where is the son now? Why is the father alone?* The close-up photograph-within-a-photograph of the father and son's image cradled in the palm of the older father's hand, juxtaposed with the more distant frame-within-a-frame depiction of the collector and his treasures, leads to questions about the very nature of position, possession, memory, and the fulfillment of desire.

Sligh's recollections of her encounter with Jones reveals further insight into his and her expectations of the project:

> Before I met him, other people in Atlanta told me Mr. Jones was really interested in art. I didn't know what his expectations were, but he was dressed very casually when I arrived at his house. I spent some time getting to know him. He took me around his house show-

ing me and talking about his art collection so I knew that was really important to him. So I asked him if he would mind changing clothes so I could make a photograph that reflected him as an important art collector. I chose his living room as the place to make the shot. He had also worked in Africa for the government and I wanted to indicate some of that interest too.[6]

Here, initially, there was a stark difference between how the sitter expected to be captured in the image and the way in which the photographer subsequently envisioned the portrayal.

Ultimately, the expectations of both were fulfilled. The photographer's intent on presenting the subject as a prominent collector is achieved through his attire, proximity to his art objects, and pose. The subject's desire for viewers to understand some of his aspirations and accomplishments is revealed in his facial expression, posture, and the setting. Further, this image is a fitting introduction to a broader discussion of portraiture, posing, and desire. It is, in fact, Paul Jones the collector—his taste and his eye—that are the unifying factors in all of the images discussed in this essay.

HOPEFUL MEMENTOS

Photography can play a powerful role in terms of cultural recovery. The camera-based image may contain memories, help us overcome loss and keep history.

> When the psycho history of a people is marked by ongoing loss, when entire histories are denied, hidden, erased, documentation may become an obsession.... For black folks, the camera provided a means to document a reality that could, if necessary, be packed, stored, moved from place to place. (bell hooks)

Paul Jones's eclectic collection of photographs by African American photographers includes wonderful examples of early portraiture. The nineteenth and early twentieth centuries saw a flourishing of professional photography studios throughout the country that were owned and operated by African Americans. Some examples are: Jules

Lion (1810–1866), Augustus Washington (1820–1875), James Presley Ball (1825–1905?), the Goodridge brothers—Glenalvin J. (1829–1867), Wallace L. (1840–1922), and William O. (1846–1890)—Addison N. Scurlock (1883–1964) and sons Robert (1916–1994) and George (b. 1919), Richard Samuel Roberts (1881–1936), Harry Shepherd (1856–date unknown), Arthur P. Bedou (1882–1966), and Elise Forrest Harleston (active 1919–1920), among others.

Arguably most prominent among them was James VanDerZee (1886–1983), proprietor for forty years of the Guarantee Photo Studio, or G.G.G. Photo Studio, in Harlem. Established in 1916, the studio was an immediate success, sparked by a glut of enlisted men going off to fight in World War I who commissioned VanDerZee to make "hopeful mementos to guard against fate."[7] VanDerZee, originally from Lenox, Massachusetts, was self-taught in photography and had worked briefly as a darkroom assistant in a Newark, New Jersey, department store. His success and popularity was also attributed to the manner in which he unapologetically idealized his subjects: "If it wasn't beautiful, why, I took out the unbeautiful-ness, put them in the position that they looked beautiful," he once explained.[8]

Assisted by his second wife, Gaynella, VanDerZee photographed the who's who of Harlem society as well as visiting celebrities and dignitaries. However, the bulk of VanDerZee's clientele was his neighbors, the men and women who lived in Harlem, many of whom were recent arrivals from the South. In the construction of a community's visual history, from which the "cultural recovery" to which bell hooks refers takes place, individuals are recorded collectively to bear witness to the fact of the documented cultural heritage and not for the perpetuation of personal beauty.

The Barefoot Prophet (ca. 1928) is a portrait of Elder Clayhorn Martin, who was a Virginia-born street-corner preacher living in Harlem. According to legend, he received the command from God at an early age to "take off your shoes, for this is Holy Ground. Go Preach My Gospel."[9] A well-known neighborhood fixture standing nearly seven feet tall, The Prophet appears subdued and contemplative in VanDerZee's portrait. He is poised

in a well-tailored double-breasted suit seated in the almost regal splendor of studio furnishings. His spiritual role and presence is further revealed in the unfettered and physical freedom of his long, unruly hair and beard, his bare feet, and revival-style tambourine. His divineness is suggested not only by the open Bible before him but also by the carefully added streaks of light that seem to emanate from the flames of two candles and a shining star through the open window in the backdrop that was added in a similar manner. VanDerZee's skill and thoughtfulness in the construction of cultural history can be seen in his iconographic portrayal of individual subjects.

A photograph of *The Black Houdini* (1924), an otherwise unidentified master of illusion (pl. 27), is similarly intriguing in its representation of the variety and complexity of experiences of African Americans in the 1920s. Locked in irons and staring directly into the camera, the magician most likely had come to Van-DerZee's studio to have a photograph made to advertise his unusual trade. On the other hand, we are struck by the image of a black man in chains as a cultural artifact and an object of visual encounter. This is deeply felt even though we simultaneously recognize his bondage as a temporary and self-induced state, and thus, part of his illusionary trick rather than as a frightening relic of slavery. The generic landscape in the backdrop helps soften the otherwise jarring impact, yet what inevitably emerges is more than a magician's calling card but a bold visual metaphor of defiance and resistance. Further, this image attests to the degree to which Van-DerZee's African American clientele relied on his ability to capture their likeness as they wished to be seen and as they desired to see themselves.

MEMORY KEEPER

Many portraits by Prentice Herman (P. H.) Polk (1898–1984) taken between 1920 and 1950 act as personal and corporate narratives of the accomplishments, positions, and status of African Americans in and around Tuskegee University. During the New Negro era, African American women frequented photographic studios to have portraits made that consciously presented positive images of themselves and projected images of progress and success within their communities as a whole. The fulfillment of this desire often included the creation of studio portraits that were initiated by the photographer. The portraits of *Catherine Moton Patterson* (1936) and *Margaret Blanche Polk* (1946) are examples, respectively, by Polk.

The Alabama native was the first student to enroll in the Photography Division at Tuskegee Institute in 1917, studying under Cornelius Marion Battey (1873–1927). Later, following his family to Chicago, he apprenticed for nearly two years in Fred Jenson's photography studio. In 1921, Polk signed up for a correspondence course in photography through which he studied Rembrandt's mastery of shadow.[10] His 1946 portrait study "from the shadow side"[11] of his wife, Margaret Blanche Polk, reveals the photographer's aesthetic and technical concerns.

Polk and Thompson married in January 1926. The striking, sensitive portrait was made twenty years later. Emphasizing her loveliness in middle age, Polk photographed his wife from a camera angle on a diagonal slightly below eye level (pl. 28). Her face and torso emerge from a rich sea of blackness, as her deliberate upward gaze accentuates the soft lean of her body. Polk possibly created the portrait to capture her likeness and to present her as an archetype of New Negro progress. She is poised and seems to look confidently toward the future. Her attire reflects financial comfort—her wide-brim hat, white eyelet blouse, finely tailored jacket, and pearl jewelry. Polk understood the importance of photographic portraits in structuring both family and collective history. According to Meredith K. Soles, for Polk "and for countless other African Americans, photographs provided a new visual means to convey emotion, personal pride, and temporality: notions often previously expressed by blacks through musical, verbal, or textual means."[12] He often shared his photographs with family members elsewhere. On family photographs sent to relatives, Polk inscribed "Lest you forget," a clear acknowledgment of photography's role as the keeper of memory.[13]

Called "the Southern VanDerZee"[14] for his extensive documentation of the African American life in and around Tuskegee, Polk displayed prints of middle-class clients in his studio window to attract others. He also had a ready clientele within the institution's administration and its professorial elite. In 1936, he photographed Catherine "Kitty" Moton Patterson, the wife of the president and daughter of his predecessor. Patterson is depicted as an upper class, accomplished black woman, seated in her well-appointed home wearing a fine lace dress and heels, playing the harp. Like Sligh's portrait of collector Paul Jones taken some sixty years later, Polk's portrait of Patterson presents the subject in the environment that most intimately defines her status and position. Not only is she *someone,* the photograph affirms that she plays a role of cultural significance to the history of Tuskegee and broader African American community.

NARRATED FICTION

Contemporary photographer Carrie Mae Weems (b. 1953) is proficient at creating narrative images that explore personal and cultural identity. Taking up photography in her twenties, she received the B.F.A. at the California Institute of the Arts and the M.F.A. from the University of California, San Diego, before pursuing graduate study in folklore at the University of California, Berkeley. Invoking the *novelistic,* or "the constant narration of the social relations of individuals, the ordering of meanings for the individual in society,"[15] Weems produces bodies of work that read sequentially like film. In the 1990 *Kitchen Table Series,* Weems created twenty black-and-white photographs that make powerful statements both as a group and as single images. Addressing the challenging nature of family relationships, Weems is self-cast in the lead role.

In *Kitchen Table Untitled* (Carrie and girl with mirrors), she focuses on the interaction between a mother and daughter with strong allusions to role-playing as it relates to parental and child responsibility. Weems presents herself and a young girl applying makeup in vanity mirrors—an act that speaks to the mother's role as teacher and model juxtaposed with the daughter's role as mentee and follower of the mother's example. In a 1993 monograph published by the National Museum of Women in the Arts, the following written narrative accompanied the photograph:[16]

> Neither knew with certainty what the future held. It could be only a paper moon hanging over a cardboard sea, but they both said, "It wouldn't be make-believe, if you believed in me."
>
> "He wanted children. She didn't. At the height of their love a child was born. Her sisters thought the world of their children. Noting their little feats as they stumbled teetered and stood. When her kid finally stood and walked, she watched with a distant eye, thinking, 'Thank God! I won't have to carry her much longer!' Oh yeah, she loved the kid, she was responsible, but took no deep pleasure in motherhood, it caused deflection from her own immediate desires, which pissed her off. Ha. A woman's duty! Ha! A punishment for Eve's sin was more like it. Ha."[17]

The impact of the image (and all images in the series) is dependent on viewer familiarity with certain iconographic associations, including the text being derived from popular song lyrics, the photograph being rooted in advertisements, and its location being the home kitchen where private family conversations take place. Her reference to "'language derived from experience'" also refers to the visual language we read into the photograph when considered separate from the text.[18]

In this work, Weems projects a view of womanhood that differs from the cultural ideals espoused during the New Negro ideal era, giving us a heroine who is not the desired, established model of motherhood. The tension in the photograph is deepened by the fact of her dual roles as artist and model—using her own likeness and directing her own pose.

It points to the fact that, in a sense, Paul Jones's role as collector mirrors the photographer's role as image-maker—to preserve a collective history and to ensure that our stories continue to be told. Likewise, using the portrait-making process Sligh has "collected" him, classifying

and categorizing him through costume, gesture, and setting so that, without words, we may know something central about who he is. Sligh, VanDerZee, Polk, and Weems have contributed to shaping the very worlds they photograph even when rendering service to their subjects as clients. They reveal ways in which photographs tell stories, preserve memories, "write" histories, and express the cultural and personal desire of a people.

NOTES

1 E. Ethelbert Miller, "In My Father's House There Were No Images," in Deborah Willis, ed., *Picturing Us: African American Identity in Photography* (New York: The New Press, 1994), 58.

2 bell hooks, "In Our Glory: Photography and Black Life," in Deborah Willis, ed., *Picturing Us: African American Identity in Photography*, 48.

3 Alex Harris and Alice Rose George, eds., *A New Life: Stories and Photographs from the Suburban South* (New York: W. W. Norton & Company, 1996).

4 According to Sligh, Jones was given the two photos separately, not as a diptych, and not with any text written on either print.

5 Conversation with Clarissa Sligh, August 2003.

6 Ibid.

7 Dr. Cheryl Finley, "Day or Night, Rain or Shine: The Photographic Legacy of James VanDerZee," in *James VanDerZee: Harlem Guaranteed* (New York: Michael Rosenfeld Gallery, 2002), 10.

8 Quoted in ibid., 10.

9 Deborah Willis-Braithwaite and Rodger Birt, *VanDerZee: Photographer, 1886–1983* (New York: Harry N. Abrams Inc. in association with The National Portrait Gallery, Smithsonian Institution, 1993), 128.

10 Amalia K. Amaki, "To Make a Picture," in *Through These Eyes: The Photographs of P. H. Polk* (Newark, DE: The University Gallery, University of Delaware, 1998), 19.

11 Louise Daniel Hutchinson, "P. H. Polk: 'Lest You Forget'," in *Through These Eyes: The Photographs of P. H. Polk*, 17.

12 Meredith K. Soles, "Mementos, Documents, and Signs: The Portrait Photographs of P. H. Polk," in *Through These Eyes: The Photographs of P. H. Polk*, 24.

13 Hutchinson, "P. H. Polk: 'Lest You Forget'," 17.

14 Belena S. Chapp, Foreword, *Through These Eyes: The Photographs of P. H. Polk*, iii.

15 Susan Fisher Sterling, quoting Stephen Heath, in "Signifying: Photographs and Texts in the Work of Carrie Mae Weems," in Andrea Kirsh and Susan Fisher Sterling, *Carrie Mae Weems* (Washington, DC: The National Museum of Women in the Arts, 1993), 26.

16 A 1990 installation view of the series on exhibition at P.P.O.W. Gallery in New York shows the text displayed with the photographs. Subsequent reproductions of the image routinely do not include the text passage. Kirsh and Sterling, *Carrie Mae Weems*, 27.

17 Kirsh and Sterling, *Carrie Mae Weems*, 78. As Sterling points out, "the imagery of text and photographs are not synchronized with one another."

18 Quoted in Susan Fisher Sterling, "Signifying: Photographs and Texts in the Work of Carrie Mae Weems," in Kirsh and Sterling, *Carrie Mae Weems*, 28.

FACING PAGE:

Detail from James VanDerZee's
The Barefoot Prophet, *1928*
(Plate 86)

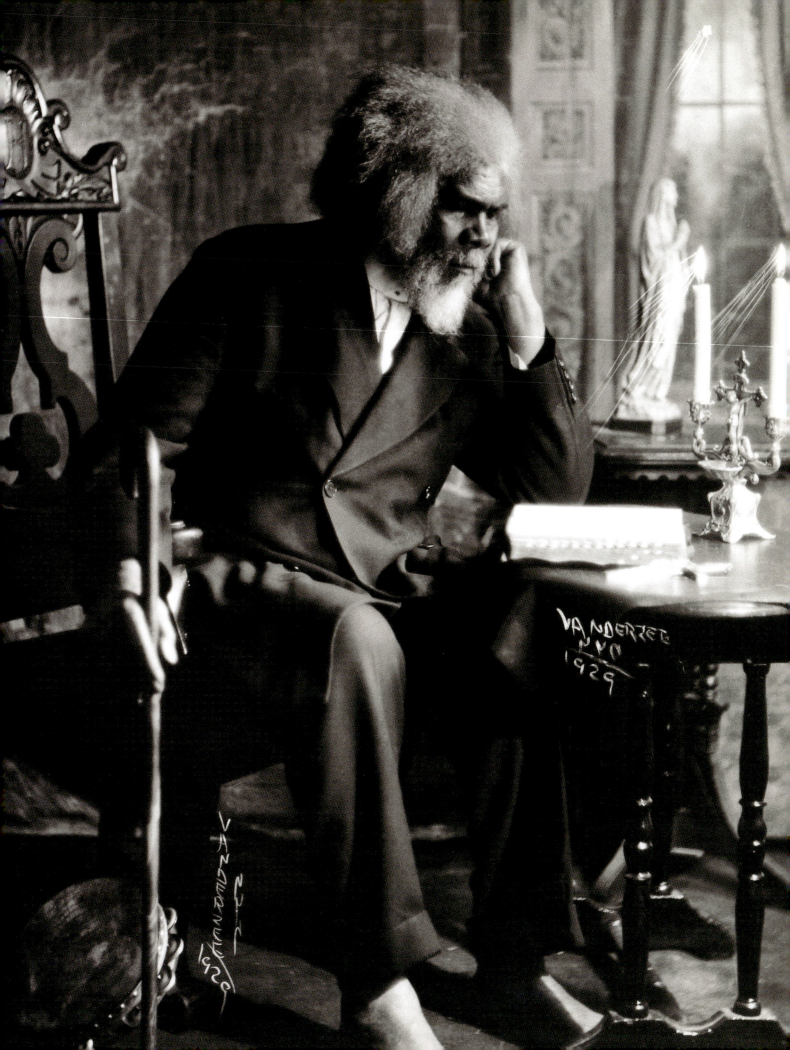

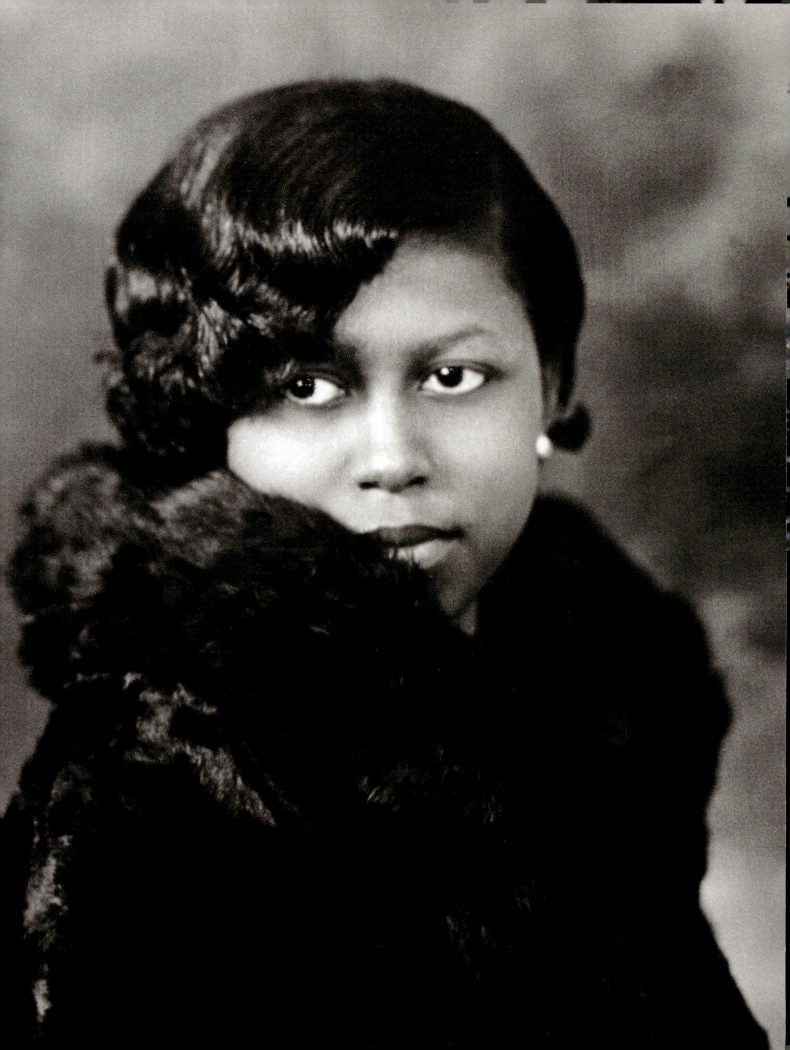

Flash from the Past:

Hidden Messages in the Photographs of Prentice Herman Polk

AMALIA K. AMAKI

"I think the past is all that makes the present coherent, and further, that the past will remain horrible for exactly as long as we refuse to assess it honestly."

—James Baldwin, *Notes of a Native Son*

IN 1936, FILM HISTORIAN WILLIAM PERLMAN WROTE IN *THE Movies on Trial* that "the influence of the screen for good or for evil cannot be overestimated. As a propaganda medium it is the most powerful of agents. Napoleon said he feared one newspaper more than a thousand bayonets."[1]

Prentice Herman Polk (1898–1984) used simple methods to unveil poignant realities about the complexities of African American life. His vehicle was photography. The truths he revealed were as varied and specific as the many subjects who elected or were cajoled into sitting for him. He created each photograph in pursuit of the complicated task of returning to the subject an honest rendition of what was seen while also handing over to them a bit of creation—a purging of their individual and societal selves into a cultural reverberation of Tuskegee the Alabama town, Tuskegee the institution, and Tuskegee the model of a different South. As quietly as it was kept until the early 1970s, the thousands of negatives made by Polk between 1920 and 1950 categorically denied the monolithic national view of African American life in the South. He, like numerous other African American image-makers from his era, was caught up in what cultural critic Cornel West describes as "the modern black diasporan problematic of invisibility and namelessness."[2]

Photography came to America's shores centuries after slavery was inflicted on African Americans. Despite the number of photographs made during the 1800s of free African Americans—largely, though not exclusively, in the North—these

69

images were virtually hidden from America's visual accounts during the nineteenth century. After the Civil War, overwhelmingly fewer African American photographers in the South maintained studios than their white counterparts. Consequently, documentary works such as Alexander Gardner's anthology *Photographic Sketchbook of the War,* and stereographs of orphans, laborers, people gathered in fields, on stoops, or in front of shacks, shanties, rickety doorways, and windows, and similar perspectives of African American life in the South were more frequently seen. Thus, the evolution of the term "stereotype."

Daguerreotypes, ambrotypes, tintypes, and albumen prints of well-dressed, nicely posed middle-class African Americans increased in number though the identity of the sitter was often unknown. In certain cases, the subject's attire offered clues to his or her profession or social status. To the casual observer, the absence of a name and other relevant data rendered the sitter not only anonymous, but sent the silent message of unimportance and contributed to the systematic devaluation of each subject as an individual and, collectively, to the dismissal of the broader community of African Americans.

Polk took great measures to ensure that the vast majority of his sitters were afforded some form of proper identification. A few exceptions were made where poetically (and selectively) names were given in the spirit of creativity and with the intent to flatter. In cases such as *The Boss* (1932) and *The Pipe Smoker* (1932), Polk used descriptive titles to evoke the sense of power, authority, and naturalness of those portrayed. By so doing, he reiterated his role as artist in addition to photographer and that of the sitter as model in addition to subject. This is particularly significant in the aftermath of modernist photographer and dealer Alfred Stieglitz's (1864–1946) radical campaign to convince the Western world that the camera was a sufficient tool for the production of "high" art.[3] Polk's art sensibility relative to photography was, in many respects, aligned with Stieglitz's, whose publication *Camera Works* (1903–1917) was devoted to advancing the work and ideologies of the members of the Photo-Seccession. From the standpoint of practice, Polk

also enjoyed engaging others around discussions of his work, and though the talks fell short of being the critiques that Stieglitz held, they were, nonetheless, indications of Polk's interest in constructive interaction for the sake of making better pictures.

Another clue to Polk's seriousness about photography as art was the liberty he took in identifying his rural subjects, and, perhaps more important, the very act itself of giving them a descriptive name. Much akin to pet names or nicknames, he attached affectionate labels that have a comedic and a cutting edge to them. Out of that dynamic comes specificity and individualism. The undercurrent of the title/label/name "The Boss" is one who controls and has dominion. It is an empowering label placed on an unlikely type. The tension that is evoked by popularizing—placing in the public and popular arena—a name that is fixed on a character type that has been established in association with labels on the opposite end of the spectrum, is evidence of the strategy and care with which the name was applied.

Jacques Lacan, exploring the relationship between the "social symbolic system and individual identity," emphasizes the impact of signs (a name) and symbols in shaping and modeling behavior and identity. He argues: "That a name, however confused it may be, designates a specific person, is exactly what makes up the transition to the human state. If one has to define the moment in which a man becomes human, we can say that it is the moment when, however little it be, he enters into the symbolic relation."[4] He extrapolates on reflection in a mirror—being unreal in that it is not you, yet being real in that it is *your* reflection—as a metaphor for the interaction between the imagined and symbolic self that is processed as identification. Thus, personal identity (perpetuation) feeds off the social (punctuation) that, in turn, reflects codified understandings of the imaged self. The key conduit here is language, visual and linguistic.

The camera is a mirror. Within it is the power of reflection. Depending on whom, what, or how, the reflection is capable of projecting the unreal and the reality of the person who poses in front of it or whose image is taken (stolen). A powerful and damaging consequence

of deliberate manipulation of reflection can be confusion. Confusion can lead to fabrication—conflicting reality with fabrications of reality is the stereotype.

The cumulative weight of media stereotypes of African Americans was enormous by the nineteenth century. Popular culture materials and commercial images in the absence of contradictory visual data became the standard for white America's perception of the African American. Minstrel shows played a critical role in fabricating portrayals of African American life, dating back to Thomas Dartmouth "Daddy" Rice who, between 1828 and 1831, performed a song-and-dance routine in blackface impersonating an old, crippled black slave dubbed Jim Crow. America's first indigenous musical theater and the first national entertainment form, the minstrel show fully developed by 1840, peaked in the post-Civil War era and remained a mainstay of stage performance until the late 1940s.[5] Feeding off the popularity of such shows, comic strips in the American press were derived heavily from the minstrel models when they were initiated in the 1890s. As Steven Loring Jones asserted in From "Under Cork" to Overcoming: Black Images in the Comics, "the blackface characterization of African Americans was so successful that it was inevitable it would also have a major impact on early motion pictures, the most powerful and influential industry of them all."[6] What had been largely a southern model became essentially the American one, and permeated every mode of public expression between 1890 and 1950.

When photographer P. H. Polk was born, roughly 250 African Americans were listed as professional photographers nationwide in directories, advertisements, society page listings, and articles. By 1930, the number escalated to 545 according to U.S. Census reports. At the same time, the images of southern culture were continually placed within the context of a racial divide that held as part of its premise stereotyped, derogatory views of African American life. From D. W. Griffith's 1915 Civil War epic, The Birth of a Nation, to popular culture materials, especially newspapers, periodicals, and commercial media, African Americans on screen and in print were established as types, not individuals,

portrayals that were disseminated throughout American society and supported by literary, historical, and critical writing.

It was a major challenge to the noble efforts of such pioneers as filmmaker Oscar Micheaux, whose productions such as Wages of Sin in 1914 and Harlem After Midnight in 1934 helped to establish an African American strategy to provide more positive representations. However, these and similar "race films" were considerably fewer in number than their denigrating counterparts and catered largely to black audiences. The films were in limited distribution in the South due to censorship bans and the ethnic emphasis. On the other hand, The Birth of a Nation, with its heroic portrayal of the Ku Klux Klan as the protectors of "the purity of southern women and the southern way life," was one of the movie industry's first blockbuster films and enjoyed national circulation. Griffith was lauded as the inventor of a new art form—the feature-length film—and praised for his effective use of close-ups, night shots, and other technological innovations. Though there were well-organized protests in at least a dozen major U.S. cities, riots, and a vigorous campaign mounted by the NAACP that led to the banning of the film in several cities, it still earned Griffith notoriety for artistic direction, and spawned several copycat movies.

Lorenzo Tucker, Micheaux's talented male lead called the Black Valentino, did not enjoy the mass viewership of white, blackface actors Al Jolson and Walter Long. Likewise, the critically acclaimed career of lead actress Anita Bush has been virtually forgotten while the many domestic characterizations of Hattie McDaniel—well-executed, but in support capacities—culminated with her receiving the Academy Award for her 1939 role as Mammy in Gone With the Wind. Though, as the Oscar recipient stated, "it was much better to play a servant than to be one,"[7] the fact remained that the collective, repetitive, and exclusive presentation of such images by the industry contributed significantly to the narrow, stereotyped perception of African Americans in general. (It is worth noting that some of her African American contemporary critics felt that Hattie McDaniel's talent as an actress was so superior that it

transcended the roles she repeatedly played.)[8] One of the few places where alternative representations could be consistently publicly seen was the African American photographic studio window. By the 1920s, as Polk embarked upon his professional career, there were increasing numbers of photographs being produced in the South by African American photographers for their African American clientele.

Born in the small town of Bessemer, Alabama, Polk deliberately chose to remain in the South as the wartime (WWI) relocation of thousands of African Americans to the industrial North was actively underway. He entered Tuskegee Normal and Industrial Institute (currently Tuskegee University) in 1916 to pursue painting, unaware that founder Booker T. Washington, who died the previous year, had established a strict policy of providing a "practical" education for students, namely, offering marketable trade skills that did not include the arts. When the dean suggested that Polk study house painting at least to learn how to mix colors, he declined. He did respond when Cornelius Marion Battey (1873–1927) solicited students for a newly formed photography program. Polk was the third student to sign up and learn basic camera and darkroom techniques. Leaving Tuskegee in 1920, he took a correspondence course the following year while working in the shipyards of Chickasaw, Alabama. Polk completed the course and joined his mother and three sisters in Chicago, where they had relocated three years earlier.

In January 1926, he married Margaret Blanche Thompson of Brunswick, Georgia. At about the same time, he met commercial photographer Fred A. Jensen, who instructed him over a period of twenty months on retouching and other printing techniques. Ironically, he financed these lessons working as a painter for the Pullman Company during the day and the telephone company at night. Within a year, Polk was a father and began working as a professional photographer. He quickly became weary of canvassing work door to door for clients, particularly with Chicago's bitter winter rapidly approaching. He and his family returned to Tuskegee, where Polk immediately opened a private portrait studio and photographed the first of his "old characters"—rural figures who arrived on

Tuskegee's campus for agricultural conferences, sales, or other related visits. In 1928, he joined the faculty at Tuskegee Institute as an instructor in the Photography Division. He worked closely with Leonard G. Hyman (b. 1895), the Division Head and Official Photographer for the institute who was active in Washington, DC, for nearly fifteen years prior to working at Tuskegee (1927–1932). Five years later Polk was named head of the photography division. He became Official Photographer in 1939, a post he held virtually until his death on December 29, 1984.

By 1935, Polk was a fixture at Tuskegee and one of its celebrities.[9] The fourth photographer to work in an official capacity for the institution following Arthur P. Bedou (1886–1966), Battey, and Hyman, his popularity stemmed in part from his ubiquitousness and his uncanny ability both to capture the likeness and tap into the uniqueness of his clients. In his official capacity, he was a most effective snatcher of opportune moments, impulsively fading into oblivion to claim a scene that compressed an entire story into a second. At the same time, he had the tenacity to manipulate and maneuver for as long as it took to catch the desired image.

No other photographer has been so readily associated with a Historically Black College or University (HBCU) as has Polk. While continuing the tradition of telling the official story of Tuskegee, he managed to instill (and extract) his own. His prolificacy and longevity aside, Polk produced some of the most provocative, profound, yet characteristic visual records of southern subjects of his time. Beginning in the late 1920s and fully matured by the early 1930s, his photographs reflected the image quality of fashion, advertising, and promotional photography for entertainers. Some possessed the appearance of documentary work, but in those instances, Polk still managed to distinguish the image with his personal stamp achieved through an expression, gesture, or play of light. Of all the images made in his official capacity, none outnumbered the photographs of renowned scientist George Washington Carver (pl. 30).

Polk made more than five hundred photographs of Carver, recording him in the laboratory, classroom, office, hallways, and agricultural fields. If Carver took a walk, or gave impromptu instruction to a student,

Polk's gaze, through the lens of his camera, was there. The trust between the two men was unquestionable, and they had a mutual understanding of the significance of the work each was doing, and the importance of the photographic record to the legacy of Tuskegee, the region, and African Americans nationwide. Carver drew widespread national attention for his inventive uses of the sweet potato, peanut, and numerous other foods in deriving 118 products, including a rubber substitute and over 500 dyes and pigments. The agricultural chemist also developed innovative soil rotation methods for conserving nutrients that greatly enhanced crop production and helped energize America's economy. Further, he created and distributed pamphlets on improved planting and soil preparation techniques to African American farmers in the South during on-site visits. He tutored those he visited so that they might pass the information on to others. Through it all, Polk was there. The results of their collaborations did not go unnoticed. Carver's laboratory and classroom became the destination of many leaders and educators, including white teachers, who brought their students to the campus in defiance of state laws.

Polk's photographs attest to Carver's national status and importance. They include portrayals of him with visitors such as President Franklin Delano Roosevelt and automobile magnate Henry Ford, whose repeated attempts to lure Carver to Michigan failed, but resulted in Ford building the Carver Industrial School in Ways, Georgia, and creating the George Washington Carver Cabin in Greenfield Village in Dearborn, Michigan, in 1942. There are also visual accounts of Carver receiving the honorary degree from Rochester University in 1941 and Stefan Thomas sculpting his portrait to commemorate forty years of service to Tuskegee and many more to the nation. The scientist instructed Polk to take his picture at every opportunity because when he was dead people would want them. Polk complied, probing beyond Carver's day-to-day public persona as Tuskegee's most famous professor and revered agricultural scientist to include aspects of his private life, emphasizing his personal commitment with improving the lives of southern African American farmers.

Polk's photographs of Carver are critical to any discussion that addresses ways that African Americans were portrayed in the South between 1890 and 1950. Carver's position as a nationally recognized and sought after figure made him an ideal subject for contradicting the popularized images by the mainstream media. Carver's combination of traits including that of academic, humanitarian, inventor, community liaison, and world-class scientist was diametrically opposed to the preoccupation of America's popular media with the stereotype of the uneducated, minstrel-derived southern black.

The same applies to Polk's numerous photographs of the Tuskegee Airmen. His images of the first squadron of African American pilots allowed by the U.S. government to fight for their country are reminders of the heroism of numerous black men in uniform. Copies of Polk's 1941 photograph of Eleanor Roosevelt and Charles Alfred Anderson (known as "Chief Anderson") just before an unprecedented flight in his two-seater plane was widely distributed to the press, yet reproduced in only a few newspapers and journals. This was the case despite the fact that the event, supported by the photograph that documented it, played a key role in securing the flight program at the institute and in allowing the participation of the airmen in America's North Africa and European campaigns during World War II.

Curator Edward F. Weeks attributed Polk's "successful and distinctive photographic sense to his human and spiritual responsiveness, the product of instinct and training that resulted in a unique ability to photographically 'touch' the subject and thereby the audience."[10] His keen attention to composition as well as sitter earned him a status rarely afforded a studio photographer. Critic Lee Fleming applauded his use of soft focus to create dream-like qualities in certain works, and the incredible sense of balance employed in others.[11] Weeks attributed Polk's popularity and notoriety to the fact that his "artistry transformed his pictures into images whose impact extended far beyond Tuskegee."[12]

At the same time, Polk continued his studio work, characterized by his signature style of making well-constructed images built around deep tones, crisp contrasts and vague, unobtrusive backgrounds. He benefited

from the institution's prestige—it was a must stop on the tour list of most major African American entertainers, writers, and athletes during Polk's initial decades there. Successful business people, leading educators, and political activists regardless of racial background were also frequently on campus. In its own right, the city of Tuskegee had a very prominent and active social elite, as well as the highest per capita level of education and income in the state in the 1940s.[13] This facilitated Polk's having a lucrative private studio business. Thus, he achieved as many classic, elegant poses of poised clients as he did in a 1936 portrait of Catherine Moton Patterson, daughter of Robert Russa Moton, Tuskegee's second president, and wife to Frederick Patterson, his successor. He took full advantage of her unusual talent as a harpist, her immaculate grooming, dress, and posture, and her image as a symbolic trilogy of the very concept of a profile—sight (her portrait), sound (her playing the harp), and memory (her personal narrative as daughter/student/wife). Polk habitually suited his clients in personalized portrayals, and while others may be less intimate, he maintained the ability to stimulate a sense of uniqueness. Stunning portraits of student Alberta Osborn (ca. 1926), graduate Mildred Hanson Baker (1937 or 1938), and wife Margaret in 1946 are among the hundreds of examples. Osborn is presented looking slightly over her right shoulder with the lower right cheek gently nestled into the hair of the dark-toned fur she is wearing. The softness of her large eyes and a tiny single pearl on her left ear are the brightest points of emphasis other than sprinklings of highlight pronouncing the sheen of her short, neatly combed black hair. While the appearance of the pose links her to that of a movie actress in a promo shot, her gaze and expression speak to a certain confidence, comfort, and calm of spirit that ensures her distinctness from other portraits. The image is also one that exemplifies Polk's propensity for "working from the dark side," or developing form out of shadow in a Rembrandt-like manner. Less dramatically applied as was the case with other images such as the 1946 portrait of his wife, Osborn's portrait, nonetheless, strongly indicates ways in which he extracted areas of formal detail out of a sea of blackness, while being equally proficient in the

manipulation of lighter tones for the sake of detail and texture. Collectively, the large body of work including photographs of his family, students, and other clients combined with those created in fulfilling his responsibilities as official photographer put forth a radically different image of African Americans in the South than was publicly seen in America. The contradiction in Polk's imagery to the exclusive media portrayal of African American women as domestics and men as field laborers hits even harder with the fact that many were taken in the segregated, Jim Crow South in the midst of the Depression. Equally significant is the point that his photographic treatment of rural subjects from the area broke from the expected and usual portrayals.

Polk felt a kinship with the people who lived in Macon County as well as those making up the Tuskegee farming community. Growing up in Bessemer, a small town adjacent to iron ore mining camps where his father worked, and farms where his mother once picked cotton, he was at ease in the company of rural workers. Over time, they became some of his favorite subjects. Called his "old characters," he portrayed them with the same intimate and personalized care afforded his clients. Unlike those who came to him to have a portrait made, Polk sought out these models, embracing and acknowledging them as legitimate and equal parts of the Tuskegee story. His intermittent departures from duties as official photographer and private studio portraitist to work as a "freelance" artist were rewarded most through the images he created of his rural models.

Not everyone was intrigued or impressed with these images. The opinions of critics were literally split over their significance and their artistry. Deborah J. Johnson considered his "old characters" stereotypes, referring to them further as "examinations of the difficulty inherent in being black and/or poor." Writer Nicholas Natanson dismissed certain of the photographs as "rustic cuteness." Polk saw these subjects as vanishing from the American scene and worthy of vicarious preservation on film and paper. He was also drawn to a "frankness and honesty about them—they were characters," and he considered his photographs candid records of who they really were, in their plainness, simplicity, and rawness. Further, he was

neither ashamed of them nor patronizing to them. As such, he considered them strong individuals, and people who gave the story of Tuskegee proper balance. Most prominent among these images, and clearly the most striking is *The Boss* (pl. 31). Polk called *The Boss* his front-runner, referring to its popularity and status as his most frequently reproduced and requested image. While there are definite parallels that may be drawn between her physicality in the photograph and that of characterizations in motion pictures and other popular media, such comparisons are superficial at best. Film portrayals of African American female subjects rarely convey characteristics of leadership, diligence, and self-sufficiency. *The Boss* is a visual paradox—seemingly typical to the extent that it portrays in a certain way the expected kind of image of a farm-working woman of the era, yet also breaks away from the tradition and established treatment of the African American laborer that encourages the viewer to lapse into voyeuristic or patronistic patterns. Polk spotted her walking across Tuskegee's campus as she gathered with the other farmers to sell her products. Finding her a striking subject, he persuaded her to come to his studio. Polk patiently explained the procedure to her, assuring her that the camera would not hurt her. The resulting photograph is one that is far from usual. She is portrayed in her own matter-of-factness—confident, hardworking, adventuresome, assertive, and stern. The pose, at an angle, and her expression, authoritative and firm, are not the result of Polk's usual tactics to encourage a response but rather how she presented herself. She wears her own clothes. She is not cloaked in victimization nor placed in pitiful surroundings. She is not helpless and she is not "cute." Instead, she projects notions of independence and is powerful in appearance and, by title, is the boss. Not to be forgotten is the fact that Polk persuaded her to pose for him because she would be paid. While he obtained the photograph he wanted, she was financially compensated. Thus, from the standpoint of the model, the pose and, subsequently, the popular image are both results of a business decision that she made. This places an additional edge on the application and implications of its title, *The Boss*.

The categorization of this and similar work as disconcerting stereotypes by Johnson and other critics is indicative of a failure to evaluate this body of work on the basis of its own pictorial merit as a group of specific portraits rather than a collection of anthropological or sociological specimens. *The Boss* is not to be studied via the deceptive things on the surface—skin tone, skin texture, size, garments, etc. She warrants examination based on her countenance and contradiction, as an image of an individual rather than a specimen. While the subjects were laborers by vocational classification, Polk did not present them as work-related models stripped of personality. They were rendered with care and as worthy components in the bigger picture of the Tuskegee, Alabama, story.

His portrayals of Henry Baker (1932), Charles Turner (1933), and George Moore (pl. 32) confirm his genuine interest in penetrating beneath the superficial characterization of type, and presenting the faces and normality of unpretentious, simple, hard-working individuals who are comfortable—in deference to their economic circumstance—in their own dark skin. George Moore, whom he photographed on numerous occasions, was one of Polk's favorite subjects. Polk stated that Moore "always wore a hat, even though it was not in good shape, but he was brought up to believe that a gentleman always wore a hat."[14] In these and similar subject-based works, Polk created some of his most intense and pensive photographs. While Turner and Moore are presented in a seemingly straightforward, matter-of-fact way, the images contain an austereness and an air of complete self-awareness permeates them. Even though Baker is posed looking up in a manner that calls to mind postures commonly seen on paper fans used in small southern churches, he, too, in an earnest conveyance of acknowledgment and submission to a different level of understanding, also espouses an awareness of "self" from a different human perspective.

In the final analysis, Polk should be seen as a model, being one of several African American photographers in the South whose studio work offered different representations of African Americans in the region. His signature style, extensive body of work, and long association with Tuskegee University established his career as an important one both to the state of Alabama and to the cultural community nationwide.

NOTES

1 William Perlman quoted in Gary Null, *Black Hollywood* (New York: Citadel Press, 1975), 7.

2 Cornel West, "Horace Pippin's Challenge to Art Criticism," in Kymberly N. Pinder, ed., *Race-ing Art History* (New York and London: Routledge, 2002), 325.

3 Stieglitz opened The Little Galleries of the Photo-Secession at 291 Fifth Avenue, New York in 1907 with the assistance of Edward Steichen. He pioneered the cause for photography and modern art from 1903 until his death in 1946.

4 Jacques Lacan, *The Seminars of Jacques Lacan*, Book I, *Freud's Papers on Technique*, quoted in Vincent F. Rocchio, *Reel Racism* (Boulder, CO: Westview Press, 2000), 17.

5 These shows primarily presented white males wearing burnt cork performing songs and skits that sentimentalized plantation life and portrayed child-like adult slaves with exaggerated features, speech patterns, and body movements.

6 Steven Loring Jones, "From 'Under Cork' to Overcoming: Black Images in the Comics," in Charles Hardy and Gail F. Stern, eds., *Ethnic Images in the Comics* (Philadelphia: Balch Institute for Ethnic Studies, 1986).

7 Null, *Black Hollywood*, 76.

8 Ibid.

9 According to alumnus Conrad Pope, "Having a portrait made by Mr. Polk was a kind of ritual. It was not a question of if you got him to make your portrait it was when. And you did not just show up at to his place expecting him to take your picture. You made an appointment. It was professional. He schooled you that way."

10 Edward F. Weeks, "P. H. Polk and Tuskegee Institute," in *P. H. Polk* (Birmingham, AL: Birmingham Museum of Art, 1983), 2.

11 Lee Fleming, "P. H. Polk Photographs," *Art in America* (October 1981), 155.

12 Weeks, "P. H. Polk and Tuskegee Institute," 3.

13 Tuskegee as a small, rural southern town enjoyed an usual economic and educational position due largely to the number of highly trained professors on the faculty of Tuskegee Institute, the presence of the only Veterans' Administration hospital after World War I for African Americans with the corresponding medical personnel and staff.

14 Polk interview by writer at his Tuskegee home in June 1981.

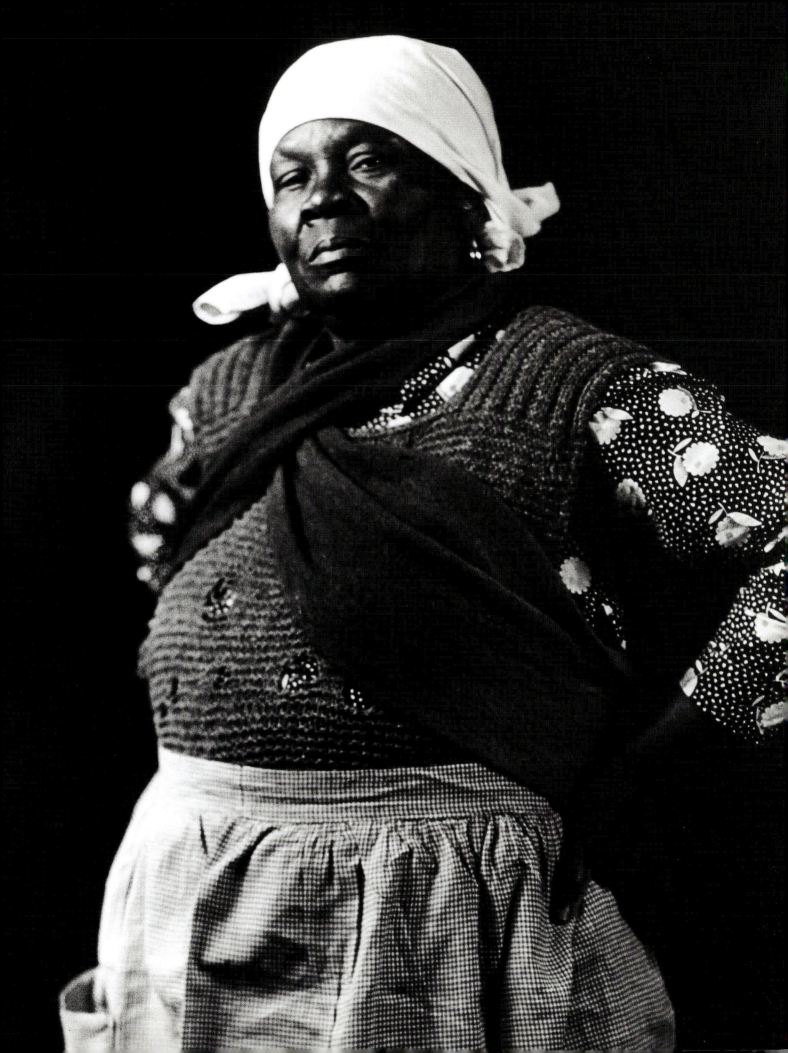

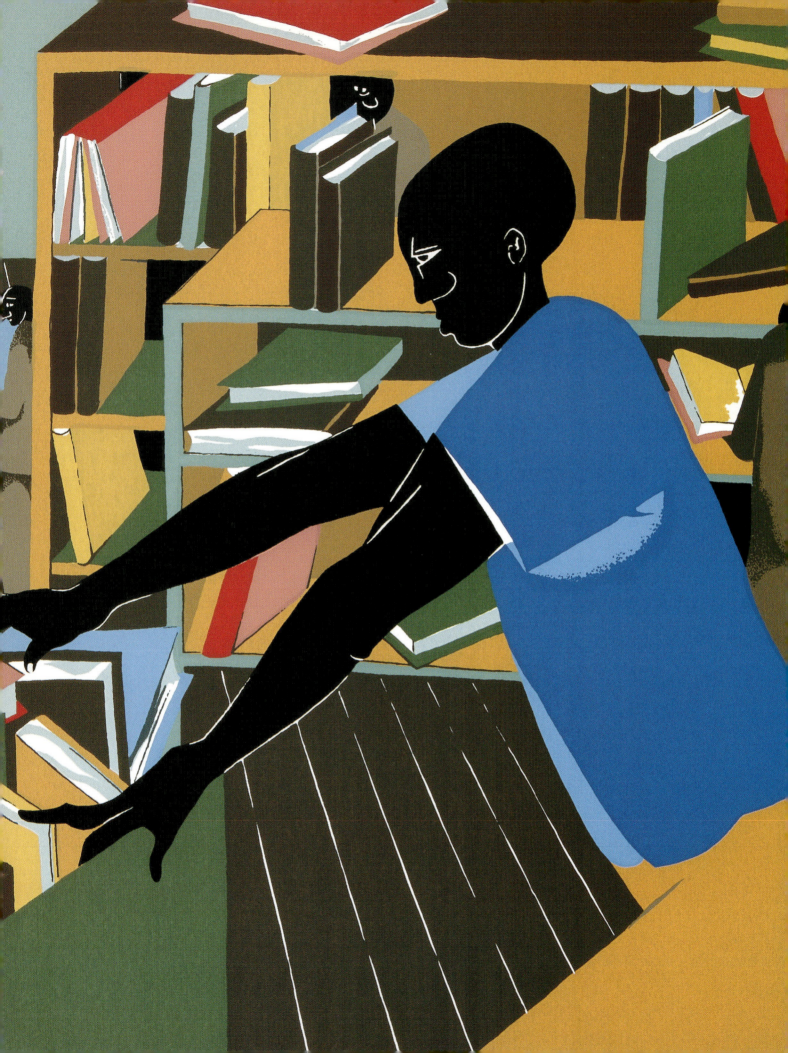

African American Printmakers:

Toward a More Democratic Art

WINSTON KENNEDY

In terms of visual art, the role that black people, their art and their ideas have played in the construction of modernity remains resolutely unrecognized by some.

— Richard Powell in *ReBirth of a Nation*

FACING PAGE:

Detail from Jacob Lawrence's
The Library, *1978*
(Plate 34)

THE PAUL R. JONES COLLECTION INCLUDES THE WORK OF A number of artists who explore African American agency using the printmaking process. Representing a range of styles, subject matter, edition formats, and historical periods ranging primarily from the 1930s era of federal art programs to the present decade, the prints in the collection contribute significantly to the breadth of discussions of African American visual expression. Some of America's best-known artists have work included in this print component, Henry Ossawa Tanner, Jacob Lawrence, Romare Bearden, Elizabeth Catlett, Charles White, and Hale Woodruff among them. Others with regional and national reputations whose first medium is printmaking are also represented.

Until the 1970s it was difficult to find considerable holdings of African American prints in collections beyond historically black colleges and universities such as Howard, Hampton, Fisk, and Atlanta. There were also only a few museums and centers with significant collections of African American prints outside the Schomburg Center for Research in Black Culture, the Museum of Modern Art, and the Metropolitan Museum of Art. With its existing print holdings, which include a major gift to the collection from the Brandywine Workshop in Philadelphia, the Paul R. Jones Collection at the University of Delaware now joins these leading institutions. This chapter introduces a few examples of the printmakers and their works represented in the Paul R. Jones Collection. While numerous methods of study and classification may be applied, this examination focuses on the narratives presented in the work of seven artists from different time periods and representing different points in their artistic development. Some stories are

derived from written texts; some are inspired by the artists' actual experiences or by members of their communities; others are imagined.

One of the oldest prints in the collection and one of the earliest acquired by Jones is a 1910 intaglio by Henry Ossawa Tanner (1859–1937) entitled *Return to the Tomb.* Tanner was the first African American artist to become internationally known, living in Paris for the majority of his career, and being the most influential model for young artists during the New Negro era.[1] Born in Allegheny—now the Northside of Pittsburgh— he was the first son of Benjamin Tucker Tanner, a bishop of the African Methodist Episcopal Church (AME) and third generation to live in the area. His family moved to Philadelphia when he was seven. He grew up in an active religious and creative environment where he was free to pursue "things of beauty." After observing a landscape painter in Philadelphia's Fairmont Park during a walk with his father at age thirteen, he decided to become an artist. He was the second African American to study at the Pennsylvania Academy of Fine Arts (c. 1879–1881), preceded by painter, miniaturist, and critic Robert Douglass, Jr., a neighbor with whom his family interacted.[2] Tanner studied under realist painter and then academy director Thomas Eakins (1844–1916); under his instruction, Tanner worked from live nude models, studied anatomy and photography, and learned to draw with color.[3] This studio pedagogy equipped Tanner with the ability to represent black subjects objectively in his paintings and to do so in a "sober" and realistic manner.

Tanner's progression toward biblical subject matter is traceable to a number of factors, most notably his background, personal faith, and trips to the Holy Land. His parents hoped he would "answer the call" to the ministry, or at least, become a Bible illustrator. Tanner's insistence on a professional art career deeply disappointed his father, who nevertheless provided moral and financial support whenever "worst came to worst." Nonetheless, Tanner was knowledgeable of the allegories of the Old and New Testaments and understood fundamental Christian iconography. He also experienced a gradual growth in his "personal walk of faith,"

and, further inspired by travel to the Holy Land, found religious scenes to be subject matter close to his heart and soul. This was further enhanced by the critical acclaim he received for *Daniel in the Lion's Den* (1895).

Tanner's etching, *Return to the Tomb,* is one of many intaglio prints he completed depicting the life of Christ. Tanner created a modernist version of the tomb visit that echoed his earlier painting *Annunciation XVIII.* Like that earlier work, *Return to the Tomb* was developed compositionally around simplicity, soft textures and tonalities, and angular light as means to achieving optimum, though not overly dramatic impact. He also continued his use of contemporary figures from his personal life as characters in the story. In the case of *Return to the Tomb,* he used his wife, Jessie MacCauley Olssen Tanner, as the model.

The three Marys are shown at the pivotal moment of their arrival at the tomb to anoint the body of Christ with spices and discover that the stone sealing the tomb has been rolled away. Tanner reduced the scene to a close-up of bodily expressions, cropping the image much like a photograph. The poses of the three main figures express their amazement, with soft facial lighting and bodies that are relatively well defined. The loosely rendered surrounding space reinforces the sense of reverence, further enhanced by the use of aquatint to create an overall dusky tone. Thematically, the scene is at the very heart of the resurrection story as well as the redemption message and call to conversion associated with it. In reducing the visual information to its fundamental players, Tanner anticipated viewers would know its full meaning.[4]

More than thirty years after Tanner created the figure-based work for which he became extremely well known, philosopher Alain Locke, in the essay "The Legacy of the Ancestral Arts," seemed to question his effectiveness in relating to the African American experience. Locke, in rephrasing an earlier call for African American artists to embrace a "sober realism" in their creative works (the first occurred in his 1922 publication *The New Negro*), emphasized his preference for racial themes and subjects. Locke praised Tanner's considerable talent, yet apparently considered his style of realism "wanting" in its ability to contribute to his vision of a Negro School of Art. Locke indicated:

If sustained and sustaining interest and support can be relied upon, the immediate future of the Negro artist can be faced with sanguine hope and expectation. From the side of the artist, the best significance of the present obvious achievement is its still greater potential promise. This is obvious both in maturing technique and in deepening significance of content. More and more a sober realism is to be noted which goes beneath the mere superficial picturesqueness of the Negro color, form, and feature and a penetrating social vision which goes deeper than the surface show and jazzy tone and rhythm of Negro folk life.[5]

Locke expressed disappointment in Tanner's lack of interest in black themes—presentations that linked African Americans to their legacy of African art. According to the Reverend W. S. Scarborough, a friend to the Tanner family, prominent African Americans hoped Tanner's work would "counterbalance" the negative treatment of black subjects more commonly seen. Tanner himself saw cultural merit in an African American artist creating alternative portrayals. At the same time, he felt that his work should be considered without racial classification, and that the African American artist could achieve acceptance in the mainstream art society.

Is it possible, at least formally and stylistically, that Scipio Moorhead sufficiently addressed some of the issues of unique imaging to which Locke referred in his eighteenth-century portrait of Phillis Wheatley (1773)—a work that is possibly the first official portrait of an African American by an African American.[6] Was there further resolution in the work of nineteenth-century artists Patrick Reason (1817–1850), Robert Duncanson (1821–1872), Edward Mitchell Bannister (1826–1901), and Henry Tanner, whose portraiture, antislavery art, landscapes, narratives, and genre paintings were among the most skillfully executed works of their time? And, ironically, Locke essentially answered the question posed in the essay itself when he stated:

[I]n our cultural situation in America, race at best can only be some subtle difference in overtones of the improbable we know and treasure nationally. We must not expect the Negro artist to be different from that of his fellow artist. Product of the same social and cultural soil, our art has an equal right and obligation to be typically American at the same time that it strives to be typical and representative of the Negro; and that, indeed if evidence is rightly read, we believe it already is and promises more to be.[7]

Henry Louis Gates argues, "Renaissances are acts of cultural construction, attempting to satisfy larger social and political needs. And the African-American post-modern renaissance—in its openness, its variety, its playfulness with forms, its refusal to follow preordained ideological lines, its sustained engagement with black artistic past—is no exception."[8] The sustained engagement to which Gates refers is evident in the collecting pattern of Paul Jones and in the innovative creative styles of many of the artists whose work was acquired. One of the most notable among them is Jacob Lawrence.

Considered to be the American artist who "reasserted the legitimacy of narrative painting as modern art," Jacob Lawrence (1917–2000) began creating images of the American scene when he was still in his teens. A native of Atlantic City, New Jersey, he lived briefly in Easton and Philadelphia, Pennsylvania, before settling in Harlem with his mother Rosa Lee and younger siblings Geraldine and William. In his early teens he began studying art with painter Charles Alston (1907–1977) at an after-school program directed by distinguished printmaker James Lesesne Wells (1902–1993). Lawrence capitalized on the vibrant and intense day-to-day Harlem environment, incorporating it into his early work. His strong sense of color and design quickly became evident, and without formal academic instruction, Lawrence rose to national prominence at a fairly young age. The winner of three successive Julius Rosenwald Fund fellowships beginning in 1939, Lawrence was actively mentored and promoted by Alston, who touted him as an unusual talent and as a self-made artist: "Lawrence's development is dictated entirely by his own inner innovations. . . . He is particularly sensitive to the life about him; the joy, the suffering, the weakness, the strength of the people he sees every day. Lawrence symbolizes

more than anyone I know the vitality, the seriousness and promise of a new and socially conscious generation of Negro artists."[9]

In 1941, at the age of twenty-four, while enlisted in the U.S. Navy, he was given a one-person exhibition at the Museum of Modern Art. The first of many major retrospectives of his work was mounted at the Brooklyn Museum in 1960, touring numerous cities under the sponsorship of the American Federation of Arts.

Renowned for his cinematic gouache and tempera series of historical figures and events, Lawrence did not begin making prints until 1963.[10] His 1978 serigraph entitled *The Library* (pl. 34) possesses many of the didactic and formal qualities of works in his earlier Toussaint L'Ouverture Series (1937–38), encompassing forty-one paintings about the Haitian Revolution of 1795, and Migration Series (1940–41), encompassing sixty panels on the migration of African Americans from the South. The unsentimental, unassuming, and yet candid re-creation of scenes from his own childhood, family stories, or historical writings that formed the basis for his critically acclaimed series is also the motivation for this print. The library as subject was a logical evolution for Lawrence since the facility was an important fixture in his personal life and work. "I spent quite a bit of my youth in libraries. I was encouraged by my teachers to go to the library, all of us were . . . and it became a living experience for us. I would hear stories from librarians about various heroes and heroines. The library in my day was a very important part of my life."[11] For Lawrence, the library served as a significant force in furthering his understanding of the history of the African American experience, particularly the economical and political forces that impacted it. To him, it also played an important role in advancing the dreams of African Americans eager for historical and practical knowledge, occupying a natural place in their everyday life.

In *The Library,* there is a simple composition based on a complex integration of art elements and design principles. The print is an unassuming depiction of the space and related activity of its users. Lawrence strengthened the design with his extensive use of bold areas of color. Many of the forms and shadows are rendered in black, giving them a more graphic presence. Creating an interior environment using a modified orthographic perspective, he references linear perspective within the same composition—the converging white lines in the floor guiding viewer attention to the center of the image.

The library, inclusive of all of its social, political, and cultural implications, is truly the subject of the print. At the same time, Lawrence offers an alternative reading of the African American presence in an art portrayal of average individuals pursuing information and knowledge as a common everyday act.

Another important artist to develop images around portrayals of daily life was Elizabeth Mora Catlett (b. 1915). Catlett has been a leader in the visual arts in the push for gender and racial equity since the early 1960s. Born in Washington, DC, she has lived and worked in Mexico since the mid-1950s, making frequent visits to the United States. She studied art at Howard University under Loïs Mailou Jones, James V. Herring, and James A. Porter. She was the first artist to receive the MFA from the University of Iowa (1940), having studied under Grant Wood who advised her to look to her own people for inspiration and "paint" what she knew intimately. Initially established as a sculptor, she turned to printmaking while raising her three sons with her second husband, Mexican artist Francisco Mora. A Rosenwald Fellowship allowed her to complete the well-known print portfolio, *The Negro Women Series* (1946–47). In this work she demonstrated her increasing use of spot color against the main black-and-white forms in the image.

In a much later print, *Singing/Praying* (1992) (pl. 35), she used a multicolor grid composition divided into four parts to refer to the interplay of individual spirit and group cohesiveness. By design it speaks to the intrinsic nature of song and acts of faith to the cultural history of African Americans. Dating back to slave-era songs, including call and response techniques, collective singing contributed to a sense of unity—a common cultural bond whether a spiritual, hymn, ballad, or secular song commonly known. Catlett's organization of this piece also calls to mind the effective role of singing in the civil rights movement, where song established the mood

surrounding the marches and demonstrations them-selves. It also supplied the rhythm and carried the core message behind the social and political act.

Her isolation of the woman in the upper field of the print is significant. She is presented on her knees with her hands in a prayerful pose and eyes closed. The floral print of her dress draws attention to its simple design. She wears no jewelry and is completely consumed in the reverence of the moment. The left panel shows a close-up of her face in a slight angle, eyes and mouth open as she sings. The two upper panels together emphasize the personal and corporate experience, also, the individual passion and faith that contributes to the group dynamic. In the lower sections, she depicts a male singer on the right, diagonally from the female, while to his right two male heads (a repeat of the same portrayal) appear to be listeners, taking in the sounds or, possibly, singing inwardly. In what may be one of her most powerful statements concerning the string of vocal music that threads the history of African Americans, Catlett may also be making a personal statement of her own affinity for song, given she had desperately wanted to become a blues singer.

Her interest in ordinary portrayals can further be seen in the color serigraph *Girl/Boy/Red Ball* (1992). In this print, she created a seemingly innocent scene of a boy and girl at play with a simple, inexpensive toy. At moments the ball appears as the sun. The neutrality of light and dark earth tones in the ambiguous background is contrasted by the rich blue and other bright colors in the clothing of the two figures. The boy's yellow pants draw attention to him, compensating for his smaller size in relationship to that of the girl with whom he plays. The interplay of color further enhances the animated feel of the piece.

Artist and art historian Samella Sanders Lewis (b. 1924) was a student of Elizabeth Catlett at Dillard University before a transfer to Hampton Institute (now University) placed her under the tutelage of Austrian-born artist Viktor Lowenfeld where she completed study in 1945. Spending her formative years in the South, she later became the first African American woman to earn the Ph.D. in art history (1951) at Ohio State University.

Maintaining a career that included both disciplines, her prolific writing included the text *African American Art and Artists* (revised, 2003).

Lewis created a graphic Passion play in the 1994 color lithograph *The Masquerade* (pl. 36). Two men and two women stand behind a third man seated at a table to the extreme right of the composition. The seated man wears a symbolic red shirt. Not only does the color draw attention to this figure, but it also identifies his impending role as victim in the unfolding drama. As he clasps a book with both hands, one of the betrayers behind him wears a partially blue jacket. Although his "friendly" right hand rests on the sitter's shoulder, his left hand extends a large knife to a second man (who is almost directly behind the seated man). A third figure looks on from a frozen position while the fifth player huddles beside her, wedged to the right edge of the scene, unable to watch and having covered her face with her hands.

Capitalizing on the universal theme of betrayal, Lewis presents a visual narrative that employs color codes, linear emphasis, and compressed space to support its intended theatrics. Her use of bold black vertical lines and compressed neutral space causes the linear component to read as bars—perhaps a reference to the criminal state of mind of the two standing male characters. The red in the clothing, hat, and hair of the three male subjects ties them together while simultaneously reinforcing the tragic divide in their relationship. Ironically, they each wear a red, white, and blue top—a subtle and ironic metaphor for the U.S. flag and united state of brotherhood. The position of the two women as forced witnesses has its own poignancy and emphasizes the potential impact of visual memory.

John Wilson (b. 1922) is one of America's most distinguished printmakers. Having studied at the School of the Museum of Fine Arts, Boston, Tufts University, and the Ferdinand Leger School in Paris, he was particularly interested in the work of Mexican muralists. He also developed an affinity for the short stories of writer Richard Wright, the highly acclaimed winner of the 1937 book of National Fiction Award for the work under the title *Fire and Cloud*,[12] which coincided with

his own concerns for themes addressing the struggles and conditions of African American people. His print series *Down by the Riverside* (2001) depicts *Uncle Tom's Children* by Richard Wright, telling the compelling story of the dilemma of Mr. Mann and his family in the Deep South.

> The river has flooded and his home is surrounded by water. His pregnant wife is in labor and he must get her to a doctor. However, he does not have a boat. He steals a boat from the local postman. During the theft he kills the postman. Though he eventually gets his wife to a doctor she dies because of birth-related complications and the delay of getting medical attention. Ironically, the authorities recruit Mr. Mann to serve on a rescue squad. During the process of that work he is called upon to rescue the family of the man he killed. The deceased postman's son recognizes him. However, Mr. Mann has no desire to kill a second time. Subsequently, the whites attempt to lynch him but he fights back. Mr. Mann is shot by a member of the lynch mob and is left to die down by the riverside.[13]

Homing in on Wright's dealings with the irony and danger associated with racial difference and oppression in America, Wilson created visual portrayals that emulate the sense of sequencing seen in stage productions. With the space operating primarily as theatrical backdrops, he built the images around tones of blue, black, and specks of light for emphasis that enhanced the general sense of emotion and desperation of the main character. As can be seen in the first print in the series, *Embarkation,* the interaction of these elements is accentuated because of his characteristic use of geometricized verticals and horizontals. In *Death of Lulu* (pl. 37), the tragic death of Mann's wife is conveyed by a detailed drawing of her body with her arm dangling over the side as if a chilling reminder of Jacques Louis David's eighteenth-century portrayal of the death of Marat during the French Revolution. Rich, deep shadows and the color blue are used interchangeably to represent the floodwaters, the river, and the threatening nature of both as well as to signify Mann's situation in general in the story.

It is in contrast with the work of younger printmaker Michael Ellison (1952–2001) who depicted scenes based upon observed events mostly in Atlanta. Living in the city for a good part of his adult life, Ellison was a graduate of the Atlanta College of Art. He created figure-based subtractive block prints in a style that leaned toward abstraction yet contained sufficient realism to permit a reading of forms by the viewer. *Brown Boy* is a print where the compressed form of a single Black man takes over most of the composition. He has fallen asleep while reading a newspaper and smoking a cigarette. The trail of smoke from the cigarette in a nearby ashtray makes a thin line against the sharp angles of his body. It intersects and echoes the form of a plant at the top of the composition. The use of low-value blues, purples, and black produces a psychologically quiet and restful mood in the image. Through his use of complex forms and subtle colors Ellison created a highly complex rendering of an otherwise simple scene.

Maryland-based printmaker Margo Humphrey (b. 1942) also looks to her surroundings for inspiration and sources of subject matter. Born in Oakland, California, she attended the California College of Arts and Crafts. Drawing from patterns and color relationships seen in African motifs, she applies personally developed coloration to compositions developed around inner city stimuli. Many of her characters are based upon observed people that she incorporates in stories derived from her own experience. Within these stories Humphrey often refers to memory and includes a playful humor. Her 1980 work *Home Town Blues* is, in one respect, a whimsical composition especially in its execution but, on the other hand, serious in terms of its commentary on homesickness. Laced within the artist's presentation of a commonly felt situation was an expression of personal longing for the nearness of the bay waters, the flora, the sunlight and winds of northern California. In *Home Town Blues,* she depicts a fantastical city: the translucent body of water in the immediate foreground contains cartoon-like plants and mammals. There is an ambiguous form at the center of the composition with a burst of energy emanating around it. In the larger surroundings are red and yellow buildings as further evidence of energy and vibrancy.

There is a blue-purple sky with yellow rays emanating from behind the buildings filled with a variety of forms. A wonderful flowerlike sunburst occupies the left portion of the sky. Toward the middle of the lithograph there is an angel in a yellow dress and green wings in the sky with an airplane, a bird, a meteor, and other forms. She flies downward, at an angle toward the central energy burst. Her shadow is reflected on the façades of buildings at the center and right of the composition.

Another example of her use of autobiographical data in clever ways can be seen in *Pulling Your Own Strings* (1981) (pl. 38). In this work, she creates an image that is, in actuality, a large-scale picture postcard. Capturing the picturesque quality of an exotic vacation local, her reference to the tropics is also a way of reconnecting visually with her own coastal hometown. Hands of two puppeteers are exposed as they control the suspended figures, a male and female dancing upon a floating stage flanked with palm trees. The backdrop of the stage contains a partially opened door and an airplane flying over a grid map. Under the airplane is the inscription "Name still fly." To the upper right on the backdrop is a female figure in a striped box with a flower in her hair holding plants. Adjacent to her is the inscription "Everybody's dream box." Although this lithograph is concerning male/female relationships in general, Humphrey also explores the complex gender role playing that people engage in due to external pressures, familial and societal. She leaves a personal mark on the image by inscribing a message in the upper left corner of the postcard: "A postcard from Tunisia. I'll be home soon. Tell everyone I said hello. Love, Margo."

One approach to constructing an African American identity has been through visual autobiography. Telling one's own story within the context of a broader history for artists established a visual pedagogy. Margo Humphrey, in a large body of lithographic work, has contributed to this use of "self" as subject.

The printmakers discussed here illustrate one of the greatest contributions of African American artists to American art: the truthful and honest imaging of African American people and culture. In so doing, they bring a greater balance to the overall portrayal of American culture and art.

NOTES

1 The New Negro era or Movement (ca. 1917–1935), also known as the Harlem Renaissance, flourished most in the 1920s. It was a time of great optimism and hope within the national African American community that sought a respectable place within American society. While it was not restricted to the North, it was facilitated by the migration of thousands of African Americans from the rural South to the urban North, Harlem being the most popular destination for many, especially numerous talented blacks in the arts. Professors Alain Locke (Howard University) and W.E.B. Du Bois (Atlanta University) were the most prominent spokespersons during the time, with Charles Johnson, James Porter, Langston Hughes, and James Weldon Johnson being among others who were at the forefront. Alain Locke coined the phrase New Negro in the 1925 special issue of *Survey Graphics*, expanding the ideas in subsequent texts that elaborated on his concepts of aesthetics specific to the African American experience based upon the African model. The climate for the movement was set largely due to the Pan-Africanist efforts of W.E.B. Du Bois dating back to the early 1900s. Pan-Africanism basically addresses unifying, promoting, and politically empowering all people of African descent. Including cultural components, Pan-Africanism emphasized overcoming religious, ethnic, language, and geographical differences.

2 For information on Robert M. Douglass, Jr., see James Porter, *Modern Negro Art* (New York: Arno Press, 1969).

3 Sharon Patton, *African American Art* (New York: Oxford, 1998), 98.

4 Biblical stories form a central spine of the African American religious experience that has been historically transformed to visual narratives. From an engraving of Nat Turner and his vision of inspired rebellion in Virginia in 1831 to a twentieth-century woodcut of a moment in the life of Dr. Martin Luther King, Jr., African American artists have revealed sensitivity to the role of the Bible and Christian teaching to African American culture. For much of the slavery era Christian stories were the only narratives allowed. At times, hearing them were the only source of comfort on the plantation and during the reconstruction period in the North. Tanner's religious works were important indicators of this cultural connection as well as ministering vehicles for those who understood the iconography and drew inspiration from them.

5 Alain Leroy Locke, *The Negro in Art* (Washington, DC: The Associates in Negro Folk Education, 1940), 10.

6 America's first African American poet, Phillis Wheatley's (1754–1784) talent secured her freedom in 1774. She personally selected Moorhead (a slave) to do her portrait for the frontispiece of her book of poetry, *Poems on Various Subjects, Religious and*

Moral, while she was still enslaved to John Wheatley of Boston. The London publisher of her poems required the portrait as an indication of her race.

7 Locke, *The Negro in Art,* 10

8 Henry Louis Gates, "Harlem on Our Minds," in Richard J. Powell and David A. Bailey, *Rhapsodies in Black: Art of the Harlem Renaissance* (London/California: Hayward Gallery, Institute International Visual Arts and University of California Press, 1997), 165.

9 Milton C. Brown, *Jacob Lawrence* (New York: Whitney Museum of American Art, 1974), 9.

10 Deborah Cullen, *Creative Space: Fifty Years of Robert Blackburn's Printmaking Workshop* (Washington, DC: Library of Congress, 2003), unpaginated.

11 Patricia Hill, *Jacob Lawrence: Thirty Years of Prints, 1963–1993, A Catalogue Raisonné* (Seattle: Francine Seder Gallery, 1994), 41.

12 Michel Fabre, *The Unfinished Quest of Richard Wright* (New York: William Morrow, 1973), 157.

13 Ibid., 158.

FACING PAGE:

Detail from Margo Humphrey's
Pulling Your Own Strings, *1981*
(Plate 38)

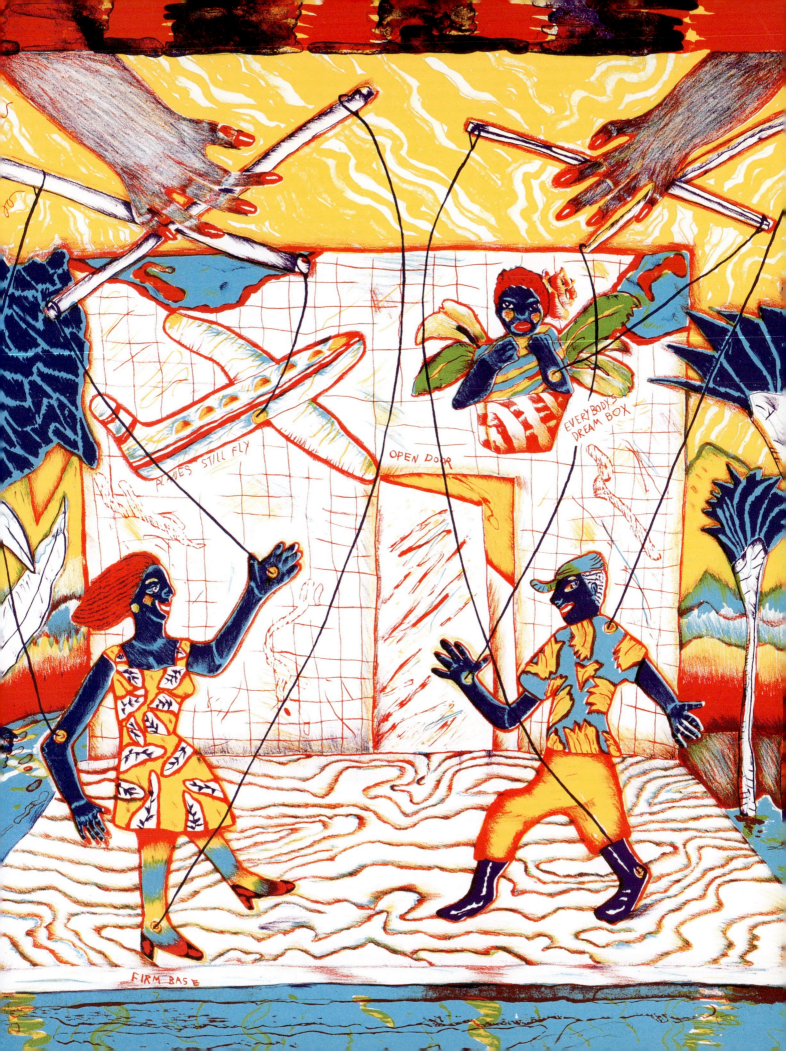

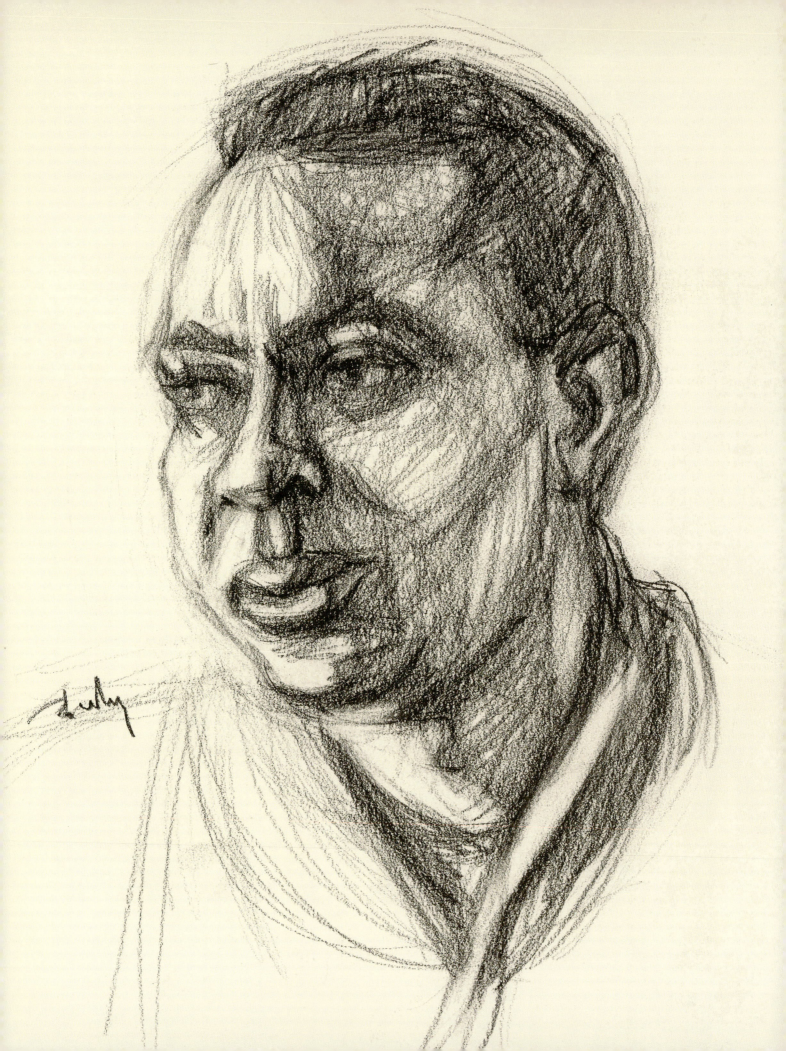

Afterword:

A Personal Appreciation –
Art, Race, and Biography

MARGARET ANDERSEN

Although we often forget it, the work of artists reminds us that the transformation of human societies toward their best possibilities is not primarily a job for political technicians, but a task requiring significant creative genius.

—Vincent Harding, *Hope and History: Why We Must Share the Story of the Movement*, 1990

I FIRST MET PAUL R. JONES AT THE UNIVERSITY OF DELAWARE AND quickly learned that his life was extraordinary—not only because of the magnificent collection of art that he has collected, but also because the seven decades of his life span an extraordinary period in American race relations and social history, some of which is revealed in his life story. Paul is not a man of great material wealth. Though now living a comfortable life—mostly because of his own shrewd investments and the current value of the art he owns—for most of his life he was a man of modest means. With a few early business investments—started on a shoestring and, later, a government worker's middle-class salary—he was able to purchase art from African American artists when few others were interested. Despite the talent of the many artists whose work and life he has supported, racism in the world of art devalued their work. Needing rent, sometimes about to be evicted, hungry, out of cash, artists would flock to his door. As Paul puts it, "Sometimes I didn't know if I was an art collector or a social worker." With an eye for interesting work, though academically untrained in art history, he would buy multiple works from the same artist, wanting to create a collection that would show the span and depth of African American artistic creativity. "There's a joke that he bought art by the pound," says Amalia Amaki, curator of the collection and Paul's good friend.[1]

The Paul R. Jones Collection is a treasure and, in keeping with Paul's wishes, is being developed at the University of Delaware as a teaching and research collection.[2]

Paul wanted his collection to go to a historically black institution. Although some museums wanted to buy individual pieces, he did not want to break up the whole. He preferred the art be in a place with the resources to preserve it, where it would be showcased and where it would become part of an educational mission. As he states, "I want it to be woven into the fabric of an institution where it will be used for teaching and exhibitions."

I have known Paul since 1997, first meeting him when I was dean of the College of Arts and Science at Delaware. He had established a relationship with our Department of Art History, long known for its scholarship on American art; the college was cultivating a relationship with him. The university had exhibited some of his collection in 1993 as part of a show on African American artists in conjunction with a symposium sponsored by the art history department. When I met him, he was serving as a member of the College Visiting Committee on the Arts.

Not long after I learned about his collection, I traveled to his home to see it firsthand. At the time, he lived in a small, three-bedroom ranch house in southwest Atlanta. I will never forget walking through the front door into a small living room (probably about 12' x 15') that was crammed with stunningly beautiful artworks. A tour of the house revealed there was art everywhere—on every conceivable inch of wall space, stacked in the corners, on the floor, in the dresser drawers, stuffed in kitchen cabinets, piled on tables, on top of and under beds—everywhere! And, as we walked around, Paul talked about each and every piece we stopped to view. He knew the artist, he knew when he bought it, he talked about what it represented, and how it moved him. I remember saying to him that day that someone needed to come with a tape recorder and just listen to him talk about the art and his life. He now lives in a larger home—designed in part to showcase what he collected out of sheer dedication to resurrecting and preserving African American culture and making it a part of the national cultural heritage.

Who is the man who has brought this creative legacy together and what does his life tell us about the place of African American art in art history, in society and culture, and in a vision of racial change? C. Wright Mills tells us that you can understand a man's life by understanding the social and historical forces that shape it. But you can also understand the social and historical forces of a time by examining a man's life.

Paul's life spans seven decades. Born (1928) in an age of agricultural and industrial peonage; educated during the peak of Jim Crow segregation; working as a civil rights mediator and as a community relations expert during the civil rights movement and its aftermath; holding a position in the Nixon administration during the Watergate scandal; and developing the nation's largest African American art collection, he has lived through some of the major events that have shaped the course of the twentieth century. His life's course is a part of American social history and is a window opening onto some of the most fascinating parts of that history.

Paul Jones is from relatively modest, though unusual origins. He is the son of Will and Ella Jones. His father worked for the Tennessee Coal, Mine, and Railroad Company (TCI) in Bessemer, Alabama, briefly as a laborer and later in the mining office where he hired workers and mediated conflicts between those in an incipient labor movement and the mine owners (employment broker in today's professional terminology). At other times, he settled conflicts between black and white workers. It was a company town—TCI owned the mines, the housing, the schools, and the commissary.[3] Because of his father's position his family enjoyed privileges that were not typical of other black mining families. The Jones family's class standing bridged the black working poor and the middle class—perhaps a juxtaposition that later enabled him to work across various social boundaries. Paul was also born into a family with a strong entrepreneurial spirit—a spirit that lives within him, too.

When he was ten years old, his family sent him north in search of a better education. He lived with older brother, Joe, and his family in New York during the school year, returning home during the summer. Attending high school in Bessemer, he graduated from Paul Lawrence Dunbar High School and later graduated from Howard University in the class of 1948. As an

adult he worked as a probation officer, a community relations specialist, a director in the Model Cities Program, a deputy director in the Peace Corps, and as a White House staff assistant in the Nixon administration. He worked to achieve civil rights and to settle racial conflict. He has forged opportunities for African Americans in political office and has striven to build better communities for those disadvantaged by racism and inequality. And, of course, he has paved a path for artists by not only sponsoring their work, but also by trying to transform the often exclusionary climate in art museums (in their collections, on their boards, and in their exhibits). Through it all, he has kept an eye on the human creative spirit through the collection of African American art.

In getting to know Paul, I quickly learned not only about the value of his remarkable collection, but also of a life that reflects some of the nation's racial history. What was it like growing up as a young boy in a company town with an incipient labor movement? What was his mother's work like? Could true friendships between blacks and whites develop in this racially stratified time? What were the schools like for a young black boy? How could a black man manage to negotiate the conflict between Sheriff Jim Clark and angry black protestors in Selma, Alabama? How did a black man with strong democratic values end up working in the Nixon administration? What was it like during Watergate? How did you get all that art? These and many other questions began my inquiry into the life of Paul R. Jones.

Usually sociologists do research by trying to discover the patterns and processes by which social structures form and evolve; this activity frequently means engaging relatively large bodies of data. Suspicious of the single case because of its inability to allow generalization, sociologists rarely examine the life of one person as a source of insight. But, if we can grasp the relationship between biography and history by studying large-scale social processes, can we not also discover social facts through the study of individual lives?

With no training or background in art history and little knowledge about art other than personal taste, I entered this project (writing about Jones's life) with only my knowledge about race and society, but with a commitment to transforming race relations through educational change. Like others, I have visited museums, have looked for images that particularly appeal to me, and have illustrated some of my published work with photographs and art that seems to capture certain ideas or events. And, because of my longstanding interest in bringing the work of those who have been ignored to the forefront of education, I have often sought images and work by women and artists of color both to inspire me and to communicate sociological ideas to students. But I never consciously thought about the transformative power of art, nor about the potential for art to become part of a sociological education. Not until I met Paul Jones. Moreover, I never imagined myself writing someone's life history. But I now see this work as both honoring Paul Jones and contributing to the sociological analysis of race in society.

Paul's life tells us much about the social and historical forces shaping race (and the arts) across most of the twentieth century. As Karen Hansen notes, biography can be a prism through which we examine the social aspects of a period of time. Hansen sees that biography accomplishes this by prompting one to ask questions about otherwise taken-for-granted phenomena, illuminating a life as a "point of entry that then connects to larger social and economic processes," and seeing how connections come together in one life.[4]

As Hansen indicates, writing a biography or life history as a sociologist differs from how traditional biographers or historians might write one. Historians use biographies to examine the role of influential people in different arenas of life.[5] Sociology's interest in collectivities, not individuals, is somewhat different. Rather than using a biography to understand an individual life, sociologists expect to focus on the larger social relations in which individual lives are experienced. Biographies can reveal the economic, cultural, and political influences that bear upon a life and that also bear upon a whole society or group. But, more than revealing society and history, biographies also connect us to the emotional and inspirational dimensions of life—dimensions of life often ignored in sociological research.

Paul Jones's life reveals much about society and social change. We see in his life how conflict and cooperation played out in the organization of labor and the early labor movement. We can identify how race is represented in the works of the African American artists that he collects. From his experience we can learn what it is like to work as one of the few black Americans in places like a Republican presidential administration, in the Peace Corps, or on elite art museum boards. We can wonder at the unique class status of an African American family perched between the black laboring class, white management, and the black middle class, and learn firsthand about some aspects of the dismantling of Jim Crow segregation. And in viewing Paul's life history we can study the role of human agency in transforming art institutions. Or, we can simply immerse ourselves in biography, the straightforward listing of dates and facts.

My objective is not to tell Paul's life as pure fact—a feat that could not be accomplished by any life history. Whether narrated by the subject, interpreted by the observer/recorder, or read by the audience, a life is interpreted. As such, subjectivity is a major part of such a research endeavor. Unlike sociological methods that allegedly rely on objective and seemingly detached forms of analysis,[6] developing a life history requires a quite intimate relationship with one's subject. The collection of the life narrative itself is a social process and, as such, subject to the same social influences that shape any social relationship. What are the implications of this fact for this methodology?

Sally McBeth writes, "A life story is more than a recital of events. It is an organization of experience."[7] As such, both the narrator and the observer have a role in how the story is told. A life history engages the memory of the narrator, the relationship between the narrator and the observer, and the observer's hand in how the life is recorded, organized, and presented. In each dimension, social factors weigh in.

Subjectivity clearly plays a clear role in the development of a life history. Life histories are reconstructed accounts of experiences lived over years; these accounts are informed by what people remember and how they experience the significance of events. As historian James Hoopes puts it, a life history from interviews is "spoken memory."[8] Memory is, after all, fallible. Memory can be wrong, incomplete, or fully made up as we continuously reconstruct our concepts of self, our relationship to others and to life events. Our account of our own lives emerges as our life does.

Since sociologists know that the self is a social construction, the point of a sociological life history is not to reveal some fundamental essence of the person, but to instill a sense of the social movement of the life and the social context in which it emerges. When readers engage a life history, they seek not only facts and events, but a sense of time, place, and being. This is created not through presentation of the facts alone, but by how a life story is told, how it is written, how it is placed in context as the author/observer develops it. Thus, no life history can be a completely objective rendering of a person's life.

In attempting to develop Paul Jones's life history, I have collected, reorganized, reordered, and, in some cases (for sake of the written word), rewritten the words that evolved from the interviews with Paul Jones. I have striven for accuracy in the telling of this life history, and hope that it also reveals the sociological context in which it was lived. Moreover, I must confess that I am not at all dispassionate about Paul Jones or the Paul Jones Collection, as claims to more objective social science methods supposedly require. On several levels this project engages some of what I care most deeply about: friendship with a man I truly admire and respect; feelings of mutuality between us as our relationship has grown over the course of this project; greater awareness of the history of race and change in the educational curricula; inspiration from the powerful images that the art invigorates; collaborative work across racial, gender, and class differences, to name but a few. And with biography and life history in mind, I rely on the words of Daniel Bertaux, "If sociology cannot relate to people, . . . it is a failure."[9]

So, what is a sociologist doing writing in the world of art and about the life of an art collector? Writing about any life engages one in a process of locating an in-

dividual in the social-historical times of his or her life. Writing about an art collector, and, in particular, an African American collector of African American art also involves locating art in the context of social institutions that have reflected the racial stratification of society. In the case of Paul R. Jones, we can observe how a person has worked to change those institutions and we can see how the exclusionary practices of those institutions over the years have constructed what we understand to be American art.

Although the task I set for myself in the future and that I have only touched on here, is to understand and interpret the collector's life, this life history also inspires a sociological appreciation of African American art itself. And because sociological research often rests on the presentation of forms of data that sometimes do not invoke human agency and human expression, writing such a life history also reminds us of the creative capacity of human beings—even under conditions of great oppression. Thus, studying the life of Paul Jones teaches us not only to appreciate his life and the social contexts in which he lived and worked, but it also teaches us to appreciate the work of artists who have been subordinated by the forces of racism.

NOTES

1 *News Journal,* Sunday, February 3, 2002, 10.

2 Paul Jones donated the Collection to the University of Delaware in 2001. You can see more about the Paul R. Jones Collection at www.udel.edu/PaulRJonesCollection.

3 To learn more about race and the mining industry during the early twentieth century, see Horace Mann Bond, *Negro Education in Alabama: A Study in Cotton and Steel* (New York: Atheneum, 1939); Brian Kelly, *Race, Class, and Power in the Alabama Coalfields, 1908–1921* (Urbana: University of Illinois Press, 2001); Philip Taft, *Organizing Dixie: Alabama Workers in the Industrial Era,* revised and edited by Gary M. Fink (Westport, CT: Greenwood Press, 1981); Russell D.Parker, "The Black Community in a Company Town: Alcoa, Tennessee, 1919–1939," *Tennessee Historical Quarterly* 37 (1978): 203–221; Deborah E. McDowell, *Leaving Pipe Shop: Memories of Kin* (New York: W. W. Norton, 1996); and Nell Irwin Painter, *The Narrative of Hosea Hudson: The Life and Times of a Black Radical* (New York: W. W. Norton, 1994).

4 Karen V. Hansen, "Historical Sociology and the Prism of Biography: Lillian Wineman and the Trade in Dakota Beadwork, 1893–1929," *Quantitative Sociology* 22 (1999): 355.

5 Ibid., 353–358.

6 For a discussion of the role of subjectivity in sociological biography, as well as in other social science methods, see Daniel Bertaux, ed., *Biography and Society: The Life History Approach in the Social Sciences* (Beverly Hills, CA: Sage Publications, 1981).

7 Sally McBeth, "Introduction: Methodological and Cultural Concerns of Collecting and Co-authoring a Life History," in Esther Burnett Horne and Sally McBeth, *Essie's Story: The Life and Legacy of a Shoshone Teacher* (Lincoln: University of Nebraska Press and Bison Books, 1998), xi–xii.

8 James Hoopes, *Oral History: An Introduction for Students* (Chapel Hill: University of North Carolina Press, 1979).

9 Daniel Bertaux, ed., *Biography and Society: The Life History Approach in the Social Sciences* (Beverly Hills, CA: Sage Publications, 1989), 43.

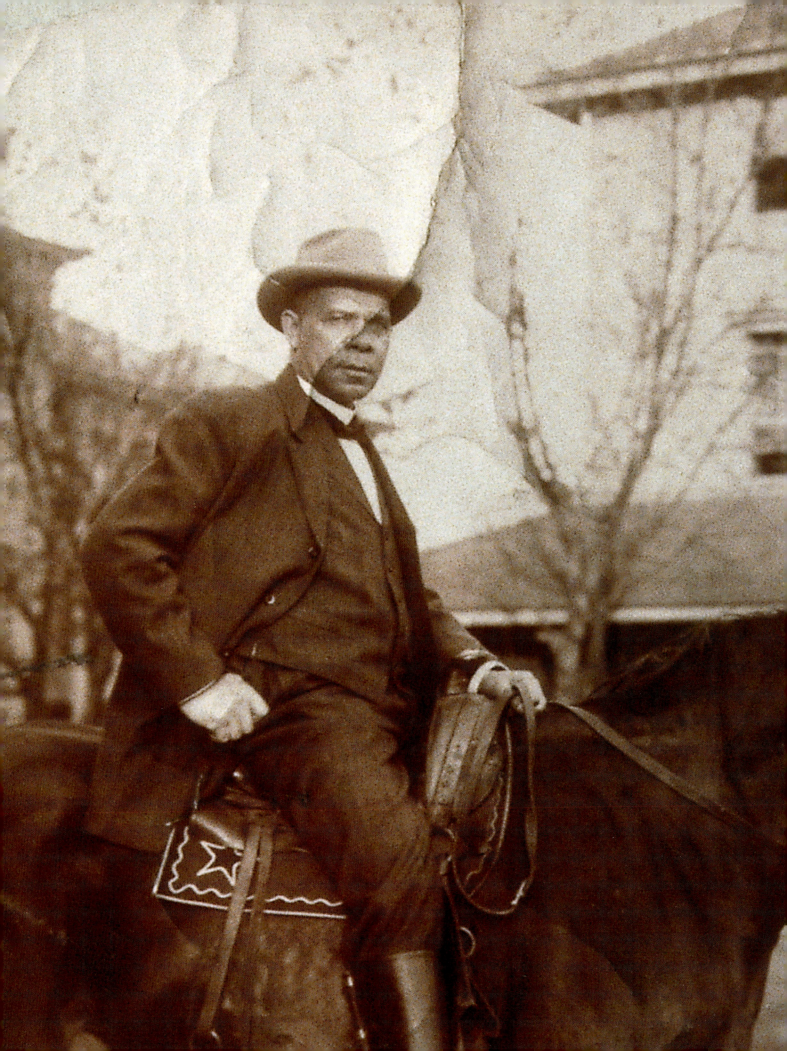

Preservation for Posterity:

The Paul R. Jones Photography Collection

DEBRA HESS NORRIS

THE PAUL R. JONES PHOTOGRAPHY COLLECTION WILL SOON BE housed in the newly renovated Mechanical Hall on the University of Delaware campus, where it will be well protected from rapidly fluctuating environmental levels and atmospheric pollutants. Light levels will be monitored and practical handling policies enforced. This remarkable collection includes photographic images of immense aesthetic, historical, and cultural value. While these images, primarily silver gelatin black-and-white photographs, are generally in stable condition, familiarity with the preservation measures described in this essay will help to ensure their availability for the education and enrichment of future generations.

COMPOSITION AND STRUCTURE OF PHOTOGRAPHIC PRINT MATERIALS

Photographic print materials have complex and vulnerable physical and chemical structures that present the collector with unique preservation challenges. Since the beginning of photography in the late 1830s, many different photographic print processes have been utilized. These include salted paper, albumen, silver gelatin, and contemporary color. The structure of historic and contemporary photographic print materials typically consists of a final image embedded in a transparent binder layer and a primary support.[1] This structure may be further complicated by additional colorants, coatings, and inscriptions, and by the presence of a secondary support such as laminated wood pulp or cotton fiberboards. The chemical composition and physical structure of these photographic print

materials must be understood to ensure their long-term care and preservation.

Photographic images are created by materials that absorb and scatter light. Final image materials include metallic silver, platinum and palladium metal, pigments, or organic dyes. The final image material in most nineteenth-century photographic prints (including salted paper and albumen) is finely divided silver, commonly referred to as photolytic silver or silver produced by light. In these processes, light-sensitive paper is placed in contact with a negative (typically collodion glass plate) and exposed to light until the image appears. Photolytic silver particles are round; they scatter light to produce the red, purple, or brown image tones associated with nineteenth-century print materials. These small particles (typically 3 to 50 nanometers in diameter) are susceptible to chemical degradation, resulting in fading, discoloration, and a loss in highlight detail—deterioration characteristics we associate with nineteenth-century photographic print materials.

The final image material in most twentieth-century silver gelatin photographic prints is filamentary silver. Produced by chemical development in a photographic darkroom, these silver particles consist of a bundle of irregular, intertwined silver filaments that are much larger in size (typically 1,000 nanometers in diameter) than photolytic silver particles. These large particles are less vulnerable to image oxidation.[2] Their irregular structure is ideal for light absorption. Filamentary silver images in stable condition are therefore characterized by a black or near-neutral image color. Degraded silver gelatin images may exhibit a color shift from neutral black to yellow brown as their filamentary structure breaks apart and no longer absorbs light effectively. Mirroring, a reflective silver image layer readily visible in raking light in the dense image areas of a print and caused by oxidation, is a common symptom of deterioration in filamentary silver images.

All silver images are affected by improper processing, specifically inadequate fixing and washing, which may result in severely yellowed or faded final image materials. Although silver image deterioration directly attributable to poor processing is not uncommon (and often encountered in newspaper morgues and other repositories that include images that may have been rapidly processed), most photographic print materials in poor condition have been damaged by exposure to poor environmental conditions and inappropriate handling and storage practices.

In platinum printing, a process prized by fine art photographers at the turn of the century for the pristine, near-neutral matte surface of the prints produced, the final image material is metallic platinum. Platinum is a noble metal; it will not tarnish, discolor, or fade. Platinum is a catalyst for cellulose degradation. For this reason, platinum prints may exhibit an embrittled and highly discolored primary support. Their pristine matte print surfaces are fragile and easily marred and abraded.

Pigments, including lamp black, burnt sienna, Prussian blue, and raw umber, have been used as the final image material in cyanotypes and gum bichromate and carbon prints. These pigments are typically dispersed in a binder and therefore tend to provide excellent image stability.

The synthetic dyes used in most color prints process—cyan, magenta, and yellow—are considerably less stable than metallic silver, platinum metal, or most pigments. These dyes will fade significantly in the dark as well as the light. The decoloration of organic dyestuffs is caused by irreversible changes in their organic structure. Image deterioration in color prints results in an overall loss of density, a shift in color balance as dye layers fade at different rates, and the formation of a yellow stain. Storage temperature will determine the rate of dye fading or staining.[3] The extent and rate of this deterioration are also dependent on the type of color print materials. The image stability of instant color processes, for example, is very poor. In comparison, silver dye bleach (or Ilfochrome) processes composed of azo dyes have excellent dark stability.

The transparent layer that suspends and protects the final image is called the binder. Binders play an integral role in determining the optical properties and stability of print materials. The binders most commonly used in historic and contemporary print processes in-

clude albumen, a globular protein from the whites of hens' eggs, and gelatin, a highly purified, commercially prepared protein produced from animal hides and bones.

Introduced in 1851, the albumen process dominated photographic processes during the nineteenth century. Albumen binder layers yellow and discolor, often because of prolonged exposure to light and conditions of high relative humidity. Because the albumen binder layer expands and contracts at a different rate than its lightweight paper support, these prints typically exhibit cracked and crazed surfaces.

Photographic gelatin is a purified, homogenous material derived from collagen. Introduced to photography in the 1880s, this binder is used today for all silver and color photographic processes. Although gelatin is a relatively stable material chemically (unlike albumen), it is responsive to changes in temperature and relative humidity. Swollen gelatin allows for the rapid diffusion of oxidizing gases and other potentially corrosive contaminants, accelerating image degradation. Gelatin binder layers are an excellent nutrient for mold and can flake excessively when exposed to fluctuating environmental conditions.

The primary support used for photographic print materials is paper. Traditionally, these paper supports have been manufactured from high-quality rag or chemically purified wood pulp. By the mid-1880s, machine-made photographic papers were often coated in the factory with "baryta" a barrier layer that consisted of the white pigment barium sulfate dispersed in gelatin. This smooth, highly reflective white layer allowed for higher contrast and glossier images.

Plastic- or resin-coated photographic papers, introduced in the late 1960s, consist of a paper core laminated between two layers of polyethylene. The uppermost layer of polyethylene is pigmented with titanium dioxide, a white pigment that releases damaging peroxides when exposed to ultraviolet light. Early black-and-white and color resin-coated print materials may exhibit spotwise fading or embrittlement and cracking of their top polyethylene layer caused by interaction with these aggressive, light-induced oxidants. Contemporary papers have increased stability (similar to that of fiber base if processed and housed properly) owing to the presence of antioxidant stabilizers.

The stability and appearance of photographic print materials may be influenced by the presence of secondary supports, hand-applied coloring, collage elements, adhesive layers, and final coatings, which may include waxes, natural resins, and gelatin.

PRESERVATION ISSUES

Photographic print materials can be damaged by exposure to inappropriate environmental conditions, careless handling practices, and the use of improper storage enclosures.

Environment Photographic print materials should be housed in a stable environment that protects them from excessive moisture, high temperatures, airborne particulates, and gaseous pollutants. The American National Standards Institute (ANSI) and other standards organizations have developed guidelines for the long-term storage of photographic materials.[4] In general, print materials should be stored at a relative humidity level of 30 percent to 50 percent. Exposure to high relative humidity levels may accelerate image and binder layer degradation, causing image fading and highlight staining, as well as biological and physical damage such as increased curl. Excessively dry conditions may cause proteinaceous binder layers to crack and craze and primary supports to become brittle and prone to hairline cracking and handling-related creases. Humidity fluctuations of greater than 10 percent should be avoided.

Room-temperature storage conditions are recommended for non-color photographic print materials. Temperature cycling should not be greater than +/-5° C over a twenty-four-hour period. Low temperature storage at 4.5° C (40°F) or below is recommended for most color photography. The construction, selection, and maintenance of cold storage facilities require specialized knowledge and may not be practical for the preservation of privately owned collections. Issues relating to

proper packing and retrieval guidelines must be developed and implemented to ensure that collection materials are not damaged when moved from one environment to another.

Photographic collections should be protected from airborne pollutants through the use of carefully monitored air filtration systems and by proper filing enclosure and lidded boxes or closed cabinetry.

Handling Photographic prints may be seriously damaged when handled carelessly, as their surfaces are delicate and easily scratched or abraded and their lightweight paper supports may be creased and torn if lifted without adequate support. Prints should be handled by their edges and properly supported at all times. Unmounted or matted photographic prints (especially large-format materials) may require a temporary auxiliary support, such as a sheet of ragboard, during handling. The practice of wearing clean cotton or nylon gloves, especially when enclosures or mats do not protect prints, should be standard procedure. Inventories and box lists will minimize handling and enhance access and preservation.

Exhibition and Display Light damage is cumulative and irreversible. Following light exposure, primary and secondary paper supports may become brittle, and binder layers will yellow and stain. Hand-colored surfaces and ink inscriptions may fade, and the color balance of contemporary materials will shift as organic dyes rapidly decolorize at differing rates.

Exhibition standards do not exist, but conservation professionals typically recommend light levels of 50 lux (5 footcandles) for no more than four months per year for nineteenth-century print materials, including salted paper, albumen, and platinum. Pristine prints are often more adversely affected than those that are somewhat faded and deteriorated. Fifty lux is also recommended for all prints from processes that use applied color or binder-incorporated aniline dyes. Most silver gelatin prints may tolerate exposure to light levels of up to 100 lux (10 footcandles), but like nineteenth-century materials, annual exhibition times must be limited. The light-fading characteristics of modern color materials

vary considerably. For most color prints, the spectral distribution of the illumination source—incandescent versus fluorescent light, for example—has little effect on fading rates. Here, it is the intensity of the illumination that is important. Color photographic materials are highly vulnerable to light-induced damage; illumination levels should be kept as low as possible.

Photographic prints should not be exposed to direct sunlight or ultraviolet light. Tungsten or fiber optic illumination should be utilized. Filters and diffusers should be incorporated into all case lighting. Framed photographs should be properly hinged or photocornered into an acid-free mat glazed with ultraviolet-filtering acrylic sheeting. Only latex paints should be used to prepare exhibition spaces, as peroxides emitted during the curing of oil-base paints will accelerate silver image deterioration.

Photographic materials must be exhibited under carefully specified and controlled conditions. The risks of temperature extremes, cycling relative humidity levels, poor handling and transport practices, potential accidents, exposure to environmental pollutants, and vandalism must always be mitigated. All photographs are affected by exhibition. The question is not if changes are taking place, but rather at what rate and how much.

Storage Enclosures Photographic prints must be housed in protective enclosures to shield them from atmospheric pollutants, including dirt and dust, and rapid fluctuations in temperature and humidity. Both plastic- and paper-based enclosures provide photographic prints with increased physical support, protecting fragile surfaces from handling-related damages such as fingerprints, abrasions, and creasing. The current ANSI standard requires that all enclosures be chemically stable and free of acids and peroxides.[5] Paper-based storage enclosures (including matboard, folder stock, and interleaving materials) should pass the Photographic Activity Test (PAT),[6] an accelerated aging test that quantitatively evaluates potentially harmful physical (abrasion) or chemical (staining and fading) between a photographic print and its enclosure. Manufacturers of paper-based storage materials should stipulate PAT results. Independent testing is also possible.

Photographic enclosures made of paper should have a high alpha-cellulose content but not contain lignin, ground wood, or alum rosin sizing. Glassine papers or Kraft paper envelopes should not be used for photographic storage. According to the American National Standards Institute,[7] papers in contact with silver gelatin prints (black-and-white images) should have a pH between 7.2 and 9.5. The alkaline reserve should be the equivalent of 2 percent calcium carbonate by weight. For color materials, the pH should not exceed 8.0; as the alkalinity increases, there is a greater potential for cyan dye fading or stain formation. At all times, physical properties such as smoothness and strength should be evaluated before a final selection is made.

For optimum handling protection, photographic prints may be matted with good-quality ragboard (that has passed the PAT). Slipsheets made of lightweight paper or polyester film may be inserted between the photograph and the window mat to guard against abrasion. When used properly, photocorners are the most reversible and safe form of attachment. In all cases, these corners must be large enough to properly support the photograph when hung vertically and situated in such a way that the print can expand slightly with changes in relative humidity. Tight corners may promote creasing or other forms of planar distortion. Corners should be fabricated from acid-free paper (plastic corners can emboss glossy surfaces) and held in place with a strip of archival-quality linen tape.

Photographic prints may also be safely housed in clear plastic enclosures. Suitable plastics include polypropylene, high-density polyethylene, and polyester. Chlorinated plastics, such as polyvinyl chloride, should never be used for the storage of photographic materials. Plastic enclosures are often not rigid enough to protect print materials from mechanical damage, including handling-related creases. A temporary auxiliary support (such as a piece of four-ply matboard) should be used wherever possible. Photographs with friable media or flaking emulsion should not be housed in plastic enclosures.

Collection size, condition, environmental parameters, projected access and use, and financial/time re-sources must be carefully considered when deciding what type and style of enclosure to use. The Paul R. Jones Collection, for example, includes many unmounted silver gelatin prints. These prints are in stable condition. Many have been and will be used by scholars and students; a large percentage will be exhibited at various venues, including but not limited to the University of Delaware. To improve handling protection, these prints may be matted with paper photocorners. Space limitations may dictate that some of these prints be housed in high-quality plastic sleeves (to facilitate viewing) and boxed for further protection. All enclosures should be of standard size; flat storage is recommended, and boxes must not be overcrowded. It may be recommended that those photographic prints that are most heavily used or in particularly fragile condition be rehoused first.

Evaluation for Conservation Treatment Photographic prints should be carefully examined and evaluated to assess the need for conservation treatment. Custodians of photographic materials should learn to identify deterioration problems that may require immediate intervention.[8] The presence of active mold growth, for example, is a critical and complex problem that must be addressed. Spore removal using special aspiration techniques combined with stringent environment controls should prevent further biodeterioration. Resultant mold staining is often permanent. Photographic print materials with active flaking binder layers, as well as those mounted with rubber cement or pressure-sensitive adhesives, should be identified for conservation treatment. These damages will worsen with time; adhesives will become intractable, and binder layers may be further damaged and lost entirely. Methods for the chemical restoration of faded photographs are currently unreliable. Further research is necessary. In some cases, however, severely faded and discolored images can be photographically or digitally copied for enhanced image resolution.

Practical, reversible, and predictable conservation treatment procedures for deteriorated photographic print materials continue to be developed and refined. In

all cases, conservation treatment should be undertaken by a trained photograph conservator and governed by informed respect for the photograph, its unique character and significance, and the photographer who created it. In the United States, conservation professionals are guided by the *Code of Ethics*[9] of the American Institute for Conservation. Similar codes guide conservation professionals internationally. Adherence to this doctrine dictates that the conservator must use materials and methods that will have the least adverse effects and that can be removed most easily and completely. In doing so, conservation treatment must not modify or conceal the true nature of the object. It must be detectable, although it need not be conspicuous, and it must be fully documented. The conservator must adhere to the highest and most exacting standards and must practice within the limits of personal competence and education.

CASE STUDY

In the fall of 1998 Yana Van Dyke, a second-year fellow in the Winterthur/University of Delaware Program in Art Conservation,[10] examined and treated a photograph of Booker T. Washington from the Paul R. Jones Collection as part of her photographic conservation graduate coursework under the author's supervision. This silver gelatin printed-out image, of central importance to the collection, was in fragile condition. It exhibited serious losses at all edges, numerous tears, creases, and other insecurities, and abundant surface dirt. The gelatin emulsion was actively flaking, and the photolytic silver image was faded and discolored (pl. 40). Following extensive photographic and written documentation, this equestrian portrait was gently surface cleaned with a water/ethanol mixture, consolidated under the microscope with a dilute gelatin solution, mended with a long-fibered paper and reversible wheat starch paste, inserted with a toned contemporary paper of similar manufacture and weight, inpainted with watercolors, humidified, and flattened. Seventy-two hours later, the image had been stabilized from further damage and visually reintegrated (pl. 41).

PRIORITY FOR PRESERVATION

Preparation of a well-balanced preservation plan requires conscientious collaboration between the conservation professional and the collector and/or custodian responsible for the collection's long-term care. Shared decision making is essential. In all cases, photographic format and process, condition, housing, access, and value must be carefully evaluated. Fortunately, the Paul R. Jones Collection of Photography is in good condition, well protected from adverse environmental conditions, catalogued for access, and housed in good-quality enclosures.

The Paul R. Jones Collection of Photography offers art conservation undergraduate and graduate students a wonderful opportunity to examine, analyze, treat, and preserve a collection of contemporary photographic materials, to work closely with a visionary collector, and to collaborate with colleagues within the university community and beyond.[11]

NOTES

1 J. Reilly, *Care and Identification of 19th Century Photographic Prints* (Rochester: Eastman Kodak Company, 1986).

2 K. Hendriks, "The Stability and Preservation of Recorded Images," in J. Storge, V. Walworth, and A. Shepp, eds., *Imaging Processes and Materials* (New York: Van Nostrand Reinhold, 1989), 637–686.

3 H. Wilhelm, *The Permanence and Care of Color Photographs: Traditional and Digital Color Prints, Color Negatives, Slides, and Motion Pictures* (Grinnell, IA: Preservation Publishing Company, 1993).

4 International Organization for Standardization (ISO), *Imaging Materials—Processed Photographic Reflection Prints—Storage Practices*, ISO 18920-2000 (Geneva, Switzerland: International Organization for Standardization, 2000).

5 D. Norris, "The Preservation of Photographic Collections in Natural History Collections," in *Storage of Natural History Collections: A Preventive Conservation Approach* (Iowa City, IA: Society for the Preservation of Natural History Collections, 1995), 355–365.

6 International Organization for Standardization (ISO), *Photography—Processed Photographic Materials—Photographic Activity Test for Enclosure Materials*, ISO 14523-1999 (Geneva, Switzerland: International Organization for Standardization, 1999).

7 International Organization for Standardization (ISO), *Imaging Materials—Processed Photographic Films, Plates, and Papers—Filing Enclosures and Storage Containers*, ISO 18902:2001 (Geneva, Switzerland: International Organization for Standardization, 2001).

8 D. Norris, *Photographs: The Winterthur Guide to Caring for Your Collection* (Winterthur, DE: The Henry Francis duPont Winterthur Museum, Inc., 2000), 79–91.

9. *Code of Ethics of the American Institute for Conservation of Historic and Artistic Works* (Washington, DC: American Institute for Conservation of Historic and Artistic Works, 1994).

10 The University of Delaware in collaboration with Winterthur Museum offers one of four master's-level programs in art conservation in the United States, one of only three programs nationally to offer a specialty in photograph conservation. Students in this program—the program accepts only ten annually—study with eighteen conservators and conservation scientists (full-time and part-time faculty) representing a broad range of conservation disciplines and educational backgrounds. The University of Delaware also offers the only formal undergraduate art conservation program in the United States.

11 In 2001–2002, the University of Delaware Art Conservation Department sponsored conservation lectures for Spelman students and the Atlanta community and worked with faculty at Spelman and Morehouse Colleges to identify required coursework in chemistry, art history, and studio art as well as Atlanta-based internship opportunities for students wishing to pursue careers in conservation. Martin Salazar, WUDPAC Class of 2002, spent one week at Spelman treating a collection of tightly rolled and damaged panoramic silver gelatin photographs from the Spelman Archives. This work, including surface cleaning, humidification, flattening, and tear repair, was conducted in the Spelman chemistry laboratories, where students were offered a rare opportunity to observe, assist, and learn about the field of art conservation. This was an exciting collaborative program that we intend to continue.

PLATE 1

Jimmie Mosely, *Humanity #2,* 1968. Watercolor, 20 x 36 in.
The Paul R. Jones Collection, University of Delaware, Newark.

PLATE 2

John T. Riddle, *Professor from Zimbabwe #1,* 1979. Acrylics on board, 36 x 28 in.
The Paul R. Jones Collection, University of Delaware, Newark.

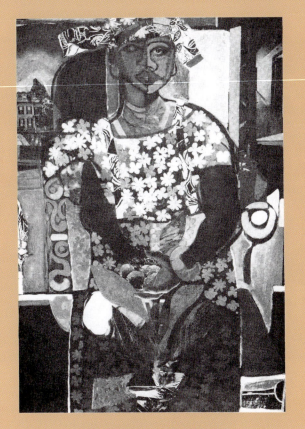

The PAUL JONES COLLECTION

KING-TISDELL COTTAGE
514 E. HUNTINGDON STREET
SAVANNAH, GEORGIA
February 3 - March 15, 1985

PLATE 3

The Paul R. Jones Collection exhibition brochure,

King-Tisdell Cottage, Savannah, Georgia, February 3–March 15, 1985.

The Paul R. Jones Archives, Atlanta, Georgia.

PLATE 4

"From The Negro Culture Collection: Paul R. Jones," exhibition sign, Savings and Loan in Charlotte, NC, 1969.
The Paul R. Jones Archives, Atlanta, Georgia.

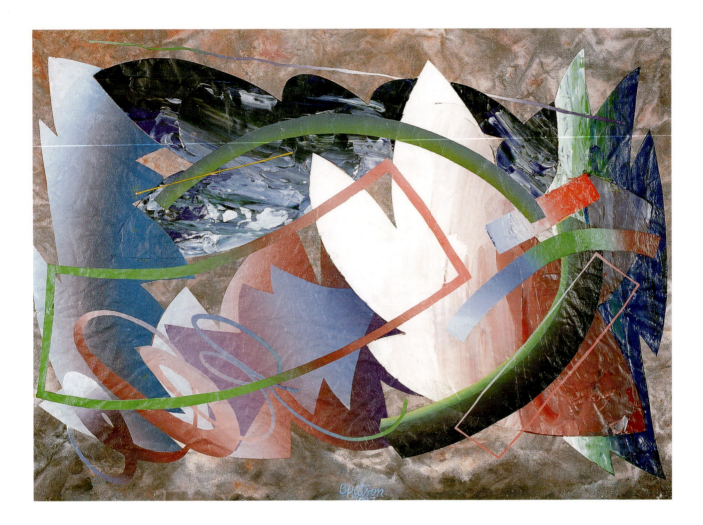

PLATE 5

Bill Hutson, *Maiden Voyage*, 1987. Acrylic on raw canvas, 22 x 29 in.
The Paul R. Jones Collection, University of Delaware, Newark.

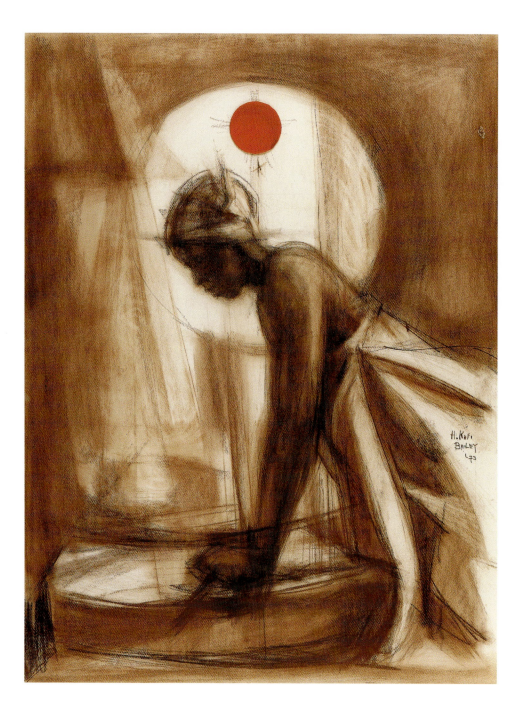

PLATE 6

Herman "Kofi" Bailey, *Woman Grinding Peppers,* 1973. Nu-pastel on paper, 40 x 30 in.
Collection of Paul R. Jones, Atlanta, Georgia.

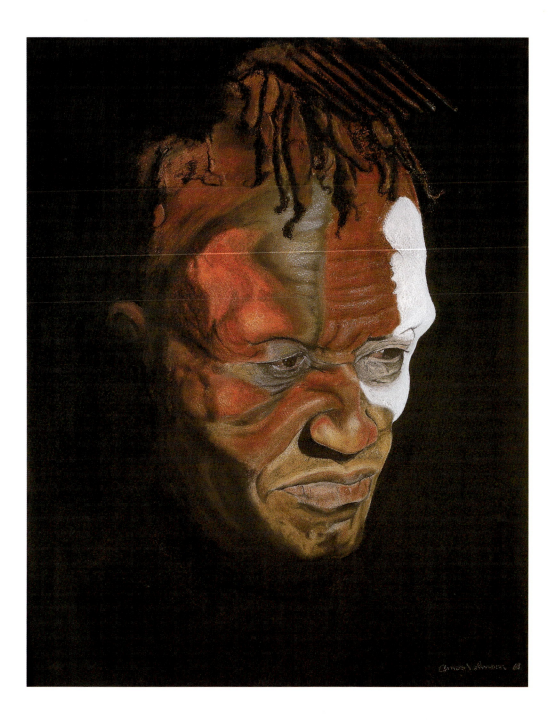

PLATE 7

Amos "Ashanti" Johnson, *Original Man*, 1968. Pastel, 35 x 29 in.
The Paul R. Jones Collection, University of Delaware, Newark.

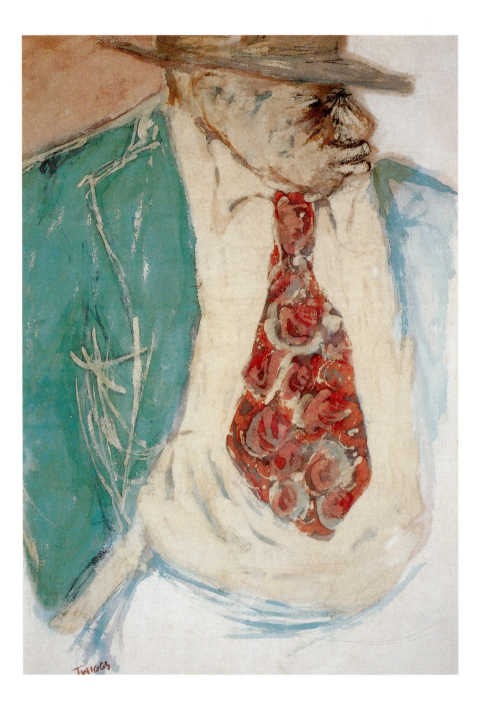

PLATE 8

Leo Twiggs, *Old Man with Wide Tie,* 1970. Batik, 38 x 28 in.

Collection of Paul R. Jones, Atlanta, Georgia.

Henry Ossawa Tanner, *Return to the Tomb,* ca. 1910. Etching, 22 x 27 in.
The Paul R. Jones Collection, University of Delaware, Newark.

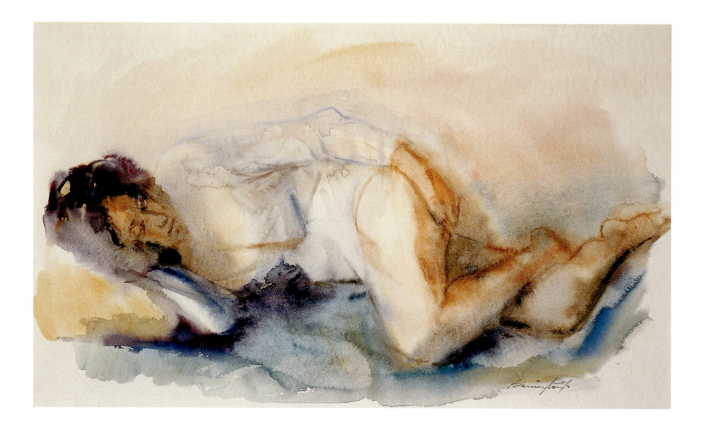

PLATE 10

Barrington Watson, *Reclining Nude,* 1972. Watercolor, 30½ x 42¼ in.

Collection of Paul R. Jones, Atlanta, Georgia.

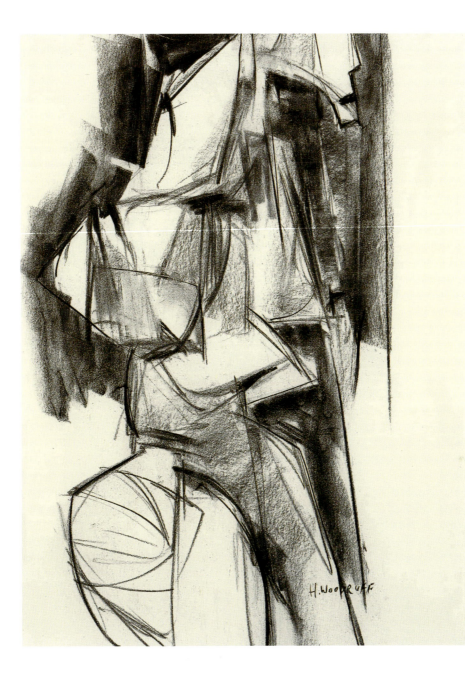

PLATE 11

Hale Woodruff, *Monkey Man #2,* 1974. Charcoal on paper, 30 x 22 in.

The Paul R. Jones Collection, University of Delaware, Newark.

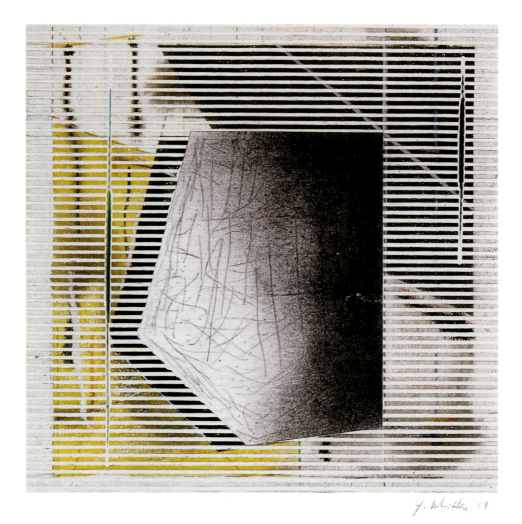

PLATE 12

Jack Whitten, *Untitled*, 1977. Pencil and acrylic on paper, 7 x 7 in.

Collection of Paul R. Jones, Atlanta, Georgia.

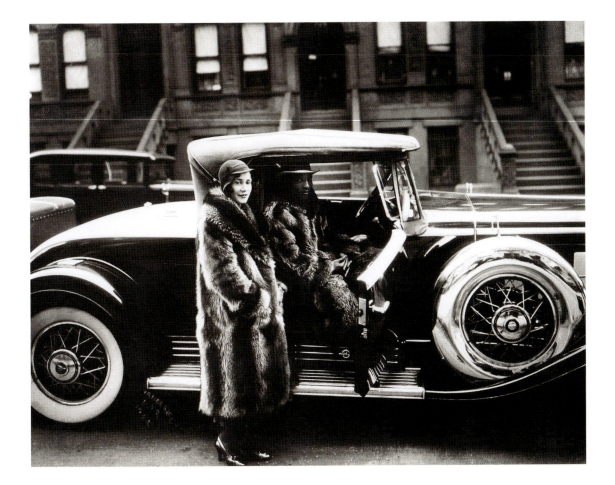

PLATE 13

James VanDerZee, *Couple in Raccoon Coats,* 1932. Gelatin silver print, 9¹/₂ x 12 in.
Courtesy of Donna Mussenden VanDerZee, New York, New York © 1998 all rights reserved.
Collection of Paul R. Jones, Atlanta, Georgia.

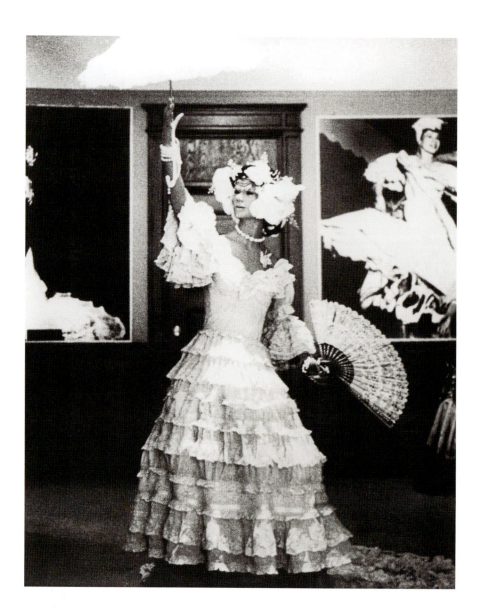

PLATE 14

Ming Smith Murray, *Katherine Dunham and Her Legacy*, 1984. Gelatin silver print, 40½ x 30¾ in.
The Paul R. Jones Collection, University of Delaware, Newark.

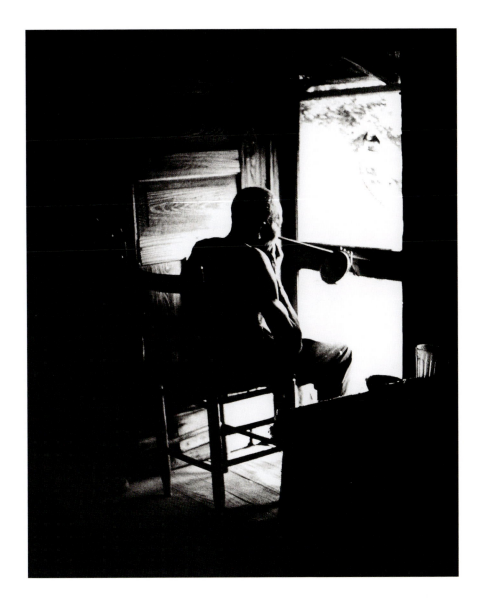

PLATE 15

William Anderson, *Man Shaving*, 1988. Gelatin silver print, 24 x 20 in.
The Paul R. Jones Collection, University of Delaware, Newark.

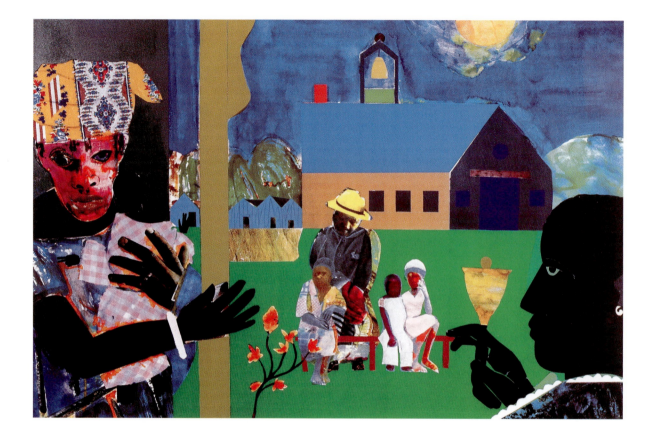

PLATE 16

Romare Bearden, *School Bell Time,* ca. 1980. Lithograph, 40 x 60 in.
© Romare Bearden Foundation / Licensed by VAGA, New York, NY.
The Paul R. Jones Collection, University of Delaware, Newark.

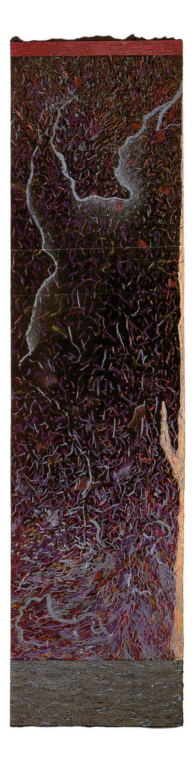

PLATE 17

Nanette Carter, *Light over Soweto #5*, 1989. Oil pastel, 60 x 17 in.
The Paul R. Jones Collection, University of Delaware, Newark.

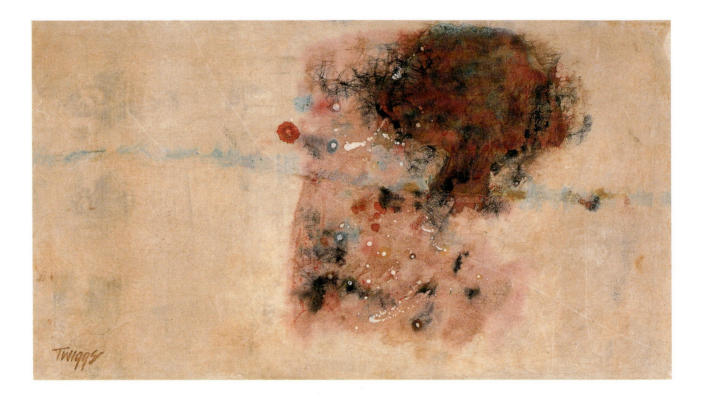

PLATE 18

Leo Twiggs, *Low Country Landscape*, 1974. Batik, 18 x 30 in.
The Paul R. Jones Collection, University of Delaware, Newark.

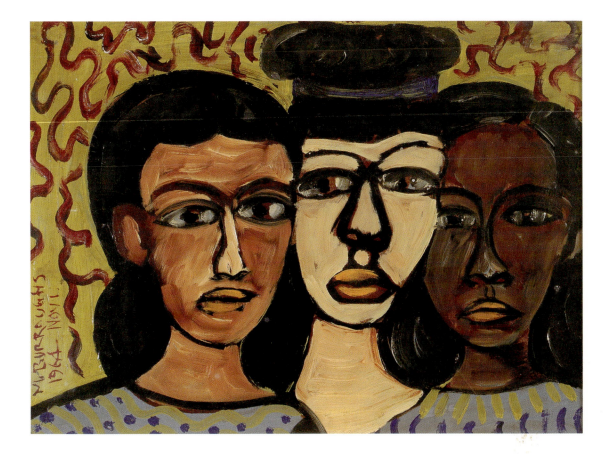

PLATE 19

Margaret T. Burroughs, *Three Souls,* 1968. Oil on canvas, 18 x 21^{1}/8 in.

The Paul R. Jones Collection, University of Delaware, Newark.

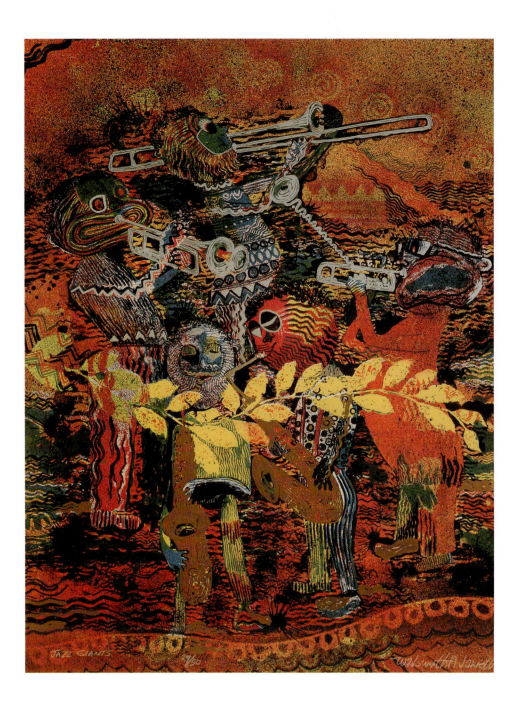

PLATE 20

Wadsworth Jarrell, *Jazz Giants,* 1987. Lithograph, 29¹/₂ x 22¹/₄ in.

Collection of Paul R. Jones, Atlanta, Georgia.

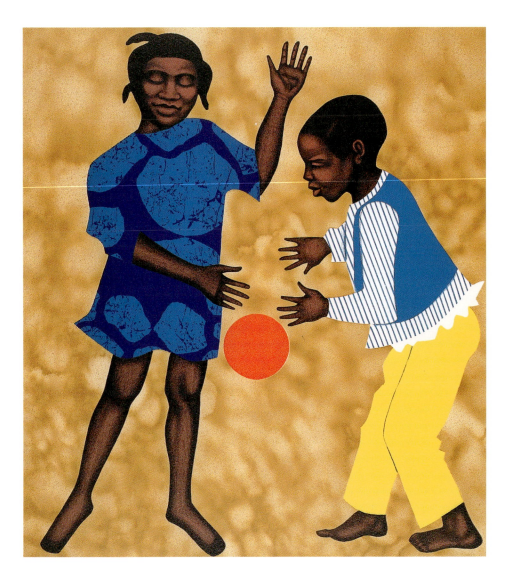

PLATE 22

Howardena Pindell, *Untitled #35*, 1974. Mixed media, 14 x 16 in.
The Paul R. Jones Collection, University of Delaware, Newark.

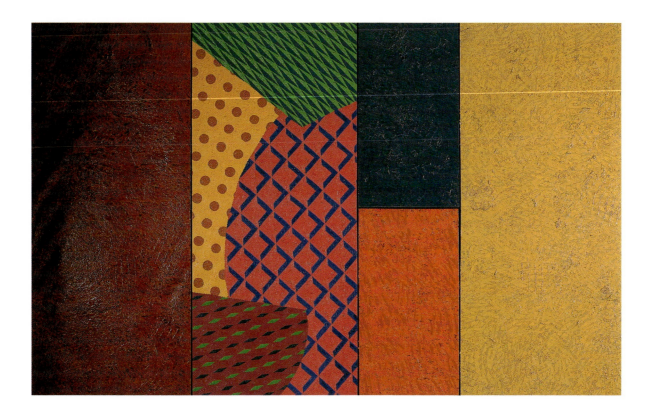

PLATE 23

James Little, *Countdown,* 1981. Glazed oil washes on canvas, 58 x 91 in.
The Paul R. Jones Collection, University of Delaware, Newark.

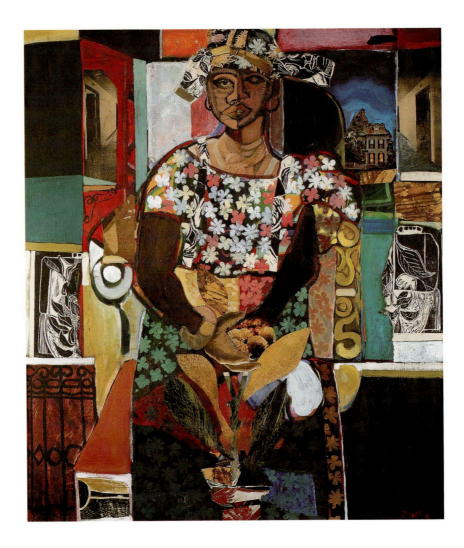

PLATE 24

David C. Driskell, *Woman in Interiors,* 1973. Mixed media painting, 47 × 40 in.
The Paul R. Jones Collection, University of Delaware, Newark.

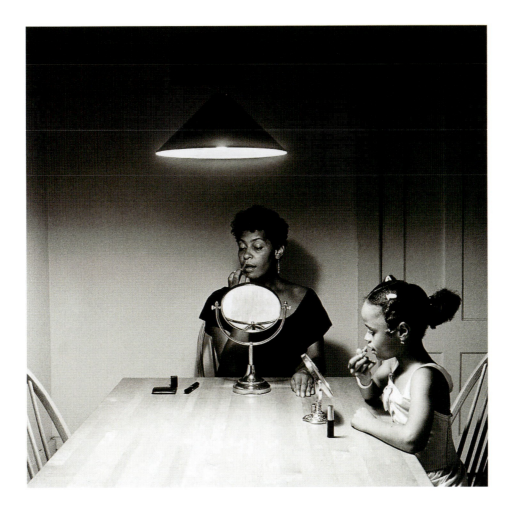

PLATE 25

Carrie Mae Weems, *Kitchen Table Series*, 1990. Gelatin silver print, 9 x 10 in.
The Paul R. Jones Collection, University of Delaware, Newark.

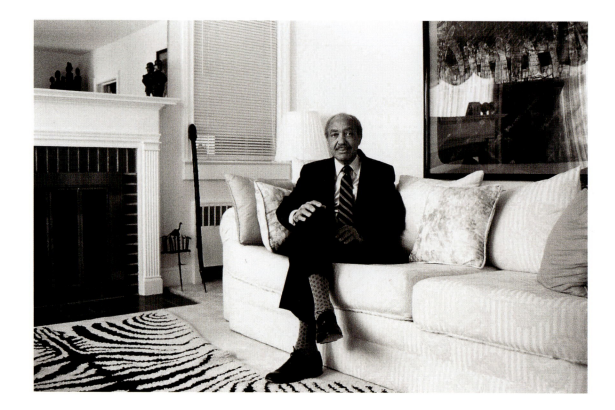

PLATE 26

Clarissa Sligh, *Portrait of Paul R. Jones,* 1996. Gelatin silver print, 8 x 10 in.
The Paul R. Jones Collection, University of Delaware, Newark.

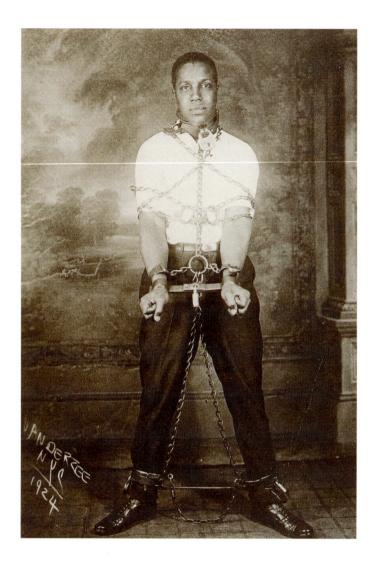

PLATE 27

James VanDerZee, *The Black Houdini*, 1924. Gelatin silver print (toned), 10 x 8 in.

The Paul R. Jones Collection, University of Delaware, Newark.

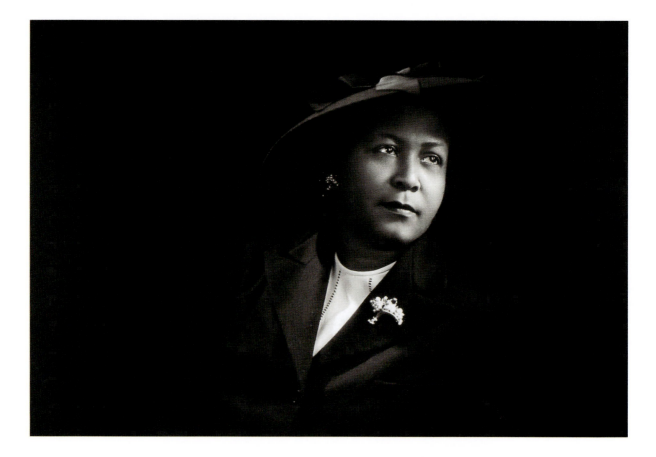

PLATE 28

Prentice H. Polk, *Margaret Blanche Polk,* 1946. Gelatin silver print, 8 x 10 in.

The Paul R. Jones Collection, University of Delaware, Newark.

Gift of Donald L. Polk (P. H. Polk Estate).

PLATE 29

Prentice H. Polk, *Alberta Osborn*, ca. 1929. Gelatin silver print, 10 x 8 in.
The Paul R. Jones Collection, University of Delaware, Newark.
Gift of Donald L. Polk (P. H. Polk Estate).

PLATE 30

Prentice H. Polk, *George Washington Carver*, ca. 1930. Gelatin silver print, 10 x 8 in.

The Paul R. Jones Collection, University of Delaware, Newark.

Gift of Donald L. Polk (P. H. Polk Estate).

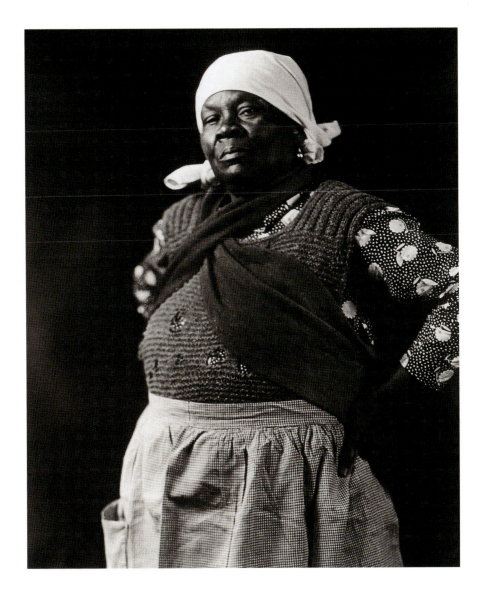

PLATE 31

Prentice H. Polk, *The Boss,* 1932. Gelatin silver print, 10 x 8 in.
The Paul R. Jones Collection, University of Delaware, Newark.
Gift of Donald L. Polk (P. H. Polk Estate).

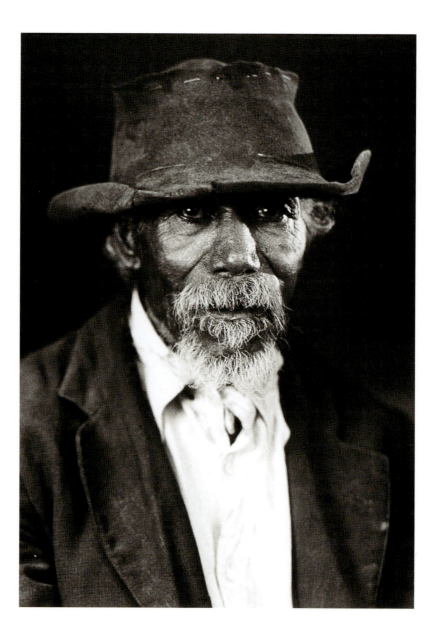

PLATE 32

Prentice H. Polk, *George Moore*, 1930. Gelatin silver print, 14 x 11 in.
The Paul R. Jones Collection, University of Delaware, Newark.
Gift of Donald L. Polk (P. H. Polk Estate).

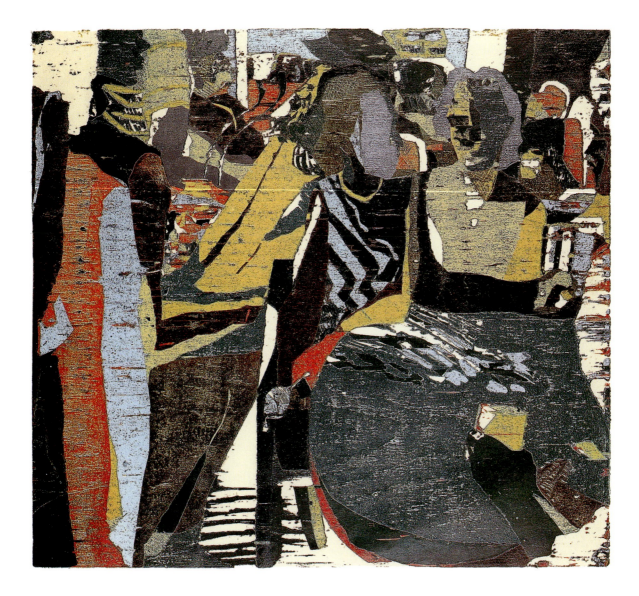

PLATE 33

Michael Ellison, *The Bar*, 1984. Subtractive block print, 23 x 35 in.

The Paul R. Jones Collection, University of Delaware, Newark.

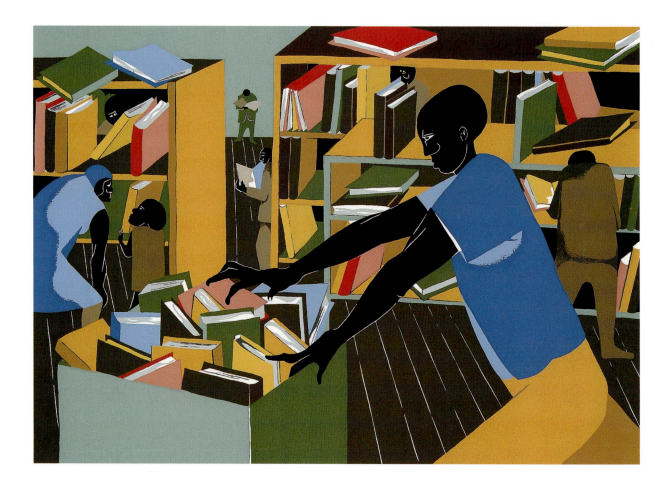

PLATE 34

Jacob Lawrence, *The Library*, 1978. Lithograph, 24 x 28 in.

© Gwendolyn Knight Lawrence, courtesy of the Jacob and Gwendolyn Lawrence Foundation.

The Paul R. Jones Collection, University of Delaware, Newark.

PLATE 35

Elizabeth Catlett, *Singing/Praying*, 1992. Serigraph, 23³/₄ x 18⁵/₈ in.

© Elizabeth Catlett / Licensed by VAGA, New York, NY.

The Paul R. Jones Collection, University of Delaware, Newark.

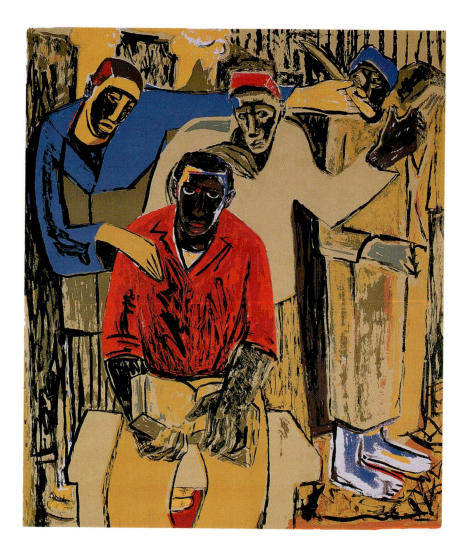

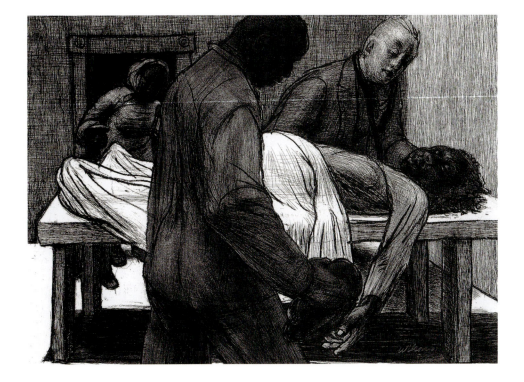

PLATE 37

John Wilson, *Richard Wright Series: Death of Lulu,* 2001. Etching, 11³/₄ x 16 in.

© John Wilson / Licensed by VAGA, New York, NY.

The Paul R. Jones Collection, University of Delaware, Newark.

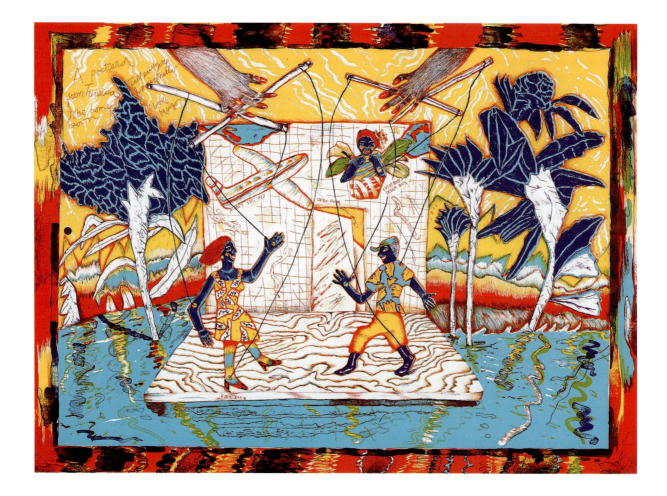

PLATE 38

Margo Humphrey, *Pulling Your Own Strings*, 1981. Lithograph, 22 x 30 in.
The Paul R. Jones Collection, University of Delaware, Newark.

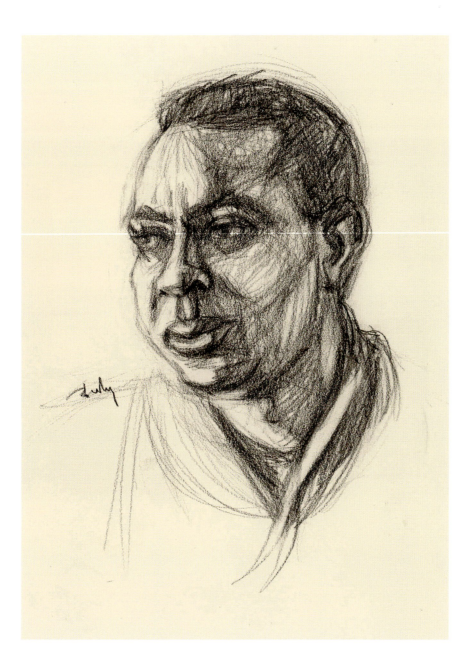

PLATE 39

Herman "Kofi" Bailey, *Portrait of Paul R. Jones,* 1973. Graphite on paper, 20 x 16 in.
Collection of Paul R. Jones, Atlanta, Georgia.

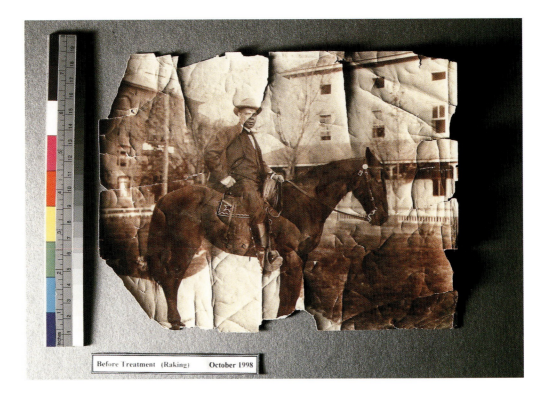

Before Treatment (Raking) October 1998

PLATE 40

Arthur P. Bedou, *Booker T. Washington,* ca. 1915, damaged silver gelatin photograph of Washington before conservation treatment at the Art Conservation Department at the University of Delaware.

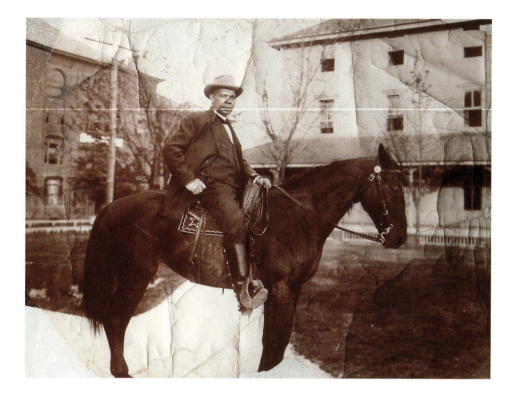

PLATE 41

Arthur P. Bedou, *Booker T. Washington,* ca. 1915, silver gelatin photograph of Washington after conservation
treatment at the Art Conservation Department, University of Delaware. Treatment procedures included consolidation
of the flaking gelatin binder layer, surface cleaning to remove embedded dirt and grime, and tear mending with
lightweight Japanese tissue and wheat starch paste. Losses in the photograph's paper support were inserted with a toned
contemporary paper and damages in the gelatin binder were inpainted with watercolors. The photograph was
humidified and flattened and housed in a protective ragboard mat for safe handling.

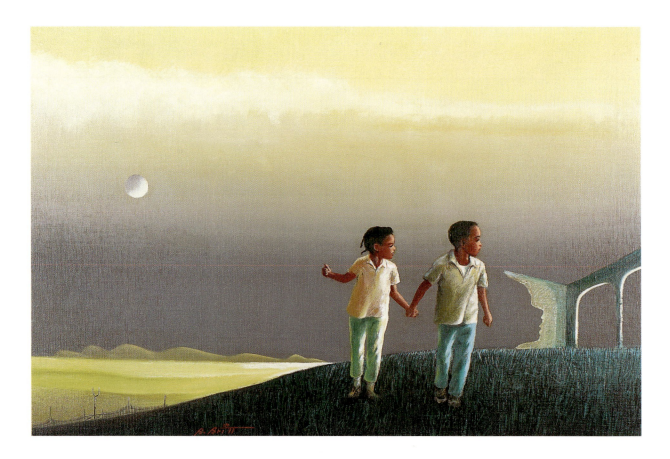

PLATE 42

Benjamin Britt, *We Two*, 1968. Oil on canvas, 24 x 34 in.

The Paul R. Jones Collection, University of Delaware, Newark.

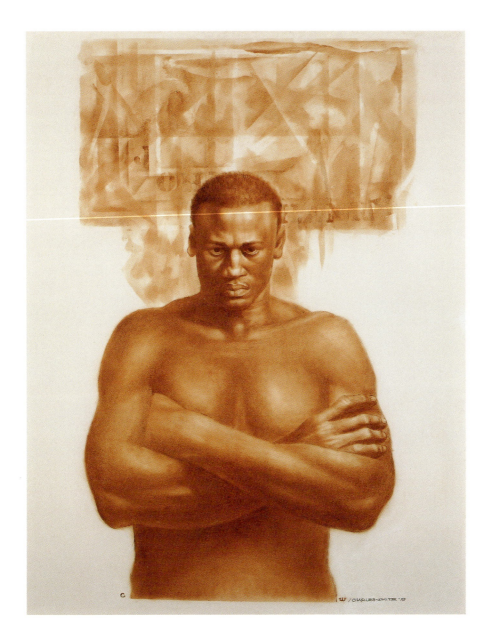

PLATE 43

Charles White, *John Henry,* 1975. Oil wash, 36 x 31 in.

© 1975 The Charles White Archives.

The Paul R. Jones Collection, University of Delaware, Newark.

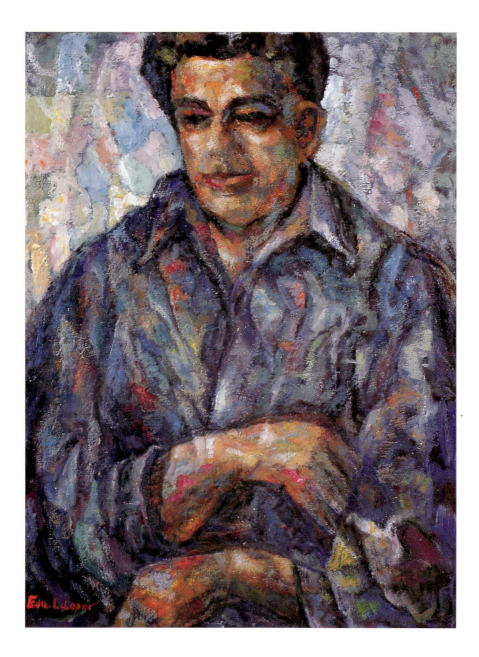

PLATE 44

Edward Loper, Sr., *Portrait of Benoit Cote,* 2000. Oil on canvas, 28 x 20 in.

The Paul R. Jones Collection, University of Delaware, Newark.

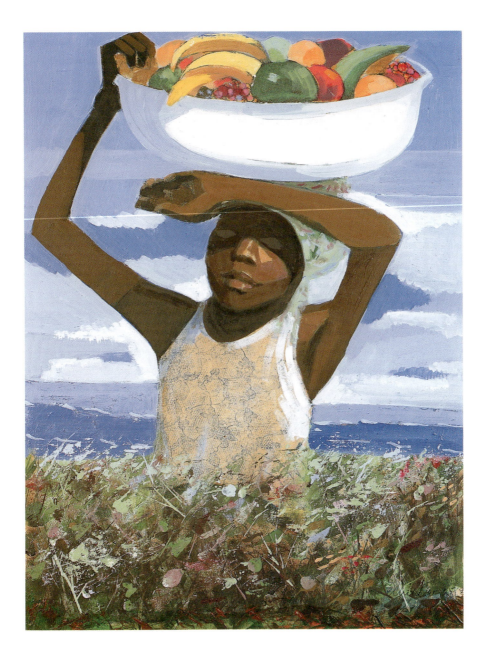

PLATE 45

Ernest Chrichlow, *Untitled,* 1985. Acrylic on board, 28 x 22 in.
The Paul R. Jones Collection, University of Delaware, Newark.

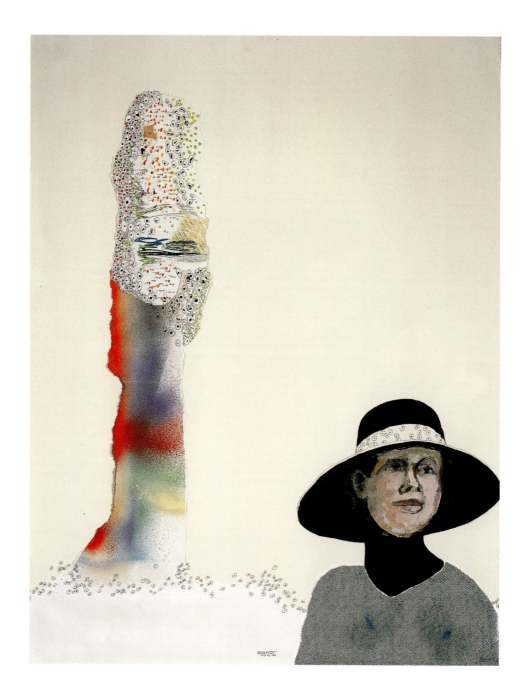

PLATE 46

Benny Andrews, *Dianne*, 1984. Mixed media, 34 x 27 in.

The Paul R. Jones Collection, University of Delaware, Newark.

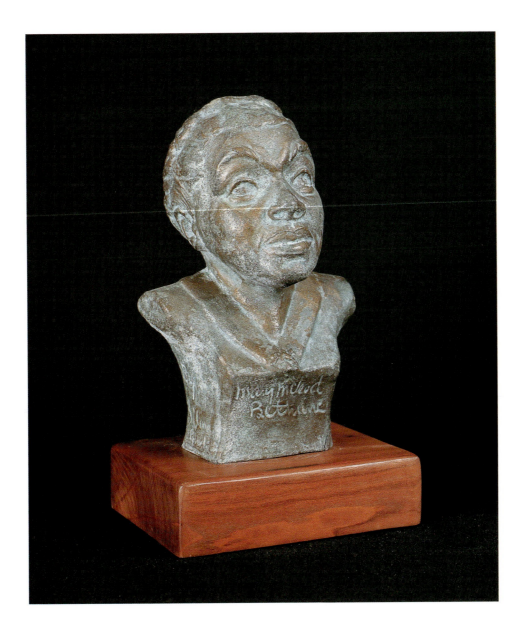

PLATE 47

Selma Burke, *Mary McLeod Bethune,* 1980. Brass, 10 x 4 x 5 in.
The Paul R. Jones Collection, University of Delaware, Newark.

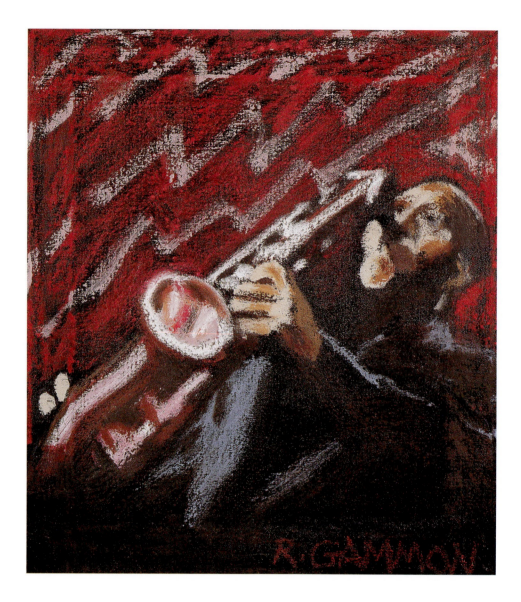

PLATE 48

Reginald Gammon, *Sonny Rollins,* 2002. Oil on canvas, 14 x 14 in.
The Paul R. Jones Collection, University of Delaware, Newark.

PLATE 49

Herman "Kofi" Bailey, *African Woman,* 1974. Graphite on paper, 24 x 18 in.
The Paul R. Jones Collection, University of Delaware, Newark.

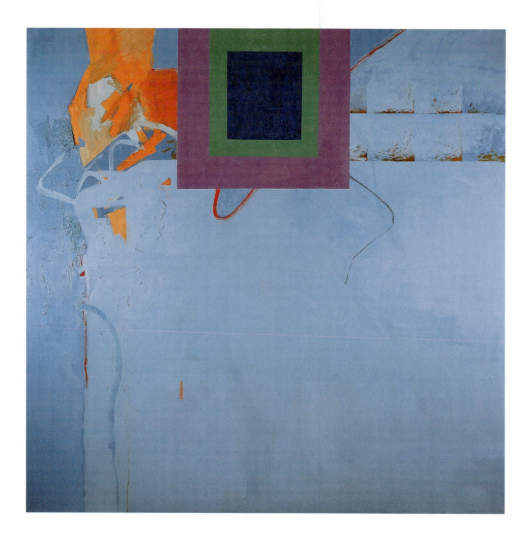

PLATE 50

Alvin Smith, *Untitled*, 1985. Acrylic on canvas, 62 x 62 in.
The Paul R. Jones Collection, University of Delaware, Newark.

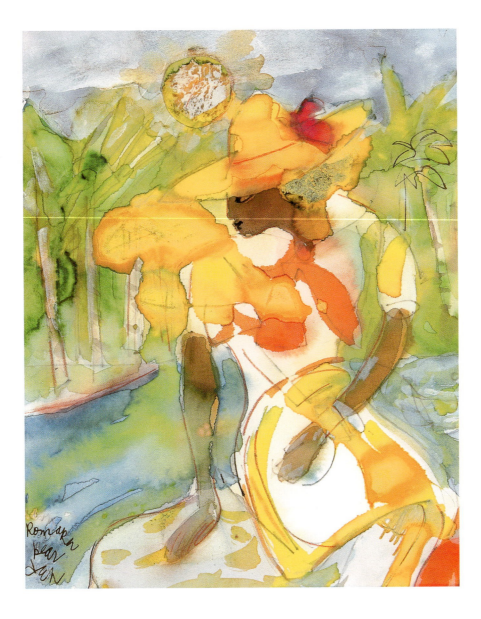

PLATE 51

Romare Bearden, *Island Scene*, 1984. Watercolor, 24 x 20 in.

© Romare Bearden Foundation / Licensed by VAGA, New York, NY.

The Paul R. Jones Collection, University of Delaware, Newark.

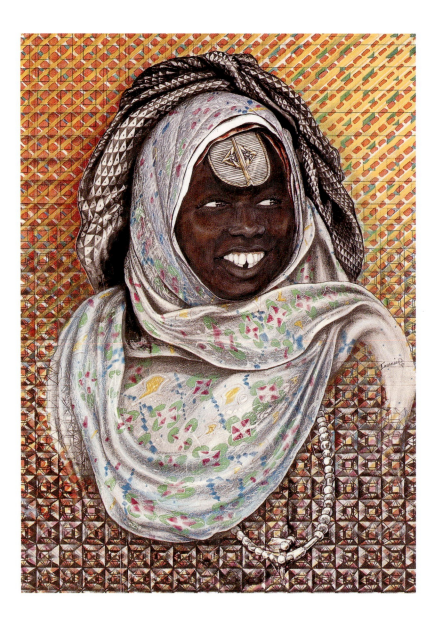

PLATE 52

Imaniah Shinar (James E. Coleman, Jr.), *Ebony Queen,* 2002. Mixed media on board, 25^1/$_4$ x 17^1/$_2$ in.
The Paul R. Jones Collection, University of Delaware, Newark.

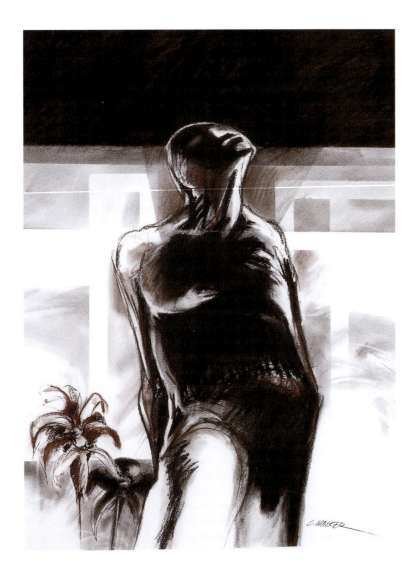

PLATE 53

Larry Walker, *Prelude*, 2000. Acrylic on paper, 38 x 26 in.

The Paul R. Jones Collection, University of Delaware, Newark.

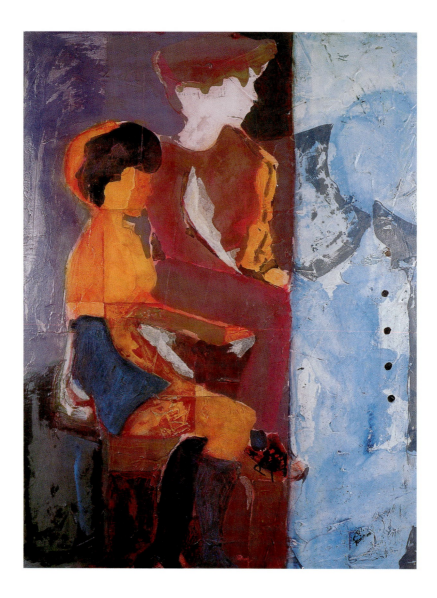

PLATE 54

John Feagin, *Reflections II,* 1973. Oil on board, 48 x 35¹/₂ in.
The Paul R. Jones Collection, University of Delaware, Newark.

PLATE 55

Frank Bowling, *Untitled*, 1980. Mixed media on canvas, 72 x 18 in.
The Paul R. Jones Collection, University of Delaware, Newark.

PLATE 56

Frank Bowling, *Untitled,* 1980. Mixed media on canvas, 72 x 18 in.
The Paul R. Jones Collection, University of Delaware, Newark.

PLATE 57

Harper T. Phillips, *Untitled,* 1974. Tissue collage, 26 x 30 in.
The Paul R. Jones Collection, University of Delaware, Newark.

PLATE 58

Jewel Simon, *Lick*, 1944. Oil on canvas, 40 x 20 in.

The Paul R. Jones Collection, University of Delaware, Newark.

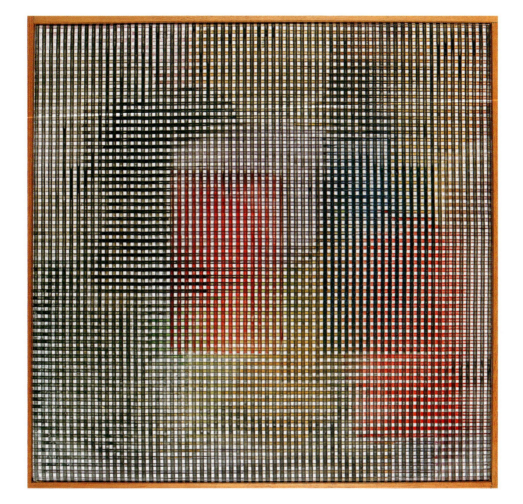

PLATE 59

Jack Whitten, *Annunciation XVIII*, 1989. Acrylic on canvas, 17 x 17 in.
The Paul R. Jones Collection, University of Delaware, Newark.

PLATE 60

Carl Christian, *Evening in Summer,* 1999. Mixed media on board, 40 x 32 in.
The Paul R. Jones Collection, University of Delaware, Newark.

PLATE 61

Aimee Miller, *Untitled*, 2001. Mixed media on board, 49 x 48 in.
The Paul R. Jones Collection, University of Delaware, Newark.

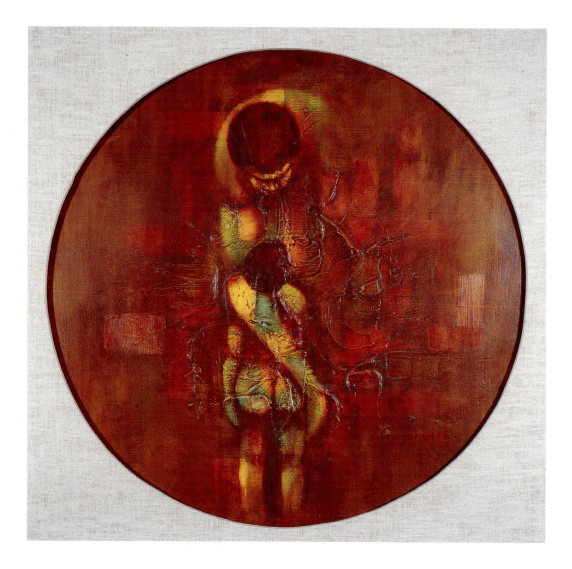

PLATE 62

Ayokunle Odeleye, *Caring*, 1972. Mixed media on board, 47 x 45 in.
The Paul R. Jones Collection, University of Delaware, Newark.

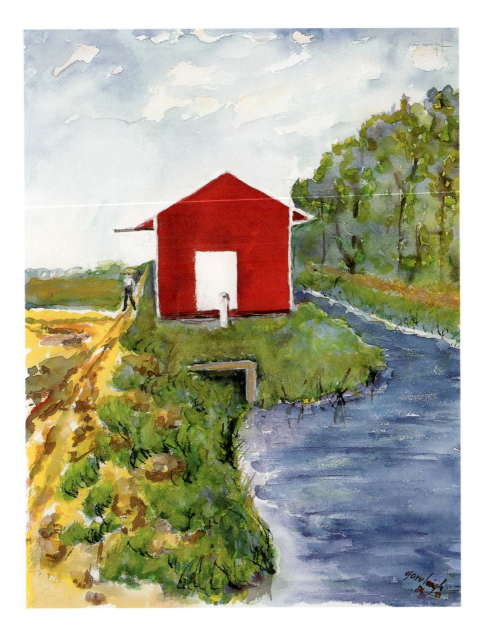

PLATE 63

Rex Gorleigh, *Red Barn*, 1981. Watercolor, 28 x 22 in.

The Paul R. Jones Collection, University of Delaware, Newark.

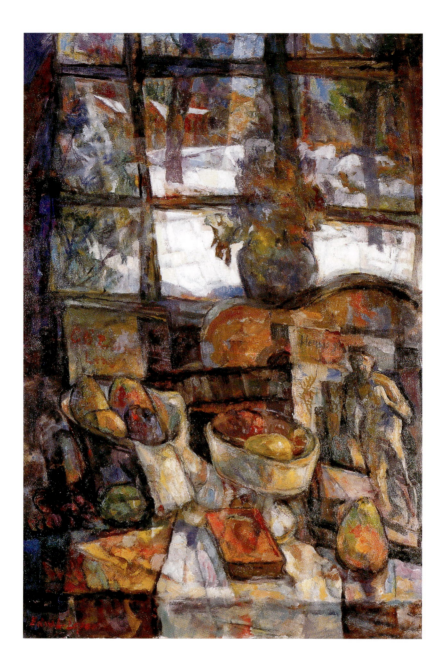

PLATE 64

Edward Loper, Sr., *Winter Still Life,* 2003. Oil on canvas, 48 x 35 in.
The Paul R. Jones Collection, University of Delaware, Newark.

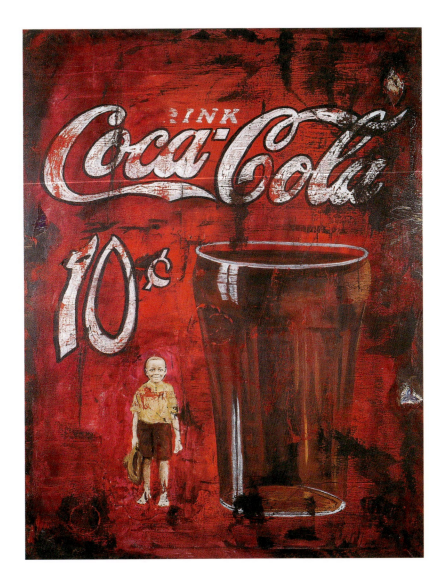

PLATE 65

Cedric Smith, *Coca-Cola,* 2002. Mixed media on canvas, 38 x 26 in.

The Paul R. Jones Collection, University of Delaware, Newark.

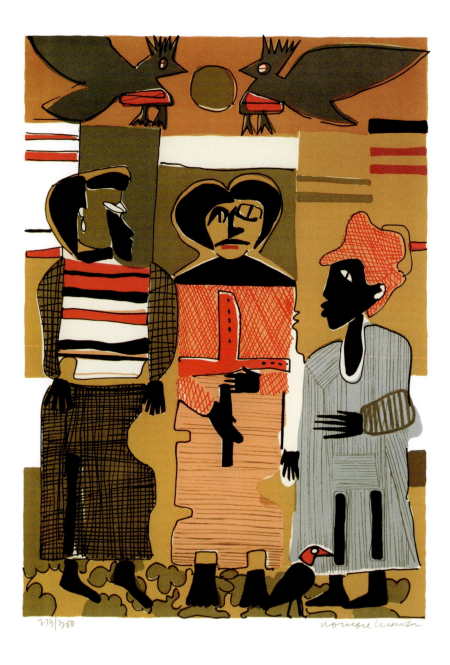

PLATE 66

Romare Bearden, *Firebirds,* 1979. Lithograph, 28 x 24 in.

© Romare Bearden Foundation / Licensed by VAGA, New York, NY.

The Paul R. Jones Collection, University of Delaware, Newark.

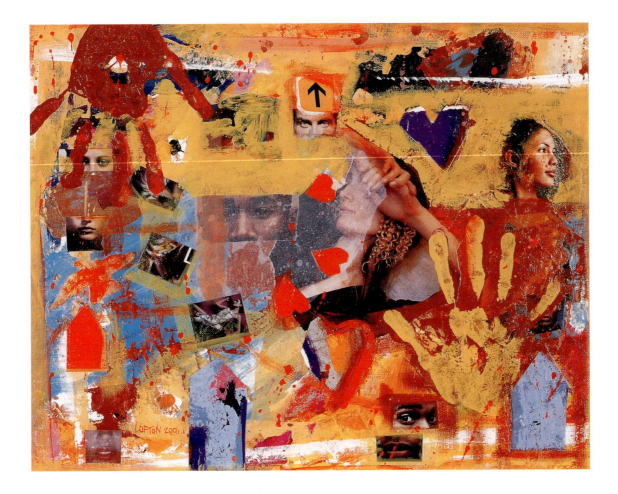

PLATE 67

Lionel Lofton, *Jungle Fever*, 2001. Mixed media on board, 18^{1}/$_{4}$ x 22^{1}/$_{4}$ in.

The Paul R. Jones Collection, University of Delaware, Newark.

PLATE 68

Camille Billops, *Fire Fighter*, 1990. Lithograph, 16 x 20 in.

The Paul R. Jones Collection, University of Delaware, Newark.

PLATE 69

Earl J. Hooks, *Man of Sorrows,* 1950. Marble, 12^1/$_2$ x 7 x 4 in.
The Paul R. Jones Collection, University of Delaware, Newark.

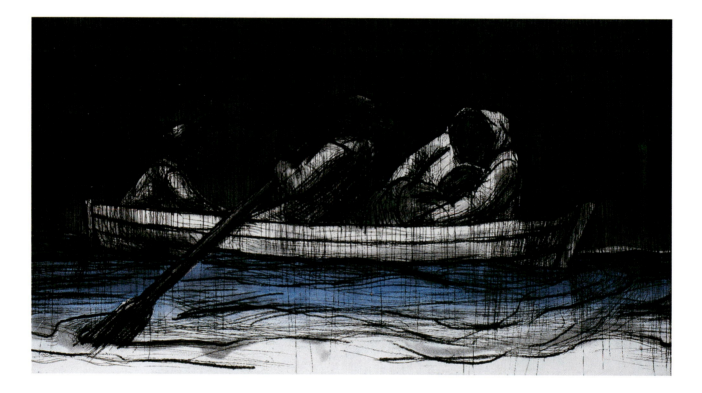

PLATE 70

John Wilson, *Richard Wright Series: Journey of the Mann Family,* 2001. Etching, 11³/₄ x 16 in.
© John Wilson / Licensed by VAGA, New York, NY.
The Paul R. Jones Collection, University of Delaware, Newark.

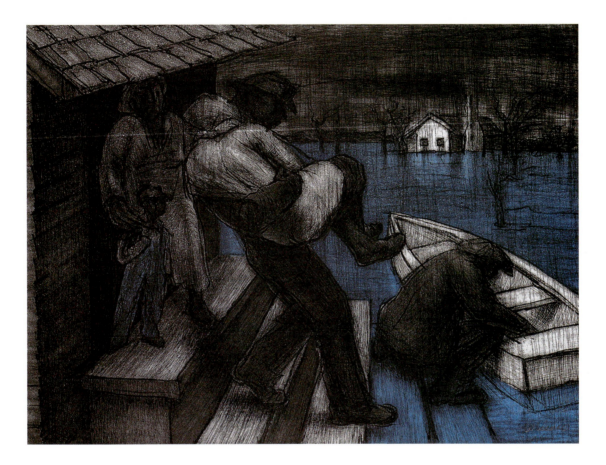

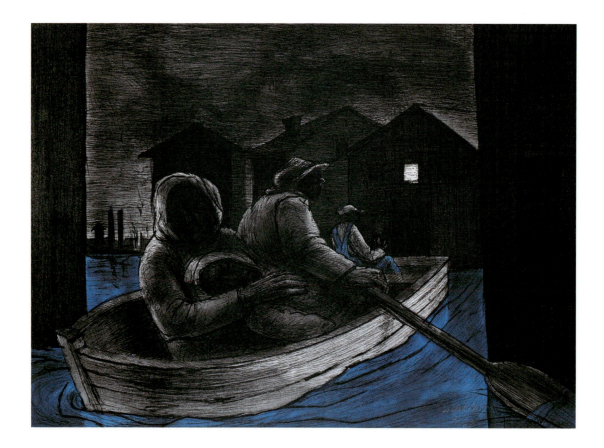

PLATE 72

John Wilson, *Richard Wright Series: Light in the Window*, 2001. Etching, 11³/₄ x 16 in.

© John Wilson / Licensed by VAGA, New York, NY.

The Paul R. Jones Collection, University of Delaware, Newark.

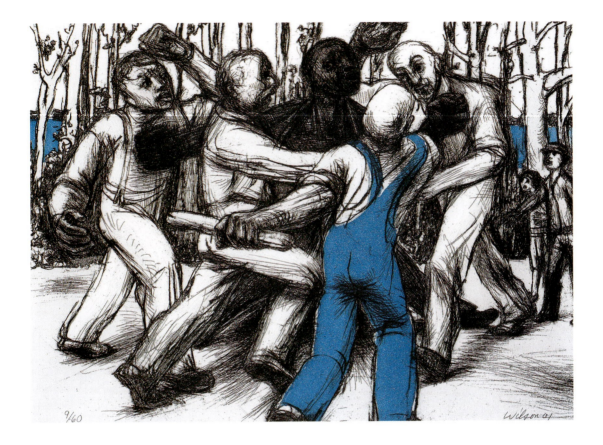

PLATE 73

John Wilson, *Richard Wright Series: Mann Attacked*, 2001. Etching, 11³/₄ × 16 in.

© John Wilson / Licensed by VAGA, New York, NY.

The Paul R. Jones Collection, University of Delaware, Newark.

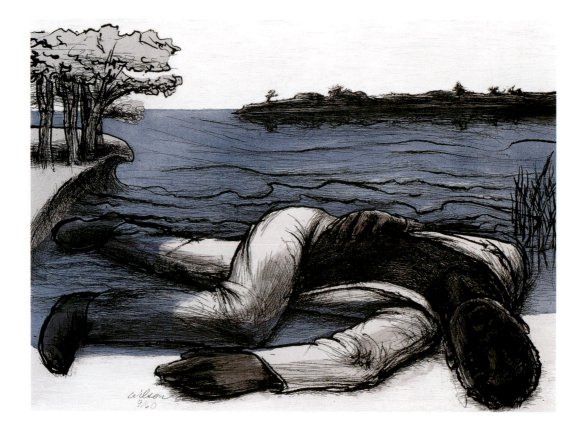

PLATE 74

John Wilson, *Richard Wright Series: The Death of Mann*, 2001. Etching, 11³/₄ x 16 in.

© John Wilson / Licensed by VAGA, New York, NY.

The Paul R. Jones Collection, University of Delaware, Newark.

PLATE 75

Charles White, *Vision,* 1973. Sterling etching, diameter 8 inches.

© 1973 The Charles White Archives.

The Paul R. Jones Collection, University of Delaware, Newark.

PLATE 76

Samuel Guilford, *9 Lives,* 1999. Watercolor, 29¼ x 34¼ in.

The Paul R. Jones Collection, University of Delaware, Newark.

PLATE 77

Hayward L. Oubre, *Miscegenation,* 1963. Wire sculpture, 25 x 20 x 13 in.
The Paul R. Jones Collection, University of Delaware, Newark.

PLATE 78

Ming Smith Murray, *Gregory Hines*, 1985. Color photograph, 20 x 16 in.
The Paul R. Jones Collection, University of Delaware, Newark.

PLATE 79

Ming Smith Murray, *Arthur Blythe in Space*, 1989. Gelatin silver print, 8 x 10 in.
The Paul R. Jones Collection, University of Delaware, Newark.

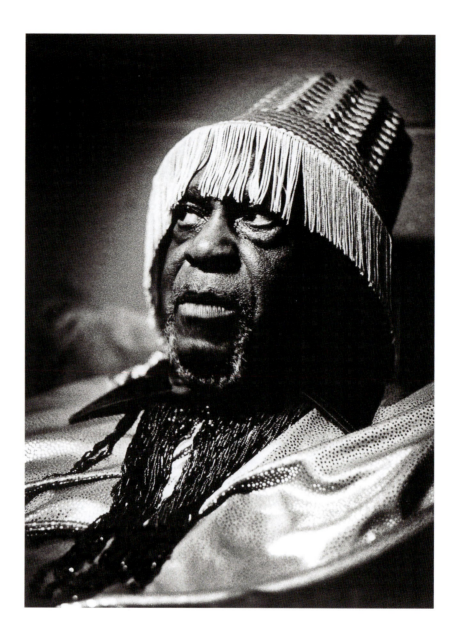

PLATE 80

William Wallace, *Sun Ra,* 1988. Gelatin silver print, 14 x 11 in.
The Paul R. Jones Collection, University of Delaware, Newark.

PLATE 81

William Wallace, *Miles Davis and Axel McQuerry,* 1989. Gelatin silver print, 14 x 11 in.
The Paul R. Jones Collection, University of Delaware, Newark.

PLATE 82

Jim Alexander, *Ellington Orchestra,* 1972. Gelatin silver print, 9 x 11⁷/8 in.

The Paul R. Jones Collection, University of Delaware, Newark.

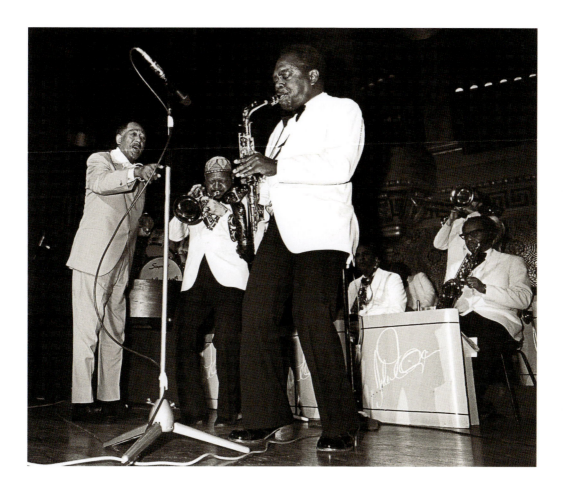

PLATE 83

Jim Alexander, *Jamming*, 1972. Gelatin silver print, 9 x 11⅞ in.
The Paul R. Jones Collection, University of Delaware, Newark.

PLATE 84

Bert Andrews, *Gloria Foster and Morgan Freeman*, 1979. Gelatin silver print, 16 x 20 in.
The Paul R. Jones Collection, University of Delaware, Newark.

PLATE 85

Bert Andrews, *Alfre Woodard and Others*, 1978. Gelatin silver print, 16 x 20 in.
The Paul R. Jones Collection, University of Delaware, Newark.

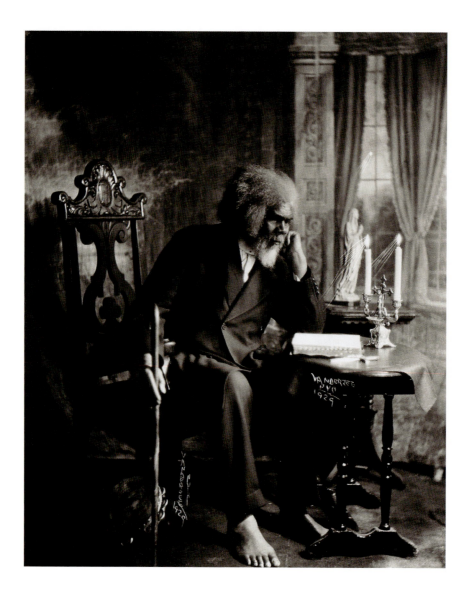

PLATE 86

James VanDerZee, *The Barefoot Prophet*, 1928. Gelatin silver print, 20 x 16 in.

The Paul R. Jones Collection, University of Delaware, Newark.

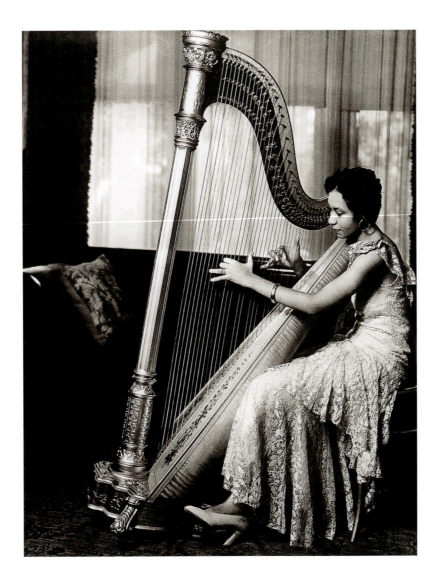

PLATE 87

Prentice H. Polk, *Catherine Moton Patterson*, 1936. Gelatin silver print, 10 x 8 in.

The Paul R. Jones Collection, University of Delaware, Newark.

Gift of Donald L. Polk (P. H. Polk Estate).

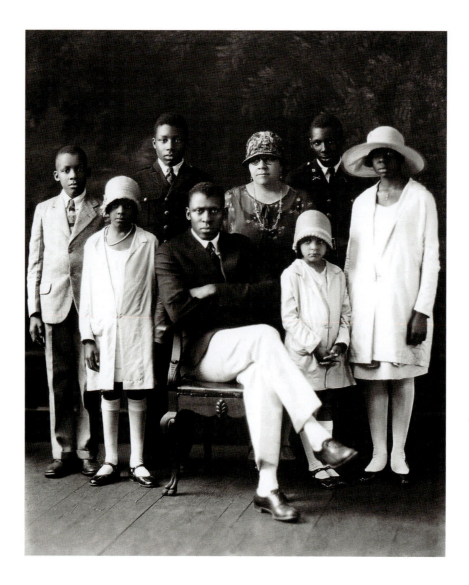

PLATE 88

Prentice H. Polk, *Mr. and Mrs. T. M. Campbell and Children,* ca. 1932. Gelatin silver print, 10 x 9 in.

The Paul R. Jones Collection, University of Delaware, Newark.

Gift of Donald L. Polk (P. H. Polk Estate).

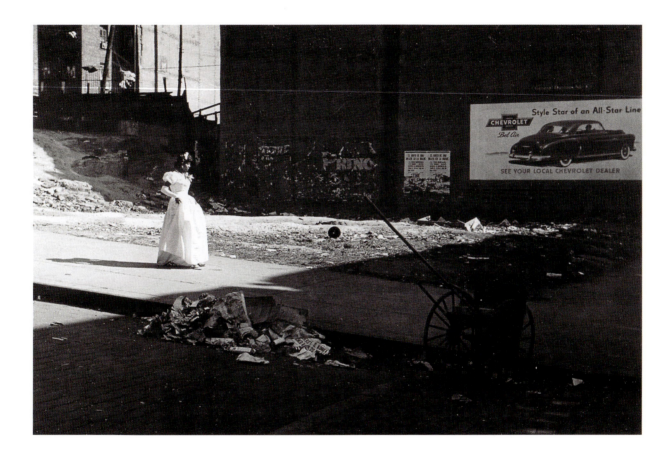

PLATE 89

Roy DeCarava, *Graduation Day*, 1949. Gelatin silver print, 16 x 20 in.

The Paul R. Jones Collection, University of Delaware, Newark.

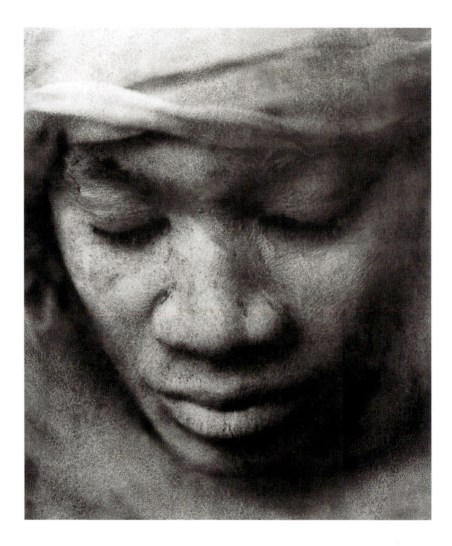

PLATE 90

Doughba Hamilton Caranda-Martin, *Untitled,* 2003. Gelatin silver print, 34³/₄ x 29⁷/₈ in.

The Paul R. Jones Collection, University of Delaware, Newark.

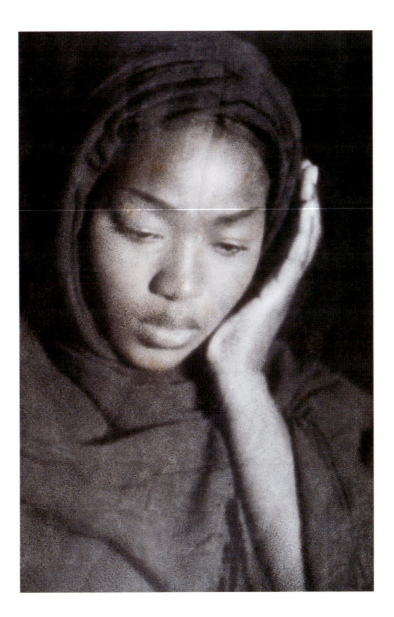

PLATE 91

Doughba Hamilton Caranda-Martin, *Untitled,* 2003. Gelatin silver print, 28 x 20 in.
The Paul R. Jones Collection, University of Delaware, Newark.

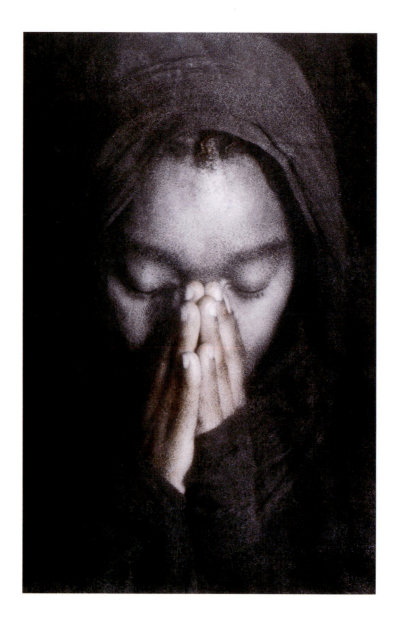

PLATE 92

Doughba Hamilton Caranda-Martin, *Untitled,* 2003. Gelatin silver print, 28 x 20 in.
The Paul R. Jones Collection, University of Delaware, Newark.

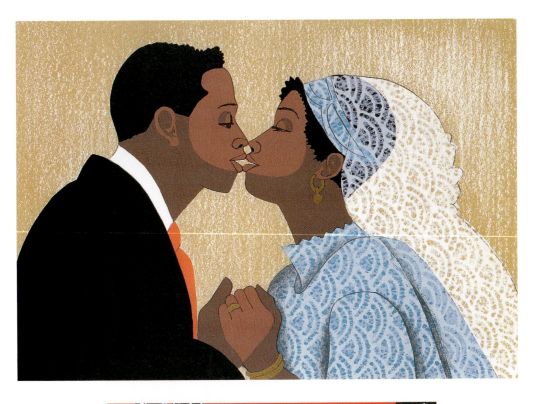

PLATE 93

Elizabeth Catlett, *Couple Kissing*, 1992. Serigraph, 23³/₄ x 18⁵/₈ in.

© Elizabeth Catlett / Licensed by VAGA, New York, NY.

The Paul R. Jones Collection, University of Delaware, Newark.

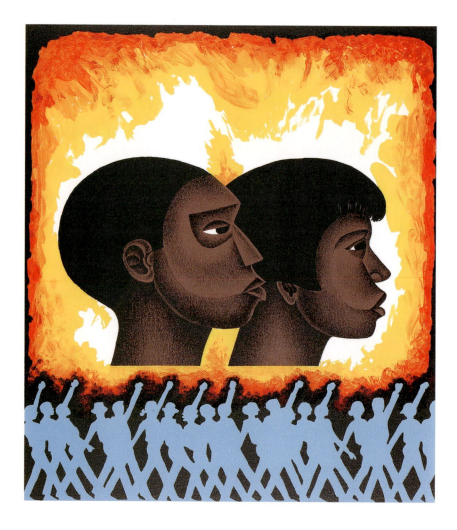

PLATE 94

Elizabeth Catlett, *Boy/Girl Profile,* 1992. Serigraph, 23³/₄ x 18⁵/₈ in.

© Elizabeth Catlett / Licensed by VAGA, New York, NY.

The Paul R. Jones Collection, University of Delaware, Newark.

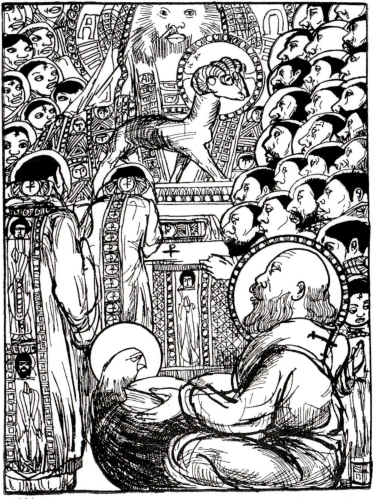

58/60 D Alan Robert Crite

PLATE 95

Allan R. Crite, *The Revelation of St. John the Divine: Procession to Ram Altar,* 1994. Engraving, 20 x 17 in.
The Paul R. Jones Collection, University of Delaware, Newark.

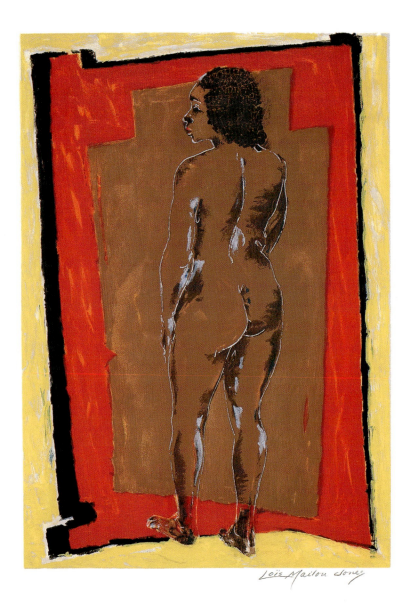

PLATE 96

Loïs Mailou Jones, *Nude,* 1996. Lithograph, 21³/₄ x 17¹/₂ in.
The Paul R. Jones Collection, University of Delaware, Newark.

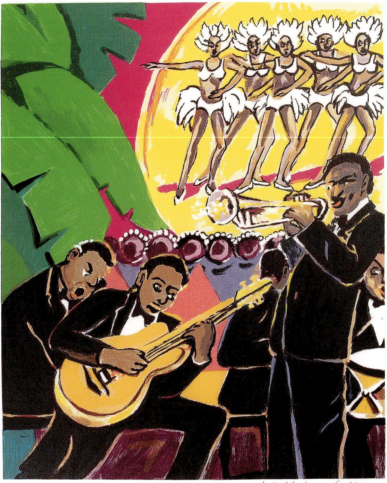

PLATE 97

Loïs Mailou Jones, *Jazz Combo*, 1996. Lithograph, 21³/₄ x 17¹/₂ in.
The Paul R. Jones Collection, University of Delaware, Newark.

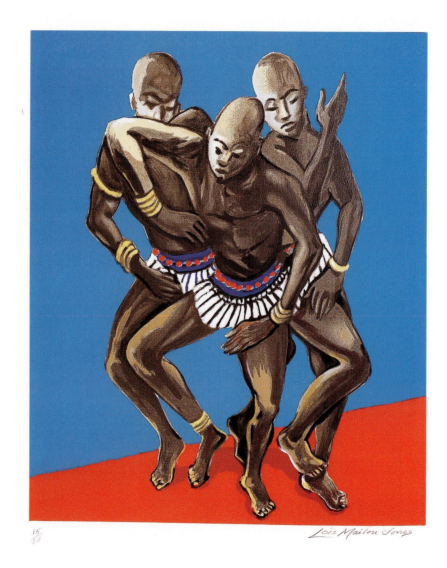

PLATE 98

Loïs Mailou Jones, *3 dancers,* 1996. Lithograph, 21³/₄ x 17¹/₂ in.
The Paul R. Jones Collection, University of Delaware, Newark.

PLATE 99

Michael Ellison, *Brown Boy,* 1985. Subtractive block print, 19 x 25 in.
The Paul R. Jones Collection, University of Delaware, Newark.

PLATE 100

Michael Ellison, *The Mall*, 1985. Subtractive block print, 26 x 40 in.

The Paul R. Jones Collection, University of Delaware, Newark.

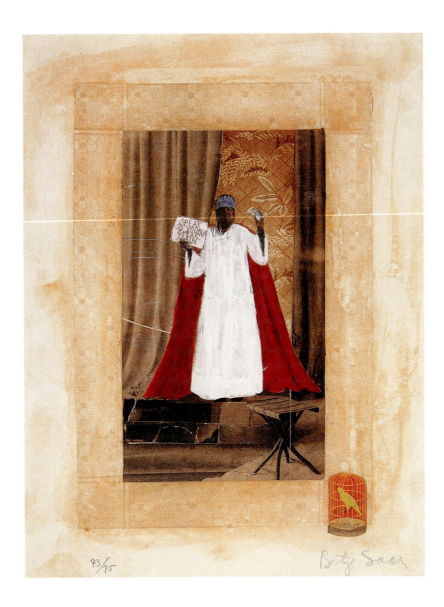

PLATE 101

Betye Saar, *Mother Catherine,* 2000. Serigraph, 20 x 16 in.
The Paul R. Jones Collection, University of Delaware, Newark.

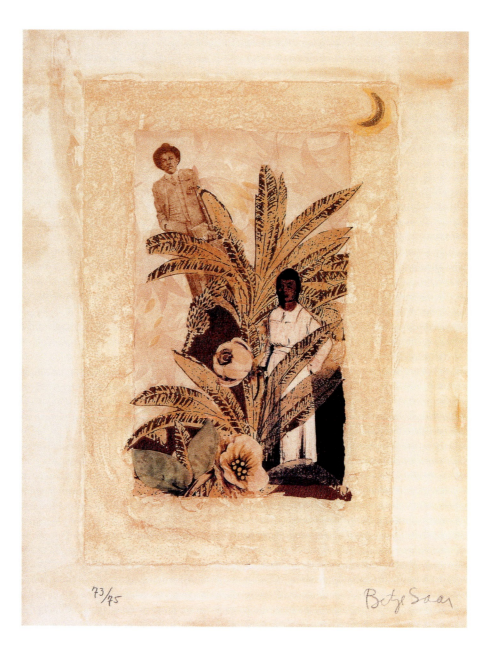

73/75 Betye Saar

PLATE 102

Betye Saar, *Magnolia Flower*, 2000. Serigraph, 20 x 16 in.

The Paul R. Jones Collection, University of Delaware, Newark.

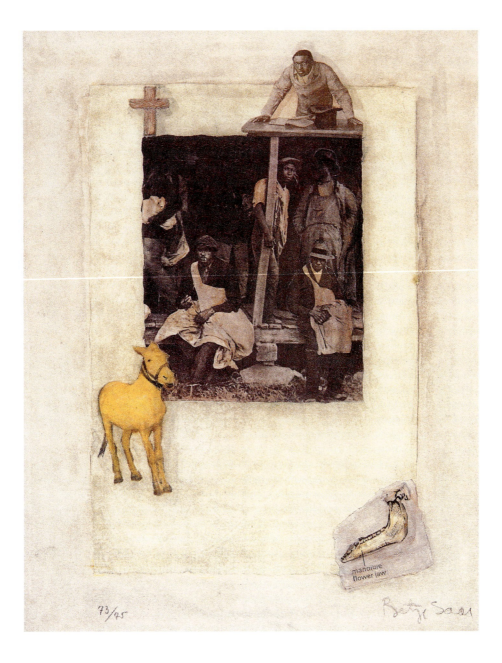

73/75 Betye Saar

PLATE 103

Betye Saar, *The Conscience of the Court,* 2000. Serigraph, 20 x 16 in.

The Paul R. Jones Collection, University of Delaware, Newark.

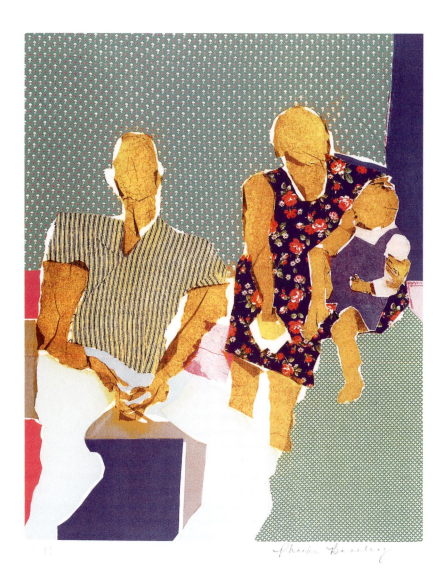

PLATE 104

Phoebe Beasley, *Man/Woman/Child,* 1998. Serigraph, 21¹/8 x 17 in.

The Paul R. Jones Collection, University of Delaware, Newark.

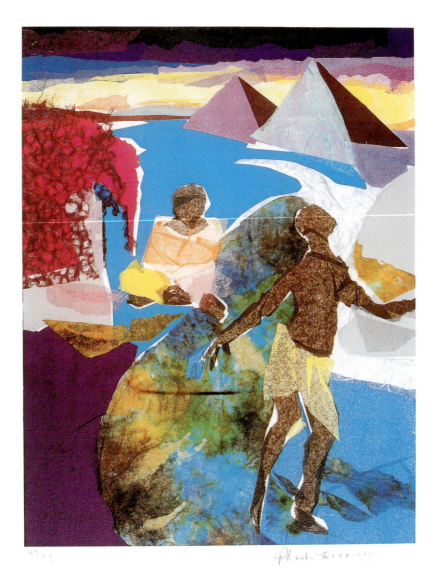

PLATE 105

Phoebe Beasley, *Yogi*, 1998. Serigraph, 21^1/$_8$ x 17 in.

The Paul R. Jones Collection, University of Delaware, Newark.

PLATE 106

John Biggers, *Untitled* (woman/planks/shell), 1996. Lithograph, 24 x 18 in.
The Paul R. Jones Collection, University of Delaware, Newark.

PLATE 107

John Biggers, *Untitled* (figures/two balls), 1996. Lithograph, 24 x 18 in.
The Paul R. Jones Collection, University of Delaware, Newark.

PLATE 108

Paul Raymond (P. R.) Jones, Jr., *Untitled*, ca. 1971. Graphite on paper, 42 x 29¹/₂ in.
The Paul R. Jones Archives, Atlanta, Georgia.

PLATE 109

Margo Humphrey, *Hometown Blues*, 1980. Color lithograph, 17³/₄ × 19¹/₄ in.
The Paul R. Jones Collection, University of Delaware, Newark.

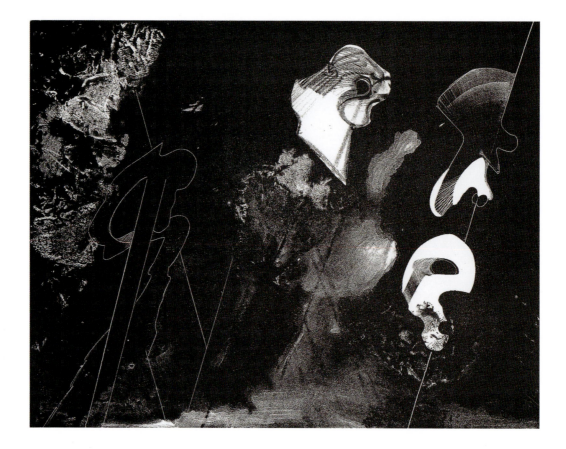

PLATE 110

Richard Hunt, *Untitled,* 1980. Lithograph, 14 x 11 in.

The Paul R. Jones Collection, University of Delaware, Newark.

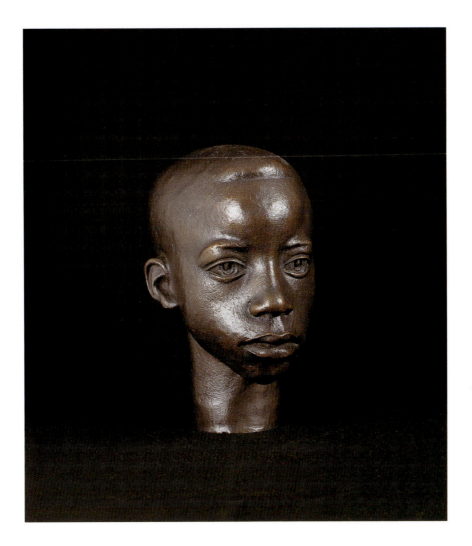

PLATE 111

William E. Artis, *Michael,* ca. 1950. Bronze, 9 x 6¹/₂ x 6³/₄ in.
The Paul R. Jones Collection, University of Delaware, Newark.

Artists' Biographies

JIM ALEXANDER

Born 1934 in Waldwick, New Jersey
Resides in Atlanta, Georgia
Photography

EDUCATION
New York Institute of Photography, 1968

MAJOR EXHIBITIONS
Auburn Avenue Resource Center Gallery, Atlanta, Georgia
Emory University, Schatten Gallery, Atlanta, Georgia
City Gallery East, City of Atlanta Bureau of Cultural Affairs,
 Atlanta, Georgia
Museum of African American Art, Los Angeles, California
Afro-American Cultural Center, Charlotte, North Carolina
University of Tennessee Center Gallery, Knoxville, Tennessee
Nexus Contemporary Art Center (now The Contemporary),
 Atlanta, Georgia
The Studio Museum in Harlem, New York
Yale University Art Center, New Haven, Connecticut
Fort-de-France Festival, Martinique

Jim Alexander distinguished himself as a documentary photographer of African American life. Beginning around 1963, after taking business courses at Rutgers University, he began making images of African Americans in the fields of art, entertainment, social activism, and other public arenas. Among his numerous images of musicians, ranging from jazz to rock, is the extensive photoessay of legendary jazz great Duke Ellington (also highlighted in the publication *Duke and Other Legends*). He recorded scenes from the civil rights era, and interpreted the lives of African Americans after the assassination of Dr. Martin Luther King, Jr. in 1968 in 200 photographs from around the country. He was commissioned to photograph Black Hebrew Israelites in Israel and had a special exhibition for the governor of Connecticut in 1972. Alexander was photographer-in-residence at Clark Atlanta University for five years.

WILLIAM J. ANDERSON

Born August 30, 1932, in Selma, Alabama
Resides in Atlanta, Georgia
Photography, sculpture, printmaking

EDUCATION
B.S., Alabama State College (now University), 1959
B.F.A., University of Wisconsin, 1962
M.F.A., Instituto Allende (San Miguel, Mexico), 1968

MAJOR EXHIBITIONS
Atlanta University, Atlanta, Georgia
Milwaukee Art Museum, Milwaukee, Wisconsin
High Museum of Art, Atlanta, Georgia
LeMoynes-Owens College, Memphis, Tennessee

Contemporary Arts Center, New Orleans, Louisiana

Corcoran Gallery of Art, Washington, D.C.

Wadsworth Atheneum Museum of Art, Hartford, Connecticut

University Gallery, University of Delaware, Newark, Delaware

Iris & B. Gerald Cantor Center for Visual Arts, Stanford University, Stanford, California

W illiam Anderson's parents encouraged him to pursue his interests in music and art at an early age even though no formal instruction was available in the public schools he attended. After two years as a music major at Knoxville College, Anderson transferred to Alabama State College (now University) to study art under Hayward L. Oubre. Under Oubre's tutelage, Anderson explored many media although he became best known professionally for his photography, an interest that began with childhood experiences in his father's darkroom related to his father's work in the medical field. Anderson's photographs often depict rural southern life and urban street dwellers such as the homeless, the unemployed, and the underemployed. Anderson's work is represented in the collections of the High Museum of Art in Atlanta, Georgia, and the J. Paul Getty Museum in Los Angeles, California.

BENNY ANDREWS

Born November 13, 1930, in Madison, Georgia

Resides in Brooklyn, New York

Collage, printmaking, graphic art

EDUCATION

B.F.A., Art Institute of Chicago, 1958

Fort Valley State College, 1948–1950

MAJOR EXHIBITIONS

Metropolitan Museum of Art, New York

Museum of Modern Art, New York

Hirshhorn Museum and Sculpture Gardens, Smithsonian Institution, Washington, DC

Bill Hodges Gallery, New York

Bomani Gallery, San Francisco, California

Dayton Art Institute, Dayton, Ohio

New Jersey State Museum, Trenton, New Jersey

Mississippi Museum of Art, Jackson, Mississippi

Wichita Art Museum, Wichita, Kansas

The Studio Museum in Harlem, New York

High Museum of Art, Atlanta, Georgia

Wichita State University Edwin A. Ulrich Museum of Art, Wichita, Kansas

Wadsworth Atheneum Museum of Art, Hartford, Connecticut

ACA Galleries, New York

B enny Andrews, the son of sharecroppers, joined the air force after studying two years at Fort Valley. Returning from duties in Korea, he attended the Chicago Art Institute with assistance from the GI Bill. He moved to New York City after graduation, and became a strong activist on behalf of African American artists. In his work, he has responded to his social and cultural environment through paintings and collages since 1956 when he was a student in Chicago. Using found objects and incorporating other materials with cutouts from publications, Andrews is inspired by the people, events, and cultural milieu from his own experiences. Often relating back to his birth state, Georgia, he developed personal icons that have been contextualized in ways that make them easily readable and widely understandable. Much of his imagery is rooted in memories and fiction narratives related to the South. He protested the exclusion of African American artists by major art institutions in the 1970s and helped found the Black Emergency Cultural Coalition and was director of the Visual Arts Program for the National Endowment for the Arts between 1982 and 1984. Andrews has had more than seventy solo exhibitions throughout the country and abroad. His work is in the permanent collections of the Museum of Modern Art in New York, the Brooklyn Museum of Art in New York, the Detroit Institute of Art, the High Museum of Art in Atlanta, the Hirshhorn Museum in Washington, DC, the Chrysler Museum in Norfolk, Virginia, the Butler Institute of Art in Youngstown, Ohio, and the O'Hara Museum in Tokyo.

BERT ANDREWS

Born 1931 in Chicago, Illinois
Died 1993? in New York, New York
Photography

MAJOR EXHIBITIONS
University of Delaware University Gallery,
 Newark, Delaware
Delaware State University Art Gallery, Dover, Delaware
Georgia State University Art Gallery, Atlanta, Georgia

Bert Andrews was the preeminent photographic record-keeper of African American theater in New York, especially the Negro Ensemble Company between 1955 and 1985. Later, he became the exclusive documenter of Woodie King, Jr.'s New Federal Theater, and worked extensively for the Richard Allen Cultural Center and the Frank Silvera Writers' Workshop. Born in Chicago, he grew up in Harlem where he was a songwriter, dancer, and singer before studying photography and becoming an apprentice to renowned jazz photographer Chuck Stewart. Andrews was a freelancer selling work to the *Amsterdam News, Our World,* and *Sepia* when a casual encounter with actress and then model Cicely Tyson initiated his shift to theater. He made more than 40,000 negatives capturing the stage careers of such distinguished performers as Morgan Freeman, Denzel Washington, Gloria Foster, Alfre Woodard, Alvin Ailey, Samuel L. Jackson, and hundreds more, spanning a thirty-five-year history. His photographs appeared in numerous national and international publications, including *Time, Newsweek, Life,* and the *New York Times*; and in several books on American theater. An all-night fire in 1988 destroyed his studio and all of his negatives. Andrews teamed with theater historian, playwright, and director Paul Carter Harrison to produce *In The Shadow of the Great White Way: Images from the Black Theater* with Thunder's Mouth Press in 1989—negatives were made from photographs collected by various people in the theater industry.

WILLIAM ELLISWORTH ARTIS

Born 1914 in Washington, North Carolina
Died 1977
Sculpture, pottery

EDUCATION
B.S., Nebraska State Teachers College, Chadron
B.F.A (1950), M.F.A. (1951), Syracuse University,
 Syracuse, New York
Art Students League, New York, 1933–1935

MAJOR EXHIBITIONS
Smithsonian Institution, Washington, DC
National Sculpture Society, New York
Howard University, Washington, DC
Indiana University Art Museum, Bloomington, Indiana
National Portrait Gallery, Smithsonian Institution,
 Washington, DC
Walker Art Center and Minneapolis Sculpture Garden,
 Minneapolis, Minnesota
New Jersey State Museum of Art, Trenton, New Jersey
The City College of New York, New York
Atlanta University Art Gallery (now Clark Atlanta University
 Art Galleries), Atlanta, Georgia
Xavier University Art Gallery, New Orleans, Louisiana
Syracuse Museum of Fine Arts (now The Everson Museum
 of Art), Syracuse, New York
American Negro Exposition, Chicago, Illinois
Whitney Museum of American Art, New York
Salons of America, Inc., New York
Harmon Foundation, New York
Scripps College Ruth Chandler Willamson Gallery,
 Claremont, California

William Artis studied with Augusta Savage in Harlem (1930s), sculptor Ivan Mestrovich, and at New York State University, New York State College of Ceramics, California State College at Long Beach, Pennsylvania State University at College Park, and Greenwich House Ceramics Center in New York. In 1946, he received a Harmon Foundation Fellowship to demonstrate his ceramics techniques at six Historically Black Colleges and Universities. He established a distinguished teaching career, briefly at Tuskegee Institute and in positions at

Nebraska State Teachers College in Chaldron from 1956 to 1966 and Mankato State College in Makato, Minnesota, in 1975. Artis worked predominately in terra cotta from 1930 to 1940, concentrating on abstraction and utility in ceramic objects thereafter. He was best known for his sensitive portrayals of unknown subjects, often male. His work is associated with the concept of "Negritude," which characterized the mythic aesthetic of the African personality as sensual and emotionally sensitive, embodying the Negro soul. He received nine Atlanta University Annual Awards (1942–1970) including two prestigious John Hope Prizes (1933, 1935), one Sculpture Purchase Prize, and six Purchase Awards. His work is in the collections of Fisk University, Hampton University, and the North Carolina Museum of Art.

HERMAN "KOFI" BAILEY

Born 1931 in Chicago, Illinois
Died February 1981 in Atlanta, Georgia
Graphic art, mixed media, illustration

EDUCATION
B.A., Alabama State University
M.F.A., University of California

MAJOR EXHIBITIONS
High Museum of Art, Atlanta, Georgia
Marietta-Cobb Museum of Art, Marietta, Georgia
University of Delaware University Gallery, Newark, Delaware
Spelman College Museum of Fine Art, Atlanta, Georgia
Lewis-Waddell Gallery, Los Angeles, California

Herman Bailey was born in Chicago but grew up in Los Angeles, California. After graduating from Alabama State University, he entered Howard University, studying with Alain Locke, Sterling Brown, and James Porter before completing graduate work in California. His work has been exhibited throughout the United States, Mexico, Brazil, Canada, and West Africa. Strongly engaged in Pan Africanism, he became closely associated with W.E.B. Du Bois, and later, with Martin Luther King, Jr. and Kwame Nkrumah, the president of Ghana. Bailey's interest in African themes and in es-

tablishing associations between African and African American experience was evident in his work, as was his strong sense of social activism and political awareness. He was a prolific artist, creating numerous drawings and prints through which he also explored many materials. Best known for his charcoal and conte drawings, Bailey's work was widely acquired by private collectors in Africa, Mexico, and South America as well as in the United States. His work is also in the collections of the High Museum of Art in Atlanta and the Spelman College Museum of Fine Art.

ROMARE BEARDEN

Born September 2, 1914, in Charlotte, North Carolina
Died March 12, 1988, in New York
Collage, painting, printmaking

EDUCATION
B.S., New York University, New York, 1935
Art Students League, New York, 1942–1945

MAJOR EXHIBITIONS
National Gallery of Art, Washington, DC
North Carolina Museum of Art, Raleigh, North Carolina
ACA Galleries, New York
Detroit Institute of Arts, Detroit, Michigan
Memphis State University, Memphis, Tennessee
The Mint Museums, Charlotte, North Carolina
Everson Museum of Art, Syracuse, New York
Pace Gallery, New York
University of Iowa Museum of Art, Ames, Iowa
Museum of Modern Art, New York
Museum of Fine Arts, Boston, Massachusetts
University of Southern California, Santa Barbara, California
State University of New York, Albany, New York
Dartmouth College Hopkins Center, Hanover, New Hampshire
Spelman College Museum of Fine Art, Atlanta, Georgia
Oakland Museum of California, Oakland, California
Corcoran Gallery, Washington, DC
Cordier and Ekstrom, New York
Michael Warren Gallery, New York
Samuel Kootz Gallery, New York

G Place Gallery, Washington, DC
Downtown Gallery, New York
Institute of Modern Art, Boston, Massachusetts

America's preeminent collagist, Romare Bearden was also a talented colorist and writer. Among the large number of African Americans moving north from the rural South in the early 1900s, his experiences from Charlotte, Harlem, Pittsburgh, Canada and, later Paris, are successfully blended into innovative imagery that was also influenced by African art and Chinese landscapes. While the dada style of mentor George Grosz (Art Students League) is traceable in Bearden's work, along with the cubist work of Picasso and Braque, the cutouts of Matisse, and the narrative paintings of Diego Rivera, the impact of jazz and blues, African American quilts, and trains are inseparable from a true understanding of his imagery. His oeuvre crosses many media of more than 2,000 known works ranging from social realism to cubism to abstract expressionism to his unique brand of modernist collage. Though he was proficient in various media, his signature style was the collage—an approach that exposed his tremendous ability to redefine collage inclusive of assemblage, papier-collé, photomontage, and color washes, and his complex narratives exploring numerous aspects of African American life. A founder of Spiral, a group of New York artists interested in participating in the civil rights struggle in America through their art, Bearden's move toward the use of purer color relationships, especially in watercolor, increased in the late 1970s inspired by his trips to the island of St. Martin. His work is in the permanent collections of the Metropolitan Museum in New York and National Museum of American Art.

PHOEBE BEASLEY

Born 1943 in Cleveland, Ohio
Resides in Los Angeles, California
Collage, printmaking

EDUCATION
B.F.A., Ohio University, Athens, Ohio
M.A., Kent State University, Ohio

MAJOR EXHIBITIONS
Schomburg Center for Research in Black Culture, New York
Anheuser Busch Gallery at Coca, St. Louis, Missouri
Museum of Science and Industry, Chicago, Illinois
The Cinque Gallery, New York
Museum of African American Art, Los Angeles, California
Smithsonian Institution, Washington, DC

Working in collage for over thirty-five years, Phoebe Beasley combines oil paint, tissue paper, cloth, and other objects to create scenes of African American life, emphasizing people of ordinary means in acts of everyday experiences. She is the only artist to receive the Presidential Seal twice, from Presidents George Bush (1989) and Bill Clinton (1993). Her numerous public projects include a twenty-five-foot ABSOLUT Vodka billboard on Sunset Boulevard, a tobacco education project with the State of California, and an outdoor mural in North Hollywood commissioned by the City of Los Angeles. Her commissioned work also appeared on the TV mini-series *Women of Brewster Place* in 1989. Beasley has had numerous solo and group exhibitions in the United States and abroad, and was honored by the State Department for her participation in the Art in Embassies Program. Her work is in the collections of the University of Texas, University of Illinois, Syracuse University, Brigham Young University, Fisk University, Kansas State University, Southern University, Swathmore College, Cooper Union, the Schomburg Museum, Bowdoin College, Dillard University, and California African American Museum.

JOHN THOMAS BIGGERS

Born 1924 in Gastonia, North Carolina
Died 2001 in Houston, Texas
Painting, printmaking, mural, graphic art

EDUCATION
Hampton Institute, Hampton, Virginia
B.S., M.S.E., Ph.D., Pennsylvania State University, College Park, Pennsylvania

MAJOR EXHIBITIONS
Penn State University, State College, Pennsylvania

Museum of Fine Arts, Houston, Texas

Virginia Museum of Fine Arts, Richmond, Virginia

The City College of New York, New York

Contemporary Arts Museum, Houston, Texas

Los Angeles County Museum, Los Angeles, California

Black Art Gallery, Houston, Texas

La Jolla Museum, La Jolla, California

Benin Sculpture Exhibition

Denver Art Museum, Denver, Colorado

Rockford College, Rockford, Illinois

Xavier University Art Gallery,
 New Orleans, Louisiana

Dallas Museum of Fine Arts, Dallas, Texas

(Clark) Atlanta University, Atlanta, Georgia

Museum of Modern Art, New York

John Biggers taught at Michigan State University, East Lansing, briefly at Alabama State College, and established the art department at Texas Southern University (1949), where he was professor for over thirty years; he retired from teaching in 1983 and devoted himself exclusively to his art. His book containing eighty-eight drawings and brief text, *Ananse: The Web of Life in Africa,* was published in 1962 based on his six-month stay in West Africa. Established as a muralist, he completed commissions for: Hampton University, (two), ca. 1944–1945; Burrows Education Building, Pennsylvania State University (1949); Eliza Johnson Home for Aged Negroes (1951); Y.W.C.A., Blue Triangle Branch, Houston (1953); Carver High School, Naples, Texas (1955); International Longshoremen's Association Local 872, Houston (1956); Dowling Veterinary Clinic, Houston (1960); W. L. Johnson Branch, Houston Public Library (1964); Hannah Hall, TSU (1967), Houston; Riverside Hospital, Houston (1976); TSU Student Union Building (1977); Florida A&M; and Houston Music Hall (1981). Biggers received Purchase Awards from Atlanta University (1950–1953), Museum of Fine Arts, Houston (1950), and the Dallas Museum of Fine Arts (1952); receiving the Harbison Award for teaching in 1968. His work is in the collections of the Pennsylvania State University, Texas Southern University in Houston, Lubbock Museum of Art in Texas, Dallas Museum of Fine Arts in Texas, Museum of Fine Arts, Houston, and Howard University in Washington, DC.

CAMILLE BILLOPS

Born August 12, 1933, in Los Angeles, California

Resides in New York

Sculpture, printmaking, film

EDUCATION

B.A., California State College, Los Angeles, California, 1960

M.F.A., City College of New York, 1973

Studied, University at the Sorbonne, Paris, France

EXHIBITIONS

Gallerie Akhenaton, Cairo, Egypt

Valley Cities Jewish Community Center,
 Los Angeles, California

Atlanta College of Art, Atlanta, Georgia

Spelman College Museum of Fine Art, Atlanta, Georgia

Montclair State College Art Gallery, Montclair, New Jersey

Bernice Steinbaum Gallery, New York

Hampton University Art Gallery, Hampton, Virginia

The Studio Museum in Harlem, New York

Bucknell University Center Gallery, Lewisville, Pennsylvania

Washington Project for the Arts, Washington, DC

Gimpel and Weitzenhoffer Gallery, New York

The New Museum of Contemporary Art, New York

El Museo de Arte Moderno La Tertulia, Cali, Colombia

Hamburg, Germany

Kaohsiung, Taiwan

Camille Billops first rose to the forefront in the visual arts field as a ceramic sculptor, but quickly became recognized for a range of additional talents including printmaking, drawing, book illustration, pottery, jewelry making, poetry, and filmmaking. She had her first one-person show in 1960 at the African American Art Exhibition in Los Angeles and was artist-in-residence at the Asilah First World Festival in Morocco in 1978. In 1975, Billops co-founded with her husband James Hatch the Hatch-Billops Collection, extensive archives of African American cultural history in the form of visual materials, oral histories, and thousands of books chronicling black

artists in the visual and performing arts. Billops began her career in filmmaking in the early 1980s with *Suzanne, Suzanne* (1982), followed by *Older Women and Love* (1987), *Finding Christa* (1991), which won the Grand Jury Prize for documentaries at the 1992 Sundance Film Festival, *The KKK Boutique Ain't Just Rednecks* (1994), *Take Your Bags* (1998), and *A String of Pearls* (2002). Billops's awards include: a Fellowship from the Huntington Hartford Foundation in 1963, a MacDowell Colony Fellowship in 1975, The International Women's Year Award for 1975–76, and the James VanDerZee Award, Brandywine Graphic Workshop in 1994. Her works are in the permanent collections of the Studio Museum of Harlem, Photographers Gallery, London, and the Museum of Drawers, Bern, Switzerland.

FRANK BOWLING

Born February 29, 1936, in Bartica, Essequibo, Guyana
Resides in Brooklyn, New York
Painting

EDUCATION
Chelsea School of Art
Royal College of Art, London, England
Slade School of Fine Arts, London, England, 1959–1962

MAJOR EXHIBITIONS
N'Nambdi Gallery, Chicago, Illinois
UFA Gallery, Chelsea, New York
Center for Art and Culture, Brooklyn, New York
Midland Art Centre, Birmingham, England
University Gallery, Bradford, Yorkshire, England
Heimatmuseum, Eckernforde, Schleswig Holstein, Germany
University of Delaware University Gallery, Newark, Delaware
Royal West of England Academy, Bristol, England
University Art Gallery, Reading, England
Castlefield Gallery, Limerick, Ireland
Tibor de Nagy Gallery, London, England
Whitney Museum of American Art, New York
Boston Museum of American Art, Boston, Massachusetts
Rice University, Houston, Texas
Princeton University, Princeton, New Jersey
State University of New York, Stony Brook, New York
Tate Gallery, London, England
Grabowski Gallery, London, England

Frank Bowling is a writer, critic, teacher, and artist. He was contributing editor and critic to *Arts Magazine* and Tutor, Camberwell School of Arts and Crafts in London, England. He has taught at Columbia University in New York, Rutgers University in New Jersey, Massachusetts College of Art, and School of Visual Arts in New York. He was artist-in-residence at the New York State Council of the Arts and the Skowhegan School of Painting and Sculpture in Maine. Bowling received the Pollock-Krasner Award in 1992 and 1998, a John Simon Guggenheim Fellowship in 1967, the 1967 Painting Prize in Edinburgh, Scotland, Grand Prize at the First World Festival of Negro Art at Dakar, Senegal, in 1966, and the Purchase Prize Award at Shakespeare Quatro-Cenetary, Stratford on Avon, England, in 1966. Bowling is best known for nonrepresentational paintings structured around color relationships, texture, and ambiguous spatial contexts. His imagery fuses compositional and surface readings linked to an African-derived and Western aesthetics. Often presented in large-scale and dramatic dimensional formats (such as extremely long and narrow), Bowling's paintings create the opportunity for varied readings and have tremendous power when considered as works structured around color and tonal relationships.

BENJAMIN BRITT

Born 1923 in Windfall, North Carolina
Death date unknown in Philadelphia, Pennsylvania
Painting

EDUCATION
Philadelphia's Museum College of Art
Hussian School of Art
Art Students League, New York

MAJOR EXHIBITIONS
Smith-Mason Gallery, Washington, DC
State Armory, Wilmington, Delaware
Xavier University Art Gallery, New Orleans, Louisiana

Studio 5 Gallery, New York

University of Pennsylvania, Philadelphia, Pennsylvania

(Clark) Atlanta University, Atlanta, Georgia

October Gallery, Philadelphia, Pennsylvania

Schaffer Gallery, Chafont, Pennsylvania

Philadelphia Art Alliance, Philadelphia, Pennsylvania

Allens Lane Art Center, Philadelphia, Pennsylvania

Wharton Art Center, Philadelphia, Pennsylvania

Cheyney University, Cheyney, Pennsylvania

Benjamin Britt painted socially sensitive narratives using the African American model to address universal issues of humanity. Working nearly exclusively in oils, his subjects tended to be conditions or states or being rather than portrayals of individuals or types. Much of his work was in a surrealist or quasi-surrealist style that relied on representation in the depiction of forms, yet contained unusual, ambivalent, or fantasy-like environments. His figurative references were often of small children or adolescents. Britt's awards include the Laura Wheeler Waring Award in 1971, Painting Award in 1957 and Popular Purchase Awards in 1964 and 1958 at the Atlanta University Annual, and First Prize, Les Beaux Arts, Vineland, New Jersey, in the mid-1950s.

SELMA HORTENSE BURKE

Born 1900 in Mooresville, North Carolina
Died 1995 in York, Pennsylvania
Sculpture, printmaking

EDUCATION
B.F.A., Columbia University
Winston-Salem State University

MAJOR EXHIBITIONS
Marietta-Cobb Museum of Art, Marietta, Georgia
University of Delaware University Gallery, Newark, Delaware
Rainbow Sign Gallery, Berkeley, California
The City College of New York, New York
Howard University, Washington, DC
Avant Garde Gallery, New York
Carlen Galleries, Philadelphia, Pennsylvania
Julian Levy Galleries, New York

Modernage Gallery, New York
(Clark) Atlanta University, Atlanta, Georgia
American Negro Exposition, Chicago, Illinois

Selma Burke became interested in forming objects in clay as a small child, pinpointing the beginning of her art-making efforts to 1907 when she dug clay out of the ground at her parent's farm in Mooresville, North Carolina, and squeezed it in her hands, attempting to shape animals with it. She later considered nursing as a career option, attending St. Agnes School of Nursing, Raleigh, and Women's Medical College in Philadelphia. She went on to study sculpture at Columbia and traveled to Europe where she studied ceramics with Povoleny in Vienna and sculpture with Maillol in Paris, returning to New York around 1940. The 1987 recipient of the Pearl S. Buck Foundation Woman's Award, Selma Burke taught at Howard University, Washington, DC, for forty-seven years (1930–1977) and at Harvard University, Livingstone College, and Swarthmore College. Her most famous work is the bust of President Franklin Delano Roosevelt that is on the United States dime. In 1944, President Roosevelt posed for the artist; her completed bronze plaque was unveiled by President Harry S. Truman in 1945 and stored at the Recorder of Deed Building in Washington, DC. Burke is best known for her plaster, clay, brass, and bronze heads of African Americans, most prominent among them being the portrait of Mary McCleod Bethune (1980). A Rosenwald Fellow in 1939, she received the Edward P. Alford, Jr. Award in the 1944 Atlanta University Annual.

MARGARET TAYLOR GOSS BURROUGHS

Born 1917 in St. Rose Parish, Louisiana
Resides in Chicago, Illinois
Painting, printmaking, illustration, graphic art

EDUCATION
B.A., Chicago Teacher's College, 1937
M.A.E., Art Institute of Chicago, 1948
Chicago Normal School

Teacher's College, Columbia University, New York

Northwestern University, Chicago

Elmhurst College, Elmhurst, Illinois

Ball State University, Museum of Art, Muncie, Indiana

House of Friendship, Moscow

International Kook Art Exhibit, Leipzig, Germany

Xavier University Art Gallery, New Orleans, Louisiana

Howard University, Washington, DC

Kenosha Museum, Poland

Market Place Gallery, New York

San Francisco Civic Museum, San Francisco, California

(Clark) Atlanta University, Atlanta, Georgia

American Negro Exposition, Chicago, Illinois

Illinois State University, University Galleries,
 Bloomington, Illinois

Winston-Salem State College Diggs Gallery,
 Winston-Salem, North Carolina

M argaret Burroughs was a founder of the South Side Community Art Center in Chicago, founder and director of the DuSable Museum of African American History in Chicago (1961), and a founder of the National Conference of Artists. She published her first children's book, *Jasper, the Drummin' Boy,* in 1947; in 1967, she and Dudley Randall edited an anthology called *For Malcolm: Poems on the Life and Death of Malcolm X,* and published several volumes of her own poetry.

Her paintings and prints are commentaries on the African American urban experience. She has work in the collections of Howard University in Washington, DC, (Clark) Atlanta University in Georgia, Oakland Museum in California, Alabama State (University), and DuSable Museum in Illinois.

DOUGHBA HAMILTON CARANDA-MARTIN III

Born in Liberia, West Africa

Photography, painting, installation art

EDUCATION

B.F.A., School of Visual Art, New York

Konola Academy, Liberia

University of Liberia

MAJOR EXHIBITIONS

Istanbul Biennial, Istanbul, Turkey

Venice Biennial, Venice, Italy

Philadelphia Museum of Art, Philadelphia, Pennsylvania

Wilma Jennings Gallery, New York

Gale-Martin Fine Arts, Chicago, Illinois

Rockland Center for the Arts, Rockland County, New York

French Cultural Center, New York

Porter Troupe Gallery, La Jolla, California

Delaware College of Art and Design, Wilmington, Delaware

The City College of New York, New York

Kenkeleba House, New York

Jamaica Center for Arts and Learning, New York

Adam Goldstein Fine Art, San Francisco, California

D . H. Caranda-Martin works in a variety of media, specializing in one-of-a kind photographs, mixed media installations, and abstract painting. His paintings explore color movement and abstract pigmentation achieved by layering oils, wax, and varnish to create a slick painted surface. Originally from Liberia, Caranda-Martin addresses such issues of multinationals, oil spills, human rights, and African history. His photographs are pensive, quiet, and introspective in a manner that renders them universally appealing.

NANETTE CARTER

Born 1954 in Columbus, Ohio

Resides in New York, New York

Painting, printmaking

EDUCATION

M.F.A., Pratt Institute of Art, Brooklyn, New York, 1978

B.A., Oberlin College, Oberlin, Ohio, 1976

L'Accademi di Belle Arti, Perugia, Italy, 1974–1975

MAJOR EXHIBITIONS

Sande Webster Gallery, Philadelphia, Pennsylvania

G. R. N'Namdi Gallery, Birmingham, Michigan

Rathbone Gallery, Albany, New York

The Sage Colleges, Albany, New York

June Kelly Gallery, New York

Franklin and Marshall College, Lancaster, Pennsylvania

Kebede Fine Arts, Los Angeles, California

Long Island University, Southampton, New York

Westminster Gallery, Bloomfield College,
 Bloomfield, New Jersey

Bloomfield College, Bloomfield, New Jersey

Jersey City Museum, Jersey City, New Jersey

Montclair Art Museum, Montclair, New Jersey

Ericson Gallery, New York

Nanette Carter has taught at City College of New York since 1992, having previously been a teacher at the Dwight-Englewood School in New Jersey (1978–1987). Her abstract paintings and monoprints are abstract narratives of the African American experience emphasizing the political nuances and overt implications that unite all people of the African disapora. Her work brings to the forefront of consideration the sight, sound, and rhythms of place as a physical and psychological series of boundaries. Carter uses color as both a code and a structural element. She was a 1981 National Endowment for the Arts Fellow and received a Pollack Foundation grant in 1994. Her work is in the collections of the Jersey City Museum in New Jersey, the Newark Museum of Art in New Jersey, The Studio Museum in Harlem, Herbert F. Johnson Museum of Cornell University in New York, Jane Voorhees Zimmerli Art Museum of Rutgers University in New Jersey, and Yale Gallery of Art in Connecticut.

ALICE ELIZABETH CATLETT (MORA)

Born April 15, 1915, in Washington, DC

Resides in Mexico

Sculpture, printmaking

EDUCATION

B.S., Howard University, Washington, DC, 1937

M.F.A, University of Iowa, Iowa City, 1940

MAJOR EXHIBITIONS

June Kelly Gallery, New York

Hampton University, Virginia

Fisk University, Tennessee

North Carolina Central University, Durham,
 North Carolina

(Clark) Atlanta University, Atlanta, Georgia

Art Institute of Chicago, Chicago, Illinois

Corcoran Gallery of Art, Washington, DC

Bomani Gallery, San Francisco, California

Sragow Gallery, New York

The Studio Museum in Harlem, New York

California State University,
 Long Beach, California

La Jolla Museum, La Jolla, California

National Center of Afro-American Art,
 Roxbury, Maryland

Museum of Modern Art, Mexico

Cleveland Museum of Art, Cleveland, Ohio

Albany Institute of History and Art,
 Albany, New York

University of Chicago, Chicago, Illinois

Baltimore Museum of Art, Baltimore, Maryland

Newark Museum, Newark, New Jersey

University of Iowa, Iowa City, Iowa

Elizabeth Catlett is one of the most respected sculptors and printmakers of America's living artists. She is the third child born to parents who were teachers, and grew up in an environment that emphasized learning and exploration and encouraged open expression. Following studies at Howard and Iowa, she continued at the Art Institute of Chicago, Illinois (1941), at the Art Students League, New York (1942–1943), with Ossip Zadkine in New York (1943), and under Jose L. Ruix and Francisco Zuniga at Escuela de Pintura y Escultura, Esmeralda, Mexico (1955, 1947–1948). The first African American recipient of an MFA in sculpture from Iowa State, she took a position at Prairie View College in Texas, and later at Dillard University in New Orleans where she pioneered the use of live models in the classroom while chair of the art department. Throughout her life and work, Catlett has been an advocate for improving the conditions and treatment of women, especially, but focusing on the struggles and triumphs of all oppressed people. She received a Rosenwald Fellowship in 1945 that allowed her to go to Mexico City and produce a body of

work on African American women. Catlett and Charles White, her husband at the time, met artists David Alfaro Siqueiros, Frida Kahlo, and Diego Rivera while renting a room from Siqueiros's mother-in-law. She and White soon returned to the states for a divorce, and Catlett went back alone. In 1947, she married Francisco Pancho Mora, a printmaker she met at the Popular Graphics Workshop. She began incorporating the historical placement and treatment of Mexican women and others into a more universalized approach in her work. Her primary subject matter, however, remained the African American woman. Catlett's work is in the permanent collections of the Baltimore Museum of Art in Maryland, High Museum of Art in Atlanta, National Museum of American Art in Washington, DC, New Orleans Museum of Art in Louisiana, Cleveland Museum of Art in Ohio, Metropolitan Museum of Art in New York, Museum of Modern Art in New York, Studio Museum in Harlem, Wadsworth Atheneum in Connecticut, Museo de Arte Moderno in Mexico City, and Narodniko Musea (National Museum) in Prague.

ERNEST CHRICHLOW

Born June 19, 1914, in Brooklyn, New York
Resides in Brooklyn, New York
Painting

EDUCATION
New York University, New York
Art Students League, New York

MAJOR EXHIBITIONS
State Armory, Wilmington, Delaware
Museum of Fine Arts, Boston, Massachusetts
The City College of New York, New York
ACA Gallery, New York
Institute of Modern Art, Boston, Massachusetts
(Clark) Atlanta University, Atlanta, Georgia
American Negro Exposition, Chicago, Illinois
Harlem Community Center, New York
Newark Museum, Newark, New Jersey
The Cinque Gallery, New York
Downtown Gallery, New York

Federal Art Gallery, New York
Smith College, Northampton, Massachusetts

Ernest Chrichlow was inspired to become an artist following an encounter with Augusta Savage and Norman Lewis in Savage's studio. He joined the Harlem Artist Guild in the 1930s and met Jacob Lawrence, Charles Alston, James Yeargans, and others. His work addresses social and political topics often using the single figure as a means to bringing focus and emphasis to his message. Chrichlow, whose parents had migrated from Barbados, returned frequently to island references as subjects, drawing particularly from Jamaica. His personal style has been referred to as interpretive realism due to the strong narrative nature of his imagery.

CARL CHRISTIAN

Born March 26, 1954, in Bessemer, Alabama
Resides in Atlanta, Georgia
Painting

EDUCATION
Art Institute of Atlanta, Atlanta, Georgia, 1984
M.M.Ed., Georgia State University, Atlanta, Georgia, 1983
B.S., Knoxville College, Knoxville, Tennessee, 1976

MAJOR EXHIBITIONS
Mary Holmes College, West Point, Mississippi
Cary-McPheeters Gallery, Atlanta, Georgia
D. Miles Gallery, Decatur, Georgia
Civil Rights Institute, Birmingham, Alabama
Morehouse College, Atlanta, Georgia
Gwinnett County Fine Arts Center, Duluth, Georgia
Atlanta Arts Festival, Atlanta, Georgia
City Gallery East, Atlanta, Georgia
Gallery 1024, Birmingham, Alabama
Municipal Gallery, Decatur, Georgia
(Clark) Atlanta University Center Library, Atlanta, Georgia
Birmingham Civil Rights Museum, Alabama

Carl Christian worked quietly and almost secretly, producing artwork while teaching in the public school system in the Atlanta area. After almost ten years,

he successfully entered his first art competition. Working primarily as an abstractionist, he applies bits of found objects and other materials to the surface of his paintings to create large-scale statements about spontaneity, intuitive patterning, and subconscious reading. Inspired by the improvisational properties of jazz and fundamental optimism about life, Christian finds the untold beauty in overlooked forms that are taken for granted. He considers his paintings explorations and experiments on texture, tactility, and form.

ALLAN ROHAN CRITE

Born 1918 in Plainfield, New Jersey

Resides in Boston, Massachusetts

Painting, printmaking, illustration

EDUCATION

School of Fine Arts, Boston, Massachusetts, 1929–1936

Painter's Workshop, Fogg Art Museum (ca. 1940)

B.A., Harvard University Extension School, 1968

MAJOR EXHIBITIONS

Boston Athenaeum, Boston, Massachusetts

Museum of Fine Arts, Boston, Massachusetts

Corcoran Gallery of Art, Washington, DC

Museum of Modern Art, New York

Art Institute of Chicago, Chicago, Illinois

Columbus Museum, Columbus, Georgia

Mount Holyoke College, Blanchard Art Gallery, South Hadley, Massachusetts

Duncan Phillips Gallery, Washington, DC

National Center of Afro-American Art, Roxbury, Maryland

Newark Museum, Newark, New Jersey

Smithsonian Institution, Washington, DC

Howard University, Washington, DC

Institute of Contemporary Art, Boston, Massachusetts

Addison Gallery of American Art, Andover, Massachusetts

Grace Horne Galleries, Boston, Massachusetts

(Clark) Atlanta University, Atlanta, Georgia

American Negro Exposition, Chicago, Illinois

Harmon Foundation Exhibitions

Boston Society of Independent Artists, Boston, Massachusetts

Allan Crite has had a long and illustrious career as an artist and mentor to numerous younger artists. He was one of the relatively few African American artists to work for the Federal Arts Project (FAP) during the 1930s and has continued to depict the conditions of African Americans over the changing decades since that time. His presentations of African Americans in community scenes were joined by an increasing interest in interpretations of religious themes, using black figures as the basis for his characterizations. He has written and illustrated several books, including *Three Spirituals from Heaven* in 1948, one of two volumes published by Harvard University Press. In portraying his religious works, Crite adopted a style that alluded to the formal religious imagery of Catholicism or the Episcopalian practices he later assumed. Crite established the Artists' Collective, a forum to support younger and emerging artists. His work is represented in the Museum of Fine Arts, Boston; the Museum of Modern Art, Phillips Collection, Corcoran Gallery, Washington, DC, Smithsonian Institution, and the Art Institute in Chicago.

ROY DECARAVA

Born 1919 in New York, New York

Resides in Brooklyn, New York

Photography

EDUCATION

Cooper Union, New York, 1938–1940

Harlem Art Center, New York, 1940–1942

George Washington Carver Art School, 1944

MAJOR EXHIBITIONS

Los Angeles County Museum, Los Angeles, California

Fotografiska Museet, Stockholm, Sweden

The Studio Museum in Harlem, New York

The Witkin Gallery, New York

Museum of Fine Arts, Houston, Texas

Museum of Modern Art, New York

Forty-fourth Street Gallery, New York

Serigraph Gallery, New York

(Clark) Atlanta University, Atlanta, Georgia

Minneapolis Institute of Arts,
 Minneapolis, Minnesota

Roy DeCarava is a Distinguished Professor at Hunter College. He was initially a painter and printmaker who began photographing to document that work. He switched to photography as a primary medium in 1947, having his first solo exhibition in 1950. He has become one of the foremost photographic artists of the twentieth century. The first African American artist to receive the Guggenheim Fellowship (1952), his images have immortalized the jazz world through his photographs of contemporaries Billie Holiday, John Coltrane, Roy Haynes, and others. He photographed for *Sports Illustrated, Look,* and numerous other journals. In 1955, DeCarava teamed with writer Langston Hughes to produce *The Sweet Flypaper of Life,* which depicts the positive side of Harlem through text illustrated with photographs. DeCarava captures moments of intimacy and beauty in his images of family, friendship, faith, and other areas of strength. His work inspired younger artists such as Beuford Smith (b. 1941) to pursue the medium. He operated one of the first fine art photography galleries between 1954 and 1956, A Photographer's Gallery in New York. He co-founded the Kamoinge Workshop, a coalition of African American photographers in New York in 1963, which he ran through 1966. In 1971, DeCarava received the Benin Award for his contributions to the African American community. He was the Blue Ribbon Winner at the American Film Festival in 1984.

DAVID CLYDE DRISKELL

Born 1931 in Eatonton, Georgia

Resides in Hyattsville, Maryland

Painting, graphic art

EDUCATION

Rijksbureau voor Kunsthistorische Documentatie,
 The Hague, Holland, 1964

M.F.A., Catholic University of America,
 Washington, DC, 1962

B.F.A., Howard University, Washington, DC, 1955

Skowhegan School of Painting and Sculpture,
 Skowhegan, Maine, 1953

MAJOR EXHIBITIONS

Corcoran Art Gallery, Washington, DC

National Museum of African American Art,
 Washington, DC

Smithsonian Museum, Washington, DC

Baltimore Museum of Art, Baltimore, Maryland

Portland Museum of Art, Portland, Oregon

Sherry Washington Gallery, Detroit, Michigan

Diggs Gallery, Winston-Salem State University,
 Winston-Salem, North Carolina

Bomani Gallery, San Francisco, California

Pellon Gallery, Washington, DC

University of Iowa Museum of Art, Iowa City, Iowa

Whitney Museum of American Art, New York

Norfolk Museum of Art, Norfolk, Virginia

James David Brooks Memorial Gallery, Fairmont State
 College, Fairmont, West Virginia

Cheekwood Botanical Garden and Museum of Art

San Diego Fine Arts Gallery, San Diego, California

Fisk University, Nashville, Tennessee

Xavier University Art Gallery, New Orleans, Louisiana

National Gallery of Art, Washington, DC

David Driskell has excelled as an artist, writer, teacher, and consultant in the field of African American art. He taught at Talladega College in Alabama, Fisk University in Tennessee, and at the University of Maryland in College Park. In 1969–1970, he was visiting professor at the University of Ife in Ile Ife, Nigeria. His years of service to Maryland were rewarded with the establishment of a center bearing his name that will focus on African Diaspora studies. His collage-based paintings and purely abstract works are stylistically linked to the collage work of Romare Bearden and any number of African influences. The subjects and themes of many of his works refer specifically to the social and political climate in America with a tendency toward interweaving in his urban settings rural references. Driskell's work is in the collections of the Corcoran Gallery of Art, Barnett Aden, Le Moyne College, Howard University, and the Smithsonian Institution.

MICHAEL ELLISON

Born 1952 in Atlanta, Georgia
Died July 22, 2001, in Atlanta, Georgia
Printmaking

EDUCATION
M.A., Georgia State University, 1983
B.A., Atlanta College of Art

MAJOR EXHIBITIONS
High Museum of Art, Atlanta, Georgia
Georgia Institute of Technology, Atlanta, Georgia
South Carolina State, Orangeburg, South Carolina
Georgia State University, Atlanta, Georgia
Atlanta College of Art, Atlanta, Georgia
McIntosh Gallery, Atlanta, Georgia

Michael Ellison mastered the subtractive linocut printmaking technique, creating colorful, abstract references to people and places in the urban centers where he lived and frequented in very low editions, usually of ten. He taught at Claflin College, South Carolina State College, and the Atlanta College of Art. He won the Georgia Business in the Arts Award in 1986 and was a first prize winner in printmaking in the Atlanta Life Insurance Company Annual Art Competition and Exhibition. Ellison's work was heavily acquired by private collectors throughout the Southeast, especially Paul R. Jones, and James Jackson and Gedney Vinings of Atlanta. His work is also represented in the permanent collection of the High Museum of Art in Atlanta.

JOHN W. FEAGIN

Born August 17, 1929, in Birmingham, Alabama
Resides in Montgomery, Alabama
Painting

EDUCATION
B.S., Alabama State University, 1957
M.A., Alabama State University, 1971

MAJOR EXHIBITIONS
University of Delaware Perkins Gallery, Newark, Delaware
Alabama State University, Montgomery, Alabama
Montgomery Museum of Fine Art, Montgomery, Alabama
Birmingham Art Festival, Birmingham, Alabama
(Clark) Atlanta University, Atlanta, Georgia

John Feagin was a dedicated teacher in the Alabama system for thirty-four years. He also taught drawing, painting, and ceramics for the city of Montgomery's recreation program for an additional ten years. As an artist, he evolved over the years from a representational to abstract and nonobjective painter. He actively experimented with ways in which to apply paint to his surfaces using different utensils and using glazes and mixtures for a variety of effects. Luminosity has remained important to him as he also worked to incorporate landscape elements. Working often in large formats, Feagin maintained a fierce interest in color as a structural and visceral point of concern as he continued to pursue surface manipulation.

REGINALD GAMMON

Born March 31, 1921, in Philadelphia, Pennsylvania
Resides in Albuquerque, New Mexico
Painting, photography

EDUCATION
Philadelphia Museum College of Art
Stella Elkins School of Fine Art
Tyler School of Art

MAJOR EXHIBITIONS
Saginaw Art Museum, Saginaw, Michigan
Smith-Mason Gallery, New York
Museum of Fine Arts, Boston, Massachusetts
Brooklyn College, New York
Minneapolis Institute of Art, Minneapolis, Minnesota
Everson Museum of Art, Syracuse, New York
Rhode Island School of Design, Providence, Rhode Island
The Studio Museum in Harlem, New York
Flint Institute of the Arts, Flint, Michigan

Reginald Gammon was at the center of the 1960s and 1970s activism in America. As a founding member of Spiral in New York, he advised Romare Bearden to use the photostat process and enlarge his photomontages to

achieve greater impact among young African American artists. He received critical acclaim for the 1965 painting, *Freedom Now,* his entry that year in the group's exhibition entitled "Black and White." The painting typified his strong, graphic, and punchy style that frequently revealed his knowledge of effective uses of photographic framing and cropping. Gammon was also noted for the formal quality in his compositions based upon his infusion of geometric properties. Based on current events, his figure-based paintings rely more on emotional impact than exact rendering. When Spiral disbanded, he joined Benny Andrews and others in the Black Emergency Cultural Coalition (BECC), adding to their protest of exclusion and ill treatment of African American artists in mainstream institutions. Gammon had a diverse work history, having worked for an advertising firm, Lifton, Gold, and Asher, for ten years (1954–1964), and having been artist-in-residence for the New York City Board of Education from 1967 to 1969. He relocated to Kalamazoo, Michigan, in 1983 when he became professor of humanities at Western Michigan University, a teaching position he held for twenty years.

REX GORLEIGH

Born 1902 in Penllyn, Pennsylvania

Died 1987 in East Windsor, New Jersey

Painting, printmaking

EDUCATION

University of Chicago, Chicago, Illinois, 1940–1941

Art Institute of Chicago, Chicago, Illinois, 1942

B.A., Livingston College, Rutgers University, New Brunswick, New Jersey, 1976

MAJOR EXHIBITIONS

Montclair State College, Montclair, New Jersey

The Art Museum, Princeton, New Jersey

The Studio Museum in Harlem, New York

Museum of Fine Arts, Boston, Massachusetts

National Center of Afro-American Art, Roxbury, Maryland

Trenton Museum, Trenton, New Jersey

Renaissance Gallery, Washington, DC

Newark Museum, Newark, New Jersey

Little Gallery, Princeton, New Jersey

New Jersey State Museum, Trenton, New Jersey

Montclair Museum of Art, Montclair, New Jersey

(Clark) Atlanta University, Atlanta, Georgia

American Artist Gallery, Chicago, Illinois

American Negro Exposition, Chicago, Illinois

Augusta Savage Studio, New York

Baltimore Museum of Art, Baltimore, Maryland

Harmon Foundation Exhibition, New York

Society of Independent Artists

Anderson Gallery

Shaw University, Raleigh, North Carolina

Gallery Strindberg, Helsinki, Finland

Rex Gorleigh began drawing at age five. Later, while living in New York, he met a number of talented figures such as Claude McKay, Aaron Douglas, and Eubie Blake who inspired him even more to pursue the arts. He studied at Howard University, the University of Chicago, with Andre L'hote in Paris, and Xavier J. Barile in New York. Gorleigh taught art at several schools, among them Studio-on-the-Canal, in Princeton, New Jersey, Palmer Memorial Institute in Sedalia, North Carolina, and Chicago's Southside Community Art Center. Rex Gorleigh first exhibited his work in the non-juried shows organized by the Society of Independent Artists in the 1920s and 1930s. Much of his work reflects a sensitivity to the socially political climate of blacks in the rural South and the economic status of the African American in general. Works from the 1980s such as his *Red Barn* reveal his longstanding interest in issues specific to the agrarian community.

SAMUEL GUILFORD

Born February 1, 1956, in Barbour County, Alabama

Resides in Atlanta, Georgia

Painting

EDUCATION

Studied, Atlanta College of Art, Atlanta, Georgia

EXHIBITIONS

Morehouse College, Atlanta, Georgia

Wire Grass Museum of Art, Dothan, Alabama

Isabel Anderson Comer Museum, Sylacauga, Alabama

Richard B. Russell Building, Atlanta, Georgia

Samuel Guilford is often inspired by family stories and biblical sources, with his work usually taking on a narrative theme by title as well as content. Although he refuses to be limited to a single style, his free-flowing style can be seen in his nonobjective, color-based works as well as his figure-based painting and watercolors. He has been influenced most by his experiences with his family while growing up in Eufaula, Alabama, and the formal instruction he received at the Atlanta College of Art.

EARL J. HOOKS

Born August 2, 1927, in Baltimore, Maryland

Resides in Nashville, Tennessee

Ceramics, sculpture, painting

EDUCATION

School of American Craftsman, New York,
 1954–1955 (certificate)

Rochester Institute of Technology, Rochester, New York,
 1954 (certificate)

Catholic University, Washington, DC, 1949–1951

B.A., Howard University, Washington, DC, 1945–1949

MAJOR EXHIBITIONS

Fisk University, Nashville, Tennessee

Lagos, Nigeria

Art Institute of Chicago, Chicago, Illinois

Everson Museum of Art, Syracuse, New York

Fort Wayne Museum of Art,
 Fort Wayne, Indiana

Smithsonian Institution, Washington, DC

Howard University, Washington, DC

Miami National, Miami, Florida

John Herron School of Art, Indianapolis, Indiana

Washington Street and Art Center,
 Somerville, Massachusetts

Memorial Art Gallery of the University of Rochester,
 Rochester, New York

American House, New York

Earl Hooks transforms biological shapes in unique ways whether using natural basic materials in his pottery or carving forms in marble. Primarily a ceramist, he creates monochromatic forms that reveal his personal sense of design, balance, rhythm, harmony, and color. Although he follows a highly technical approach, Hooks maintains a commitment to the African American experience and expression. Hooks taught at Fisk University for more than twenty years, remaining a prolific sculptor throughout that time. Hooks was a prizewinner at Indiana University and the John Herron Art School in Indianapolis in 1959, DePauw University, and the South Bend Art Center.

MARGO HUMPHREY

Born 1940 in Oakland, California

Resides in Hyattsville, Maryland

Printmaking

EDUCATION

B.F.A., California College of Arts and Crafts,
 Oakland, California

M.F.A., Stanford University

Whitney Museum of American Art, Summer 1972

MAJOR EXHIBITIONS

Print Biennale in Ljubjiana, Slovenia

Museum of Modern Art, New York

National Gallery of Art, Washington, DC

Smithsonian Institution, Washington, DC.

Bradford Galleries, London, England

Museum of Modern Art, Rio de Janeiro, Brazil

San Francisco Legion of Honor, San Francisco, California

Margo Humphrey is an accomplished printmaker and teacher. Currently on the faculty of the University of Maryland, College Park, since 1989, she began teaching at the University of California in 1973. In her third year there, she was invited to teach at the University of the South Pacific at Suva, Fiji. She has also taught at the University of Texas, San Antonio, and as a visiting professor at the Art Institute of Chicago. Through the United State Information Agency Arts Program, she

has taught at Yaba Technological Institute of Fine Art, Ekoi Island, Nigeria; the University of Benin, Benin, Nigeria; the Margaret Trowell School of Fine Art, Kampala, Uganda; and the National Gallery of Art, Harare, Zaire. Humphrey creates brightly colored narrative prints that relate to various social and interfamilial interactions. Using color patterns and relationships that allude to African flags, textiles, and icons, she presents an immediate association to that culture by relating to casual or playful events.

RICHARD HOWARD HUNT

Born September 12, 1935, in Chicago, Illinois
Resides in Chicago, Illinois
Sculpture, printmaking

EDUCATION
B.A.E., Art Institute of Chicago, 1957
University of Chicago
University of Illinois, Chicago

MAJOR EXHIBITIONS
Laumeier Sculpture Park, St. Louis, Missouri
Indiana State University Art Gallery,
 Terre Haute, Indiana
Museum of African-American History,
 Detroit, Michigan
Illinois State Museum, Chicago and Springfield, Illinois
Lakeside Gallery, Lakeside, Michigan
Holland Area Arts Council, Holland
Michigan George N'Namdi Gallery, Detroit, Michigan
The Studio Museum in Harlem, New York
Andre Zarre Gallery, New York
Worthington Gallery, Chicago, Illinois
University of Notre Dame, The Snite Museum of Art,
 Notre Dame, Indiana
Addison /Ripley Fine Art, Washington, DC
Woodlot Gallery, Sheboygan, Wisconsin
Whitney Museum of American Art, New York
Metropolitan Museum of Art, New York
Museum of Modern Art, New York
Museum of Contemporary Art, Chicago, Illinois
Minneapolis Institute of Art, Minneapolis, Minnesota

Milwaukee Art Center, Milwaukee, Wisconsin
Cleveland Institute of Art, Cleveland, Ohio
University of California, Los Angeles, California
Art Institute of Chicago, Chicago, Illinois
Arkansas Art Center, Little Rock, Arkansas
Yale University School of Art and Architecture,
 New Haven, Connecticut
Wesleyan College, Macon, Georgia
Solomon R. Guggenheim Museum, New York
University of Illinois, Urbana, Illinois
Newark Museum, Newark, New Jersey
Carnegie Museum of Art, Pittsburgh, Pennsylvania
Cincinnati Art Museum, Ohio
American Federation of the Arts, New York
Israel Museum, Jerusalem
Alan Gallery, New York
Contemporary Arts Museum, Houston, Texas

In 1963, critic Hilton Kramer wrote, "Richard Hunt is one of the most gifted and assured artists working in the direct-metal, open-form medium—and I mean not only in his own country and generation, but anywhere in the world. What may not be so immediately apparent is the speed and aesthetic ease with which he has achieved so remarkable a position." Some of the linear dominance prevalent in Hunt's sculptural work was carried over into his prints, particularly a series of dark-toned pieces that continued to explore balance, motion, and light. Hunt has received numerous honors and awards including two Guggenheim Fellowships, a Ford Foundation Fellowship, the James Nelson Raymond Foreign Travel Fellowship to study in England, France, Spain, and Italy (in 1957–1958), and several prizes from the Art Institute of Chicago. He has also received twelve honorary degrees from such institutions as the University of Michigan and Northwestern University, and been affiliated with more than twenty institutions in guest professorships or residencies. He taught as Michigan State University, East Lansing (1997); State University of New York, Binghamton (1990); Kalamazoo College, Kalamazoo, Michigan (1990); Harvard University, Cambridge, Massachusetts (1989–90); Eastern Michigan University, Yipsilanti, Michigan (1988); and Cornell University, Ithaca, New York (1985).

Hunt has served on more than twenty boards, committees, and commissions since 1960 with agencies and organizations in the art field. His work is represented in numerous collections, such as the Metropolitan Museum of Art, Whitney Museum of American Art, the Art Institute of Chicago, Israel Museum, Albright-Knox Art Gallery, Loyola University, Guggenheim Museum, and the Oakland Museum, among others.

BILL HUTSON

Born 1936 in San Marcus, Texas
Resides in Pennsylvania

EDUCATION

University of New Mexico, Albuquerque, New Mexico, 1956–1957
Los Angeles City College, Los Angeles, California, 1958
San Francisco Academy of Art, San Francisco, California
Philadelphia's Museum College of Art, Philadelphia, Pennsylvania
Hussian School of Art
Art Students League, New York

MAJOR EXHIBITIONS

Franklin and Marshall Phillips Museum, Lancaster, Pennsylvania
Newark Museum, Newark, New Jersey
National Center of Afro-American Art, Roxbury, Maryland
University of Texas Art Museum, Texas
Baltimore Museum of Art, Baltimore, Maryland
Salon de Juvisy, France
Galerie Re Cazenare, Paris, France
Mickery Gallery, Amsterdam, The Netherlands
Gallery de Haas, Rotterdam, The Netherlands
Stedlijk Museum, Amsterdam, The Netherlands
Gallery Krikhaar, Amsterdam, The Netherlands
Prism Gallery, San Francisco, California
San Francisco Museum of Modern Art, San Francisco, California
The Studio Museum in Harlem, New York
Columbus Museum of Art, Columbus, Ohio

Hutson, largely a self-taught artist, began drawing at a fairly young age as a positive distraction during periods of idleness. He began considering art as a possible profession in the 1960s after experiencing programs in New Mexico and California. Between 1963 and 1970, he traveled extensively in Europe with stays in Paris, London, Amsterdam, and Rome, exhibiting widely during that time and his work being acquired by several institutions. Greatly influenced by his movement and travel, Hutson's art assumed properties related to the phenomenon. At the same time, he sought the infusion of cultural intent. His abstract objects, some of which are extremely large scale, are architectonic in style and combine a variety of materials, often two or three dimensional in format. His work is in the collections at the National Gallery of Southern Australia, Midtown Galleries, New York, and Morgan State College, among others. Having been on the faculty from 1989 to 2001, he was named the Jennie Brown Cook and Betsy Hess Cook Distinguished artist-in-residence at Franklin & Marshall College.

AMOS "ASHANTI" JOHNSON

Born 1950 in Berkley County, South Carolina
Resides in Charleston, South Carolina
Graphic art, printmaking

EDUCATION

Syracuse University, Syracuse, New York

MAJOR EXHIBITIONS

Marietta-Cobb Museum of Art, Marietta, Georgia
University of Delaware University Gallery, Newark, Delaware
High Museum of Art, Atlanta, Georgia
Parthenon Museum, Nashville, Tennessee
Alabama State University Art Gallery, Montgomery, Alabama
Emory University, Schatten Gallery, Atlanta, Georgia
National Black Arts Festival, Atlanta, Georgia
King-Tisdell Cottage, Savannah, Georgia

Amos "Ashanti" Johnson assumed the "Ashanti" name because he held a close, personal affinity for the Asante people in Ghana, and it was also a way of connecting to Africa and signifying that the association car-

ries over to his aesthetics as an artist. Johnson stylistically follows the tradition established by Charles White. A prolific draftsman, like the artist he so admired (White), Johnson put a premium on his drawings with the intent that they portray the dignity and spirituality of African American people. He is also interested in expressing the relationship between diaspora people and the continent of Africa. Johnson became extremely interested in White's work while he was an art student at Syracuse University. He considered White his mentor (though they never met) through his work, setting up reproductions of the elder artist's imagery in his studio and literally copying them, sometimes breaking the image down into a line-by-line/mark-by-mark scenario. Johnson was convinced that representational imagery was the best means to conveying cultural identity. His work is in the collection of the High Museum of Art.

LOÏS MAILOU JONES

Born 1905 in Boston, Massachusetts
Died 1998 in Washington, DC
Painting, illustration, printmaking

EDUCATION
B.A.E., Howard University, Washington, DC
Art Students League, New York
Boston Normal Art School, 1926–1927 (certificate)
School of the Museum of Fine Arts, Boston, 1923–1927
Academie Julian, Paris, France, 1937–1938
Ecole des Beaux Arts, Paris, France, 1937–1938

MAJOR EXHIBITIONS
Corcoran Museum of Art, Washington, DC
Art Institute of Chicago, Chicago, Illinois
High Museum of Art, Atlanta, Georgia
Fisk University, Nashville, Tennessee
The Studio Museum in Harlem, New York
Howard University, Washington, DC
Museum of Fine Arts, Boston, Massachusetts
State Armory, Wilmington, Delaware
Gallerie International, New York
Washington Watercolor Society
Society of Washington Artists

American Watercolor Society
Xavier University Art Gallery, New Orleans, Louisiana
Rhodesia Museum, Salisbury, Maryland
Washington Art Guild, Washington, DC
Phillips Collection, Washington, DC
Seattle Art Museum, Seattle, Washington
National Gallery of Art, Washington, DC
Baltimore Museum of Art, Baltimore, Maryland
Institute of Modern Art, Boston, Massachusetts

Loïs Mailou Jones successfully blended European early modernist styles with pure African-derived elements in much of her work. Although her oeuvre was diverse, her figurative work, landscapes/rooftops, and design images hold traces of an African sensibility and knowledge of European approaches. Best known for her paintings, she was also highly regarded as a teacher. Jones was a professor at Howard University for forty-seven years (1930–1977). Elizabeth Catlett and David Driskell are two of her most prominent former students. Among the first African American graduates of the Boston Museum School of Fine Arts, she established the art department at Palmer Memorial Institute in Sedalia, North Carolina, and was one of the strongest advocates for African American artists. Her work is in the collections of the Brooklyn Museum, the Phillips Collection, the Corcoran Gallery of Art, the Palais National in Haiti, and the Walker Art Center.

PAUL RAYMOND (P.R.) JONES, JR.

Born September 20, 1956, in Birmingham, Alabama
Resides in Los Angeles, California
Graphic art

EDUCATION
Studied, West Los Angeles Community College, California

MAJOR EXHIBITIONS
Marietta-Cobb Museum of Art, Marietta, Georgia

P. R. Jones worked for eleven years as a member of the computing staff of Hughes Aircraft in Los Angeles, California. His association with artist Amos Johnson in the 1970s sparked an interest in sketching and

drawing. The works he produced were primarily portraits and narrative scenes.

JACOB LAWRENCE

Born September 7, 1917, in Atlantic City, New Jersey
Died June 13, 2000, in Seattle, Washington
Painting

EDUCATION
Harlem Art Workshop, New York, 1932–1939
Harlem Community Art Center, New York, 1936
American Artists School, New York, 1937–1939

MAJOR EXHIBITIONS
American Artists School, New York
Seattle Art Museum, Seattle, Washington
The Phillips Collection, Washington, DC
High Museum of Art, Atlanta, Georgia
Whitney Museum of American Art, New York
Herbert F. Johnson Museum of Art, Ithaca, New York
National Institute of Arts and Letters
Newark Museum, Newark, New Jersey
Museum of Modern Art, New York
Metropolitan Museum of Art, New York
Art Institute of Chicago, Chicago, Illinois
Brandeis University, Waltham, Massachusetts
Museum of Fine Arts, Boston, Massachusetts
Portland Museum of Art, Portland, Oregon
National Institute of Arts and Letters
Boston Institute of Modern Art, Boston, Massachusetts
Baltimore Museum of Art, Baltimore, Maryland
Brooklyn Museum of Art, Brooklyn, New York
Hirshhorn Collection, Washington, DC
Rhode Island School of Design, Providence, Rhode Island
New Jersey State Museum, Trenton, New Jersey
Museum of Modern Art, São Paulo, Brazil

Jacob Lawrence has been a prominent figure on the American art scene for more than sixty years. His most revered body of work is his *Migration Series,* sixty panels completed in 1941 when Lawrence was twenty-three years old. Capturing the story of the African American exodus from the South to the North after World War I, Lawrence included extensive text, affirming the reality of the historical event and assuring its connection to the present day is realized. Inspired by his first mentors, painter Charles Alston and sculptor Augusta Savage, Lawrence made the transition from Atlantic City and Philadelphia to Harlem's burgeoning culture community with relative ease. Early on, his preference for strong design, carefully formed color relationships, and a cubist-expressionist style was evident. By 1937, he was already working in a small panel format. Throughout his career, Lawrence created images of American life and heritage through the voice and experience of the African American. His work is in most major collections in the country, including the Metropolitan Museum of Art, the Museum of Modern Art, and the Whitney Museum of American Art.

SAMELLA SANDERS LEWIS

Born 1924 in New Orleans, Louisiana
Resides in California
Painting, printmaking

EDUCATION
M.A., Ph.D., Ohio State University
B.S., Hampton University, 1945

MAJOR EXHIBITIONS
Hampton University Museum, Hampton, Virginia
Fisk University, Nashville, Tennessee
Newark Museum, Newark, New Jersey
North Carolina Central University Art Museum, Durham, North Carolina
Clark Atlanta University Art Galleries, Atlanta, Georgia
Art Institute of Chicago, Chicago, Illinois
The Fine Arts Museum of San Francisco, California
High Museum of Art, Atlanta, Georgia
Corcoran Gallery, Washington, DC
The Studio Museum in Harlem, New York
Colby College Museum of Art, Waterville, Massachusetts
University of Maryland, College Park, Maryland
Whitney Museum of American Art, New York
State Armory, Wilmington, Delaware
La Jolla Museum of Art, La Jolla, California
Howard University, Washington, DC

Samella Lewis was the first dual-doctorate major in fine arts and art history. Her stay at Hampton Institute (now Hampton University) in the 1940s was a pivotal stage in that career. She transferred to Hampton from Dillard University in New Orleans with her mentor, well-known African American artist Elizabeth Catlett, and was encouraged to continue doing the M.A. and Ph.D. work in art history, with a concentration on Asian and African arts and culture. Under the tutelage of Viktor Lowenfeld at Iowa, she created *Waterboy,* her first canvas painting and a work she did for personal satisfaction rather than a class assignment. Lowenfeld had heightened her sensitivity to pure colors from a symbolic standpoint and as a means to avoid muddying them in mixing. In the painting, she also began to move away from an imitative approach to making a portrait. Lewis also excelled as a teacher, having served as professor of art history at Scripps College for many years. She also is founder and publisher of the Hampton University–based *International Review of African American Art,* and has written important books on African American art as well as children's books. Lewis's work is included in many private collections, important galleries, and museum collections including Atlanta University and the High Museum of Art, Atlanta, Georgia; the Baltimore Museum of Art, Baltimore, Maryland; Hampton University Museum, Hampton, Virginia, and the Oakland Museum, Oakland, California.

JAMES LITTLE

Born 1952
Resides in New York
Painting

EDUCATION
M.F.A., Syracuse University, New York, 1976
B.F.A., Memphis Academy of Art, Tennessee, 1974

MAJOR EXHIBITIONS
Walker Art Center, Minneapolis, Minnesota
Nexus Contemporary Art Center (now The Contemporary), Atlanta, Georgia
Marietta-Cobb Museum of Art, Marietta, Georgia

University of Delaware University Gallery, Newark, Delaware
Pennsylvania State University, University Park, Pennsylvania
Chrysler Museum of Art, Norfolk, Virginia
University of Maryland Art Gallery, College Park, Maryland
State University of New York, Westbury, New York
Bucknell University Art Gallery, Lewisburg, Pennsylvania

The first generation of African American artists pursuing pure abstraction in their work emerged around 1960. Al Loving and William T. Williams were prominent in the development of geometric abstraction. Alma Thomas and Sam Gilliam were veterans in the color field school. Jack Whitten and Howardena Pindell captured, in distinct and individual ways, a sense of emphasis on process. James Little's abstract works burst on the art scene in the 1980s, and seemed to adhere to the tenets of pure abstraction on the one hand—containing an obvious reliance on color, surface texture, the interaction of elements in such a way that the topic, theme, and message are the painting itself—yet on the other hand, his manipulation of these points was done in such a way as to evoke associations with African aestheticism—tones, shine, patterning, and the nature of use of compartmentalization.

LIONEL LOFTON

Born 1954 in Houston, Texas
Resides in Houston, Texas
Painting, printmaking, mixed media

EDUCATION
Texas Southern University, Houston, Texas
M.A., University of Houston, Clear Lake, Texas
B.A., Prairie View A&M University, Texas

EXHIBITIONS
El Paso Museum of Art, Texas
San Antonio Museum of Art, Texas
Hunter Museum of Art, Chattanooga, Tennessee
Museum of African Life and Culture, Dallas, Texas
Artistic Expressions, Atlanta, Georgia
McAnthony's Gallery, Fort Worth, Texas
Thelma Harris Gallery, Berkeley, California
Museum of Science and Industry, Chicago, Illinois

Philadelphia, Pennsylvania

Albuquerque, New Mexico

Lionel Lofton is best known for his colorful abstract paintings though he also frequently works in printmaking and mixed media, combining acrylics, watercolor, and color pencil. His imagery often refers to concepts of inner strength, beauty, and spirituality. He was greatly influenced by John Biggers under whom he studied early in his development as an artist. His work has been seen extensively throughout the United States, especially in traveling exhibitions.

EDWARD L. LOPER, SR.

Born 1916 in Wilmington, Delaware

Resides in Wilmington, Delaware

Painting

MAJOR EXHIBITIONS

Michael Rosenfeld Gallery, New York

Delaware Art Museum, Wilmington, Delaware

Edward Loper is a state treasure to most Delawareans in the art community. Born on the east side of Wilmington, Loper has spent the majority of his life in the state perfecting his painting style, continuing to do so via a personal exploration of color and abstraction. Loper became interested in art when he was twenty years old and began working for the Index of American Design of the Works Progress Administration. By 1953, Loper was working full-time as an artist and art teacher, instructing hundreds of students over the decades. Having attended art classes at the Barnes Collection in Pennsylvania, Loper began fracturing the picture plane in the 1950s. Creating a kaleidoscope effect, he emphasized color increasingly more by the next decade. Loper is the subject of the thirty-minute video, *Edward L. Loper: Prophet of Color*. His work is in the permanent collections of the Philadelphia Museum of Art, the Corcoran Gallery of Art, the Museum of African American Art in Tampa, the Museum of American Art/Pennsylvania Academy of Fine Arts, Howard University in Washing-

ton, DC, Clark Atlanta University Art Galleries, and the Delaware Art Museum.

AIMEE MILLER

Born 1978 in Atlanta, Georgia

Resides in Atlanta, Georgia

Painting

EDUCATION

M.F.A., University of Delaware, Newark, Delaware, 2004

B.A., Spelman College, Atlanta, Georgia, 2001

MAJOR EXHIBITIONS

Newark Arts Alliance, Newark, Delaware

University of Delaware University Gallery, Newark, Delaware

Actors Theatre of Louisville, Louisville, Kentucky

Spelman College Museum of Fine Art, Atlanta, Georgia

Aimee Miller is a member of the field of younger African American artists pursuing abstraction as a means to expressing personal interests. Relating her color fields to the nonphysical "landscapes" of faith and buoyancy in flight, Miller seeks to evoke viewer experiences that parallel actual physical realities but are brought into play because of memory triggered by the visual/physical reality of the painted surface.

JIMMIE LEE MOSELY

Born 1927 in Lakeland, Florida

Died 1974 in Maryland

Painting, printmaking, sculpture, mixed media

EDUCATION

M.A., Pennsylvania State University, 1955

B.A., Texas Southern University, 1952

MAJOR EXHIBITIONS

Marietta Cobb Museum, Marietta, Georgia

University of Delaware University Gallery, Newark, Delaware

Philadelphia Civic Center Museum, Philadelphia, Pennsylvania

Smith Mason Gallery

Jonade Gallery, Baltimore, Maryland

Xavier University Art Gallery, New Orleans, Louisiana

(Clark) Atlanta University Art Gallery, Atlanta, Georgia

Illinois State University, Illinois

Nelson Gallery, Kansas City, Missouri

Atkins Museum, Kansas City, Missouri

Working in watercolor in a manner that loosely referred to the style of Maurice Prendergast, Mosely consistently addressed street scenes and other community settings often with the African American portrayed in nonracial contexts. In other cases, as with *Protest* (1965), his watercolors respond to the social climate of the era. Mosely was director of art education at Maryland State College and president of the National Conference of Artists.

MING SMITH MURRAY

Born June 14 (undisclosed year) in Detroit, Michigan

Resides in New York

Photography

EDUCATION

B.S., Howard University, Washington, DC

EXHIBITIONS

Museum of Modern Art, New York

The Studio Museum in Harlem, New York

Smithsonian Institution, Washington, DC

Atlanta History Center, Atlanta, Georgia

Metro's Center for Visual Arts, University of Colorado at Denver

Rush Art Gallery, New York

Watts Tower, Los Angeles, California

African American Museum, Philadelphia, Pennsylvania

California African American Art Museum, Los Angeles

Art in the Atrium, Morristown, New Jersey

Georgia State University Gallery, Atlanta, Georgia

University of Delaware University Gallery, Newark, Delaware

Delaware State University, Dover, Delaware

Ming Smith Murray spent much of her youth in Columbus, Ohio, in a neighborhood that inspired some of her earliest approaches to image making. She creates allegorical, often atmospheric photographs that are frequently drawn from personal experiences and dreams. Avoiding literalness in much of her work, which is primarily black and white, she presents personalized depictions of people, places, objects, and events with theatrical drama and highly manipulated senses of atmosphere. Loaded with secret messages and allusions to coded data, her photographs read as visual diary entries that are sometimes evocative and other times blurred to the point of being disturbing.

AYOKUNLE ODELEYE

Born in 1951(?) in Newark, New Jersey

Resides in Stone Mountain, Georgia

Sculpture, painting

EDUCATION

M.F.A., Howard University, Washington, DC, 1975

B.F.A., Howard University, Washington, DC, 1973

Virginia Commonwealth University, Richmond, Virginia, 1969

MAJOR EXHIBITIONS

Thelma Harris Art Gallery, Oakland, California

Kennesaw State University, Kennesaw, Georgia

Savannah State University, Savannah, Georgia

Marietta-Cobb Museum of Art, Marietta, Georgia

Tubman Museum, Macon, Georgia

Camille Love Gallery, Atlanta, Georgia

Valdosta State University Fine Arts Gallery, Valdosta, Georgia

Nexus Contemporary Art Center (now The Contemporary), Atlanta, Georgia

Spelman College Museum of Fine Art, Atlanta, Georgia

Howard University, Washington, DC

Ayokunle Odeleye was born in Newark, New Jersey, and raised in Fredericksburg, Virginia, where he attended high school. He began college at Virginia Commonwealth University in Richmond, Virginia, and later moved to Washington, D.C. Currently on the faculty at Kennesaw State University in Kennesaw, Georgia, he has taught at Howard University in Washington, D.C., and Spelman College and Georgia State College in Atlanta, Georgia. Known for his large and small-scale sculpture in a variety of media, Odeleye specializes in

large-scale environmental sculpture for public spaces. Having been awarded thirteen public art commissions, his work may be seen in Dallas, Texas, Pensacola and St. Petersburg, Florida, Wilmington, North Carolina, Richmond, Virginia, Mt. Rainer and Baltimore, Maryland, and at six sites in Atlanta, Georgia. Odeleye's work in the permanent collections of numerous institutions including Howard University Gallery of Art in Washington, D.C., Spelman College Museum of Fine Art in Atlanta, and Morehouse College in Atlanta.

HAYWARD LOUIS OUBRE, JR.

Born 1916 in New Orleans, Louisiana
Resides in Winston-Salem, North Carolina
Sculpture, painting, printmaking

EDUCATION
M.F.A., University of Iowa, 1948
Studied, Atlanta University, 1940
B.A., Dillard University, New Orleans, 1939

Oubre taught at Florida A&M University (1948), Alabama State College (currently University, 1949–1965), and Winston-Salem State University (1965–1981), chairing the department from 1965 to 1981. He also instituted the art studio major at Winston-Salem State. As an artist, Oubre worked in a social realist style in the 1940s and 1950s, and later explored the implications of color and texture in his paintings. Oubre is best known for his wire sculpture, some of his figurative pieces being life size and formed exclusively with wire cutters and pliers.

HARPER TRENHOLM PHILLIPS

Born August 28, 1928, in Courtland, Alabama
Died July 27, 1988, in New York
Painting, collage, mixed media

EDUCATION
M.A., New York University, New York, 1957
B.S., Alabama State University, Montgomery, Alabama, 1951

EXHIBITIONS
Whitney Museum of American Art, New York
The Louvre, Paris, France
Howard University, Washington, DC
National Academy Galleries, Washington, DC
Virginia Museum, Richmond, Virginia
University of Delaware, Perkins Center Gallery, Newark, Delaware
Madison Gallery, New York
Delaware State University, Dover, Delaware

Harper T. Phillips distinguished himself as an artist and a teacher. After attaining a master's degree in New York, he taught at Columbia University Teachers College, Manhattan Community College, Bergen Community College, and the Creative Arts Academy of New York. He also taught at Grambling State University, Alabama State University, Hampton University, and The Horace Mann Lincoln Institute. His paintings and murals were shown across the United States and abroad. He completed commissions for Morehouse College in Atlanta, the Martin Luther King Dexter Avenue Memorial Church in Montgomery, and the state of New York. His use of bold abstraction and brilliant colors characterizes his paintings and collages, which vary from figural to fantastical abstraction. Phillips's artwork is in the collections of (Clark) Atlanta University in Atlanta, Georgia, Hampton University in Hampton, Virginia, Alabama State University in Montgomery, Alabama, Howard University in Washington, DC, and Jackson State University in Mississippi.

HOWARDENA PINDELL

Born 1943 in Philadelphia, Pennsylvania
Resides in New York
Painting, collage, graphic art, printmaking

EDUCATION
M.F.A., Yale University, New Haven, Connecticut, 1967
B.F.A., Boston University School of Fine and Applied Art, 1965

MAJOR EXHIBITIONS
Spelman College Museum of Fine Art, Atlanta, Georgia
Louisiana Museum, Copenhagen, Denmark

G. R. N'Namdi Gallery, Birmingham, Michigan

Whitney Museum of American Art, New York

Howardena Pindell currently works in an autobiographical style as a means to discussing and focusing on issues of race, class, gender, and abuse. In the late 1970s, Pindell pasted punch-paper holes onto paper and canvas in ways that related her work to process art. She worked with the Museum of Modern Art in New York for twelve years as exhibition assistant, curatorial assistant, and associate curator. Since 1979 she has been professor of art, State University of New York at Stony Brook. Pindell has also been visiting professor at Yale University, and visiting faculty member at Skowhegan School of Painting.

PRENTICE HERMAN POLK

Born 1898 in Bessemer, Alabama

Died 1984 in Tuskegee, Alabama

Photography

EDUCATION

Tuskegee Institute, Tuskegee, Alabama, 1916–1920

Apprenticed with Fred Jensen, Chicago, Illinois, 1922–1926

MAJOR EXHIBITIONS

Spelman College Museum of Fine Art, Atlanta, Georgia

Art Institute of Pittsburgh, Pittsburgh, Pennsylvania

Iowa State University Museums, Ames, Iowa

University of Delaware University Gallery, Newark, Delaware

Atlanta University Center, Atlanta, Georgia

Emory University, Schatten Gallery

Birmingham Museum of Art, Birmingham, Alabama

California Museum of African American History, Los Angeles, California

Ledel Gallery, New York

Corcoran Gallery, Washington, DC

Douglas Elliot Gallery, San Francisco, California

Pyramid Gallery of Art, Detroit, Michigan

Nexus Contemporary Art Center (now The Contemporary), Atlanta, Georgia

House of Friendship, Soviet Union

Washington Gallery of Photography

The Studio Museum in Harlem, New York

Tuskegee Institute, Tuskegee, Alabama

New York Museum of National History, New York

Prentice Herman Polk was the preeminent recorder of Tuskegee University (then Institute) from the late 1920s through the civil rights era, and through his photographs of the noted scientist George Washington Carver. Polk created more than 500 negatives of Carver, capturing him in every conceivable situation on the campus. He also documented the string of illustrious visitors to the campus, including the nation's top political, social, education, and entertainment leaders from all racial backgrounds. At the same time, he enjoyed a lucrative studio business, making photographs of students, citizens, and models through which he established his technique of "working from the dark side"—revealing form by working from the deeper tones to the lighter ones.

JOHN T. RIDDLE

Born March 18, 1933, in Los Angeles, California

Died March 2002 in Atlanta, Georgia

Sculpture, painting, printmaking

EDUCATION

M.F.A., California State University, Los Angeles, 1973

B.A.E., California State University, Los Angeles, 1966

MAJOR EXHIBITIONS

High Museum of Art, Atlanta, Georgia

Atlanta University Center Inc., Atlanta, Georgia

San Jose State College, San Jose, California

University of Iowa Museum of Art, Iowa City, Iowa

California State College, Los Angeles, California

Ankrum Gallery, Los Angeles, California

Brockman Gallery, Los Angeles, California

Oakland Museum of California, Oakland, California

John Riddle returned from a tour in the U.S. Air Force and taught at Los Angeles High School and Beverly Hills High School before moving to Atlanta, Georgia, in 1984 to teach at Spelman College. His work chronicles the history of the African American experience through

the biographies of historical figures, significant events, and important literature. Riddle responded to the turbulent civil rights era of the 1960s, especially the 1965 Watts riots, by developing work rooted in African American consciousness. His early figurative paintings were in a flat painted style reminiscent of the works of Jacob Lawrence and Romare Bearden. But, finding painting too passive, he began exploring the streets in South Central Los Angeles collecting rusted metal, discarded machines, and other debris to use in his assemblages. He returned to Los Angeles in 1999 to work at the California African American Museum. Riddle received three first prizes in the Watts Festival in California and won a California Emmy Award for "Renaissance in Black," which aired on KNBC-TV in 1971. His work is in the collections of the High Museum of Art in Atlanta, Georgia, and the Oakland Museum in Oakland, California.

BETYE IRENE (BROWN) SAAR

Born July 30, 1926, in Los Angeles, California

Resides in Los Angeles, California

Assemblage, collage, printmaking, installation

EDUCATION
B.A., University of California, Los Angeles, 1949

Studied, Pasadena City College, Pasadena, California

Studied, California State University, Long Beach

MAJOR EXHIBITIONS
Whitney Museum of American Art, New York

The New Museum of Contemporary Art, New York

San Francisco Museum of Modern Art, California

Fresno Art Museum, Fresno, California

The Studio Museum in Harlem, New York

Museum of Contemporary Art, Los Angeles, California

Parson-Otis Institute, Los Angeles, California

Philadelphia Museum of Art, Pennsylvania

Spelman College Museum of Fine Art, Atlanta, Georgia

Minnesota Museum of American Art,
 St. Paul, Minnesota

University of Maryland Art Gallery,
 College Park, Maryland

Museum of Fine Arts, Houston, Texas

Betye Saar's career spans more than fifty years of work in assemblage, collage, printmaking, installations, and design, which has not only established her as one of America's most innovative practitioners but has also inspired her two daughters (Allison and Lezsley) to follow and succeed down a similar path. She, too, was creatively stimulated by the experiences of family and environment. Growing up in the midst of her mother's interest in knitting, jewelry making, and sewing had an impact, as did growing up in Watts where she witnessed Simon Rodi building the famous Watts Tower using such items as discarded bottlecaps, glass, and shells. Betye Saar was further influenced by the box art of Joseph Cornell after seeing an exhibition of his work at the Pasadena Art Museum (currently the Norton Simon Museum) in 1968. She began working with boxes and windows to encase images that spoke to her personal history, including her mixed heritage. Objects such as gloves, jewelry, fur, old family photographs, and other diverse (sometimes found) items were combined to create allegorical, mystical, and socially challenging works of art. This included image references to African American memorabilia and stereotypes such as Aunt Jemima. Her work is in the collections of the Metropolitan Museum of Art in New York, the Hirshhorn Museum and Sculpture Garden in Washington, DC, the High Museum of Art in Atlanta, Georgia, the National Museum of American Art in Washington, DC, and the Whitney Museum of American Art in New York.

IMANIAH SHINAR (JAMES COLEMAN, JR.)

Birthplace and date unknown

Resides in Washington, DC

Painting, graphic art

Imaniah Shinar is a multitalented artist, skilled not only in the visuals arts as a painter and draftsman but also as a talented vocalist and musician who plays several instruments that he usually crafts himself. In his artwork, Imaniah focuses on subjects ranging from

traditional still-lifes to portraiture. The subjects in his portraits are generally derived from his own imagination and speak to a fundamental idea of African American presence and type that conveys a strong sense of high regard and deep affection.

JEWEL WOODARD SIMON

Born July 28, 1911, in Houston, Texas
Died December 1996 in Atlanta, Georgia
Painting, graphic art

EDUCATION
B.F.A., Atlanta College of Art, Atlanta, Georgia, 1967
B.A., Atlanta University, Atlanta, Georgia, 1931

MAJOR EXHIBITIONS
High Museum of Art, Atlanta, Georgia
(Clark) Atlanta University, Atlanta, Georgia
Winston-Salem State University, Winston-Salem,
 North Carolina
Spelman College Museum of Fine Art,
 Atlanta, Georgia
Huntsville Museum of Art, Huntsville, Alabama
International Society of Artists, New York
Japan Metropolitan Museum, Tokyo, Japan
Florida A&M University, Tallahassee, Florida
Emory University Schatten Gallery, Atlanta, Georgia
Illinois State University, Normal, Illinois
Mount Holyoke College, South Hadley, Massachusetts
Georgia Institute of Technology, Atlanta, Georgia
Southern Illinois University, Edwardsville, Illinois
Carnegie Museum of Art, Pittsburgh, Pennsylvania
Jackson State College, Jackson, Mississippi
Stillman College, Tuscaloosa, Alabama
West Virginia State College, West Virginia
Oakland Museum of California, Oakland, California
University of California, Los Angeles, California
Howard University, Washington, DC
Museum of Fine Arts, Houston, Texas

Jewel Simon considered art a pastime until her drawings quickly sold at a fundraiser for the high school where she taught. Holding a degree in mathematics, she developed an interest in art while studying at Atlanta University. Settling in Atlanta with her husband in 1941, Simon studied charcoal drawing under Bertha L. Hellman for two years. In 1946, she studied painting under Hale Woodruff, and, in 1947, sculpture under Alice Dunba. Simon persisted until she was allowed to enter the Atlanta College of Art, having been repeatedly denied because of a policy not to admit African Americans, and became the school's first black graduate. She won eight Purchase Awards and six honorable mentions at the (Clark) Atlanta University Annual. Her work appeared on the cover of the January 1973 issue of *Crisis* (NAACP) magazine.

CLARISSA T. SLIGH

Born 1939 in Washington, DC
Resides in New York
Photography, mixed media

EDUCATION
M.F.A., Howard University,
 Washington, DC, 1999
M.B.A, University of Pennsylvania, 1973
B.F.A., Howard University,
 Washington, DC, 1972

MAJOR EXHIBITIONS
Smithsonian Institution

Clarissa Sligh is a widely exhibited independent artist whose work centers on personal memories and events as acts or reclamation. In constructing alternative versions she redefines and re-presents her story, taking ownership over her past and future. Through photography, writing, drawing, and computer manipulations she examines family, society, ethnicity, and gender from her perspective as an African American woman. She became known for her subtle reworkings of such books as the Dick and Jane series of the 1940s–1960s, which involved use of her own family snapshots. She employs various computer, photo, and graphic media to produce prints and books that involve a re-visioning of the semiotics of cultural icons and histories.

ALVIN SMITH

Born November 27, 1933, in Boston, Massachusetts
Died 2001
Painting, illustration

EDUCATION
B.A., University of Iowa
University of Illinois
Kansas City Art Institute
Columbia University Teachers College, New York
New York University, New York

MAJOR EXHIBITIONS
Fisk University, Nashville, Tennessee
Art Institute of Chicago, Chicago, Illinois
Corcoran Gallery of Art, Washington, DC
The Studio Museum in Harlem, New York
University of Delaware University Gallery,
 Newark, Delaware
Brandeis University, Waltham, Massachusetts
Museé Rath, Geneva, Switzerland
Brooklyn Museum of Art, Brooklyn, New York
Mount Holyoke College, South Hadley, Massachusetts
Columbia University Teachers College, New York
National Academy Galleries, New York
Purdue University, West Lafayette, Indiana
(Clark) Atlanta University, Atlanta, Georgia
Toledo Museum of Art, Toledo, Ohio
Dayton Art Institute, Dayton, Ohio

Al Smith taught in high schools and taught art education at Queens College in Flushing, New York. He also illustrated children's books, winning the Newberry Award for Maia Wojciechowska's *Shadow of the Bull* (1965). He received the Pollock-Krasner Award for lifetime achievements in art. Smith won the painting award given by the *Chicago Tribune* in 1954, four purchase awards from the Atlanta University Annual between 1962 and 1967, and four purchase awards at Dayton Art Institute between 1961 and 1966. His work is in the collections of the Dayton Art Museum, National Museum of American Art, Smithsonian Institution, Columbia University, Clark Atlanta University, and Tougaloo University in Mississippi.

CEDRIC SMITH

Born 1970 in Philadelphia, Pennsylvania
Resides in Atlanta, Georgia
Painting, mixed media

MAJOR EXHIBITIONS
Eclectic Connection Fine Art Gallery, Summit, New Jersey
Thelma Harris Gallery, Oakland, California
In The Gallery, Nashville, Tennessee
Robert Matre Gallery, Atlanta, Georgia
Atmosphere Gallery, New York
Barbara Archer Gallery, Atlanta, Georgia
Noel Gallery, Charlotte, North Carolina
Beverly Libby Gallery, Atlanta, Georgia
Morris Brown College, Atlanta, Georgia
Tubman Museum, Macon, Georgia
Black Fine Art Show, New York
Courtland Jessup Gallery, New York
Fine Art Images, Richmond, Virginia
Hannibal International Fine Art, Brooklyn, New York
Gallery B Ltd, Atlanta, Georgia

Cedric Smith and his family moved from Philadelphia to Thomaston, Georgia, when he was very young. Influenced by the rural southern environment he experienced growing up, traditional landscapes, and popular media, Smith creates collage paintings that superimpose period photographs with contemporary commercial logos and labels. His work is in Georgia collections including the Francis Walker Museum in Thomaston, Tubman Museum in Macon, and Morris Brown College in Atlanta.

HENRY OSSAWA TANNER

Born June 21, 1859, in Pittsburgh, Pennsylvania
Died May 25, 1937, in Etaples, Normandy, France
Painting, printmaking

EDUCATION
Philadelphia Academy of Fine Art

MAJOR EXHIBITIONS
Philadelphia Museum of Art, Philadelphia, Pennsylvania
Smithsonian Institution, Washington, DC

University of Texas Art Museum, Texas

Howard University, Washington, DC

Spelman College Museum of Fine Art,
 Atlanta, Georgia

Morgan State College, Baltimore, Maryland

University of California, Los Angeles, California

Xavier University Art Gallery, New Orleans, Louisiana

Philadelphia Arts Alliance, Philadelphia, Pennsylvania

National Artist Club Galleries, New York

Salon des Artistes Français, Paris, France

American Art Galleries, New York

Vose Galleries, Boston, Massachusetts

Knoedler Gallery, New York

Carnegie Museum of Art, Pittsburgh, Pennsylvania

Pennsylvania Academy of Fine Arts,
 Philadelphia, Pennsylvania

Exhibition of the Society of American Artists

Philadelphia Art Club, Philadelphia, Pennsylvania

Universal Exposition, Paris, France

Henry Ossawa Tanner was the first African American artist to become internationally well known. Convinced that artists should be free to pursue their craft without adhering to culturally determined guidelines, he painted only a few genre scenes, although they remain among the most recognizable. He routinely used people that he knew well, including his father who wanted him to become a minister. He was named an honorary Chevalier of the Order of the Legion of Honor in 1927, France's highest honor; and he became a full academician of the National Academy of Design. His work is represented in the collections of the Louvre in Paris, Pennsylvania Academy of Fine Arts, the Art Institute of Chicago, the Metropolitan Museum of Art, Los Angeles County Museum of Art, and the High Museum of Art.

LEO F. TWIGGS

Born 1934 in St. Stephens, South Carolina

Resides in Orangeburg, South Carolina

Batik painting

EDUCATION

Ph.D., University of Georgia, Athens, Georgia

M.F.A., New York University, New York

B.A., Claftin College

MAJOR EXHIBITIONS

Georgia Museum of Art, Athens, Georgia

Marietta-Cobb Museum, Marietta, Georgia

University of Delaware University Gallery, Newark, Delaware

Smith-Mason Gallery, Washington, DC

Columbia Museum of Art, Columbia, South Carolina

The Mint Museum, Charlotte, North Carolina

University of Cincinnati, Cincinnati, Ohio

University of Georgia, Athens, Georgia

Indiana University, Bloomington, Indiana

Leo Twiggs is nationally regarded for his unique batik painting style that incorporates the ancient wax resin and dye process (associated with both Africa and Indonesia) with modern expressionistic painting techniques and innovative materials. The South Carolina native was the first African American to receive his doctorate in art education from the University of Georgia. Having been at South Carolina State University (initially South Carolina State College) since 1964, he founded the art department in 1973, serving as chair until his retirement in 1998. During much of that time he was also director of the I. P. Stanback Museum and Planetarium. While his imagery addressed a number of specific themes over the years, he consistently drew from the southern landscape environmentally and metaphorically. In 1981, he was the first visual artist to receive the South Carolina Governor's Trophy known as the Elizabeth O'Neil Verner Individual Award. Twiggs has presented more than fifty one-man shows and his work hangs in American embassies in Rome, Togoland, and Dacca.

JAMES VANDERZEE

Born June 29, 1886, in Lenox, Massachusetts

Died May 15, 1983, in New York

Photography

Metropolitan Museum of Art, New York

Museum of Modern Art, New York

Smithsonian Museum of Art, Washington, DC

Smithsonian National Portrait Gallery, Washington, DC

Memphis Brooks Museum of Art, Memphis, Tennessee

High Museum of Art, Atlanta, Georgia

Nexus Contemporary Art Center (now The Contemporary), Atlanta, Georgia

Settling in New York in 1905, James VanDerZee found the "city within the city" to be a place where he could work a traditional job, photograph his family and friends, and play the piano and violin in his free time. Within a few years he initiated his self-taught career as a photographer from a studio on 125th Street. With his most prolific period being 1920–1945, he became one of the busiest photographers in the city, and soon was regarded as the foremost recorder of the Harlem Renaissance era (ca. 1917–1933). His portrayals of people and events on the city's streets distinguished him from many other studio photographers. His images of weddings, funerals, family gatherings, and formal, posed portraits sometime included hand-drawn marks used to heighten the desired effect. Prolific until the end, VanDerZee's later subjects also reflected the successful and the famous, including portraits of Lou Rawls (1980), Romare Bearden (1981), Jean Michel Basquiat (1982), and his final sitting, Regenia Perry (February 5, 1983). VanDerZee photographs are in the collections of the Metropolitan Museum of Art in New York, the Museum of Modern Art in New York, the Studio Museum of Art in New York, and the Amon Carter Museum in Fort Worth, Texas.

LAWRENCE (LARRY) WALKER

Born October 22, 1935, in Franklin, Georgia

Resides in Stone Mountain, Georgia

Painting, mixed medium

EDUCATION

B.S., M.A., Wayne State University

Huntsville Museum of Art, Huntsville, Alabama

City Gallery East, Atlanta, Georgia

Georgia State University, Atlanta, Georgia

Mississippi State University, Mississippi State, Mississippi

Nexus Contemporary Art Center (now The Contemporary), Atlanta, Georgia

Sacramento State College, Sacramento, California

New Jersey State Museum, Trenton, New Jersey

Oakland Museum of California, Oakland, California

Smith-Mason Gallery, Washington, DC

Fresno Art Center, Fresno, California

Stanford University, Stanford, California

Wayne State University, Detroit, Michigan

Stanislaus State College, Turlock, California

University of Michigan, Dearborn, Michigan

Anna Werbe Gallery, Detroit, Michigan

Saginaw Art Museum, Saginaw, Michigan

Larry Walker grew up in New York's Harlem, the location that formed the basis of his interest in urban environments. He taught at the University of the Pacific in Stockton, California, for nineteen years—seven as department chair—and at Georgia State University in Atlanta, Georgia, for seventeen years, serving as chair for six years. Beginning in the late 1970s he emphasized large-format presentations of urban scenes and established the red wall as a repeated object in his work. His figurative works are generally of male silhouettes in black and white or deep reddish-browns and white blends with a few streaks of color. The forms are portrayed as anonymous, loosely defined beings in cosmic surroundings. His work is in the collections of the University of the Pacific, Stockton, the Oakland Museum, Pioneer Museum, and Haggin Art Galleries.

WILLIAM ("ONIKWA BILL") WALLACE

Born November 15, 1938, in Chicago, Illinois

Resides in Chicago, Illinois

Photography

Studied Kennedy-King College, Chicago, Illinois

MAJOR EXHIBITIONS

Museum of Science and Industry, Chicago, Illinois

Kenkeleba Gallery, New York

DuSable Museum, Chicago, Illinois

University of Delaware University Gallery,
 Newark, Delaware

Delaware State University, Dover, Delaware

Georgia State University, Atlanta, Georgia

"Onikwa Bill" Wallace was a staff photographer for the *Chicago Daily Defender* for several years before establishing himself as one of the nation's most prolific and intense fine art photographers. Although he has produced hundreds of works on a variety of subjects, his portrayals of entertainers and other performers across the spectrum of disciplines have brought him his greatest recognition in recent years. From the highly successful jazz and other musicians to those who take to the streets of New Orleans and other cities as festival or parade participants, Wallace captures the nature of their experiences in crisp, well-defined black-and-white photographs, which have caused him to be considered among the nation's best in his field. While maintaining his own successful film production studio in Chicago, Wallace continues to document with fine accuracy the essence of his subjects' talent, energy, and spirit at the height of their performances—often from very close range—without intrusiveness. His work is included in numerous major collections throughout the United States.

CARRIE MAE WEEMS

Born 1953 in Portland, Oregon

Resides in upstate New York

Photography

EDUCATION

Studied, University of California, Berkeley

M.F.A. University of California, San Diego, 1984

B.F.A. from California Institute of the Arts, Valencia, in 1981

MAJOR EXHIBITIONS

Dartmouth College, Hanover, New Hampshire

Nelson Atkins Museum of Art,
 Kansas City, Missouri

High Museum of Art, Atlanta, Georgia

International Center of Photography, New York

Williams College Museum of Art,
 Williamstown, Massachusetts

Museum of Fine Arts, Houston, Texas

Minnesota Museum of American Art,
 St. Paul, Minnesota

Spelman College Museum of Fine Art,
 Atlanta, Georgia

National Museum of Women in the Arts,
 Washington, DC

Contemporary Arts Museum, Houston, Texas

Whitney Museum of American Art at
 Phillip Morris, New York

Boston University Art Gallery, Boston,
 Massachusetts

Carrie Weems calls attention to racially motivated habits and systems in contemporary life through her manipulation of images or concepts associated with a previous era. Her use of unexpected surfaces and poignant messages reverberate through the multiple components of her series. Weems is particularly well known for work that critically investigates the representation of African Americans. At times, her work provides an alternative view, if not one that begins the process of wiping the undesired image from memory. This treatment of time-distanced materials is, interestingly enough, the implied intent in her controversial multilayered work *The Hampton Project,* where she reinterprets the turn-of-the-century photographs taken by Frances Benjamin Johnston (1864–1952) at the Hampton Normal and Agricultural Institute (now Hampton University). *Carrie Mae Weems: The Kitchen Table Series* is another. Her series *Ritual and Revolution* has been shown in Chicago, Berkeley, Dakar, and Berlin. In 1999, Weems received an honorary degree from the California College of Arts and Crafts, Oakland. She has taught at Harvard University, Williams College, and Hunter College.

CHARLES WHITE

Born April 2, 1918, in Chicago, Illinois
Died October 3, 1979, in southern California
Painting, graphic art, education

EDUCATION

Taller de Grafica, Mexico
Escuela de Pintura y Escultura de la Secretaria de Educacion Publica, 1946
Art Students League, New York, 1942
Art Institute of Chicago, 1936

MAJOR EXHIBITIONS

Hunter Museum of American Art, Chattanooga, Tennessee
Brooklyn Museum of Art, Brooklyn, New York
High Museum of Art, Atlanta, Georgia
San Francisco Museum of Modern Art, San Francisco, California
Internationale Buchkunst-Asstellungin, Leipzig, Germany
University of California, Riverside, California
Los Angeles County Museum of Art, Los Angeles, California
Smithsonian Institution, Washington, DC
Metropolitan Museum of Art, New York
Museum of Fine Arts, Boston, Massachusetts
Whitney Museum of American Art, New York
Howard University, Washington, DC
New York University, New York
Hunter, The City University of New York, New York
Brooklyn Museum of Art, Brooklyn, New York
University of Chicago, Chicago, Illinois
Baltimore Museum of Art, Baltimore, Maryland
Newark Museum, Newark, New Jersey
Institute of Modern Art, Boston, Massachusetts
ACA Galleries, New York
Art Institute of Chicago, Chicago, Illinois

Charles White was seven years old when a birthday gift of a set of paints caused him to think about art as a profession. Like Jacob Lawrence, Bill Hutson, and numerous other artists, White frequented the library, thoroughly researching and getting to know the individuals and events that greatly shaped American society. Admired in the states and abroad, his expressionistic style brought a unique social consciousness to visual art expression. In his work, collectively, we are given a graphic portrait of American life and history. His achievement in the field brought him awards such as a National Scholarship Award in 1937, the Childe Hassam Award from the American Academy of Art, and the Adolph and Clara Obrig award from the National Academy of Design, among numerous others.

JACK WHITTEN

Born December 5, 1939, in Bessemer, Alabama
Resides in New York
Painting

EDUCATION

Cooper Union for the Advancement of Science and Art, New York, 1960–1964
Southern University, Baton Rouge, Louisiana, 1959–1960
Tuskegee Institute, Tuskegee, Alabama, 1957–1959

MAJOR EXHIBITIONS

Newark Museum, Newark, New Jersey
Cure Gallery, Los Angeles, California
G. R. N'Namdi Gallery, Birmingham, Michigan
California Afro-American Museum, Los Angeles, California
Horodner Romley Gallery, New York
Jamaica Arts Center, Jamaica, New York
Hampton University, Hampton, Virginia
Onyz Art Gallery, New York
Bucknell University, Lewisburg, Pennsylvania
Museum of Modern Art, New York
The Studio Museum in Harlem, New York
Hofstra University, Hempstead, New York
Trenton State College, Trenton, New Jersey
P.S.1, Long Island, New York
Phoenix Art Museum, Phoenix, Arizona
New Museum of Contemporary Art, New York
Robert Miller Gallery, New York
Metropolitan Museum of Art, New York
Montclair State College, Montclair, New Jersey
New York State University College at Brockport, New York
Whitney Museum of American Art, New York
Pratt Institute, Brooklyn, New York

Center for Visual Arts, New York

Aldrich Museum of Contemporary Art, Ridgefield,
 Connecticut

Vassar College, Poughkeepsie, New York

New York University, Stony Brook, New York

Allan Stone Gallery, New York

For many years, Jack Whitten as a painter explored modernist concepts of space. His paintings are often optical challenges, abstractly designed to the point of fluctuation between references to mystical fields derived from a landscape tradition, geometrically based studies of color and light and associated implications, and any number of surface/process considerations. Ranging from large scale to small formats, his works interact via bits and bites of color, texture, light, and space—both real and illusionary—to read as icons in addition to functioning as individual works.

JOHN WOODROW WILSON

Born 1922 in Boston, Massachusetts

Resides in Boston, Massachusetts

Printmaking, sculpture, graphic art

EDUCATION

Escuela de las Artes del Libro, Mexico, 1954–1955

Esmeralda School of Art, Mexico City, 1952

Instituto Politecnico, Mexico City, 1952

Fernand Leger's School, Paris, 1949

Tufts University, 1947

School of the Museum of Fine Arts, Boston, 1944

MAJOR EXHIBITIONS

Museum of Modern Art, New York

Metropolitan Museum of Art, New York

National Academy of Design, New York

(Clark) Atlanta University, Atlanta, Georgia

Art Institute of Chicago, Chicago, Illinois

Smith College, Northampton, Massachusetts

Detroit Institute of the Arts, Detroit, Michigan

Bezalel Museum, Jerusalem

Boris Mirski Gallery

Newark Museum, Newark, New Jersey

American International College, Springfield, Massachusetts

Cincinnati Art Museum, Cincinnati, Ohio

Museum of Fine Arts, Boston, Massachusetts

The City College of New York, New York

Musée des Beaux-Arts, Rouen, France

Bibliotheque Nationale, Paris, France

(Clark) Atlanta University, Atlanta, Georgia

Albany Institute of History and Art, Albany, New York

Downtown Gallery, New York

John Wilson presents a gripping interpretation of the Richard Wright series: *The Story of the Mann Family.* True to his dramatic approach, he emphasized the figure being challenged in the image, building other elements around characters. He was the recipient of the John Hay Whitney Fellowship in 1950 and five Atlanta University Purchase prizes. His work is in the collections of the Museum of Modern Art, Schomburg Center, Smith College, Brandeis University, Tufts University, (Clark) Atlanta University, and many more.

HALE ASPACIO WOODRUFF

Born 1900 in Cairo, Illinois

Died 1980 in New York

Painting, mural, printmaking, education

EDUCATION

Harvard University, New Haven, Connecticut

Academie Moderne, Paris, France

John Herron Art Institute, Indianapolis, Indiana

MAJOR EXHIBITIONS

The Studio Museum in Harlem, New York

Whitney Museum of American Art, New York

Museum of Fine Arts, Boston, Massachusetts

Los Angeles County Museum of Art,
 Los Angeles, California

San Diego Museum of Art, San Diego, California

High Museum of Art, Atlanta, Georgia

La Jolla Museum, La Jolla, California

New York University, New York

Albany Institute of History and Art, Albany, New York

Baltimore Museum of Art, Baltimore, Maryland

Museum of Fine Arts, Dallas, Texas

Harmon Foundation, New York

Valentine Gallery, New York

Pacquereau Gallery, Paris, France

Art Institute of Chicago, Chicago, Illinois

Kansas City Art Institute, Kansas City, Kansas

University of North Carolina, Chapel Hill, North Carolina

State Museum of North Carolina, Raleigh, North Carolina

University of Southern Illinois, Carbondale, Illinois

University of Michigan, Dearborn, Michigan

Tuskegee Institute, Tuskegee, Alabama

Hampton Institute, Hampton, Virginia

Hale Woodruff is among the most important African American artists of the twentieth century. As a young painter, he developed a serious interest in African art as a part of personal exploration of aesthetics and actively collected it. He vigorously pursued and engaged Henry Ossawa Tanner when he traveled to France eager to garner knowledge from the highly respected artist, and, understanding the relationship between African art and the cubism of Picasso, Braque, and others, took every opportunity to view examples of their work firsthand. A model teacher, Woodruff established the art department at Spelman College in Atlanta (assisted by Nancy Elizabeth Prophet) and initiated the Atlanta University Annual Exhibition and Competition (1942–1971). He was a founder and central member of Spiral, a group of New York artists who sought an activist platform through art that corresponded to that demonstrated in America's streets during the civil rights era. Best known for painting the *Amistad* Murals (1938–1939) at Talladega College in Alabama, Woodruff was highly regarded among his peers for his modernist paintings as well. Drawing from the stimuli around him, he mastered each of the stylistic approaches he attempted from social realism to cubist-based abstraction. Woodruff's work is in collections at Spelman College, (Clark) Atlanta University, the Newark Museum, New York State University, and New York University.

Compiled by Amalia K. Amaki with the assistance of Aimee Miller and Monique Neal.

Notes on Contributors

AMALIA K. AMAKI is curator of the Paul R. Jones Collection and an assistant professor of art and Black American studies at the University of Delaware. She has written several articles, catalog essays, and art reviews along with two books-in-progress, *Freedom Lights the Way: A History of All-Black Shows in America* and *Posed Pictures: Critical Readings in the Photographs of Prentice Herman Polk*.

MARGARET ANDERSEN is a professor of sociology at the University of Delaware and the author of four books including *Race, Class, and Gender* (2000) and *Thinking about Women: Sociological Perspectives on Race and Gender*. She is currently working on a biography of Paul R. Jones with Carole Marks.

MARCIA R. COHEN is a professor of art at the Atlanta College of Art and a nationally known artist and color theorist who has lectured extensively on the theoretical topics related to color throughout the United States and Europe.

ANN EDEN GIBSON is a professor of art history at the University of Delaware. She writes extensively on abstract expressionism and has authored two books on the subject, *Issues in Abstract Expressionism: The Artist-Run Periodicals* and *Abstract Expressionism: Other Politics*.

WINSTON KENNEDY is a professor emeritus in art history at Howard University and a scholar-in-residence at the Schomburg Center for the Research in Black Culture. He specializes in the history of African American prints and African American printmaking workshops.

DIANA MCCLINTOCK is a professor of art history at the Atlanta College of Art. She is nationally known for her work on issues related to American art and modern art.

DEBRA HESS NORRIS is director of the Winterthur/University of Delaware Art Conservation Program and project director of the Andrew W. Mellon Collaborative Workshops in Photograph Conservation. She is a world-renowned authority on photography conservation and author of numerous articles, brochures, and book chapters in the field, with her forthcoming book focusing on the treatment of historic and contemporary print materials.

IKEM STANLEY OKOYE is an associate professor of art history at the University of Delaware. He has written extensively on African architecture, African art, and African American art. His two books in progress are *Hideous Architecture: Feint, Modernity, and Occultation in African Building Practice* and *A Critique of the Idea of the Vernacular in African Architecture*.

SHARON PRUITT is an associate professor of art history at East Carolina University and has written articles and essays on contemporary African art and African American art subjects. She is currently completing a book on North Carolina African American artists.

CARLA WILLIAMS was the 2002–2003 Rockefeller Fellow in the Humanities at Stanford University. A writer and editor, her latest publication is *The Black Female Body: A Photographic History* (with Deborah Willis).

Index

ABOUT THE TYPE

This book was set in Scala, a family of typefaces by the Dutch type designer Martin Majoor. Designed in the 1980s as a proprietary typeface for use by the Vredenburg concert hall in Utrecht, the Netherlands, Scala was first issued in digital form by FontShop International, Berlin, in 1991, followed by a companion sans serif in 1993. Both Scala and Scala Sans are neohumanist typefaces, based on historical humanist letterforms, yet thoroughly modern and individual designs.

Designed and composed by Kevin Hanek

Printed and bound in China by Everbest Printing Company Limited